THE ART OF MODERN TAPESTRY

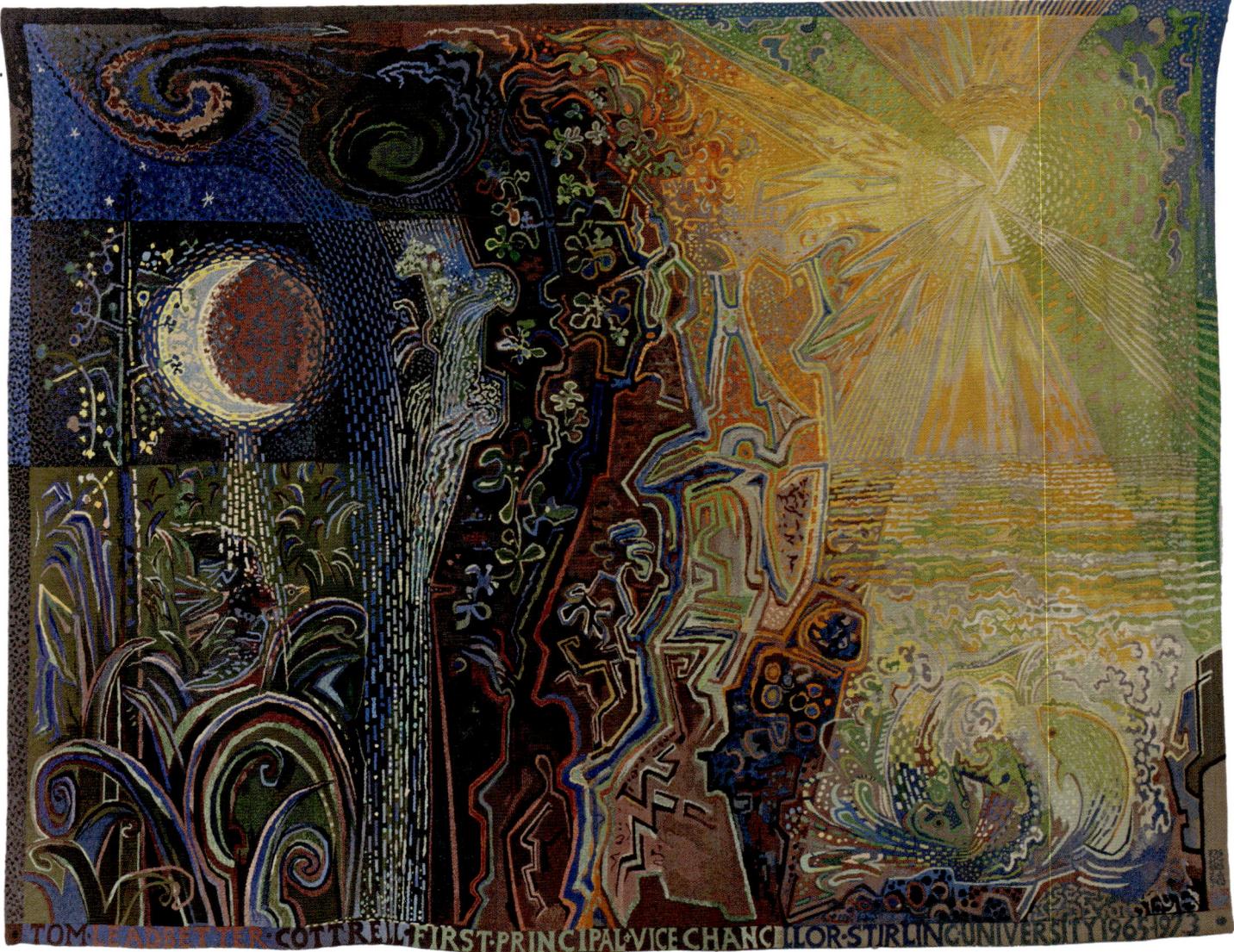

TOM·LEADBETTER·COTTRELL·FIRST·PRINCIPAL·VICE·CHANCILLOR·STIRLING·UNIVERSITY·1965·1973

THE ART OF MODERN TAPESTRY

DOVECOT STUDIOS SINCE 1912

EDITED BY ELIZABETH CUMMING

WITH AN ESSAY BY DOVECOT DIRECTOR DAVID WEIR

LUND HUMPHRIES IN ASSOCIATION WITH DOVECOT STUDIOS

First published in 2012 by Lund Humphries,
in association with Dovecot Studios

Lund Humphries
Wey Court East
Union Road
Farnham
Surrey GU9 7PT

Lund Humphries
Suite 420
101 Cherry Street
Burlington
VT 05401-4405
USA

www.lundhumphries.com

Dovecot Studios
10 Infirmary St
Edinburgh EH1 1LT

www.dovecotstudios.com

Lund Humphries is part of Ashgate Publishing

British Library Cataloguing in Publication Data

The art of modern tapestry : Dovecot Studios since 1912.
 1. Dovecot Studios--History. 2. Tapestry--Scotland--
 Edinburgh--History--20th century.
 I. Cumming, Elizabeth. II. Weir, David.
 746.3'94134-dc23

ISBN: 978-1-84822-105-5

Library of Congress Control Number: 2011942849

Edited by Abigail Grater
Designed by Caroline and Roger Hillier, The Old Chapel Graphic Design, www.theoldchapelivinghoe.com
Set in Bembo and Felix Titling
Printed in China

Frontispiece
John Craxton
The Four Seasons
1975–6
Cotton warp, wool
396.2 × 523.2 cm (156 × 206 in)
University of Stirling

CONTENTS

FOREWORD

Dovecot Studios are probably best known today for the contemporary work they have carried out in association with many well-known artists, including 27 members of the Royal Academy and 21 members of the Royal Scottish Academy, as well as important designs created by their own weavers. Dovecot was originally established in 1912 by the Marquess of Bute to supply his houses with tapestry. Exactly a century on, we are proud and delighted to be celebrating both the Marquess's inspired decision and the exceptional range and quality of work that has been achieved over 100 years.

My awareness of Dovecot began in 1988 when my wife, Elizabeth, and I were invited to the 'cutting off' ceremony for a tapestry based on *Humankind*, a painting by Sir Robin Philipson. We found ourselves in awe of the expertise with which the weavers could develop any design presented to them. Their attention to detail and their skill in blending and mixing yarns on the bobbins to create a rich depth of colour with a three-dimensional effect has to be seen to be believed. The interaction between artist and weavers was especially fascinating to watch. Shortly after our visit, I was asked to contribute to the development of the Edinburgh Festival Theatre; rather than simply donating money, I challenged the theatre's managers to show other forms of art on the building's blank walls and they accepted. I commissioned a group of three paintings by Barbara Rae entitled *Carnival Edinburgh*, and one of these designs was chosen by the weavers and interpreted by them to create the tapestry which hangs in the Theatre today. During one of our many visits to see this work in progress, we saw a speculative tapestry from a design by Elizabeth Blackadder being completed; we purchased it, and enjoy it in our house each day.

When we heard of the imminent closure of Dovecot Studios we decided it was an artistic gem which could and must be saved. It seemed inconceivable that such an important part of Scotland's cultural landscape should be lost, and we felt it was essential that the skill of weaving should be retained in Scotland and brought to the attention of people worldwide.

After an unsuccessful first attempt to buy the Dovecot Studios building together with its contents in 2000, we bought some of the looms and the wool stock and hired two of the weavers. Next we had the problem of finding

somewhere for the weavers to continue their work. We rented a building behind Donaldson's School for the Deaf and raised awareness of the Studios by winning a number of tapestry commissions while we searched for the right permanent home. We eventually found the dilapidated Infirmary Street Swimming Baths, a fine late Victorian building on the Buildings at Risk Register and situated close to the centre of the city. In saving this magnificent structure, we also established a new home for Dovecot Studios with additional exhibition spaces for the creative arts. In 2010 *The Independent* included Dovecot in its list of the top 50 galleries and museums in the United Kingdom. We hope that you too will be captivated by the 'magic of the space'.

We have created a charitable body, the Dovecot Foundation, to ensure the Studios will have a secure future. We work closely in association with other arts bodies and, through promoting Dovecot Studios worldwide to obtain new commissions and work with new artists and designers, we aim to create links with similar organisations in other countries. Most importantly, we wish to train new weavers to continue the Studios' fine tradition.

The journey we have taken since 2000, when we decided to rescue Dovecot Studios, the Edinburgh Tapestry Company and the skill of weaving in Scotland, including finding temporary premises and then a permanent home and converting it to its new use, has sometimes been fraught and has certainly not been easy. It could not have been possible without the help and hard work of many people, and Elizabeth and I would like to thank each of them for the part they have played – especially David Weir, who accepted the role of Director at the beginning.

Elizabeth and I are proud to be part of the line of supporters of the Dovecot Studios stretching back over the last hundred years, and of the very special art of tapestry. This book accompanies an exhibition, elements of which will tour internationally. Both book and exhibition celebrate a distinguished history but they also, equally importantly, celebrate our plans for an exciting future for this unique aspect of Scotland's rich cultural heritage.

Throughout its existence Dovecot Studios has relied on patronage, initially from the Butes, and then the Nobles, back to the Butes and then the Salvesens and now it has been gifted and is owned by The Dovecot Foundation. New commissions ensure the future of the Studios. They will embellish any space. Tapestry enhances life.

Alastair Salvesen, CBE, Chairman, The Dovecot Foundation and Dovecot Studios

A CENTURY AT DOVECOT

ELIZABETH CUMMING

Tapestry is an extraordinary and special art which brings together two worlds – those of craft and of visual art – to make a new one. At its best, an artist and weavers create a unique work in which skill, texture, colour, form and space together spark magic which is visual, tactile and, far from least, intellectual. A weaving is as individual as the weaver who interprets a design. Over the last century the master weavers of Dovecot Studios in Edinburgh have produced nearly 800 tapestries and rugs ranging from the more traditional, finely woven hangings to dazzling and often experimental textile art. Dovecot's story is remarkable and unique.

The beginnings were quite modest. It was simply the creation of the fourth Marquess of Bute (1881–1947) who wished to furnish his homes with modern tapestry. He wished, as his brother Lord Colum Crichton-Stuart (1886–1957) later put it, to 'found a small industry on classical lines … without any hope of profit … [and] in the national interest'. Brave though this may sound, it in fact followed a recent family tradition. Lord Bute's father, famously the leading patron of the architect and designer William Burges, had established a substantial workshop in wood craftsmanship in Cardiff to embellish his houses. He also had had an interest in tapestry and was appointed to the Royal Windsor Tapestry Manufactory's committee in 1877. Some of the weavers who left the Royal Windsor works set up their own workshop in Soho where among their tapestries are known to have been subjects relating to Scottish history. All these factors may well have informed the fourth Marquess's decision to have his own historical tapestries.

The artist came first, ahead of any decision on who might make the tapestries. By early 1909 William Skeoch Cumming (1864–1929), an Edinburgh military artist and portraitist, was designing 'the Mountstuart Highland tapestry' to decorate the Great Hall at Mount Stuart, the extravagant neo-Gothic palace designed by

Fig. 1
Alfred Priest
Verdure Piece (detail)
1938
Wool
183 × 233 cm (72 × 191¾ in)
The Bute Collection at
Mount Stuart

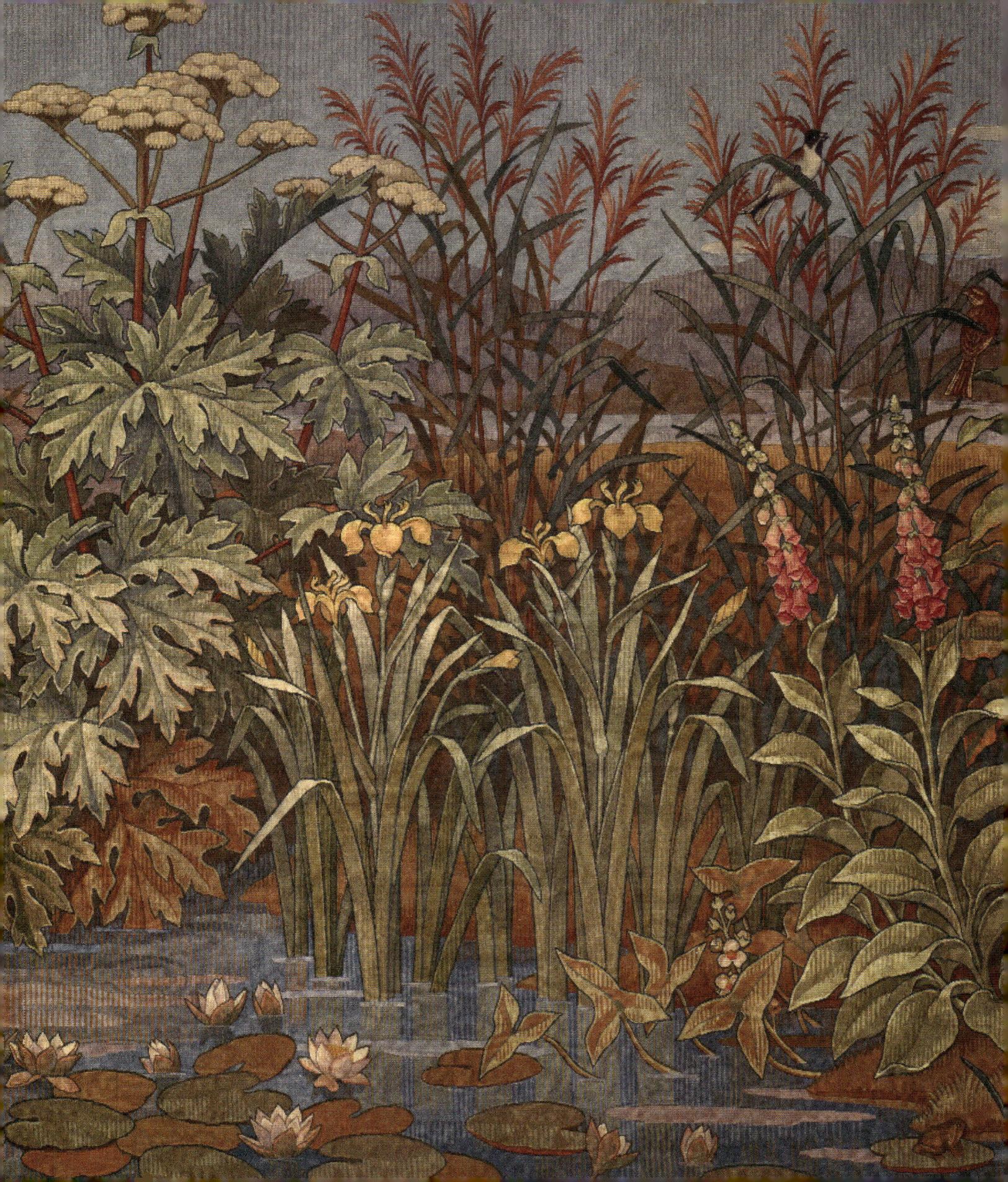

Robert Rowand Anderson for the third Marquess. However, Lord Bute was not yet entirely convinced of the need to open a brand-new workshop. He received a report submitted by a certain Augustin Rischgitz who, after consulting the Musées Royaux des Arts Décoratifs et Industriels in Brussels, confirmed in late 1910 that there was no current atelier working in the old Flemish tradition. At this point William George Thomson (1865–1942) was commissioned to prepare a report on the location, staffing and equipping of a new studio.

Thomson had studied art in Aberdeen and London and tapestry design in Paris and Madrid, and had worked for two years in the Textiles Department of London's Victoria & Albert Museum. His 'report on the procedure of having tapestries woven from cartoons' advocated establishing a weaving studio in 'a healthy location' near Edinburgh. Land which had formerly served as a market garden was identified in the village of Corstorphine, west of the city. The new building, according to the feuing, or land lease, papers of 1911, was to be a 'studio of an attractive and artistic design for carrying on the industry of tapestry making'. There was to be 'no running machinery or factory chimney allowed'. Built of 'brick and harled and slated or tiled' and 'of not less value than five hundred pounds', its surrounding land was to be used exclusively 'as garden ground or for planting or as pleasure ground'. Adjacent stood a fine sixteenth-century dovecot, or 'doocot' in Scots – the sole surviving part of the medieval Corstorphine Castle. The picturesque yet highly functional new studio, built by Thomas Wallace, could not have been a more romantic setting (fig.2).

Dovecot Studios were first formally named in November 1911 on Thomson's orders for wools and silks from London firms. The staffing of this new studio, never a 'workshop', happened gradually. His recommendation had listed a resident artist and a director, a foreman 'tapissier' and five other weavers, office staff and a porter and general handyman, plus women attendants for sweeping etc. Most, but not the last, were recruited. Thomson himself was in post as director of weaving from the autumn of 1911, interviewing weavers and ordering fine and coarse yarns and winding warp from London firms. At the same time he had a Gobelin *haute lisse* (upright as opposed to horizontal) loom in pitch pine made by a workshop in the village, along with weavers' combs in boxwood and bobbins in coconut tree wood. The first weavers, John (Jack) Glassbrook (1889–1917) and Gordon Berry (*d*.1917), arrived at the start of 1912. Both men came from the Morris & Company weaving workshops established in 1881 by William Morris (1834–96) at Merton

Fig.2
The original Dovecot Studios
with the dovecot to the left,
Corstorphine, Edinburgh,
*c.*1985

Abbey, in what was then Surrey. His company had been restructured in 1875 with Morris as principal partner. He learned to weave, with tapestry – deeply infused by the past but also consciously modern in design – soon becoming an important area of production for the firm. Both Glassbrook and Berry had been employed there since the mid-1900s, and had worked on several tapestries designed by Edward Burne-Jones and John Henry Dearle including versions of the celebrated *Angeli Ministrantes* and *Angeli Laudantes*. These tapestries and others, with their careful arrangement of costumed figures within a mass of beautifully observed natural details, provided a perfect grounding for the experience of making the first Dovecot tapestry, *The Lord of the Hunt* (see plate 2). The looms were warped from February and the Studios were now ready for work (figs 3, 4 and 5).

At Dovecot there was a clear physical demarcation of production. The two wide rooms to the north of the building – maximising the natural light – provided a weaving room to the west, and to the east a studio for the design of tapestry which was soon filled with artistic props plus a camera and photographic supports: Skeoch Cumming was using his Royal Scottish Academy training for

Fig.3 (right)
William Skeoch Cumming
The Lord of the Hunt (detail)
Section completed 1920–24
The Bute Collection at
Mount Stuart

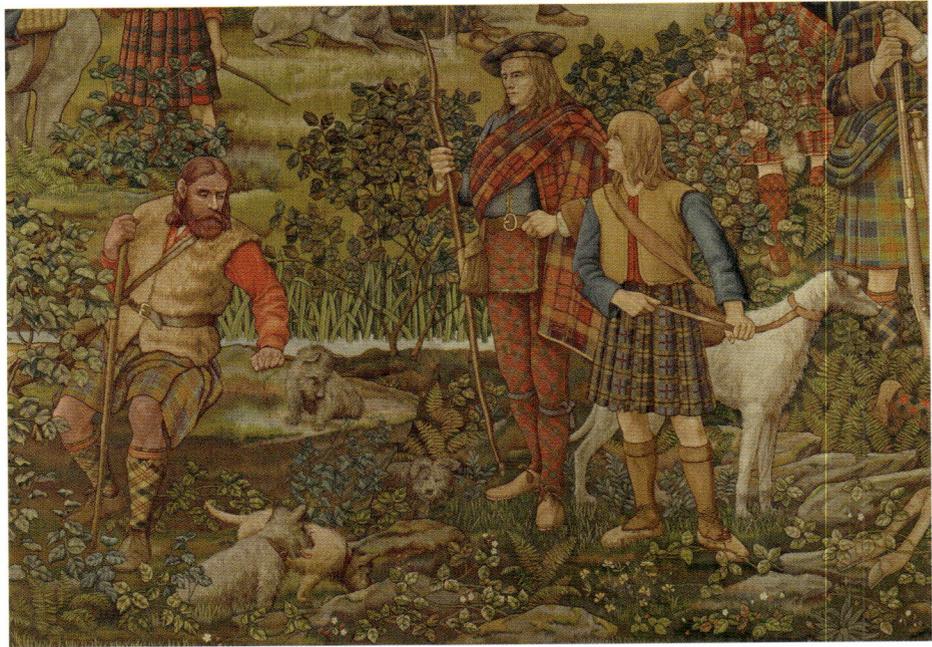

Fig.4 (below left)
William Skeoch Cumming
The Lord of the Hunt (detail)
Section completed 1915–16
The Bute Collection at
Mount Stuart

Fig.5 (below right)
William Skeoch Cumming
The Lord of the Hunt (detail)
Section completed 1912–14
The Bute Collection at
Mount Stuart

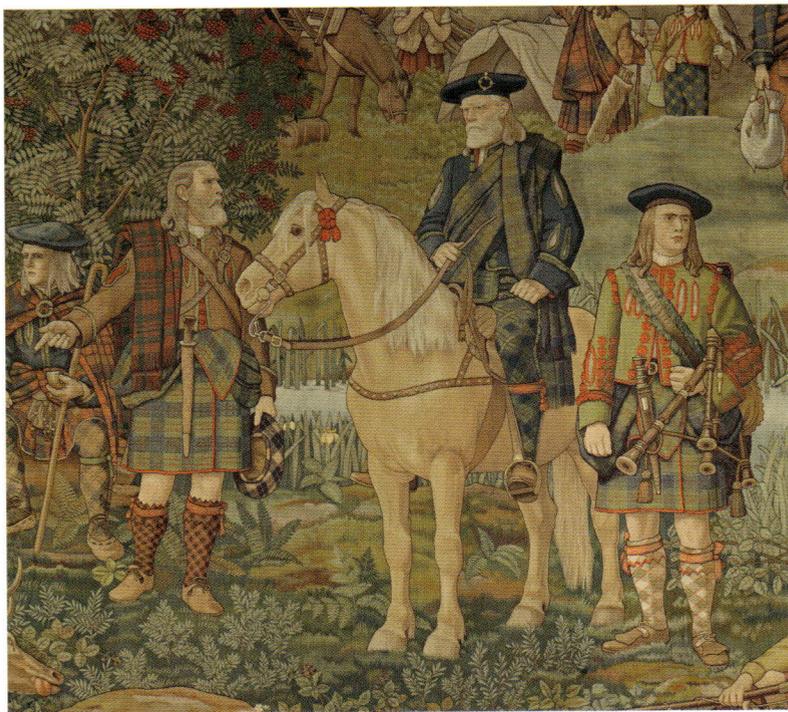

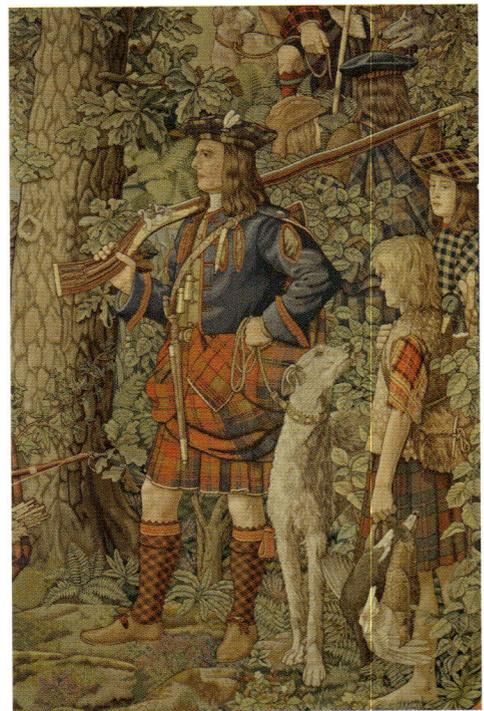

his vast historical tapestries. The other rooms were small offices, a rest room and ancillary accommodation. Four apprentice weavers were recruited from local schools to join Glassbrook and Berry from their fourteenth birthdays and were soon taught Morris company ways of weaving on a small loom – James Wood and David Lindsay Anderson (1898–1974) from July 1912 and Ronald Cruickshank (1898–1969) and Richard (Dick) Gordon (1898–1985) from the following January. With a caretaker and a night watchman the team was complete. However, the team so carefully set in place in 1912–13 would be dramatically depleted by the Great War which enforced the closure of the Studios in 1916. William Thomson headed south to lead George Frampton's weaving classes for war-disabled servicemen. Tragically, the two senior weavers would never return to Edinburgh: Berry was killed in action on 24 April 1917 and Glassbrook would die of war wounds less than six months later, on 26 September. When the Studios reopened in 1919, none of the boy weavers had yet completed their seven-year apprenticeships. It remained a young team, none older than their early twenties: David Anderson was appointed director of weaving and found new apprentices.

Fig.6 (below left)
The first weavers in the weaving studio, c.1914

Fig.7 (below right)
Weavers relaxing in the garden of the studio, late 1920s
Left to right: George Cribbes, Richard Gordon, Stanley Ebbutt, David Lindsay Anderson, John Louttit, Ronald Cruickshank

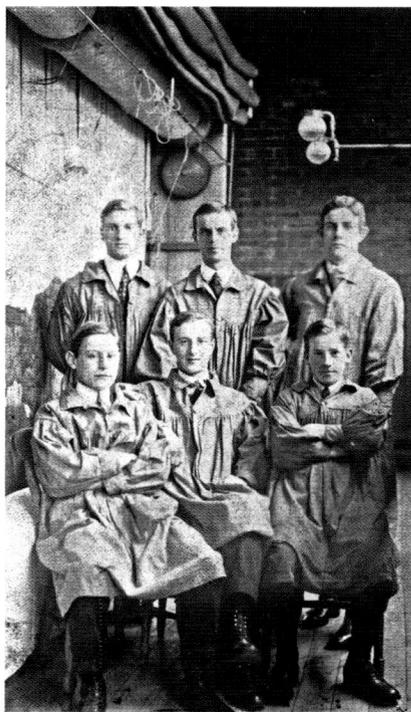

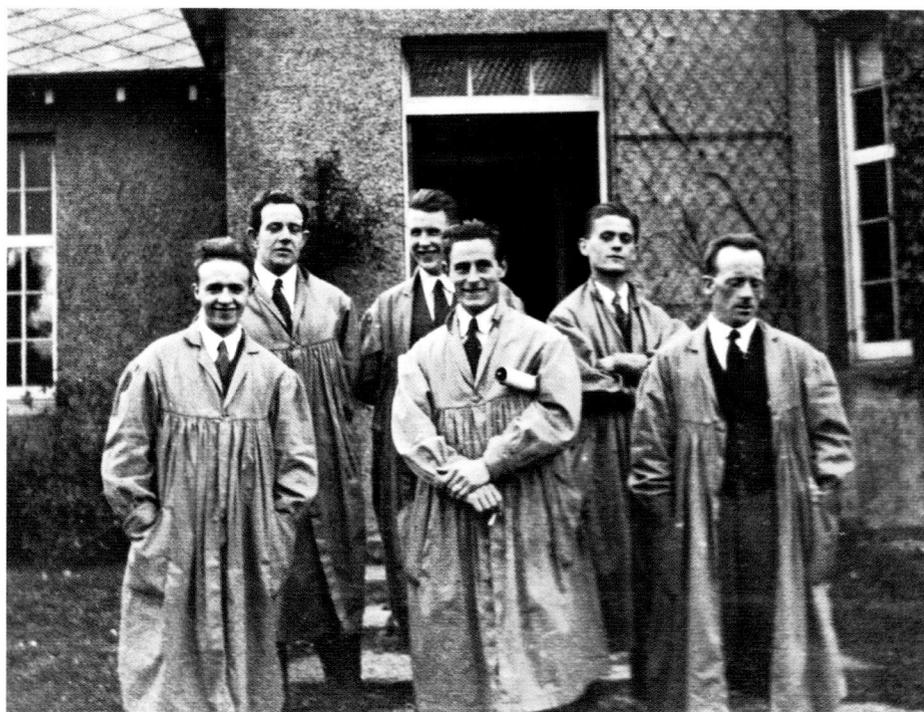

The methods of designing and making the tapestries may seem curious to us nowadays when weavers are expected to improvise. Once the overall composition was approved by Lord Bute, posed photographs were taken on which more detailed figure studies were based. The design was then worked up by the artist and enlarged by hand to produce a full-size cartoon; often this was done by another artist, such as Harold Vivian in London whose large rolled designs would be sent north by train. Finally, this cartoon would be positioned on the wall of the weaving room, with a mirror and the loom between it and the weavers. A tapestry at this date was woven from the back, with the weavers parting the warp to see the front of the tapestry reflected in the mirror. This was a traditional practice and one with which Glassbrook and Berry were very familiar. But it is a far cry from today's method of working where weavers face the front of a tapestry, and also use heavier warping with more blended colours.

Following *The Lord of the Hunt*, two further tapestries were more historical, being woven pictures of a romanticised Jacobite Scotland – *The Duchess of Gordon*, completed in 1926, and *Prayer before Victory, Prestonpans*, cut off in 1933. Skeoch Cumming also proposed several subjects from Burns but these were never accepted or designed. Another piece, *The Prince of the Gael*, or *Glenfinnan*, again based on a design by the artist but reworked by illustrator Paul Woodroffe (1875–1954), still remains half-finished on the loom. Warped up in 1938, it was hardly underway when war broke out. Woodroffe also revised a celebration of Highland games, *The Time of the Meeting* (fig.8), completed in 1936, and supplied other unwoven artwork in the 1930s. However, two tapestries completed in the inter-war years have a different character. Alfred Priest (1874–1929) provided designs for *The Admirable Crichton* (see plate 3), a Hollywood-inspired Renaissance epic piece first mooted as early as 1915, and the quiet, lyrical *Verdure Piece* (fig.9) which shows the pond at Mount Stuart. All were deliberately designed to fit well into Bute homes.

Fig.8
David Lindsay Anderson and fellow weavers in the design studio preparing the cartoon for *The Time of the Meeting*, *c*.1934

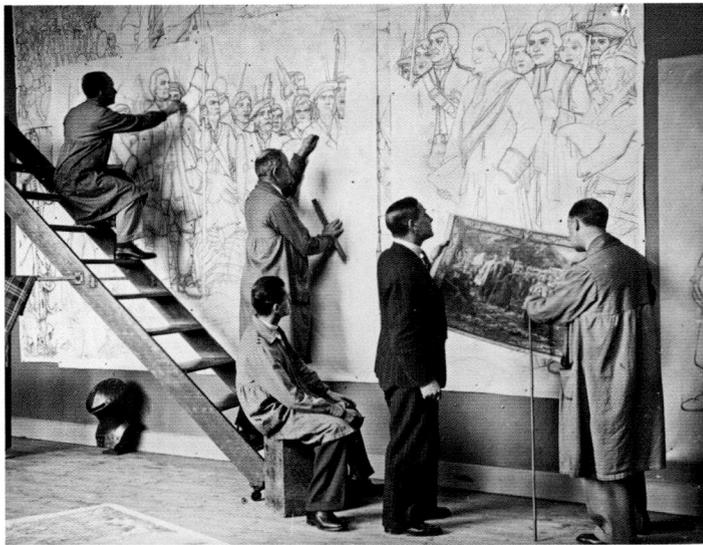

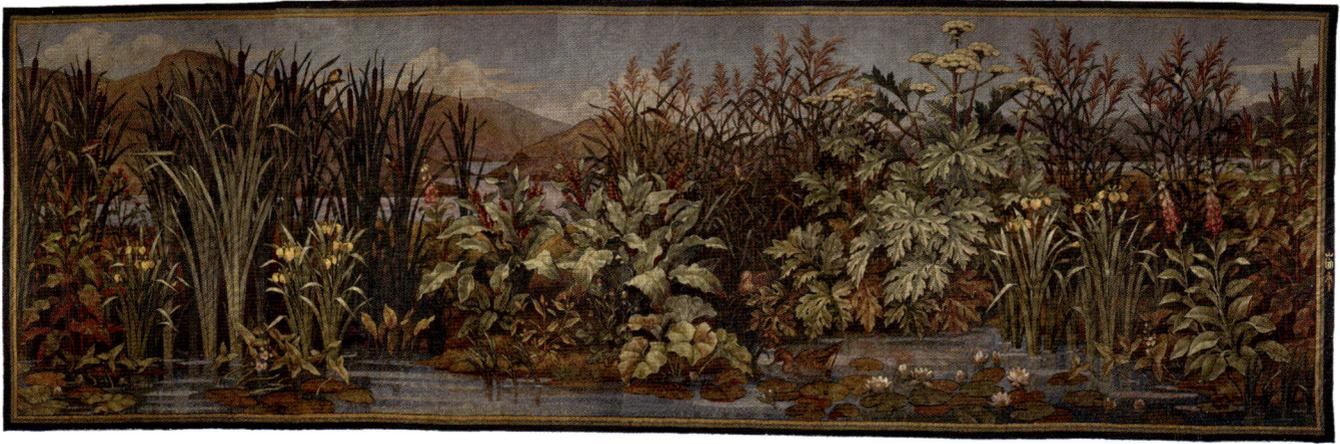

Fig.9
Alfred Priest
Verdure Piece
1938
Wool
183 × 233 cm (72 × 191¾ in)
The Bute Collection at
Mount Stuart

These tapestries, each having its own distinct identity and character, were still made on traditional lines in the manner of the Gobelins workshops, with extremely fine weaving of 18 warps to the inch. Apart from their highly individual designs, they draw their distinct identities from their palette of wools, metallic threads and silks – taken from a stock of literally several hundreds of colours. The Studios' daybooks, or diaries, record what was being woven when and by whom, and refer to Anderson as 'head tapissier', a term he preferred to 'master weaver' or similar. Ronald Cruickshank , Dick Gordon and the new young recruits John Louttit, Stanley Ebbutt and George Cribbes were listed as 'tapissiers', although they were registered for tax purposes as 'artist weavers', a term which has remained in use.

In 1910 Rischgitz had stressed the 'importance of a carefully selected limited range of colours, most carefully dyed'. While organically dyed wools supplied by Appleton Brothers of London were used for *The Lord of the Hunt*, Anderson took a lead from the Gobelins, and formed a warm working friendship with its dyer, Monsieur Pascal, until the latter's dyeworks closed in the summer of 1930. Anderson wrote then to Monsieur Planes, the Gobelins' director, to say how helpful Pascal had been when good dyes were difficult to find immediately after the war. Cards of required tints were sent over and well matched, and an ample supply of dyed wools was built up. The weavers all visited Paris exhibitions and the Gobelins in the 1920s. From the second tapestry onwards, aniline dyes had been used, this offering a wide range of colours and a completely different palette for each tapestry, and the guarantee of non-fading. Rose pinks, golds and bright blues were in tune with the glamour of post-war Paris and its own tapestry production. In the later 1930s wools were supplied by the Aubusson firm run by Monsieur Legoueix.

NEW WORLD, NEW WAYS

By the end of the Second World War, Lord Bute was in failing health. In 1938 he had given the Dovecot building and ground to his son, Lord David Stuart (1911–70). Everything now changed: Lord Bute's brother Lord Colum, sons Lords David Stuart and Robert Crichton-Stuart (1909–76) and daughter Lady Jean Bertie (1908–95) and her husband the Hon. James Bertie (1901–66) developed Dovecot on a business footing – as the Edinburgh Tapestry Company (henceforth ETC) which was formally incorporated on 9 April 1946. They were anxious for the Studios to evolve into a commercial concern which might earn income but also, importantly, play a part in the British post-war recovery of culture and manufacture. As early as February 1946 they were taking advice from the national government's new Council of Industrial Design (CoID). Its chairman, Sir Thomas Barlow, suggested that Lord Robert Crichton-Stuart first approach the artist John Armstrong as one particularly experienced in textile design. Armstrong would design *Madonna of the Sea* for the company in 1949. More significantly, Graham Sutherland (1903–80), Stanley Spencer (1891–1959), Frank Brangwyn (1867–1956), Winifred Nicholson (1893–1951) and Vanessa Bell (1879–1961) were also named as potential artists. The company decided to commission four cartoons for tapestry, two from 'artists in modern contemporary design' – that meant Spencer plus one other, perhaps Robert MacBryde (1913–66), Robert Colquhoun (1914–62) or Bell – plus one in the conventional style, probably Brangwyn, and a fourth by the Swiss artist Nicolas Zuberbühler.

Lord Robert met a number of these artists in London. In March 1946 he saw 'the two Roberts' (Colquhoun and MacBryde) who agreed to provide designs. He commented appreciatively that their 'style and interpretation was ultra modern. MacBryde, especially, struck me as an interesting character, and he spoke intelligently about the limitations of the medium'. However, in the event neither artist's work would be woven. Spencer, who was currently working in Glasgow, immediately agreed to design for the 'Edinburgh Tapestry Factory', as he called it. Lord Robert found Spencer wildly 'excited' by his visit to the Studios and wanting it to weave 'all his works': he suggested *The Resurrection* in the Tate but it was pointed out to him that it would take four years to weave. His *Gardener* (also known as *A Man with Cabbages*) was woven in 1949.

The date fixed for the Studios' restart was 1 April. For several weeks David Anderson had been kept informed of Lord Robert's various discussions with

artists. Ronald Cruickshank, Dick Gordon and John Louttit had resigned their current employments to head back to Corstorphine, but a fortnight before the start date Anderson, now in his late forties, took up a more lucrative position with the Civil Service. In offering his continuing support he noted that 'instead of undertaking huge cartoons requiring considerable historical research, long preparation and great care to ensure the maintenance of balance, colour and tone throughout a tapestry ... production will mainly concern small panels from finished designs lending themselves to straightforward interpretation ... speed and accuracy in interpretation in order that production costs may be kept to a reasonable minimum ...'. This summarised the new position realistically and well. Despite a dramatic change in scale, fine weaving would remain the primary focus, modernised by a deliberate change in the type of artist employed.

Cruickshank now took charge of the day-to-day running of the Studios. His life would be very different from the old days, and initially he had to contend with far more than the pre-war work, not least all the paperwork generated by the strict government rationing rules and regulations applied by the Board of Trade through the Scottish District Wool Rationing Committee. Among other tasks, he was responsible for supervising the weavers, buying looms – including some old French ones from the now defunct Cambridge Tapestry Company workshops, purchased through the firm of Francis & Co. – and ordering yarns and equipment. A keen eye on expenditure was essential: in 1950 ETC's directors would ask him to sell the old pre-war wool stock, retaining only as much of it as was needed to complete *The Prince of the Gael* which was still wrapped in storage. (Much later, some of these wools were selected for the recent Victoria Crowe tapestry, *Two Views* (see plate 33).) The sale emphasised the fresh start for the Studios, its relatively late timing reflecting the canny nature of the period.

As suitable artists were identified by the Bute family, Cruickshank would often be summoned at short notice to London, as well as receiving others when they ventured north. They discussed their designs, colour palettes and how best to interpret the art. He also hired new apprentices: first Alex Jack in 1946; then Fred Mann (1931–2008) in 1947; Archie Brennan (*b*.1931), Ronnie McVinnie (*b*.1932) and Ian Inglis in 1948; Harry Wright (1934–2010) in 1949; and Harry Whitmore in 1950. The apprentices were trained initially on a small loom to ensure they could keep a neat, straight edge: their first task on a Dovecot piece was normally an area of plain weaving, usually a border. They had to learn just how much weft

to put in to work a clean piece of weaving, until it became almost second nature. This was as true in the 1940s as it had been in 1912 and it still is today. The influx of new apprentices would be encouraged to design a few tapestries of their own – an idea which would become standard within a generation.

First to be warped on the loom was an experimental tapestry, a brilliantly coloured interpretation of Paul Gauguin's (1848–1903) painting *Ia Orana Maria* (1891; Metropolitan Museum of Art, New York) in which detailed natural forms all but subsume the figures in a way not so dissimilar to the pre-war epic tapestries but now using a new, bright European palette (fig.10). Cruickshank apparently worked here from a cartoon photographically scaled up from a postcard. This allowed him a total freedom of colour, or at least the palette afforded by rationing. He chose and placed these with care in the design. The tapestry became an essay in colour arrangement and pattern. Hatching was enjoyed as much for its own decorative value as a way to interpret three-dimensional form. A second Gauguin, based on *Jacob Wrestling with the Angel (The Vision after the Sermon)* (1888; National Gallery of Scotland, Edinburgh), would be woven within two years, and a third, *Te Aa No Areois* (1892; Museum of Modern Art, New York), as an apprentice piece by David Cochrane (*b.*1967) in 1989. But mostly the weavers were supplied with brand-new designs, starting with Brangwyn's classical *The Wine Press* (fig.11).

The move towards a stronger British identity had been set in place back in the 1930s with Paul

Fig.10
after Paul Gauguin
Ia Orana Maria
1946
Wool
170.2 × 132 cm (67 × 52 in)
National Museum of Scotland

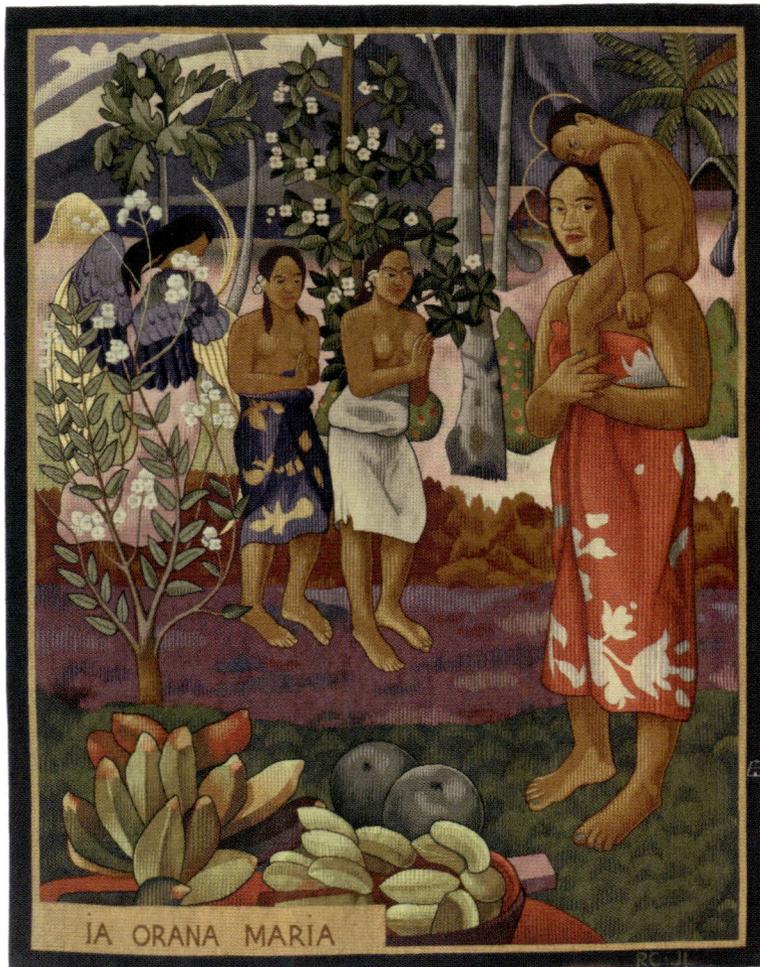

IA ORANA MARIA

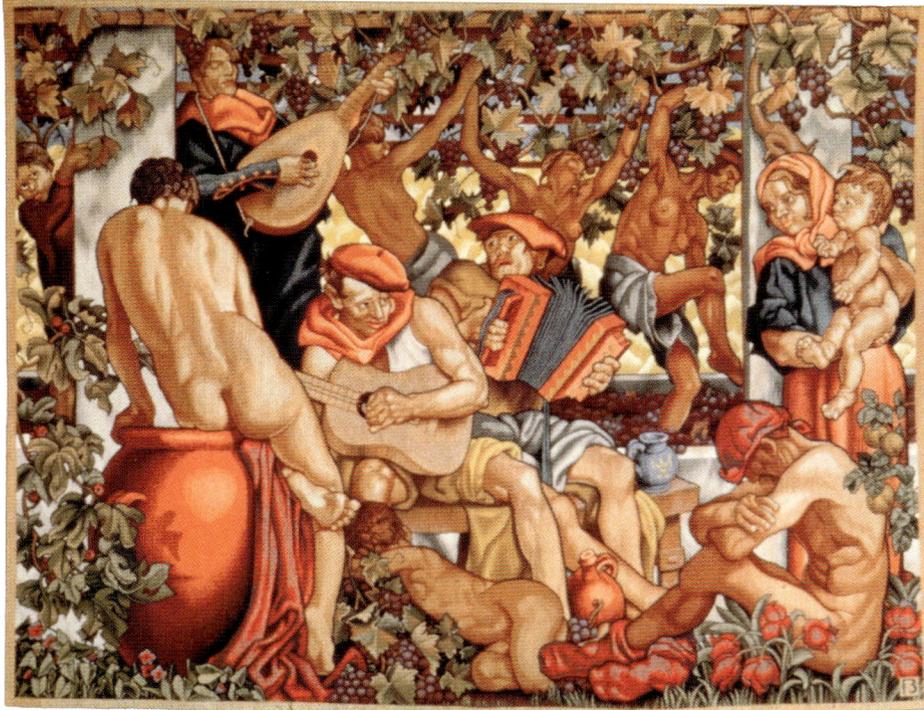

Fig.11
Frank Brangwyn
The Wine Press
1947
Wool
121.9 × 213.4 cm (48 × 84 in)
Location unknown

Woodroffe's involvement in revising Skeoch Cumming's later designs, and the Anglicised name 'Dovecote' which persisted from the late 1920s into the 1950s. With many of the chosen English artists well established back in the 1930s as painters, printmakers and applied artists, a market was more assured and positioned ETC within a field of British mainstream modernism. The league of artists whose designs would be woven included not only Irish artist Louis Le Brocquy (*b.*1916), and Englishmen Julian Trevelyan (1910–88), Cecil Beaton (1904–80), Edward Wadsworth (1889–1949), Cecil Collins (1908–89), Graham Sutherland, Michael Rothenstein (1908–93) and Ronald Searle (1920–2011), but also the Scottish painter Donald Moodie (1892–1963) and Jankel Adler (1895–1949), now based in Glasgow (figs 12, 13, 14 and 15). Many of their tapestries date from 1949–50. A number designed chair seats – Beaton among them (fig.16). The correspondence relating to these commissions is relaxed and friendly, with artists asking for sample wools and colour charts to be posted to them and obviously enjoying the challenge of translation and realising completely new identities for their designs.

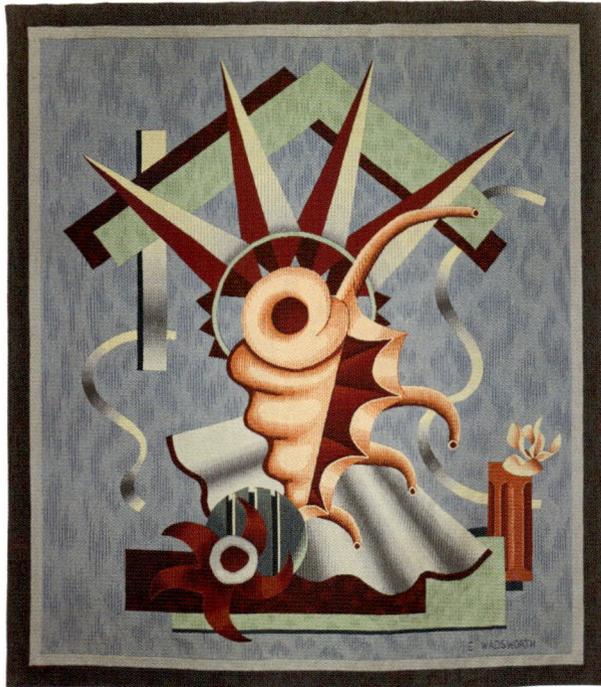

Fig.12 (left)
Edward
Wadsworth
Marine Still Life
(also known as
Stars and Shells)
1949
Wool
168 × 142 cm
(65 × 36 in)
Private
Collection

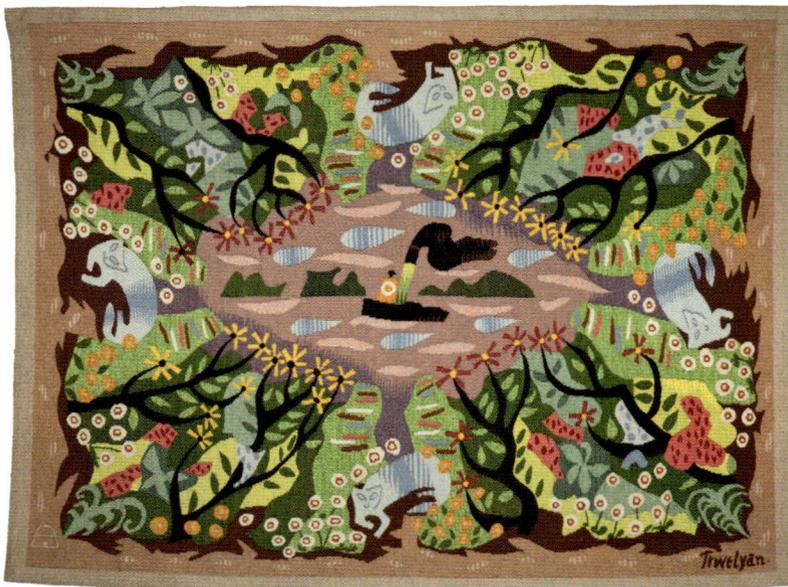

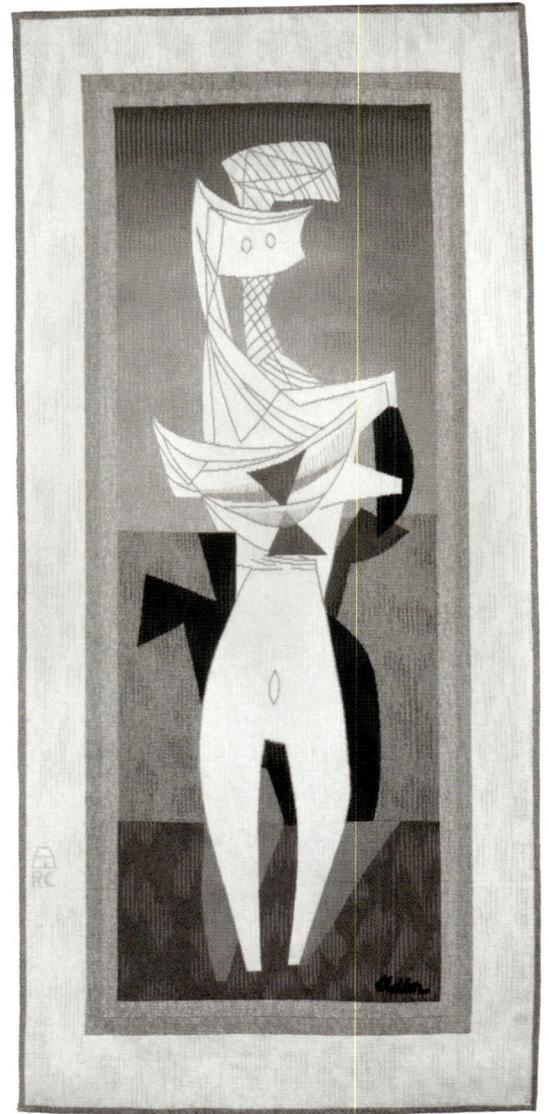

Fig.13 (left)
Julian Trevelyan
Pastoral (also known
as *Decorative Panel* and
Hammersmith Garden)
1948
Wool
90 × 120 cm
(35½ × 47¼ in)
Private Collection

Fig.14 (above)
Jankel Adler
Seated Woman
1949
Wool
185.4 × 91.4 cm
(73 × 36 in)
Private Collection

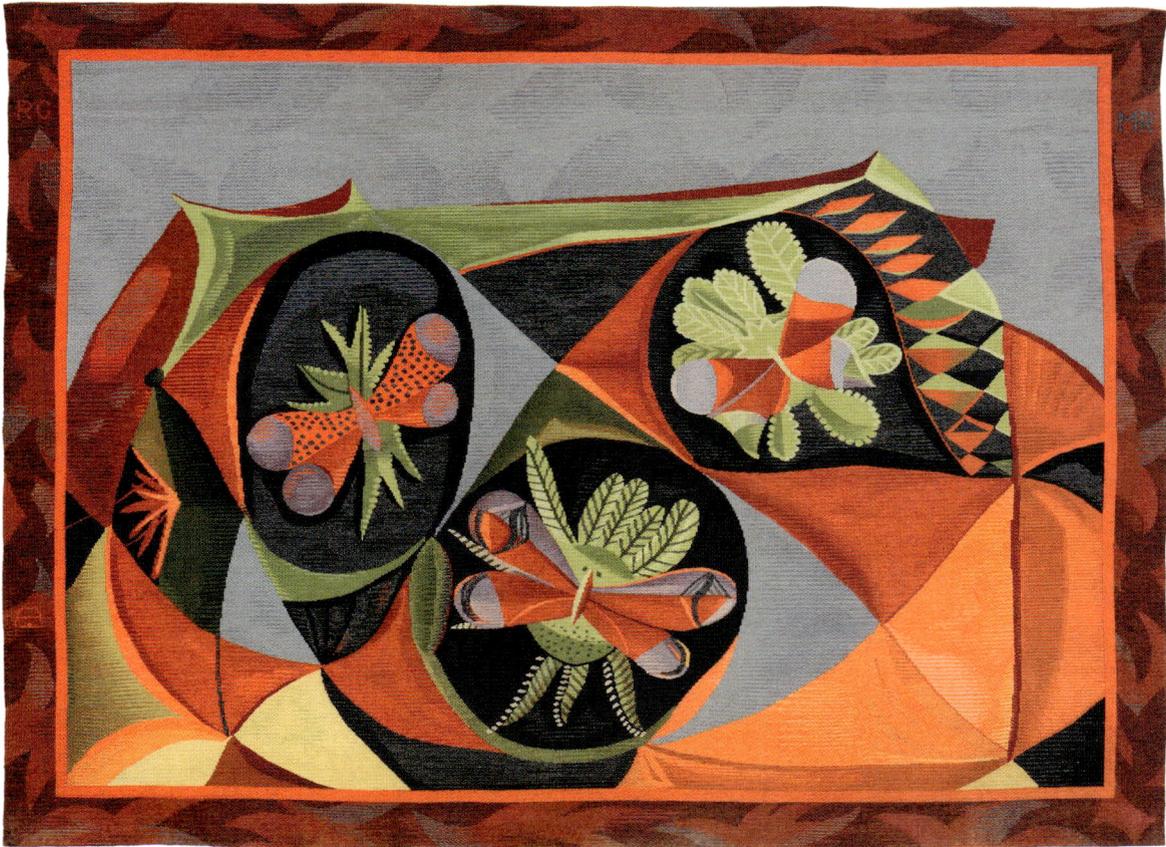

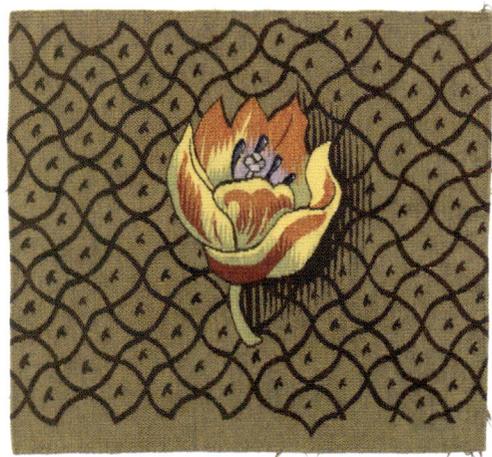

Fig.15 (above)
Michael Rothenstein
The Butterflies
1950
Wool
134.6 × 177.8 cm
(53 × 70 in)
Private Collection

Fig.15 (right)
Cecil Beaton
Chair seat (*Tulip*)
1948
Wool
54.9 × 59 cm
(21½ × 23¼ in)
National Museum of
Scotland

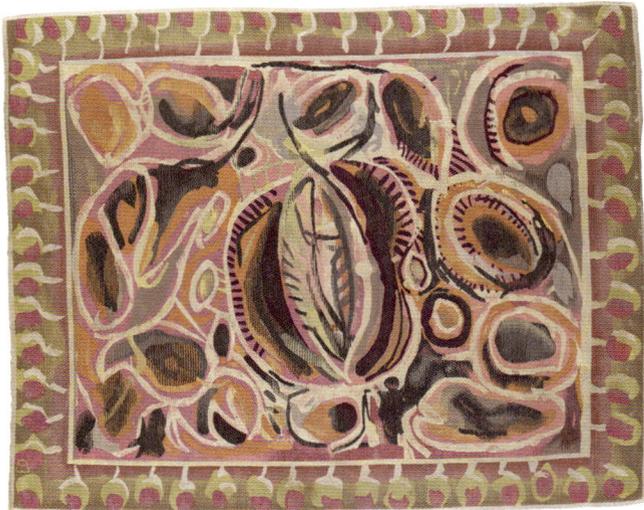

Fig.17
Graham Sutherland
Carpet
1950
Wool
121.9 x 182.9 cm (48 × 72 in)
Private Collection

However, many more designs were supplied than would be chosen to be woven, including a *Last Supper* and a carpet by Brangwyn, and tapestries *Peacock* by Humphrey Spender (1910–2005) and *Squid* by Wadsworth, plus designs from Mervyn Peake (1911–68), Rex Whistler (1905–44), John Hutton (1906–78), John Farleigh (1900–65), Vanessa Bell, Duncan Grant (1885–1978) and Philip Julian. Another artist invited to submit a design was Augustus John (1878–1961). The aim was to establish the workshop as key to a new British romantic tradition in the decorative arts: all these artists worked in either a pastoral idiom or, in the case of the Adler, a more European figurative style. Colours were bright and freshly fashionable – reds and pinks, blues, purples and yellows; the designs modern and appealing. An abstract patterned carpet designed by Graham Sutherland (fig.17) was sold on completion to his solicitor, Wilfrid Evill.

There was another side to the Company's work which ticked along in the background quite happily. Apart from tapestries and the Sutherland carpet, domestic furnishings such as chair seats were also made to designs by weavers Ronald Cruickshank and John Louttit in a modern update of an old-fashioned style. Traditionalism, so much a part of the pre-war Scottish culture, was maintained in new work and a steady quantity of repair work, and into the 1950s through a series of extremely fine heraldic panels, many designed by Don Pottinger (1919–86), but of which by far the most magnificent, and indeed most beautiful, was that designed by Stephen Gooden (1892–1955) and woven for the then Queen (later the Queen Mother) (fig.18). Following in the footsteps of Queen Mary, Her Majesty and her younger daughter Princess Margaret paid two visits to the Studios, first in 1946 and then in September 1950 to cut off the tapestry. At Corstorphine it was the custom for a lady to cut off a tapestry, using a pair of special 'gold' scissors.

The immediate post-war years were ones in which there was a driven determination to succeed, and part of this involved raising awareness of the Studios' potential. Dovecot, or rather the new Edinburgh Tapestry Company,

sent work, including Donald Moodie's *Celtic Pastoral*, to 'Enterprise Scotland', a major post-war exhibition designed by architect Basil Spence (1907–76) at the Royal Scottish Museum (now the National Museum of Scotland). The Studios were accustomed to sending tapestries out for public display. Back in the pre-war days Dovecot had contributed to a major 1933 'Tapestry' exhibition at the Royal Scottish Academy, the 1938 Empire Exhibition in Glasgow and the 1939 'Scottish Art' at the Royal Academy, but in seeking commissions it now entered a period of more urgent public promotion in both exhibitions and the press. The Company's directors entered into dialogue with the Arts Council and, following the essential appointment of artist Francis Rose (1909–79) as artistic adviser (effectively a consultant artistic director), with the British Council and several of London's newest

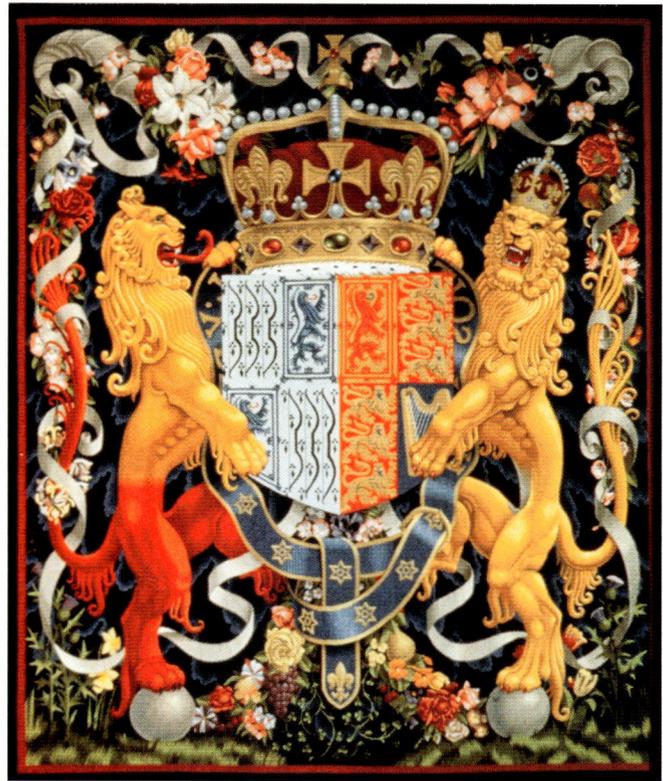

Fig.18
Stephen Gooden
Arms of HM Queen
Elizabeth
1950
Wool
264.2 × 223.5 cm
(104 × 88 in)
HM Queen Elizabeth II

commercial galleries, such as the Redfern and the Heffer. Rose, an artist and designer respected by society, was on nodding terms with government officials, collectors, galleries and artists at home and abroad, and the Bute family equally welcomed his advice and that of government directors. There were plans to exhibit the new tapestries at home and abroad, and even in South America. The most fruitful conversations were with the proactive government's Council of Industrial Design which, like its parent organisation the Board of Trade, was keen to promote partnerships and offer commercial advice.

MODERNITY AND TRADITION

Rose's own Dovecot designs were largely for domestic furnishings, but his market was far from local. For the Gertrude Stein memorial room in New York he designed a carpet, and another plus chair seats for the residence of Mrs Helen

Resor, an advertising executive and leading light in New York society. His designs were floral – the taste of the day – or modern Gothic, and all were woven in Edinburgh in 1948. Although largely an absentee adviser, Rose did help the Studios gain some steady exposure in the press as well as arrange to showcase the work. In 1948 the *Illustrated London News* ran a lavishly illustrated feature, 'An ancient art which has had a revival in Scotland'. Here the photographs showed the weavers at work, all wearing the blue smocks which had been *de rigueur* since 1912; as at the Gobelins (and indeed with the Impressionist painters), wearing the colour blue helped visually in working with colour. In 1950 two exhibitions were held: 'Recent Tapestries woven by the Edinburgh Tapestry Company', presented by the Arts Council of Great Britain in London at the start of the year, and 'Dovecote Tapestries' at Gladstone's Land, Edinburgh, under the auspices of the Saltire Society, the national society for Scottish culture – underlining the tradition still inherent in the company – during the summer's Edinburgh International Festival. The latter included 19 tapestries but a staggering 55 different cartoons, some for tapestries never to be woven, by Michael Ayrton (1921–75), Vanessa Bell, Duncan Grant, Robert Crawford, Ernest Dinkel (1894–1983), Charles Pulsford (1912–89), Anne Redpath (1895–1965), Rex Whistler and Nigel McIsaac (1911–95), a mix of English and Scots. The London display had had six tapestries and 13 designs. One key work exhibited in both shows was Graham Sutherland's *Wading Birds* of 1949 (see plate 4), to be bought (as also was Spencer's *Gardener*) by Basil Spence in the mid-1950s. It was requested for Sutherland's core display, with Wadsworth, in the British Pavilion at the XXVI Venice Biennale in 1952. Glasgow Art Gallery showed Dovecot work in December 1950 and January 1951 to an audience of almost 34,000 visitors. ETC had put itself on the map: following the Arts Council exhibition, the textile company Courtaulds briefly flirted with the idea of taking a financial interest in it.

While these relatively small and focused exhibitions drew attention to new Dovecot work, it was seen within the wider Scottish context at 'Living Tradition of Scotland', a major display of contemporary crafts designed by Robert and Roger Nicholson at Edinburgh's Royal Scottish Museum. This was mounted by the Council of Industrial Design's Scottish Committee in the summer of 1951. One highlight of the whole event was the practical demonstrations by Scottish craftsmen and women in pottery, net making, woodcarving and weaving – all Dovecot's weavers took part to make this a truly 'living' occasion. Here they were

seen not as part of a new wave of British decorative artistic practice but more specifically as modern inheritors of craft skills which were an inherent part of the Scottish character, bringing elegance, beauty and artistry to the modern age. Meanwhile on London's South Bank the larger Festival of Britain exhibition included Sax Shaw's (1916–2000) *The Lion and the Oak Tree* of 1948 as the centrepiece of the Lion & Unicorn Pavilion: the only new works sent were a carpet and four cushion covers woven for the parlour in the Festival's Homes and Gardens Pavilion to designs by Bianca Minns of Associated Designers Ltd.

Artists' attitudes to ETC were wide-ranging. Nigel McIsaac recruited friends and fellow Edinburgh art teachers such as Charlie Pulsford and Tom Pow to try to offer to design for the company. Although this came to nothing, McIsaac, the art teacher at the Royal High School, had taken one of his pupils, Harry Wright, along to Corstorphine where a Henry Moore tapestry, *Three Figures*, was on the loom. Harry was entranced by the energy and sheer modernity of the place – and was taken on as an apprentice. The studio and weaving would become his entire life. Moore himself, however, was one of many artists to have an arm's-length relationship with Dovecot, delivering designs to the Bute family in London thence to be sent north by train. Moore was one of many who only saw a finished tapestry in London. When he did so he appeared surprised by its quality. The real exceptions amongst the English artists were Spencer, already noted, and Edward Bawden (1903–89) who spent some days at the studio in 1949. Although there may have been more, the Dovecot daybooks record only one visit to the Studios by Graham Sutherland, in October 1952, and then in the company of Basil Spence and Lady Jean Bertie. This was in connection with a key episode during this period – and probably the most celebrated of all – relating to the possible contract to weave Sutherland's great tapestry for Coventry Cathedral. Spence had won the competition to design Coventry in 1951. He wanted a large tapestry to be the main focal point – designed by Sutherland whose 1946 painting of the Crucifixion for St Matthew's Church, Northampton, he admired. It was a similar approach to that of Colin St John Wilson much later at the new British Library where a Dovecot interpretation of an R.B. Kitaj (1932–2007) painting would shape the interior space.

The flurry of exhibitions of 1949–51 had resulted in few sales or commissions. In 1951, as the weavers wove quietly in 'Living Traditions', their livelihood was on the line. A new crippling 66⅔ per cent purchase tax, the precursor of today's

VAT, was introduced from August. The apprentice weavers were told the Studios were likely to close, a situation exaggerated in the press as early as September when G.L. Conran wrote in *The Times*, 'the present tax policy has already led to the decision to close the Edinburgh Tapestry Company ... there is no other organisation to take its place and unless something is done to ease the position of the individual master weavers who remain, a major work which should be of symbolic as well as artistic value will not be undertaken in Great Britain'. Several apprentices, including Ronnie McVinnie, left that autumn.

Dovecot, however, staggered on, desperately dependent on Coventry and reassured repeatedly by Spence that they would win the job; only in 1956 would ETC receive the news from the Cathedral that Pinton Frères, an Aubusson firm, would weave the tapestry. The dividing wall between the design studio and the weaving room had been partly removed to prepare for the new wide loom made by Arrol Young of Galashiels. The Dovecot directors had no alternative but to shed more staff. By Christmas 1953 Ronald Cruickshank had been advised to leave, and would set up his own Golden Targe weaving studio in Edinburgh, a short-lived but significant venture, before he left for America a few years later.

Thus by late 1953 a point had been reached when Dovecot's future as a commercial workshop had been truly jeopardised and new champions were urgently needed to move it forward. They were to be found locally. Since 1949 Lord David Stuart had leased historic Acheson House (restored between the wars by Robert Hurd for his father) in the Canongate to serve as a Scottish Craft Centre (SCC). This developed as an outlet to support home-grown studio and architectural crafts through display in its historic domestic setting. The collective organisation had a warm relationship with Dovecot, particularly with Cruickshank and Lady Jean Bertie. James Stenhouse of the SCC was always keen to know all about ETC's methods of designing, and how much was left to the artistry of the weavers. Cruickshank, an elected member of the SCC, had often attended its meetings and was the spokesman for Dovecot.

REVITALISATION

With Dovecot struggling to survive, in early 1954 SCC's chairman John Noble (1909–72) and the Glasgow designer Harry Jefferson Barnes (1915–82), convener of the SCC panel, together bought majority shares in the ETC. The two new

owners split their responsibilities evenly. Barnes, then deputy director of the Glasgow School of Art, involved himself in broadening the scope of production, but Noble was more concerned with the financing of the work. Although only intermittently on site, he in fact dealt with most of the important correspondence, including the last letters from the Coventry committee. Noble and Barnes soon engaged an artistic director, Sax Shaw, to develop a small productive workshop.

The move towards modernising Dovecot tapestry into a weaver's art rather than an artisan's craft began properly with Shaw. Before 1950 he had already designed two tapestries for the Studios, including *The Lion and the Oak Tree* and *Fighting Cocks*. The first, Shaw said, had been 'spoilt by Cruickshank with his silly tapestry hatching which I stopped when I began at Dovecot', the second 'I was in charge of [with] no hatching at all'. A Yorkshireman, Shaw had studied painting in Huddersfield and at Edinburgh College of Art. After the war he had completed his College studies and was awarded a travel bursary taking him to Paris, where he visited the Gobelins. On his return to Edinburgh he had taken up weaving and was employed in 1949 by the College as a 'colour master' to teach drawing and stained glass. He was an 'assistant' to the new Head of the School of Architecture, R. Gordon Brown.

After Cruickshank's departure the studio's day-to-day management had been put in the hands of Dick Gordon, an unassuming man for whom fine craftsmanship was the primary measure of excellence. This was now complemented by Shaw's direction and artistic flair. Dovecot began to weave tapestries for corporate commissions, such as Martin's Bank and Rolls-Royce, thanks largely to John Noble's recommendations. These still remained relatively few in number, and tapestry weaving was kept alive mainly through manufacture of mostly small-scale domestic pieces – chair seats (including sensitive repair work on old weavings) and covers, rugs and small wall hangings, plus church furnishings, with commissions from across central Scotland as churches were built or refurbished. New pulpit falls and hangings were designed in the vivid and dynamic style of Sadie McLellan (Sally Pritchard) (1914–2007) which particularly suited stark modernist interiors – McLellan and her husband Walter Pritchard (1905–77) had shown designs in 'Dovecote Tapestries' in 1950 (figs 20 and 21). Two expressive domestic pieces, a rug and a wall hanging, were designed for John Noble in 1955 by Nadia Benois whose uncle, Alexandre Benois, had contributed to the major 'Diaghilev' exhibition held recently at the art college (figs 22 and 23).

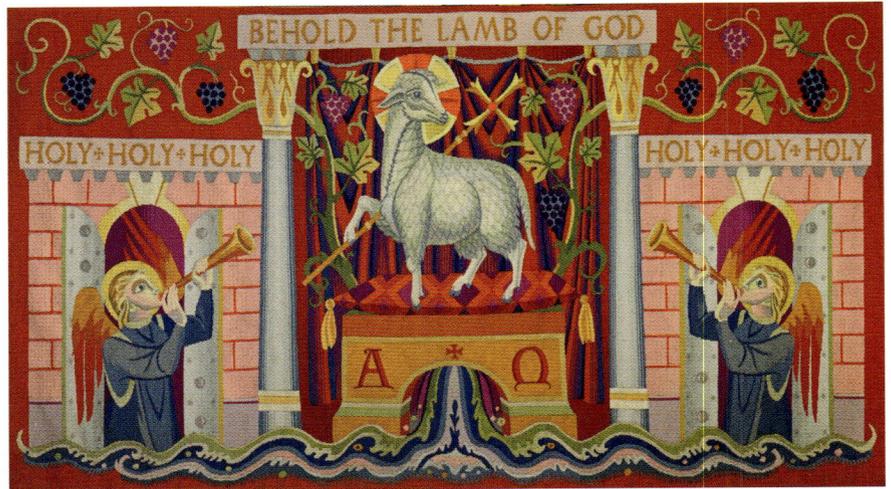

Fig.19 (above left)
Sax Shaw
Chair seat
*c.*1955–6
Wool
39.5 × 52 cm (15½ × 20½ in)
Ardkinglas Collection

Fig.20 (above right)
Sally Pritchard (Sadie
McLellan)
The Lamb of God
1957
Wool
91 × 160 cm (35¾ × 63 in)
Cambuslang Parish Church

Fig.21 (right)
Sadie McLellan
The Risen Christ
1961
Wool
180 × 119 cm (70¾ × 46¾ in)
Cambuslang Parish Church

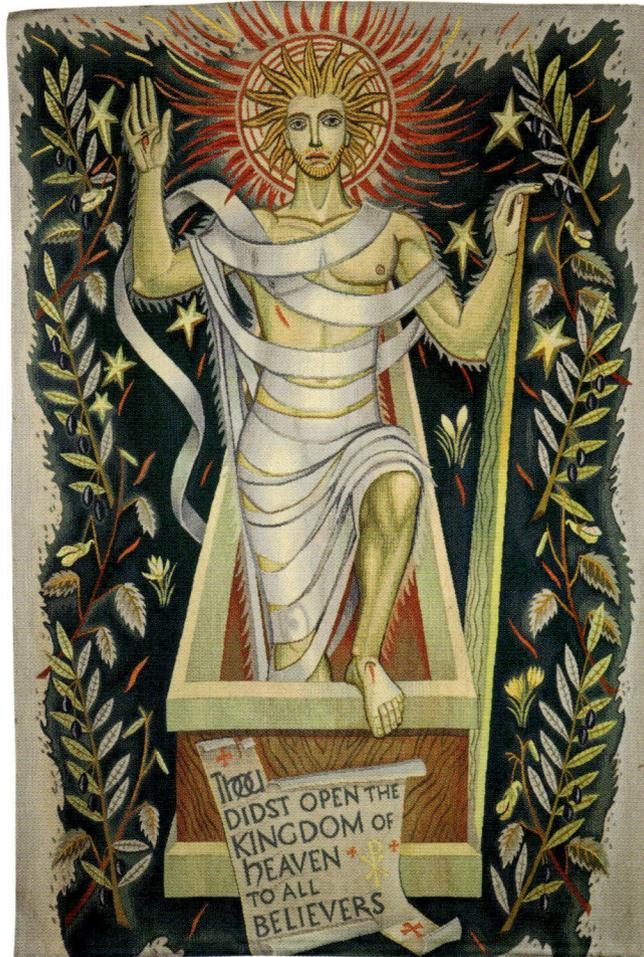

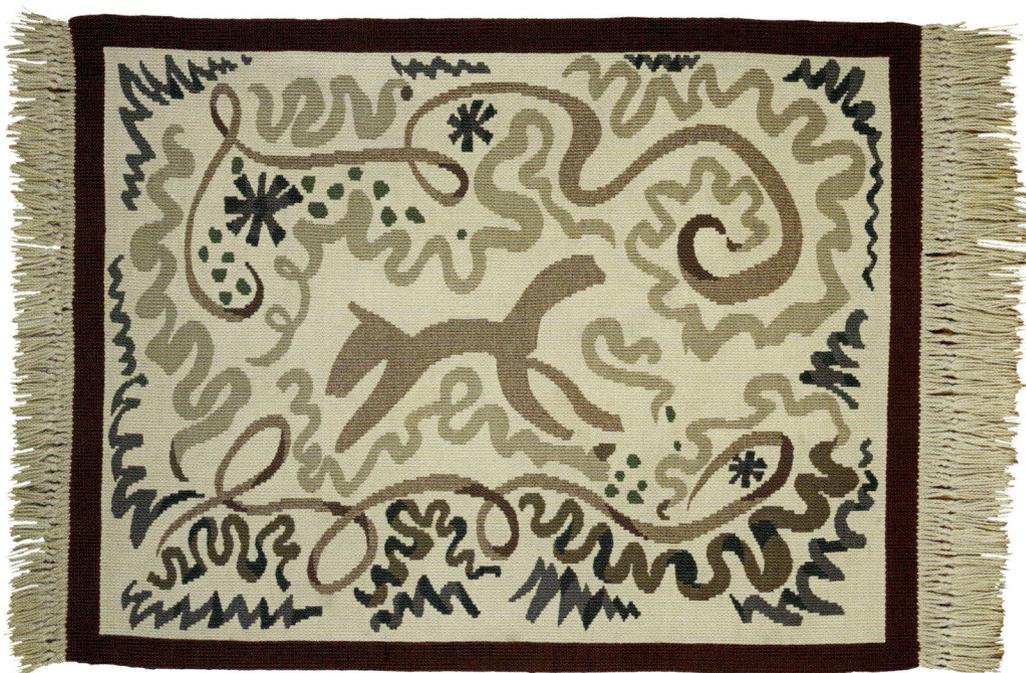

Fig.22
Nadia Benois
Noble carpet
1955
Wool
129 × 190 cm (50¾ × 74¾ in)
Ardkinglas Collection

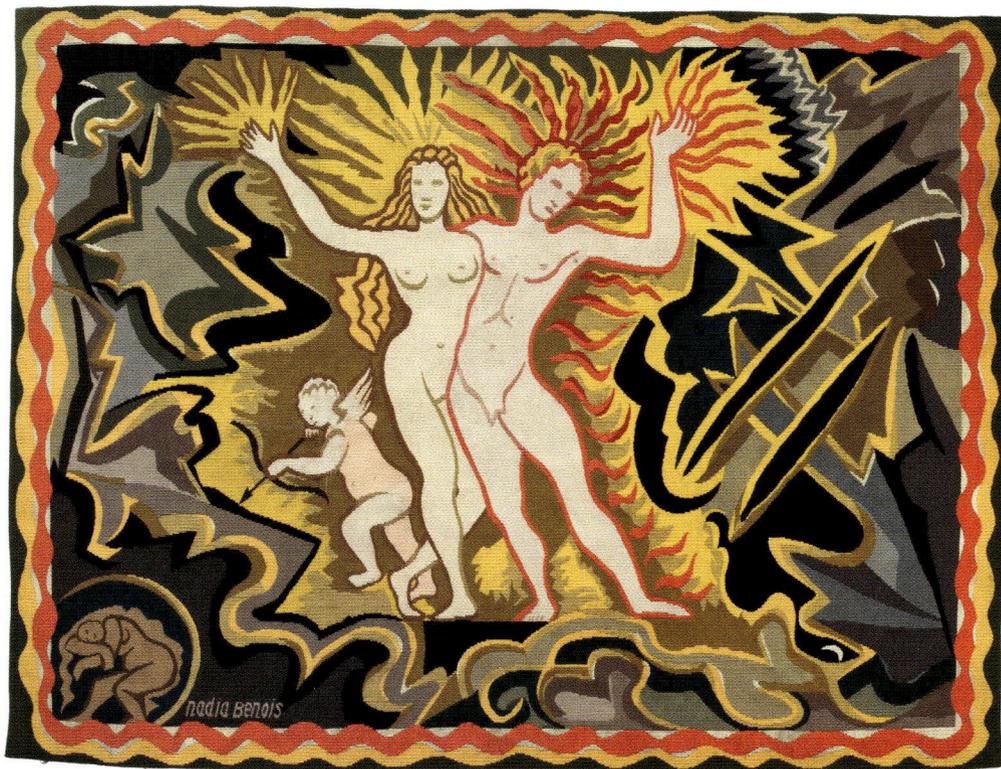

Fig.23
Nadia Benois
Light and Day (Aether and Hemera)
1955
Wool
146.5 × 188 cm (57¾ × 74 in)
National Museum of Scotland

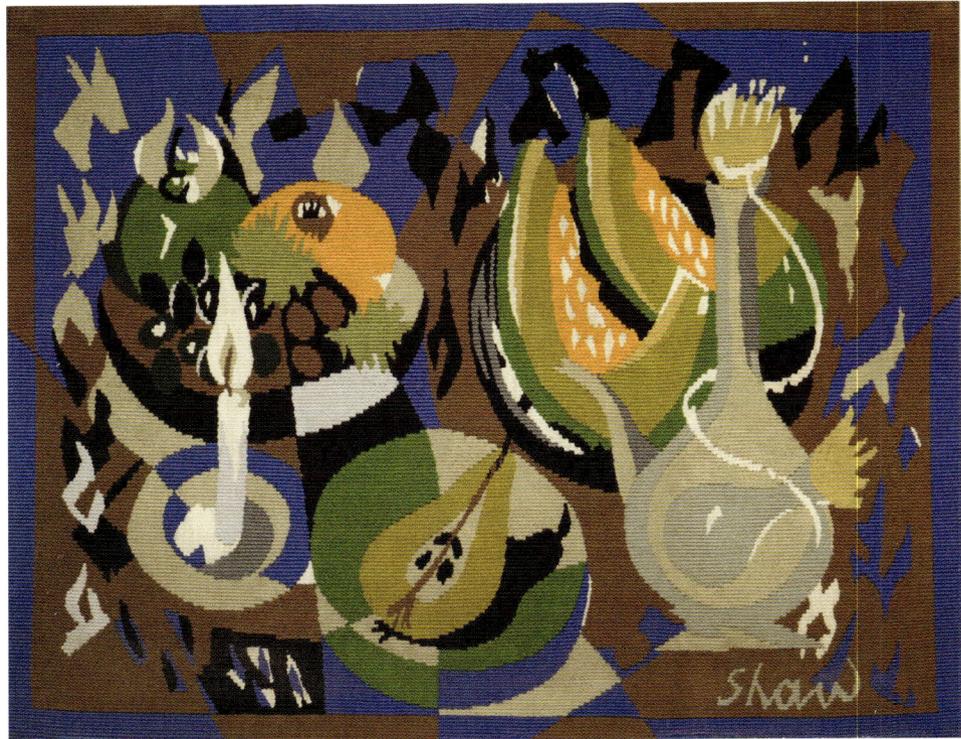

Fig.24
Sax Shaw
Still Life
1957
Wool
65 × 81 cm (25½ × 32 in)
Private Collection

Mostly, however, tapestry designs were produced in-house by Shaw himself using a limited but finely selected palette and combining stylised figures with patterned nature. Still life, an academic yet fashionable subject for British and French painters, was also turned into a vehicle for tapestry, acquiring its own intrinsic tactile beauty (fig.24). But perhaps the culmination of Shaw's work with ETC was his superb, pantheistic *The Cycle of Life* (1957–8) for Warriston Crematorium (see plate 6). At ETC Shaw replaced the Studios' motif, until then a dovecot, with a stylised dove to serve as its signature. Overall, there is a distinctive style to the work of the mid-1950s, figurative for the most part, and simpler, even lyrical, in design. This is seen in one of the last tapestries woven under Shaw's artistic directorship, *Phases of the Moon* (1958) by John Maxwell (1905–62), the leading Scottish neo-romantic painter and graphic artist (see plate 7). In Shaw's own work there is a finely tuned balance of elegance and energy.

Shaw's view of tapestry was shaped by what was going on in France. He had been there just as the country's tapestry was being revitalised. The medium's

potential had been recognised by a painter, Jean Lurçat (1892–1966), on visiting the town of Angers where the magnificent fourteenth-century *Apocalypse* hangs in the cathedral. Tapestry for Lurçat was not an outmoded method but at heart a modern medium admirably suited to all sorts of interiors, replacing the mural art of earlier times. It could introduce an astonishing variety of tactile and colour values which had powers of their own, especially in the hands of a fine and individual weaver. Experiment was encouraged in France – and creative designs might echo the vibrant cut-outs of Matisse. Shaw was captivated.

On Barnes's recommendation, ETC also recruited Robert (Bob) Stewart (1924–95), the head of printed textiles at Glasgow School of Art, to diversify output and provide some steady income, even if only a small amount. The fact that both he and Shaw were recruited from Scottish art colleges was a sign of genuine artistic regeneration and of confidence in Scottish affairs. Stewart had been in France at the same time as Shaw. He too was now passionate about modern tapestry, and in fact had already had designed for Dovecot, a tapestry called *Bird of Paradise* which was woven by Louttit in 1950. He was now keen to start a printed textile workshop at Dovecot, although by this stage he was already working with textile producers Donald Brothers in Dundee and Liberty, the upmarket London department store. But here his current role was to expand ETC beyond weaving. Harry Barnes spent a day a week at Dovecot. During his own two Dovecot days per week, Stewart introduced tiles (figs 27 and 28) and printed fabrics as a more commercial side to the studio's regular work. With no purchase tax on tiles these were affordable, costing around four shillings (20p) each. Johnson Matthey supplied onglaze enamels for silk-screening and firing, while Campbells in Edinburgh and Carter & Co. of Poole provided blanks. The tiles were in two thicknesses, thinner for wall and thicker for table use, and the latter could be set in ironwork frames as table pot stands or used in interior design. A mix of bird and tree tiles were used in a London fireplace for the London-based typographic designer Ruari McLean. From September 1954 a range of tiles was on display at the SCC, and by November some thirty tile designs and colourways were on offer to upmarket interior design outlets such as Liberty, various branches of Woollands including Knightsbridge, York Tenn in Doncaster, Interior Decorations in Sheffield, and Elders in Glasgow. By the autumn Stewart noted that commercial demand was 'staggering'. Dovecot tiles were also sold through the SCC and the Centre for Scottish Crafts at St Ninian's, Stirling.

Fig.25 (above)
Robert Stewart
Sample of printed textile with
a design based on barbed wire
1954
Cotton
Private Collection

Fig.26 (right)
Robert Stewart
Sample of printed textile
with a design of three men
in a boat
1954–5
Cotton
136 × 93 cm (53½ × 36½ in)
Private Collection

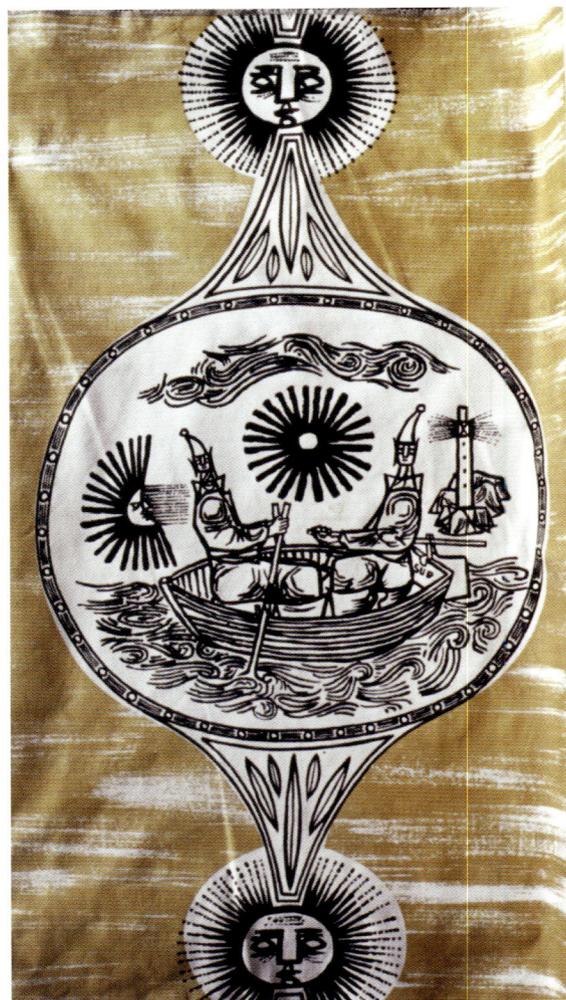

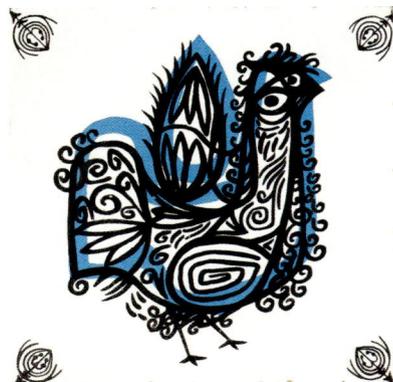

Fig.27 (far left)
Robert Stewart
Tile with bird decoration
c.1954–7
Ceramic
15.2 × 15.2 cm (6 × 6 in)
Ardkinglas Collection

Fig.28 (left)
Robert Stewart
Tile with design of three men
c.1955–6
Ceramic
15.2 × 15.2 cm (6 × 6 in)
Private Collection

In the mid-1950s some printing of textiles was carried out by a former student, Margaret Stewart (*b*.1932), who also designed cushion covers (fig.29), made up elsewhere, and table linen. Lime green was noted as particularly popular in the first year. A proper screen-printing section was planned but space was limited and it was considered easier to keep fabric length production at Glasgow School of Art. As both space and funds allowed, new staff were taken on to print, and the tableware also consisted, briefly, of napkin rings as well as ceramic pot stands. Liz Arthur, Bob Stewart's biographer, has noted his ambition for the workshop at Dovecot to diversify even more – into decorative bookbinding endpapers, and even furniture. He carried on at Dovecot until 1957 when he returned to teaching full-time and Tom Shanks (*b*.1921) took over responsibility for the printing. There were also plans to produce quality wallpaper, the necessary equipment for which had been purchased by 1961 when everything was transferred to a space in a blind factory in Bridgeton, Glasgow. Harry Barnes and Gordon Huntly both supplied tile designs. The printing of ceramics and paper goods was taken over by GSA-trained Peter Powell (*b*.1940) both in Bridgeton and on its return to Corstorphine by the mid-1960s. Printing continued into the early 1970s when the workshop, which used one part of the weaving room, closed, but Powell carried it on privately elsewhere.

Shaw left Dovecot in 1958 to take up the challenge of heading the Stained Glass Department at the art college. By that time he had started to experiment with weaving facing the loom, although it would be a few years yet until the studio weavers changed their own methods. During Shaw's first three years at the college one of his students was Archie Brennan, newly returned from National Service (with some study at Carlisle College of Art) following a year with Cruickshank's Golden Targe Studio and two more in France drawing and painting and studying tapestry. Brennan majored in tapestry and stained glass and also studied the core discipline of drawing and painting plus printed textiles. For his postgraduate year he concentrated solely on tapestry.

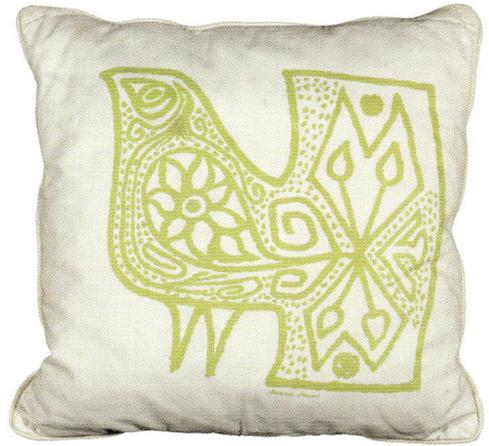

Fig.29
Margaret Stewart
Cushion cover, two sides
c.1955
Cotton
35 × 35 cm (13¾ × 13¾ in)
Ardkinglas Collection

Only three tapestries are known to have been woven between 1959 and 1961 but they were not insignificant. One was an armorial piece for the Leathersellers in London; the others were two companion tapestries on the themes of 'space' and 'time' for the English Electric Company (figs 30 and 31). Designed by Hans Tisdall (1910–97), known as a muralist and designer of the entrance to the Festival of Britain's Fun Fair, these two pieces were the first wholly abstract artworks which invited the weavers to introduce texture and pattern for its own sake. They were typical of the new design colours of the period, one basking in hot golds, oranges and reds, the other in more autumnal colours of acid yellows, ochres and browns. The financial and critical success of these designs soon led to a number of other tapestries, including one for the Ionian Bank and a smaller one, *Armada*, another richly coloured and textured corporate work, for the Pfizer Foundation (fig.32) – all arranged by Noble. Douglas Grierson (*b*.1946) started his weaver's apprenticeship as the piece for the Ionian Bank (today the Alpha Bank), *The Golden Lion*, was on the loom (fig.33). He recalls that:

> it was probably the first time I had come into close contact with an abstract piece of work, and I was so impressed. The colours of reds and gold were set against the gloomy interior of the studio, the washed floorboards, the brown cork walls and the evenness of the north light. I thought it was the most beautiful thing I had ever seen. One of the main jobs of an apprentice was to wind spools and bobbins for the weavers. Here the bobbins were a fairly complicated affair with a myriad reds, blues, mauves and gold. The design depicted the bank's logo, with both the lion and background broken up by varying triangular shapes.

Although this particular tapestry was woven at 12 wpi, others used only 8. Archie Brennan used just 7 wpi in 1962 to work a design of Gordon Huntly's – shades of tapestries to come.

Tisdall formed a solid working friendship with the studio and went on to design a monumental tapestry called *The Elements* for Manchester University, where he had painted murals. An experimental couple of designs of 1964 and 1965 entitled *Man in the Moon* was followed by several others until 1971. Jefferson Barnes prepared several more finely warped (at 12 wpi) armorial panels for

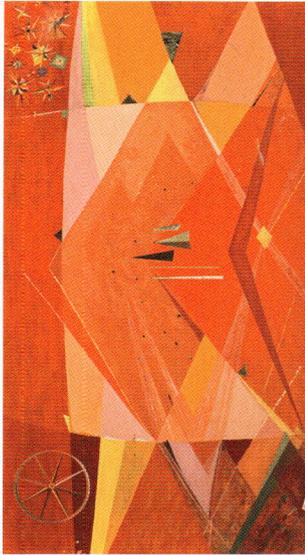

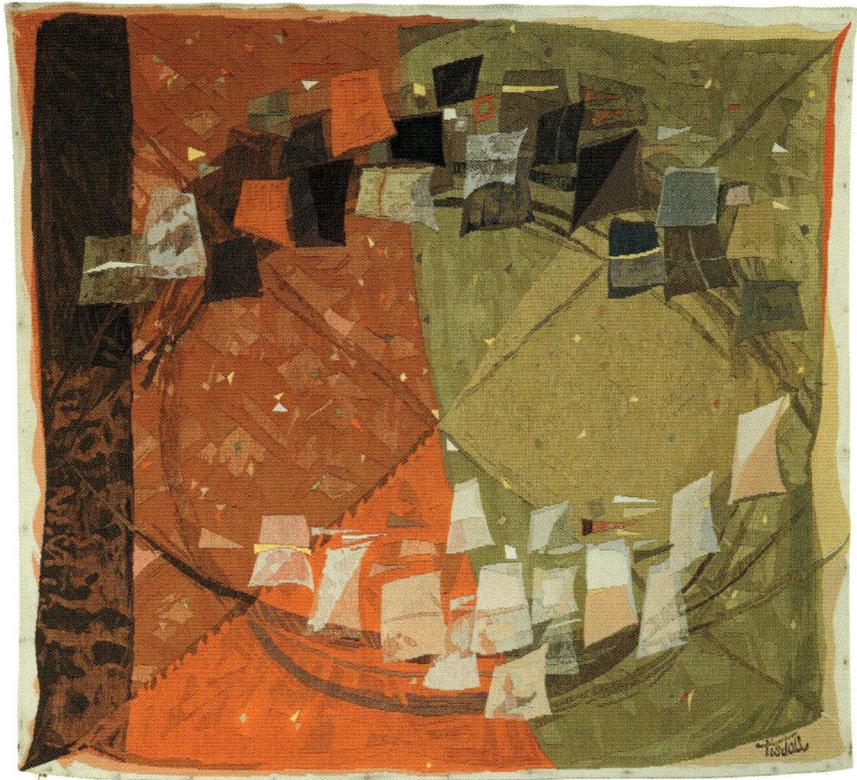

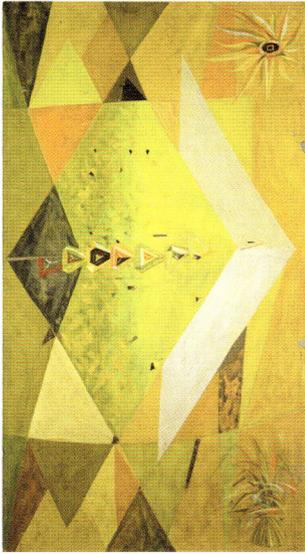

Fig.30 (left above)
Hans Tisdall
Design for *Space* tapestry
1960
Gouache on paper
117.3 × 62.5 cm (46¼ × 24½ in)
Private Collection

Fig.31 (left)
Hans Tisdall
Design for *Time* tapestry
1960
Gouache on paper
117 × 62.5 cm (46 × 24½ in)
Private Collection

Fig.32 (above)
Hans Tisdall
Armada
1962
Wool
168 × 188 cm (66 × 74 in)
University of Edinburgh

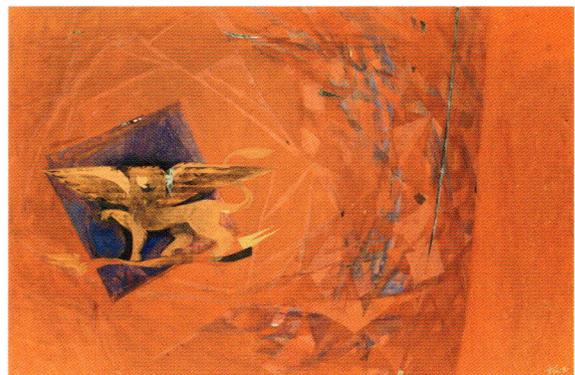

Fig.33 (right)
Hans Tisdall
The Golden Lion tapestry:
design for the Ionian Bank
1961

Gouache on paper
77 × 113.1 cm
(30¼ × 44½ in)
Private Collection

weaving, and this traditional side to ETC carried on quietly through the 1960s, a legacy of the immediate post-war years. Dovecot also began to broadcast its skills once more. In 1961 weavers took a small loom to the Aldeburgh Festival; six years later the possibility of either borrowing or commissioning tapestries for the town's Festival Theatre was aired by Peter Pears, but nothing came of it. Dovecot under Archie Brennan also contributed to the international tapestry scene from the early years of the Lausanne Biennale, first held in 1962 – Tisdall's pieces were amongst the first sent over.

In a sense, the year 1962 would see a neat end to Dovecot's first half century. A major exhibition was prepared by the Scottish Committee of the Arts Council of Great Britain to look back at Dovecot's achievements – but the catalogue only records tapestry and its designs, with no evidence of its workshop of the previous eight years. Shown in the Committee's rooms in Rothesay Terrace during the Edinburgh Festival, it featured some 32 tapestries; 19 of the smaller pieces were later exhibited at the Scottish College of Textiles in Galashiels, centre of Borders textile production. This looked back to the past, but in that year several modern traditional armorial works had also been woven, and Tisdall's *Armada* was Dovecot's first tapestry for an Edinburgh building. Hot on its heels came the earliest design from Joyce Conwy Evans (*b*.1929) for the new Hilton Hotel in Park Lane, London. Like Tisdall, and subsequently Harold Cohen (*b*.1928), Eduardo Paolozzi (1924–2005) and Tom Phillips (*b*.1937), Conwy Evans has regularly worked with Dovecot, establishing a strong dialogue of ideas and enjoying a culture of mutual respect. Conwy Evans came to Dovecot initially through a recommendation from the Royal College of Art. Working at that date with architect Hugh Casson's office, she encouraged the use of textiles in a number of public buildings, the Hilton being the first, where her *Spirit of Dance*, a lively abstract in hot colours and rhythmic forms, hung the entire height of a circular stair leading to the ballroom. With the Tisdalls and Conwy Evans' weavings, the road to a more abstract, architectural type of work had been taken.

Dick Gordon retired in 1963 after 50 years of weaving, during which time he had witnessed a radical shift from Arts and Crafts practice into modernism. The return of Archie Brennan to the Studios, as weaving and, from that year, artistic director, launched a major new way of working whereby a design was more intuitively and freely interpreted by the weavers. This also corresponded to attitudes within modern architecture where materials and forms of the 1960s

demanded a less old-fashioned type of wall hanging, possibly abstract in design. At the same time, older buildings, particularly churches, could be updated via the introduction of modern textiles. At Dovecot the greatest revolution in the entire process of making came in 1963–4 when the weavers switched from working the back of a tapestry to facing the front surface, for the first time confronting their production face on (fig.34). This happened gradually, one weaver at a time, and demanded a huge, and probably traumatic, leap of faith for each. It involved a complete rethink of what had been nigh on semi-automatic weaving. But if a piece were to be truly creative and intuitive then this was a necessary step.

The other change related to the fineness or coarseness of the warping, which went hand in hand with the introduction of strong, high-spun cotton from Musselburgh in East Lothian, of the kind used for making fishing nets. In 1964 several pieces were warped at only six to the inch, among them Brennan's glorious *Aberdeen '64* tapestry for Aberdeen Art Gallery (see plate 8). Its abstracted forms may be partly a response to Tisdall's approach to tapestry, but Brennan took them into an energised windy northern 'landscape' in which the force of the elements is presented in dynamic colour and texture. Here surface and creative detailing are perfectly integrated.

Other changes were afoot. Brennan had been the first weaver to come through a college training as an artist, and more than half in the future would train at art college ahead of serving their studio apprenticeships. Maureen Hodge (*b.*1941), the first female weaver at Dovecot, joined in 1964 after art college, and wove on Aberdeen's tapestry. Since then many others have come as graduates of Edinburgh College of Art, often via the Tapestry Department which Brennan developed from the existing weaving classes in 1962. In the mid-1960s there was as yet little room, or need, for speculative work which might or might not sell, as a steady flow of commissions came to Dovecot – the result of ETC's owners but also of the realisation abroad that new ideas in textiles were coming on stream. The start of this, in fact, had been the Tisdall commissions.

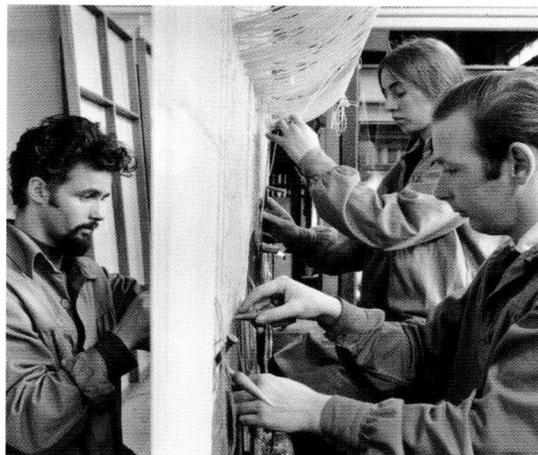

Fig.34 (above)
Harry Wright weaving from the back of the loom as Maureen Hodge and Douglas Grierson weave from the front, *c*.1964

Fig.35 (below)
Fred Mann winding wools from spools to make a mixture to be transferred to bobbins for weaving, *c*.1964

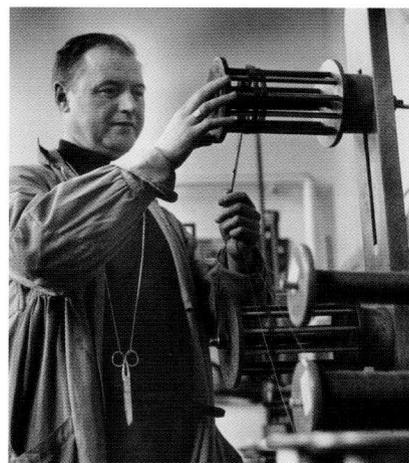

The variety of production in the mid-1960s was remarkable, and the range of patrons interesting. There were a few ecclesiastical pieces, but corporate commissions were now beginning to filter through. Insurance companies with spanking new buildings started to commission tapestry – the London and Edinburgh Insurance Company was one, in 1966. Motherwell's town councillors asked Brennan to design a piece for their meeting room in the new civic centre in 1967, and Midlothian council followed suit in 1969 – Brennan here contrasting the energised map of the region with vibrant patterned areas of lines, squares and dots. And, as a sign of both broader cultural prosperity and the engagement of avant-garde artists with the medium, two museums were important patrons. The Victoria & Albert Museum, whose Circulation Department lent quality objects to museums and organised touring exhibitions, commissioned a major tapestry, *Overall*, from leading American artist Harold Cohen (see plate 9). This was a key collaboration between him and Dovecot which followed a tapestry for British Petroleum and an experimental abstract now with Edinburgh Council (fig.36), all predating the invention of Cohen's own AARON computer technology and its use as a design tool. *Overall* was woven in 1967, a year in which Eduardo Paolozzi designed his great tapestry for the Whitworth Art Gallery at the University of Manchester – the first of some eight commissions from the artist (see plate 10). Maureen Hodge has recently written of this key period:

Fig.36
Harold Cohen
Untitled
1966
Cotton warp, wool
185.4 × 182.9 cm
(73 × 72 in)
City Art Centre, Edinburgh
Museums and Galleries

> The quality of work produced by a tapestry atelier depends largely on three components: the artist designer, the director of weaving and the weavers, and on how they all inter-react with each other and the cartoon. The interpretation and translation from one medium to another is paramount of course. The final result being striven for should have more of the *spirit* of the original than any *copy*

could, but is there perhaps something beyond this? The best tapestries depended on the quality of their initial cartoons and this is borne out again and again, for example, in the tapestries of artists like Harold Cohen and Eduardo Paolozzi. Beyond their status as artists, this group understood tapestry and they knew and exploited what the weavers could do. The best were the best to start off with and they are still the best today.

Brennan and Paolozzi shared an interest in the wider field of popular culture and both amassed collections of everyday objects. Brennan has referred to this as 'contemporary archaeology'. The late Revel Oddy, museum curator and himself a weaver, described a visit to Brennan's home as 'like walking into an enlarged and more varied version of a woman's handbag'. Wide-open thinking and experiment were vital. One key feature of Brennan's approach was to produce a number of sample weavings for discussion with an artist. In the Dovecot Paolozzi works, however varied the 'style' of each weaver, it is remarkable how the artist's thinking absorbs their differences, making them above all 'Paolozzi pieces'.

Dovecot's willingness to experiment resulted in a rich variety of production. In London, Joyce Conwy Evans had been commissioned to prepare designs for a ceremonial trumpet tabard and robe edgings for the Royal College of Art, which was celebrating its new university status (fig.37). She had found Dovecot through the RCA. This commission meant using a variety of materials in creative ways: gold and silver leaf from supplier William Hutchison was spun round silks; metal threads and even non-tarnishing gold lurex were used. Different forms of knotting and half-hitching raised the surface and gave a sturdier quality than embroidery would have allowed. Conwy Evans, who today still designs and also teaches embroidery, had become interested in the possibility of an increased layering of materials, and Maureen Hodge, who had woven on the College edgings, in the same year wove a small panel of a bird in its natural habitat, *Woodthorpe*, for the artist to enhance with embroidery. Two of the most striking weavings in terms of materials and workmanship were Conwy Evans' altar frontals for King's College Chapel, Cambridge, where

Fig.37
Joyce Conwy Evans
Royal College of Art robes
(detail)
1967
Cotton warp, wool, metallic thread
Royal College of Art, London

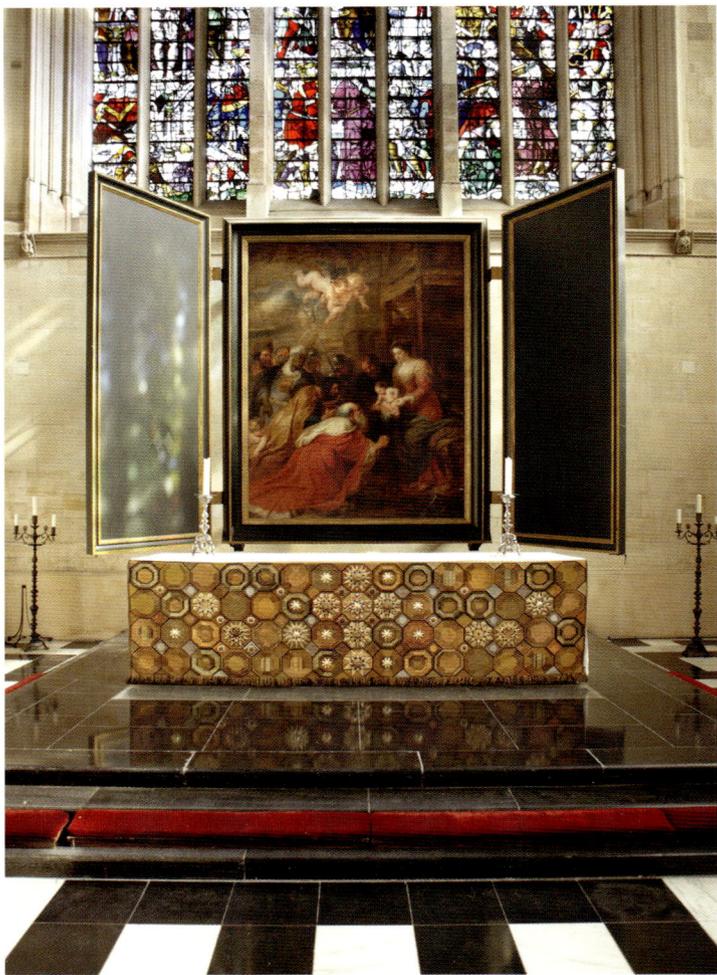

weavings were adorned with beads, metallic threads and stitchery (fig.38). Traditional yet modern, such exotic work perfectly fitted an age of intercultural activity. At the same period tile decoration had restarted in Corstorphine, with the City of Edinburgh and its expanding university both placing major orders. The media also became important to advertise modern tapestry's potential. Brennan designed *Twa Corbies*, woven by Hodge, to be the background for a short BBC television film made in 1967. He would make a longer film for the BBC in 1971, focusing mainly on the designing and making of his large, layered 1970 tapestry for the Scottish Arts Council's Charlotte Square board room. Brennan had won the Council commission in competition against Bob Stewart.

The major commissions of the mid–1960s provided some prosperity for ETC which in 1966 was able to purchase the studio building and its land from Lord David Stuart. The company was strong for now, but besides presenting a modern face to the world, it recognised the need for continuity in maintaining skills and

Fig.38
Joyce Conwy Evans
King's College Chapel altar frontal
1968
Cotton warp, wool, metallic thread, glass
66.2 × 343 cm (26 × 135 in)
King's College Chapel, University of Cambridge

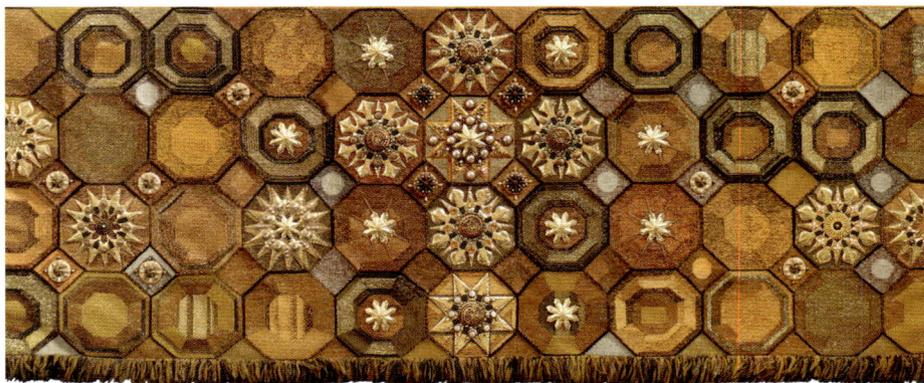

continuing to offer more traditional textile work as needed. Dovecot, sometimes on the recommendation of local furniture and furnishing company Whytock & Reid, carried on its regular background work of repairs to historic tapestries and furnishings. Holyrood Palace required repair work, and Floors Castle in Roxburghshire needed tapestry and chair work over a long period. Some of it was worked by Archie Brennan's sister, Julia Robertson, who from 1964 also managed the office day to day and wrote up the daybooks, keeping everything running smoothly. On occasions she also helped with warping looms and printing the ceramic tiles. Other staff engaged to do repair work were Evelyn Graham and Doreen Tarbit. In addition relatively small commissions such as borders for kneelers for Glasgow Cathedral were carried out.

It would be wrong to consider that Brennan dominated daily life at Dovecot. Setting up and teaching in the Tapestry Department at the art college took up several days per week, making his post of artistic director very much a part-time occupation – and this would continue under his successors Fiona Mathison (*b.*1947) and Joanne Soroka (*b.*1949). By now Fred Mann and Harry Wright were the master weavers who developed the new Dovecot 'style', joined by Douglas Grierson in 1961 as the first apprentice to serve a five-year, not a seven-year, apprenticeship and in 1964 by Hodge. Others to come from the college included Mathison in 1970 (part-time during summer holidays and ahead of her postgraduate study), Neil McDonald in 1971 and Jean Taylor (*b.*1949) the following year. The weavers wove side by side on a loom, each tapestry a union of their individual ways of working, their unique styles interpreting a design little by little. While weavers' work is as individual as that of any artist or craftsman, it is also a strongly shared experience. In the production of the major tapestries, turns are taken on a loom week by week, the younger weavers joining the experienced. Skills and ideas are continually explored and passed down – it is very much learning by doing.

In this difficult craft, some of the most problematic issues have been raised by artists who are completely unfamiliar with tapestry. A case in point was David Hockney's (*b.*1937) first tapestry with Dovecot, *Play within a Play* (fig.39), woven in 1969, in which the source was a painting of roughly the same size. This was interesting in concept, a tapestry within the painting to be reworked as a new tapestry, but it soon proved to be a nightmare to interpret. Much of the background sky and land areas within the 'tapestry' of the artwork used multi-

colour sweeps which were relatively tedious to weave or difficult to interpret and had to involve using and cutting off far more bobbins of wool than was the norm. Brennan shared an interest in the ideas of layering of images, in *trompe l'oeil* and perspective, enjoying the fun and fascinated by the potential of it all. He developed it in several of his own pieces, such as *Kitchen Range* and *Hearth* (1974) (fig.40) for the Edinburgh architect Michael Laird and a series called *At a Window* (from 1973) (fig.41 and see plate 19) where the love of strong pattern, of textiles within textiles, and of the possibilities of playing with a third dimension contrasts with Paolozzi's or Cohen's primary concern with two-dimensional surface values. Such patterning thus contributes to the electric vibrancy of late Pop Art, while still concerned primarily with the objects of everyday life. In this period Brennan also made a few pieces of jokey soft sculpture – in *Steak and*

Fig.39 (right)
David Hockney
A Tapestry made from a Painting, made from a Painting of a Tapestry, made from a Painting (*Play within a Play*, 1st edition)
1969
Cotton warp, wool
172.7 × 213.4 cm (68 × 84 in)
The David Hockney Foundation

Fig.40 (opposite, above)
Archie Brennan
Kitchen Range and *Hearth*
1974
Cotton warp, wool
122 × 96.5 cm (48 × 38 in)
and 45.7 × 147.3 cm
(18 × 58 in)
Private Collection

Fig.41 (opposite, below)
Archie Brennan
At a Window III (also known as *The Wine Cask* and *The Wine Flask*)
1974
Cotton warp, wool
188.6 × 112 cm (74¼ × 44 in)
Ardkinglas Collection

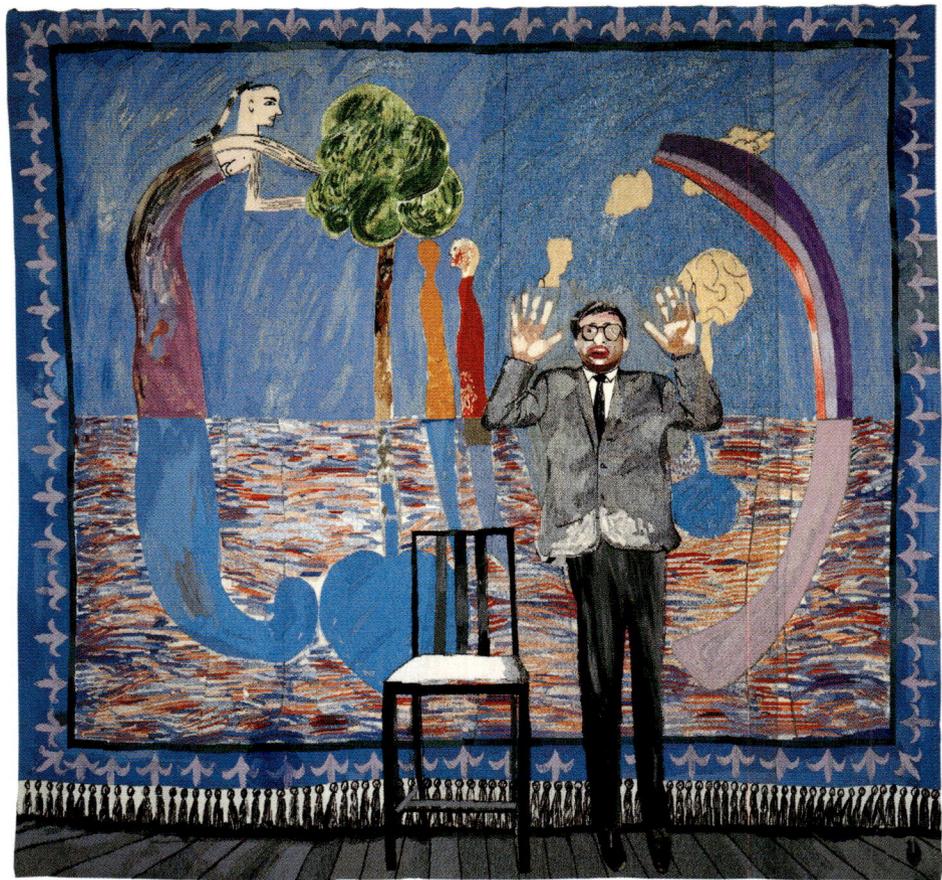

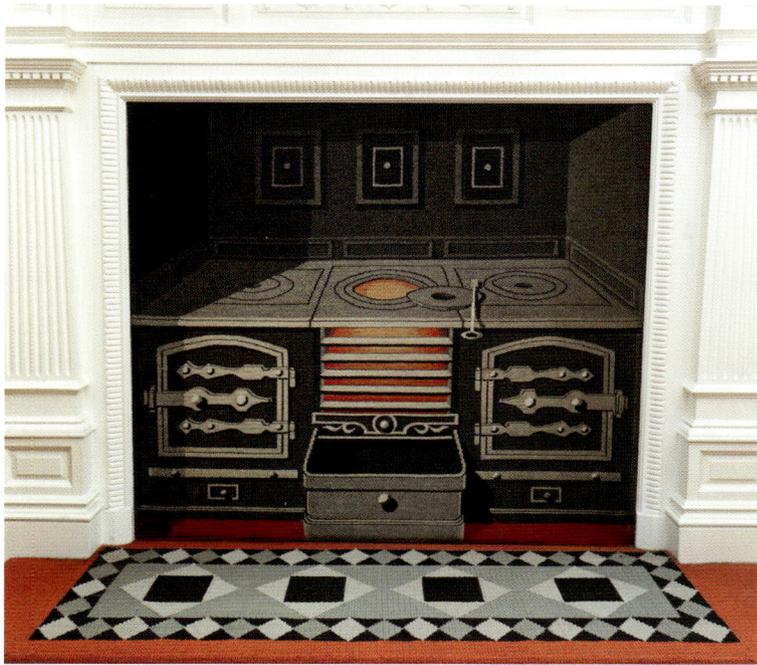

Sausages (1972), he wove the steak and Fiona Mathison knitted and stuffed the sausages.

Such work was often speculative, and ran alongside church and public commissions; and again, different types of layering – of material and process – were vital to the new work. Two artists should be acknowledged here: Bernat Klein (*b*.1922) and Tom Phillips. Klein, a painter as well as a textile designer but above all a colourist, wished to explore the effect of light on surface. In the late 1960s Klein had begun to take photographs of details of his paintings. Over two years Dovecot's weavers worked with him, translating these details of thick, worked paint into extraordinary layered skins of weaving. With Phillips' key work *After Benches* (1973) (see plate 13), the source was a postcard from his vast collection – which had become two prints, then a painting, before being interpreted here in tapestry and thereafter issued as another postcard. The journey of translation was physical but also intellectual and cultural at each stage. Text along the foot of the tapestry narrates its journey. After the first (left) section, the four weavers here – Fred Mann, Douglas Grierson, Neil McDonald and Jean Taylor – gave individuality to

THE EDINBURGH TAPESTRY CO. LTD.

Fig.42 (above)
Fred Mann
Edinburgh Tapestry Company logo
1973
Cotton warp, wool
63.5 × 426.7 cm (25 × 168 in)
Private Collection

Fig.43 (below)
Archie Brennan
Muhammad Ali (and detail)
1973
Wool
91.4 × 152.4 cm (36 × 60 in)
Private Collection

their sections. Unlike later speculative pieces, this was not specifically woven to earn money and has remained with the artist – a sign of Phillips' commitment to the craft and of the creativity and prosperity of the times in which it was made. The success of this remarkable work lies in the happy partnership of artist and studio. *Complete Colour Catalogue* neatly records the colours used in all the studio's productions between May and September that year. Phillips has worked several times with Dovecot, including a major piece for Morgan Grenfell in 1980 and, above all, a suite of six tapestries completed in 1981 for St Catherine's College at the University of Oxford where they complete the Arne Jacobsen building (see plate 17). These are among the finest twentieth-century tapestries, superb in concept and inventive in their fabrication. Brennan enjoyed the partnership and has since woven postcards received from Phillips. They shared an interest in design sourced in popular culture. *After Benches* was woven in the same year as Brennan's *Muhammad Ali* (fig.43), with its design derived from a television image of the boxer, and Brennan would turn to press photography for three sporting tapestries in 1976 and 1977: *Runner*, the Meadowbank Stadium tapestry and *Brendan Foster*.

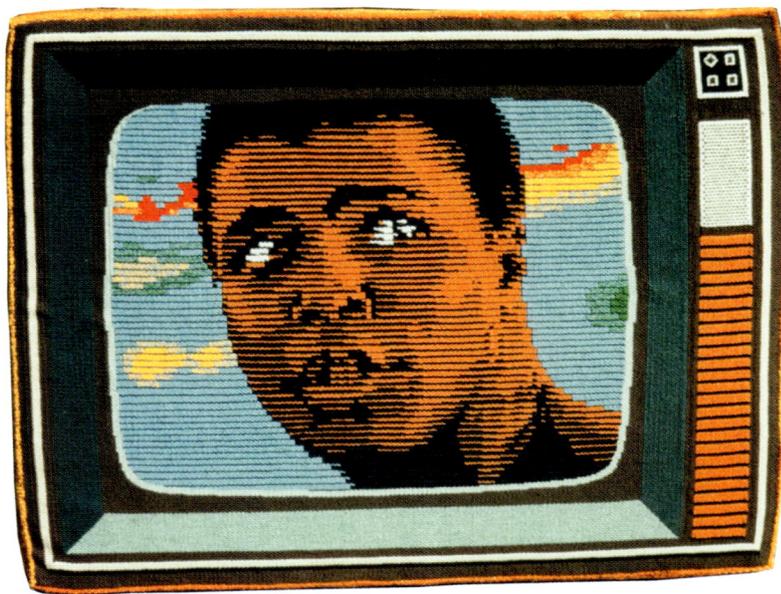

INTERNATIONAL VENTURES

Behind the scenes the issue of financing the Studios continued to be problematic, even at this date when experimentation was vital to its dynamic and development. John Noble (fig.44) died unexpectedly in 1972. He had generously kept Dovecot afloat at times when sales and commissions were scant. In June his seat on the ETC board was taken by his son, Simon John Noble (1936–2001) (known variously as Johnny or Sammy), who also became company secretary. He soon proved to be as strongly committed as his father. In September the Hon. David Bathurst of Christie's New York and Brennan were also appointed directors. Maureen Hodge left Dovecot in 1973 to teach in the Tapestry Department at the art college. The workforce she was leaving was not a particularly contented one. The weavers were conscious of an inequality, and specifically of the availability of additional paid freelance work to those who were college-trained, such as Taylor or McDonald. By the end of the year Harry Wright's (temporary) departure was symptomatic of discontent among the weavers, and a substantial increase in wages had to be put swiftly into place. On joining ETC's board, Johnny Noble, who owned the company French & Foreign Wines Ltd, investigated the French pricing of tapestries, which he found much higher. By 1974, as Brennan reported, much depended on 'costing the tapestries realistically and putting the fairly new situation of a full order book to the test of really realistic prices'. Noble wanted ETC to continue cautiously for the time being 'as a small private company' with its viability dependent on its own efforts rather than subsidy from private or public sources: quality rather than quantity was still to be the rule.

Through the 1970s the range of patrons was wide – banks and insurance companies, civic centres and sports stadiums, technical colleges now made universities, hotels, chapels and churches, plus the more occasional private commission or purchase. The Scottish Arts Council, having chosen Brennan over Bob Stewart in 1968 for its own boardroom tapestry,

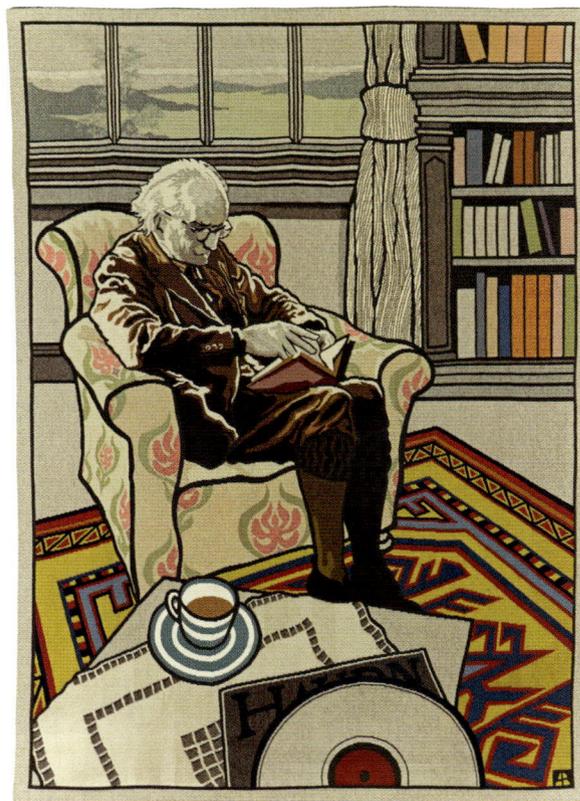

Fig.44
Archie Brennan
Portrait of Mr Noble (second weaving)
1981
Cotton warp, wool
244 × 183 cm (96 × 72 in)
Ardkinglas Collection

Fig.45
Robert Stewart
Glasgow Cathedral tapestries
1978–9
Cotton warp, wool
Three panels, two sizes
457.2 × 304.8,
457.2 × 274.3 cm
(180 × 120, 180 × 108 in)
Glasgow Cathedral

commissioned the latter to design a piece for the University of Strathclyde which was woven in 1970. This was regarded by Brennan as a particularly successful collaboration. Stewart's designs would also be woven for the crypt of Glasgow Cathedral (a triptych of symbolic forms and shadows, 1979) (fig.45) and Glasgow City Chambers (*Glescau*, 1982). *The Four Seasons*, another magnificent tapestry this time for the University of Stirling, was designed by John Craxton (1922–2009) and woven in 1975–6 to commemorate Tom Cottrell, its first principal (see frontispiece). In an age in which textile crafts were enjoying a real renaissance at both professional and amateur levels, Dovecot also supplied materials to a number of weaving groups and individuals. For example, ETC's daybooks record delivery of 36 large bobbins and 2 metres (6 feet) of studded tape to Gerald Laing (1936–2011) at his restored Kinkell Castle on the Black Isle. Better known as a sculptor and painter, he had started a weaving workshop in 1970 for local young adults, Brose Patrick (Scotland) Ltd, which used modern artists' work as a basis

for the tapestries. Some seven teenagers were employed for a four-year period before moving to better-paid jobs in the oil industry. More than seven weavings from Henry Moore's designs, passed to them by Archie Brennan, were made there; then Moore turned to the West Dean College in Sussex – a studio which in the 2000s would weave the seven reproduction tapestries for Stirling Palace.

Also financially underpinning these years, but in fact the most demanding of all in this period, were the 48 tapestries woven for Gloria Ross (1923–98). A New York philanthropist and businesswoman with a passion for needlecraft and especially tapestry, Ross commissioned workshops and studios to make editions of tapestries which were sold, often through the Pace Gallery, New York, to museums, corporations and individuals. Between 1969 and 1980 she placed orders with Dovecot for tapestries to be woven from paintings or maquettes by mostly American painters – the exception being Jean Dubuffet (1901–85). Pieces by her sister, the artist Helen Frankenthaler (1928–2011), and her brother-in-law Robert Motherwell (1915–91) became abstract textiles – Motherwell's was the first to come off Dovecot's looms (see plate 11). Other artists whose images were sent over to Corstorphine for working included Robert Goodnough (1917–2010), Adolf Gottlieb (1903–74), Jack Youngerman (*b*.1926), Kenneth Noland (*b*.1924) – and Louise Nevelson (1899–1988), among whose tapestries the set of 'uniques' (i.e. non-editioned tapestries) proved to be some of the most challenging (fig.47). Many other studios – mostly in France and America – also wove for Ross, who labelled each work 'a Gloria F. Ross tapestry'. Letters flew back and forth, telephones rang and Ross called in person from time to time to assess progress and standards of production. Samples were woven for discussion and hopefully approval by both Ross and the artist, but in these cases the artists did not

Fig.46 (below left)
Helen Frankenthaler
After *1969 Provincetown Study*
One of an edition of four
woven 1970–76
Cotton warp, wool
259.1 × 172.7 cm
(102 × 68 in)
or 228.6 × 144.8 cm
(90 × 57 in)
Private Collection

Fig.47 (below right)
Louise Nevelson
Desert
1977–8
Cotton warp, wool
244 × 129.5 cm (96 × 51 in)
Museum of Fine Arts, Boston

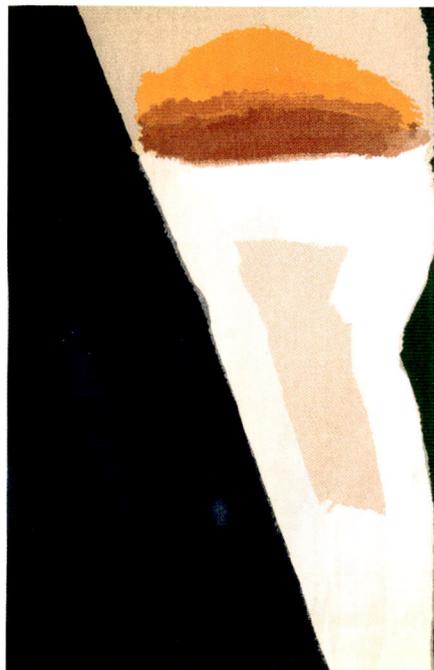

Fig.48
Graham Sutherland
Carpet
1976
Cotton warp, wool
365.8 × 274.3 cm
(144 × 108 in)
Private Collection

personally visit Dovecot. Nonetheless, the tapestries built an international platform for ETC's reputation and still today feature in several American museum collections. The abstract images with which the Studios were supplied allowed scope for a range of weaving, including the knotting and half-hitching which were also used in the Bernat Kleins.

Taking its lead from printmaking and sculpture, editioning tapestry was almost standard practice by the late 1960s. Changes were frequent after the initial weaving, often at the behest of Ross. The initial plan for a particular edition was also sometimes modified. A case in point was Nevelson's *Sky Cathedral,* a series begun in 1972 (see plate 15). Correspondence between Edinburgh and New York records the experimentation which the weavers wished to introduce, and the extent to which their vision, based on long experience, was at times radically controlled and restricted by concerns from America. The financing of some of the tapestries was also discussed in the mid–1970s, when Ross suggested ETC fund the Nevelsons, and she be formally appointed ETC's agent in the United States. No such agreement was ever reached. But, however demanding the relationship might have been at various times, there is no doubt that this was an exciting period for Dovecot – and provided support for the Studios.

Another key source of income at this time came from businessman Nigel Broackes, for whom several important Graham Sutherland pieces were woven: a large carpet (fig.48) and a wall tapestry *Form Against Leaves* in 1976, with two more the following year, *Emblem on Yellow* and *Emblem on Red*. Broackes had considered developing a tapestry collection; he was particularly keen on Sutherland, and Brennan's advocacy of editioning this artist's designs was shrewd. An edition of five was agreed with the artist's estate. Brennan also engaged Broackes in discussion on other potential artists such as Peter Blake, but only the Sutherlands were ever made.

By the mid-1970s Brennan's own career had become international. He had participated in key tapestry Biennales since they were inaugurated in the 1960s, and had since enjoyed various consultancies including at the Victoria Tapestry Workshop in Melbourne and as a visiting lecturer at the National School for the Arts in Papua New Guinea. Then in 1977 he became joint chairman of the British Craft Centre. Johnny Noble worried about ETC's dependency on him, noted that new blood was needed and considered that Dovecot might become almost a hindrance to Brennan's career. In February 1978 Brennan announced he was leaving Dovecot to teach in Papua 'for an indefinite period', but, serving on the ETC board, he retained shares in the company until 2000. A number of possible successors were discussed. He left in April; weaver Fiona Mathison, who also taught with Maureen Hodge, took over as part-time artistic director. Mathison, like all the best weavers, had her own voice in her fine work. In her case she draws on her surroundings with wit, alternating, as she herself says, between reality and fantasy.

During the 1970s a number of young weavers joined Dovecot including Gordon Brennan (b.1956; a nephew of Archie), Ellen Lenvik (b.1946), Belinda Ramson, Joan Baxter, Willie Jefferies, Johnny Wright (b.1961; Harry's son), and Janette Wilson. They came through different routes – Gordon Brennan serving his apprenticeship before studying at Edinburgh College of Art where he teaches today. Most stayed for only a few years and perhaps up to ten, but Johnny Wright became part of the long-term team. Through this decade Dovecot tapestries had been seen in a number of exhibitions – at the Midland Group Gallery in Warwick and Burleighfield Printing House (for the Reyntiens Trust) in 1974, the Durham Light Infantry Museum and Glasgow School of Art in 1976, Edinburgh College of Art in 1977. These exhibitions were essential to raise awareness of the Studios as wages, and thus costs, rose and the basic financing of production became ever more difficult. In 1973 Brennan had warned Paul Cornwall-Jones, Hockney's dealer, that the second weaving of *Play within a Play* would be considerably more

Fig.49
Fiona Mathison
A Clean Sheet
1980
Cotton, linen, polystyrene
136 × 249 cm (53½ × 98 in)
National Museum of Scotland

expensive than the first. Fees to artists such as Hockney just a few years later could be as high as £2,000 plus VAT, as was paid for the two *Blue Guitar* suite pieces of 1976 and 1977–8. Despite Noble's recent wish to continue without national funding, a series of conversations opened with the Scottish Arts Council in the late 1970s. In the summer of 1977 Brennan was discussing the option of an exhibition of large tapestries with Bill Buchanan, the Council's art director, which would be linked to commissioned work – but permanent sites for them had to be identified.

Fig.50
Graham Sutherland
Form Against Leaves (2nd edition)
1980
Cotton warp, wool
203.4 × 175.3 cm (80 × 69 in)
Ardkinglas Collection

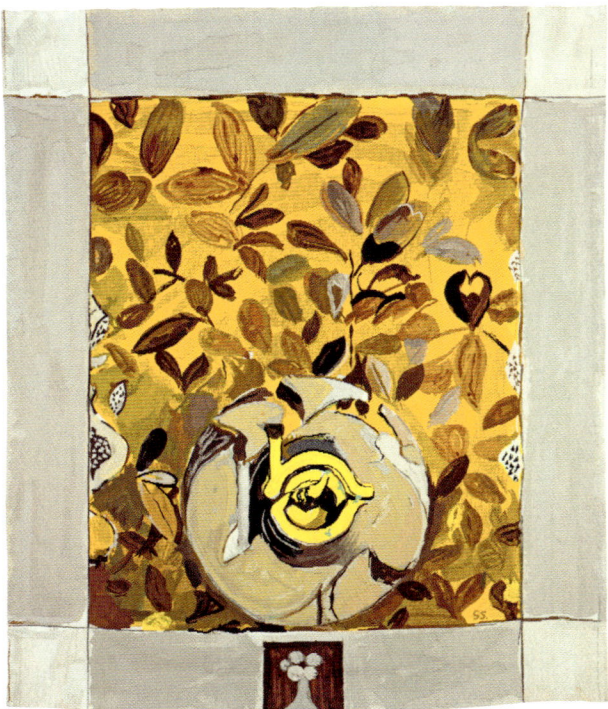

FEAST OR FAMINE

When Mathison took over from Brennan as artistic director the order book had been thinning fast. There had been proposals which took time to negotiate yet came to nothing, including two tapestries after Picasso. A John Piper (1903–92) commission for Sussex University in 1978 was followed by the start of what would become absolutely key to the studio's survival and development – Tom Phillips' suite of (initially three) tapestries for St Catherine's College, Oxford. Piper's *The Five Gates of London* had been woven for the company Sedgwick Forbes three years earlier (see plate 16). In August 1979 Mathison met Rob Breen, the Scottish Arts Council's exhibitions officer, to discuss a major retrospective exhibition. Planned for 1982 to celebrate 70 years of Dovecot, it was brought forward thanks to a gap in the exhibition programme and the Council's sympathy for the Studios. 'Master Weavers: Tapestry from the Dovecot Studios 1912–1980' was held at the Royal Scottish Academy during the 1980 Edinburgh Festival with a substantial, fine catalogue mostly written by Maureen Hodge and published by Canongate. It was organised in a relative rush, with new work woven specially including John Houston's (1930–2008) *Sunset over the Sea* and Graham Sutherland's *Form Against Leaves* (fig.50). But they did not sell.

Noble had written that January to the Council's then art director, Philip Wright, that ETC was going through

'something of a crisis' concerning cash flow: 'this is a moment when we badly need help'. Wright offered as much help as he could to this 'private owned limited company with profit distributing status':

> In keeping with our esteem for the Dovecot Studio's standards and the works of art/craft it produces, we have given an undertaking to consider offering up to half the costs of two tapestries a year, one woven to a design by an outside artist, and the other to a design by a weaver employed at the Dovecot Studio – for a publicly accessible site in Scotland.

It was a tricky one to realise, however, and the dialogue continued well into the early 1980s.

In the recession commissions were particularly delicately handled and sometimes relied on the artist being generous. In 1982 Paolozzi, for example, would waive his design fee for a piece for Leicester University, but still the university had problems funding its tapestry. Enquiries from private individuals for new tapestries were steered towards the existing collection of unsold works. Following even the publicity of 'Master Weavers' and a BBC television programme *The Craft of the Weaver* focusing on Dovecot, few purchases were made – five post-war tapestries, including the Wadsworth and Trevelyan, were bought by a Scottish collector, and a Gauguin tapestry and the Cecil Beaton chair seat were amongst pieces sold to the National Museums of Scotland in 1981. No line of new commissions streamed in, but the solid relationship earlier forged with Tom Phillips and St Catherine's College had extended his original three tapestries to a fine suite of six.

In 1981, as the Oxford tapestries were completed, Fiona Mathison decided not to continue as artistic director (although remaining as a consultant until 1984), and artist Margaret (Maggie) Liddle was appointed to succeed her. Liddle designed two tapestries to be woven slightly later for local communities – Carricknowe Church and the Royal Edinburgh Hospital. Towards the end of 1981, with

Fig.51
Tom Phillips
Una Selva Oscura
1980
Cotton warp, wool
Dimensions unknown
Location unknown

few pieces on the loom (including Bob Stewart's *Glescau* tapestry for the Glasgow City Chambers and a work commissioned through Leslie Chabot of the Vesti Swiss commercial agency) or in sight, the cash flow situation was desperate. Some weavers had already left, and three more – Douglas Grierson, Johnny Wright and Jean Taylor – were briefly laid off in November, leaving Fred Mann and Johnny's father Harry Wright to weave a private commission from Conwy Evans. Loyalty had always been strong at Dovecot: the archives record how Grierson dropped to half-time working, and at one stage wove without pay.

Thus 1982 became yet another year for essential reassessment. Douglas Hall, Keeper of the Scottish National Gallery of Modern Art, had commissioned a tapestry for the collection from a design from John Mooney (*b*.1948), and this, with the Paolozzi and the Stewart plus a few smaller pieces including some Sutherland samples, helped keep the Studios afloat. But, as Johnny Noble wrote in February to Tim Mason, director of the Scottish Arts Council, once those were completed 'we shall be short of work'. There was interest from such places as Pitlochry Festival Theatre but they had few funds to offer. There was affection within art circles for Dovecot, with Mooney and fellow artist Bob Callender buying tiles and frames from studio stock to offer a little money. Some teaching was organised to generate some income, but in July Liddle left Dovecot.

Joanne Soroka, a Canadian weaver who had trained at the art college, was appointed from August. The task of finding commissions and raising funds was a top priority. In the spring of 1982 Harry Jefferson Barnes died, and the various share holdings in ETC were restructured. His shares were bought by Cumbrae Properties which also owned Bute Fabrics, a top-quality commercial weaving manufactory started by the Bute family after the war, and other businesses. The sixth Marquess, John Bute (1933–93), at this stage a minority shareholder, was

Fig.52
John Mooney
Miniature
1983
Cotton warp, wool
7 × 75 cm (2¾ × 29½ in)
Ardkinglas Collection

increasingly aware of the desperate financial situation. While other shareholders including Noble remained on the board, from March 1983 Lord Bute became the majority shareholder. As consultant, Fiona Mathison voiced the studio's worry that Dovecot might move west to the island of Bute, but this proved to be unfounded, much to the relief of the weavers.

During the five years of Joanne Soroka's tenure as artistic director, and that of her successor, James More (1946–2011), the process of seeking commissions at home and abroad continued unceasingly. North America and Scotland both benefited, with trade centres in Kansas City and Tokyo showing work, and several Canadian commissions coming to Edinburgh. These included a suite of three tapestries (1983) after Jessie Willcox Smith's (1863–1935) illustrations to Robert Louis Stevenson's *A Child's Garden of Verses* which were sent to a Kansas City store and are now in a nearby children's hospital. Harold Cohen had two further tapestries woven, though not for a United States collection. Ahead of Soroka's arrival, Sam Ainsley (*b*.1950) had brought in a design for a sample weaving for General Accident's headquarters in Perth which proved a major commission (see plate 20). It took Dovecot's weavers into new territory. In all, 15 odd-shaped sections were woven and mounted on wire mesh before being layered on the wall. Ainsley also designed a series of ten spinnaker nylon 'kites' on aluminium frames, sewn by Dot Callender, which as light mobiles or 'spatial hangings' floated in the atrium of Esso's Mossmorran depot in Fife (fig.52). In late 1986 another new departure, recorded in board minutes under 'research and development', was the introduction of gun-tufted rugs. This had grown out of Douglas Grierson's weaving of hand-knotted rugs for his own use at Dovecot.

In addition to recruiting artists and herself designing for the Studios, plus the normal daily tasks of managing and monitoring quality, Soroka saw her role at Dovecot as being its prime advocate in the art marketplace. She broadcast Dovecot's history, speaking at various conferences including 'Textiles for Interiors' at Highland Craftpoint in Beauly, Inverness-shire in March 1983 and for the

Fig.53
Sam Ainsley
Esso kites
1985
Spinnaker nylon, nylon thread, aluminium
Various dimensions
Esso, Mossmorran

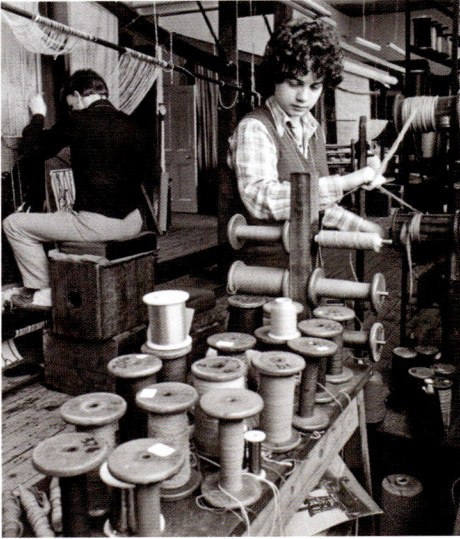

Fig.54 (above)
Johnny Wright weaving as Shirley Gatt makes up a colour mixture of different threads using a variety of spools, c.1983

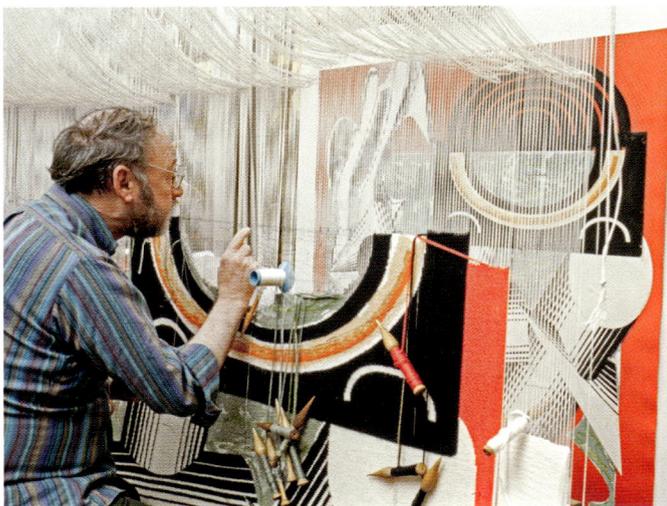

Association of Art Historians a year later. In 1985 she organised two displays at the art college as part of its 'Edinburgh–Dublin' exhibition during the Festival, one of ETC work, while the other, 'Straight off the Loom', featured contemporary Scottish tapestry. Apart from Hodge, Mathison and Soroka herself, one weaver included in the latter was Shirley Gatt (b.1959) who had joined Dovecot straight after art college in 1982 and wove on some of the key tapestries of the later 1980s and 1990s. In 1986 another apprentice, David Cochrane, was taken on, his wage and lodging allowance supported by the Scottish Development Agency.

However, realising assets continued while the board had its unsold stock valued and Soroka organised several displays. In March 1983, 38 pieces from the 1950s – including chair seats, table covers and both religious and domestic tapestries from stock – were offered for sale through the George Street store of Martin & Frost, though only eight in fact sold. That summer the architect Ben Tindall arranged a display reflecting the ideas of philosopher and priest Teilhard de Chardin, including Cohen and Sutherland pieces, at New College, Edinburgh University. In addition many magazines carried features on Dovecot, from *Building Design* to *The World of Interiors*, *Country Life* to *Crafts*, carrying on Mathison's publicity at home and in the USA.

Within Soroka's period of tenure Joe Tilson's (b.1928) major print-based piece, *Proscinemi for Kore*, was woven (fig.56). Perhaps the highest point was the remarkable suite of tapestries designed by American artist Frank Stella (b.1936) after his *Had Gadya* series from El Lissitzky (fig.55 and see plate 21). The chairman of the PepsiCo corporation, Donald Mackenzie Kendall, an American of Scottish descent, visited the Studios and was entranced. The result was 11 tapestries which still fill the company's entrance in New York. Like Sam Ainsley's Mossmorran installation, these are an intrinsic part of the space, enlivening it with rhythm and colour. Stella, like Cohen, visited the Studios on several occasions. He

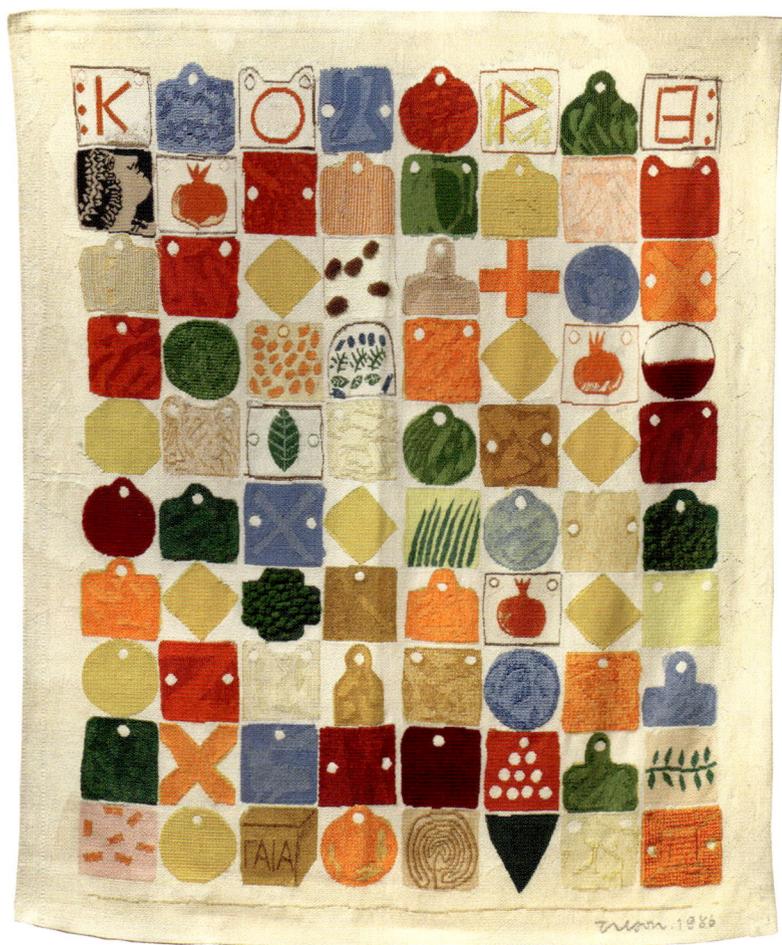

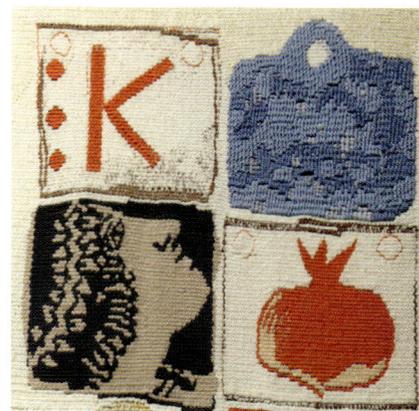

bought some nine rugs from stock, still in use in his home. For once the suite was completed months ahead of schedule, allowing it to be displayed at the Scottish National Gallery of Modern Art. The gap on the looms also meant a twelfth tapestry was woven that summer and kept by Kendall himself.

Despite the success of the Stella commission, the order book was again thin. Weaving the Stellas may have occupied the looms but its publicity had not yielded further commissions, and with Richard Smith's (*b*.1931) *Multilayers*, a speculative piece, due for completion in March 1987, Soroka had to admit that some of the weavers would soon have nothing to do. She left Dovecot that month to return to an independent career as a tapestry maker. After a gap of some six months, James More of the Scottish College of Textiles in Galashiels was engaged as managing director. He immediately designed the first major tapestry in over a year, for the Dunedin Fund Managers (see plate 22).

Fig.56
Joe Tilson
Proscinemi for Kore (and detail)
1986
Cotton warp, wool
244 × 200.8 cm (96 × 79 in)
Private Collection

Fig.55 (opposite, below)
Fred Mann weaving Frank
Stella's *Then Came a Dog and
Bit the Cat*, the third of his
Had Gadya series, 1986

Designing apart, More's time as Dovecot's director was also largely taken up with publicity at home and abroad including possible trade exhibitions in Japan. With the backing of the ETC board, he set about promoting Dovecot as essentially a Scottish tapestry studio. To do this, five different 'collections' were announced to emphasise Dovecot's heritage while stressing the artistic and practical values of tapestry. Paramount was the 'Scottish Collection' created 'in collaboration with Scottish artists to celebrate the 75th anniversary of the founding of the Company's studios'. John Houston's *Sunset over the Sea* had in fact been woven for 'Master Weavers', but more recently Elizabeth Blackadder's (*b*.1931) *Irises* and *Tulips* were commissioned by Cumbrae and ETC director Peter Simpson ahead of More's arrival. As advertised by More, this series had 'authority, grace and eloquence' – artists such as William Littlejohn (1929–2006) and Robin Philipson (1916–92) were invited to work with the weavers to create a series of key modern artworks which in aggregate have a clear identity (see plate 23).

The matching of Scotland's colourist art tradition with the craft was perfect. Supported by Lord Bute, who would lead the creation of the new Museum of Scotland, a series of key Scottish tapestries resulted from the weavers' collaboration with Philipson, John Bellany (*b*.1942), Blackadder, Adrian Wiszniewski (*b*.1958), Glen Scouller (*b*.1950) – and More himself. Most of the artists found this experience deeply enriching, Bellany writing that 'the whole creative process has been a joy from start to finish'. Unfortunately, some of these did not find a ready buyer. The marketing of Dovecot did however often pay off and some major commissions came in, such as Duncan Shanks' (*b*.1937) vibrant *The Source of the Clyde* (1991) for the Glasgow Royal Concert Hall (fig.58) and Bruce McLean's *Tapestry for an Ante Room in a Cultural Cathedral* for the National Museum of Scotland in the same year. There were of course other ventures with non-Scots, such as knitwear designer Kaffe Fassett (*b*.1937) whose suite of four *Ginger Jar* designs was woven speculatively in 1992–3 and widely publicised through popular magazines (fig.60), and Mick Rooney's (*b*.1944) *Buried Treasure* of 1992 which went to TSB Birmingham through James Knox's company Art for Work (fig.62).

With Dovecot now again primarily celebrating the pure Scottishness of its productions, various local institutions came forward to discuss commissions for new buildings. One of the most lucrative commissions came from Scottish Provident. Designed by Blackadder, it was warmly received by the insurance

Fig.57 (opposite, above left)
John Bellany
Clapham Concerto
1988
Cotton warp, wool
267 × 213.4 cm (105 × 84 in)
Northumbria University

Fig.58 (opposite, above right)
Duncan Shanks
The Source of the Clyde
1991
Cotton warp, wool
255 × 250 cm
(100½ × 98½ in)
Glasgow Royal Concert Hall

Fig.59 (opposite, below)
Bruce McLean
Tapestry for an Ante Room in a Cultural Cathedral
1991
Cotton warp, wool
259 × 198 cm (102 × 78 in)
National Museum of Scotland

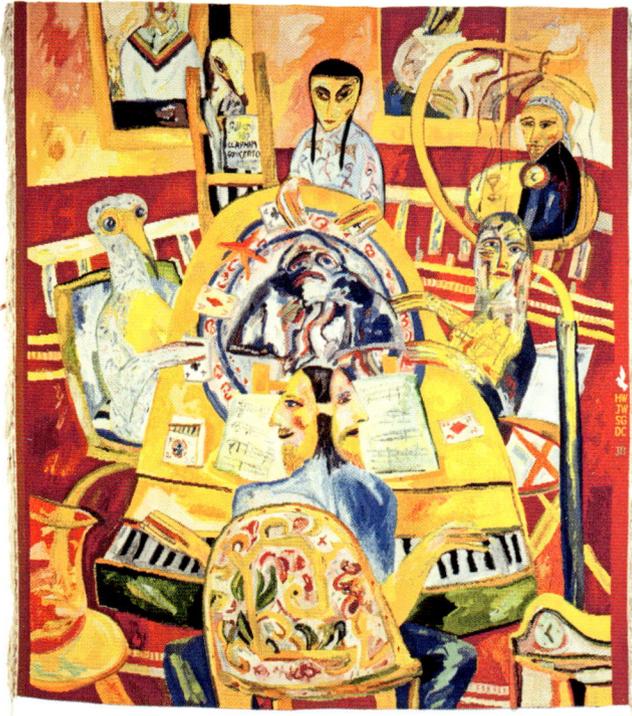

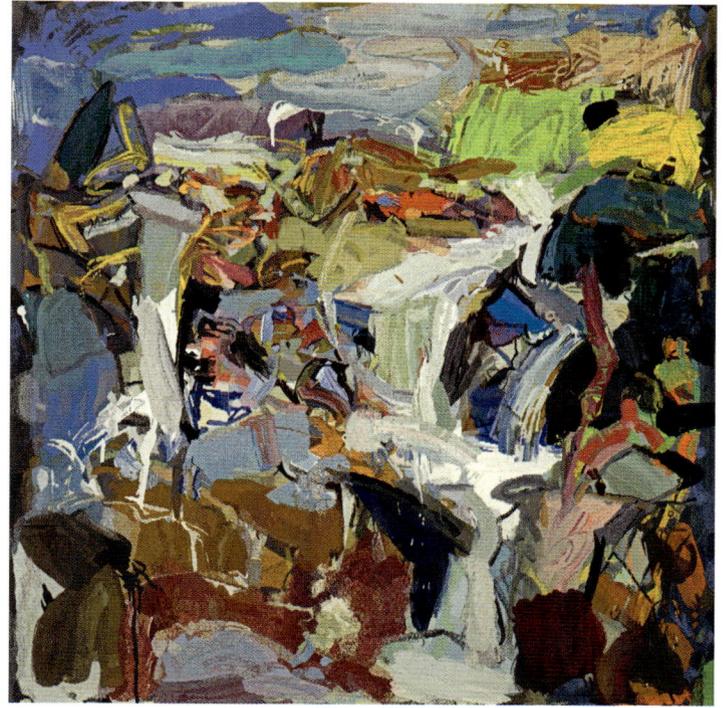

company who declared that 'in a fairly intangible way' it reflected Scottish Provident's 'growth and the nature of the industry'. Another proposal, in 1992, for a suite of tapestries for the National Library of Scotland's new Causewayside building and 'to celebrate forty years of achievement', came to nothing. Others, including one from the Bank of Scotland for its tercentenary, would be realised.

In addition, there were more experimental pieces such as *Charlie's Retired*, a response to a proposal from London dealer Fischer Fine Art to weave a detail from a photograph of the Berlin wall (see plate 25). A sample was woven in August 1990, and the tapestry itself that September and October by Shirley Gatt and David Cochrane (fig.63). This extraordinary piece was intended 'to recreate the distinctive quality and colour of

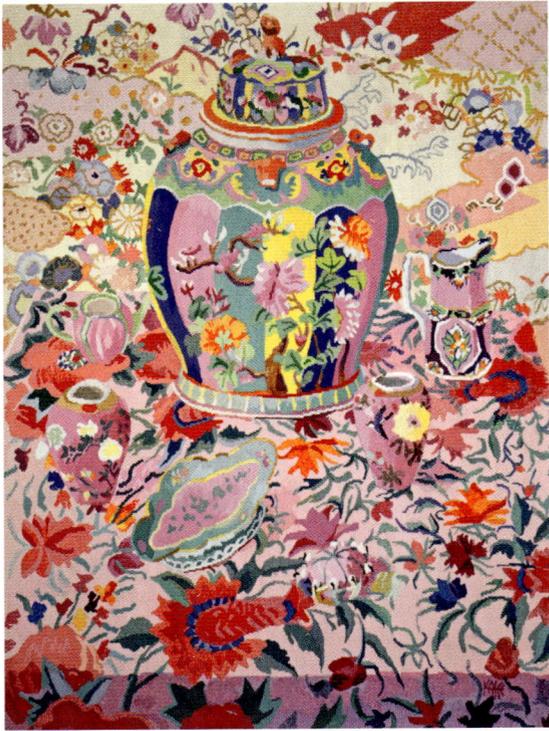

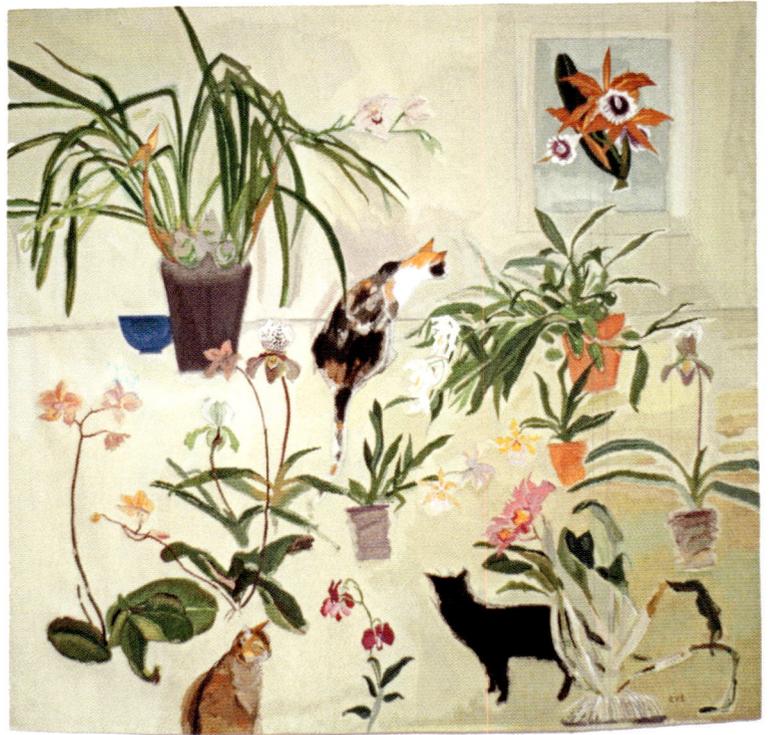

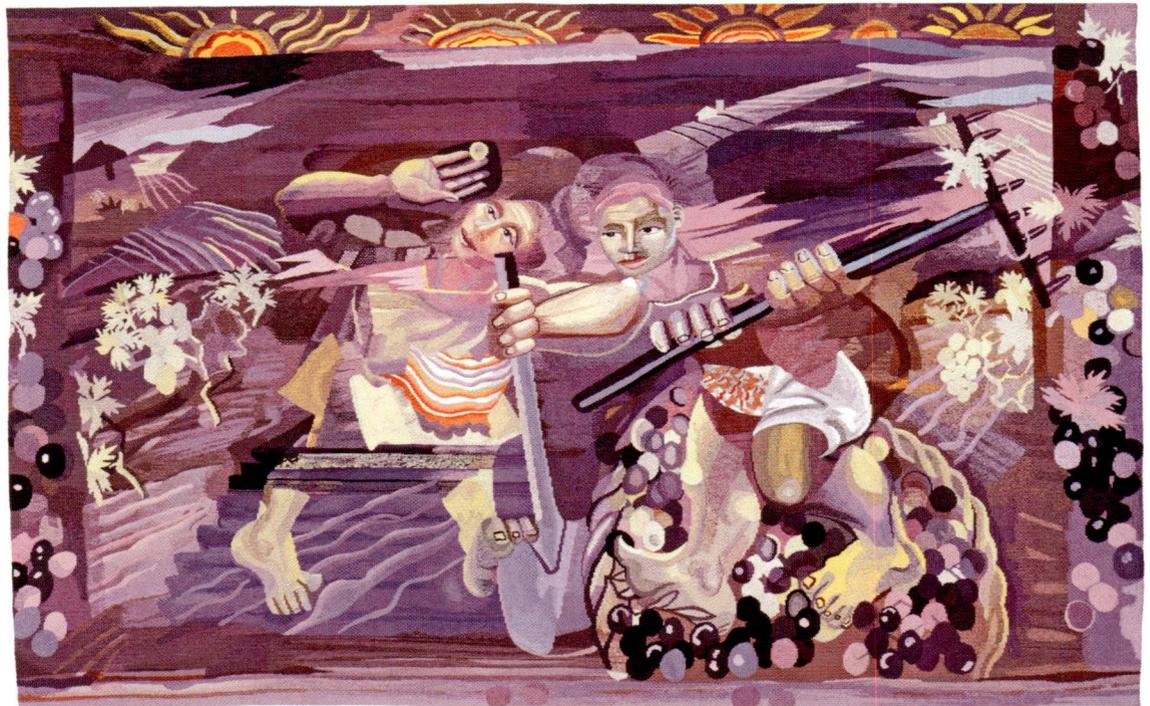

Fig.60 (above left)
Kaffe Fassett
Pink Ginger Jar
1992
Cotton warp, wool
203 × 155 cm (80 × 61 in)
Private Collection

Fig.61 (above right)
Elizabeth Blackadder
Cats and Orchids
1993
Cotton warp, wool
206 × 206 cm (81 × 81 in)
Private Collection

Fig.62 (right)
Mick Rooney
Buried Treasure
1992
Cotton warp, wool
191 × 304 cm
(75¼ × 119¾ in)
Location unknown

the wall's surface without sacrificing any of their [the weavers'] artisan traditions'. Probably the most celebrated modern tapestry produced by Dovecot also began to be negotiated in this period – R.B. Kitaj's *If Not, Not* for the British Library (see plate 27). Woven on a massive 9-metre (30-foot) loom specially made by Albert Gill, it took a painting in the Scottish National Gallery of Modern Art as its source.

The Library tapestry would be a welcome commission but it did not happen overnight – in fact, it was only cut off the loom in 1997 and, as Douglas Grierson notes, its weaving was by no means a simple affair. Another recession called for wider marketing. In 1992 More looked for greater proactive networking, involving art consultancies, agencies, architects and commercial dealerships. He believed it was working and that the company would exist on commissioned work and expand when recession lifted. Various ideas were put forward, such as classes and vocational courses, even establishing a design studio with a creative fabric workshop. Yet, as in past times, the possibility of staff redundancies was never far away. In an emotive letter, More wrote to Lord Bute that:

Fig.63
Charlie's Retired on the loom, 1990

> our weavers, their intellect, skill, emotion, integrity, sense of past, present and future makes the cloth. There is no machine to switch on. The cloth is not insensitive to the weaver. Our weavers earn little as it is, would they come back? Break the continuity … [and] you destroy their emotional and intellectual context. By making such a break … you destroy the ongoing sense of creativity, ethos and philosophy of the studio … . What the studio is – its magic hangs by a very fine thread.

These are words which ring so true of much of the Studios' history.

To expand the range of artworks, More persuaded the ETC board to fund the purchase of an industrial Hoffman tufting gun which speeded up rug production and is still used today. Altogether some fifty rugs, many designed by Grierson or

More, were made in five years. Some were also editioned, and offered through art and business agents such as Rob Breen's Art in Partnership and Art for Work. Tufted wall panels of Scottish landscapes were produced as well. One was made for an oil-rig restaurant, another of *The Forth Bridge* designed by Grierson for Hewlett Packard in South Queensferry.

By now the weavers were designing more works themselves as part of their 'professional development' – quite a change since the early years. Shirley Gatt's tapestry of 1990 for Abbey National at Milton Keynes is one example. Yet more experimental than these was a series of ropework hangings which More developed with weaver Fred Mann. These used thick cotton cord in more than one weft at a time so that the wefts could be manipulated to create movement on the surface of the cloth. Some of these were large pieces, and, with a quick production time containing costs, were meant to appeal to architects on the limited budgets of the early 1990s.

Dovecot also stocked a supply of Dovecot Silks, which was an independent venture started about 1986 by Peter Simpson, managing director of Bute Fabrics and a member of several of John Bute's company boards. In charge of the making of quality batik and hand-painted silk scarves was Adele Barclay, a young graduate of Dundee's Duncan of Jordanstone College of Art. The company, named by John Bute, paralleled his Recollections enterprise of quality reproduction furniture and sculpture casts. More marketed the silks thoroughly, offering them to the Mackintosh Society, the National Trust for Scotland, top museums in London and Scotland and leading fashion houses from Vivienne Westwood to Jasper

Conran and upmarket shops including Liberty and Hobbs, but the unit cost was simply too high for stock to be taken up.

In late 1992 More countered a proposal from his board to sell the Corstorphine property and move Dovecot to the new Ben Dawson industrial building in Musselburgh, East Lothian. He argued that the space was inadequate and inappropriate and that the move would affect the company's work, its development and its potential viability. The proposal was defeated and Dovecot carried on as it was. However, in 1993 Lord Bute died, and that autumn More took up an appointment as Professor of Design at Newcastle University. Eileen Lauder (*b*.1940), who had worked on marketing at Dovecot since 1988, joined the ETC board and took over as studio director. Architects working on new projects were targeted, with the government's 'Percent for Art' scheme sometimes helping a commission. With her trade experience, Lauder continued to promote the Studios at home and also abroad. Such marketing was expensive in itself, and its costs were rarely covered by the income it generated. An exception was the display of Rosamund Brown's *Chinese Landscape*, paid for by property developers Hongkong Land in 1994. The tapestry was later bought by a private client in Glasgow.

Fig.68 (below)
Willie Rodger
Once in a Blue Moon
1995
Wool
183 × 155 cm (72 × 61 in)
Private Collection

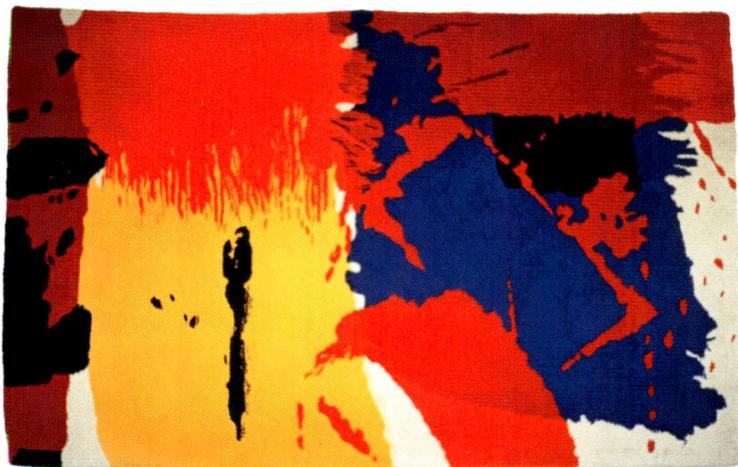

Several commissions initiated in More's time were now successfully completed, such as the Bank of Scotland triptych and Leonard McComb's (b.1930) *Fishes & Invertebrae Under the Ocean*, a celebration of new marine-sourced drugs, for Boots in Nottingham, arranged again through Art for Work, plus a suite of tufted rugs designed by Adrian Wiszniewski (fig.69), the Barbara Rae (b.1943) tapestry for the new Edinburgh Festival Theatre (see fig.76) and, not least, the British Library tapestry project which had been in the air since 1991. The Scottish Poetry Library commissioned a hanging from a design by Ian Hamilton Finlay (1925–2006) which also joined other local craft work (fig.70). James Joll set up a Paolozzi tapestry for the Pearson company, currently on loan to Frank Gehry's Maggie's Centre in Dundee. High points were the commissions for the new Museum of Scotland – a Kate Whiteford (b.1952) tapestry, *Corryvrechan* (see plate 28), and a fine rug, *Hill Fort*, designed by Rae for the Bute Room – which would be a memorial for Lord Bute. As well as all these the proportion of speculative work steadily grew, awaiting clients.

Much commissioned work was relatively small and of the type woven throughout earlier years – for churches, private clients and hotels, and for artists to include in their exhibitions with dealers. Rugs now quickly became a mainstay of regular production. A rug in which the colours were 'richer and more defined as opposed to the more chalky quality of paints' (Douglas Grierson) of Norma Starszakowna's (b.1945) design was requested by the Scottish Arts Council as part of their office refurbishment in 1994. Wiszniewski's *Dynasty* rugs (with such titles as *Family Plot, Power Struggle, Intellectual, Descending Staircase, Greek Millionaire, Oil Men* and *Fleur*) were based on a selection from 26 drawings made during an episode of the television series *Dynasty* and would win the New York International Design Award. A commission from Sally Greaves-Lord (b.1957) for four rugs to include in her display in 'Living at Belsay', an English Heritage and

Northumberland Arts contemporary craft initiative for Belsay Hall during the Visual Arts UK festival in 1996, came to Dovecot through More, successor to the late fashion designer Jean Muir on the festival's selection committee. Rugs were also made for Stirling Castle.

CLOSURE – AND A NEW BEGINNING

Following John Bute's untimely death in early 1993 and More's departure that autumn, the Bute family generously continued to support ETC; but by the millennium the day-to-day costs were not matched even vaguely by sales and commissions. There was no successor to the British Library tapestry which had brought in close on £200,000, largely from the National Lottery. Money was poured into supporting the Studios and debts totalling £350,000 were recorded in the press. By October 2000 the board of Cumbrae Properties had taken the decision, with considerable regret, to close the company at the end of the year. Staff were made redundant. Alastair (*b.*1941) and Elizabeth Salvesen (*b.*1946), determined to save the Studios, offered for the company, name, archives, business and assets, but negotiations collapsed in March 2001. The local press covered the Studios' closure with such headlines as 'End looms as Marquess cuts tapestry free', and in April the building and land were put on the market, again to popular dismay.

However, a new dawn for Dovecot was about to break. Salvesen bought two looms, the wool stock and other weaving equipment, incorporated the names Dovecot Studios Ltd and Edinburgh Tapestry Company Ltd and employed two weavers Douglas Grierson and David Cochrane plus a new Director, David Weir (*b.*1964). They then established themselves as Dovecot Studios and succeeded in creating a tapestry studio in a building behind Donaldson's School. Edinburgh University's Professor Henry Walton was keen to find the funding and commission a major tapestry *To a Celtic Spirit* by Alan Davie (*b.*1920), to be hung in the atrium of the new medical school adjacent to the Royal Infirmary at Little France, south Edinburgh (see plate 30), and this was backed financially by the Morton Trust on the advice of Douglas Connell. The promise of this tapestry, priced at £100,000, was of great assistance while the future permanent location and identity of the new Dovecot was being discussed. One idea, proposed by the then director-general of the National Galleries of Scotland, was to open a tapestry museum with workshop

Fig.69 (opposite, above)
Adrian Wiszniewski
Family Plot from *Dynasty* rug series
1993
wool
275 × 183 cm (108¼ × 72 in)
Private Collection

Fig.70 (opposite, below)
Ian Hamilton Finlay
Green Waters
1998
Cotton warp, wool
241.3 × 124.5 cm (95 × 49 in)
Scottish Poetry Library, Edinburgh

Fig.71 (below)
Douglas Grierson
Dovecot Logos
2003
Cotton warp, wool
120 × 120 cm (47¼ × 47¼ in)
Dovecot Studios

Fig.72 (right)
Paul Furneaux
Inner Landscape
2003
Cotton warp, wool
214 × 140 cm (84¼ × 55 in)
Dovecot Studios

Fig.73 (opposite above)
Craigie Aitchison
Still Life (Miniature)
2004
Cotton warp, wool
29 × 25 cm (11½ × 9¾ in)
Dovecot Studios

and exhibition space in the main Donaldson's building, but the Galleries had no funding for this. The Salvesens eventually found the former Infirmary Street Swimming Baths, in the centre of Edinburgh and derelict. They totally refurbished it and eventually it reopened in 2008 as the new Dovecot Studios. Now airy exhibition spaces, offices and a vast weaving floor in what was once the principal swimming pool provide a quite different building from the old, purpose-built Arts and Crafts tapestry 'manufactory'. As David Weir writes here (see pp 66–83), the new building offers the opportunity to build a programme of not only exhibitions but also workshops, talks and performances. Dovecot seeks to nurture modern craft, but of course tapestry and textiles in particular. The Dovecot Foundation was set up in 2010 to further this cause.

The tapestries now created at Dovecot include, as before, a mix of commissions for public spaces and private homes. Many are designed in-house by the weavers, others by British, and often Scottish artists such as Barbara Rae, Elizabeth Blackadder and Willie Rodger (b.1930) – the last providing many designs for tufted rugs and miniatures. More recently several artists, such as Marc Camille Chaimowicz (b.1947), have commissioned rugs as a constituent of their installation pieces. A sense of experiment and exploring the potential of textile method and materials seems to be in the air, with sculptural works such as Claire Barclay's (b.1968) *quick, slow* and David Poston's (b.1948) *Red Rectangles* and *Green Circles* using the weavers' skills to explore, share and realise ideas (see plates 35 and 36).

Looking back, the Studios' varied productions have both mirrored and contributed to the art movements of the last century, from Arts and Crafts fine weaving with its pictorial sources in tradition and nature and its organically dyed wools, via the neo-romantic traditionalism of the post-war years, through Pop and expressionism of the 1960s and 1970s, to today's redefinition of weaving within craft. But its productions also have their own momentum, always unique and special in colour and character but equally reflecting the values shared by individual weavers and artists. Weavers and directors have come and gone. Right up to the present Dovecot has been endowed by remarkable philanthropy and enjoys widespread affection. Nearly 800 tapestries and carpets, plus some chair seats and costumes, have come off its looms, but its productions have also briefly included decorated tiles, printed textiles and other domestic furnishings. Its story is one of artistic enterprise and skill – but primarily of commitment by weavers and directors to a craft which today remains strong and true.

Fig.74 (below)
David Cochrane
Water Surface
2007
Cotton warp, wool
139.7 × 170.2 cm (55 × 67 in)
Private Collection

DOVECOT TODAY

DAVID WEIR DIRECTOR, DOVECOT STUDIOS

We build our futures on the past and Dovecot is no exception. In 2000 Johnny Bute, the seventh Marquess, and his family were faced with a difficult decision – either continue to support an enterprise that required substantial investment of time and money and had often struggled to make ends meet, or face the option that new blood, new direction and new artistic vision were needed to reinvigorate the Studios. That impetus came from a couple well known in Scotland for their support of the arts, encompassing a wide range of activities from the commissioning of a new organ for Edinburgh's St Giles' Cathedral to a travelling scholarship for graduates of Scottish art colleges. Alastair and Elizabeth Salvesen had first visited the Studios with Robin Philipson in the 1980s to see one of his tapestry collaborations with Dovecot's weavers cut from the loom. The introduction to the Studios led in turn to the Salvesens commissioning Barbara Rae, a leading Scottish artist and Royal Academician, to create a design for a tapestry for the newly renovated Festival Theatre in Edinburgh. The resulting *Carnival Edinburgh* tapestry, with its virtuoso weaving, now hangs in the Festival Theatre above the black-and-white bar, and many theatregoers have spent time identifying the weavers' initials secreted in the image while awaiting mid-performance sustenance (fig. 76).

A telephone call from Alastair Salvesen is frequently intriguing, and in 2000 his call was exactly that: had I heard of Dovecot Studios in Corstorphine? The answer, relayed somewhat cautiously, was: yes – and why? The Studios were facing closure, and he and his wife were adamant that such a jewel in Scotland's creative landscape should not be allowed to disappear. With a consultancy contract for an investment management company coming to an end, and a long-held ambition to become involved in something more creative than my original legal

Fig. 75
The weaving floor at Dovecot Studios, Infirmary Street, 2012

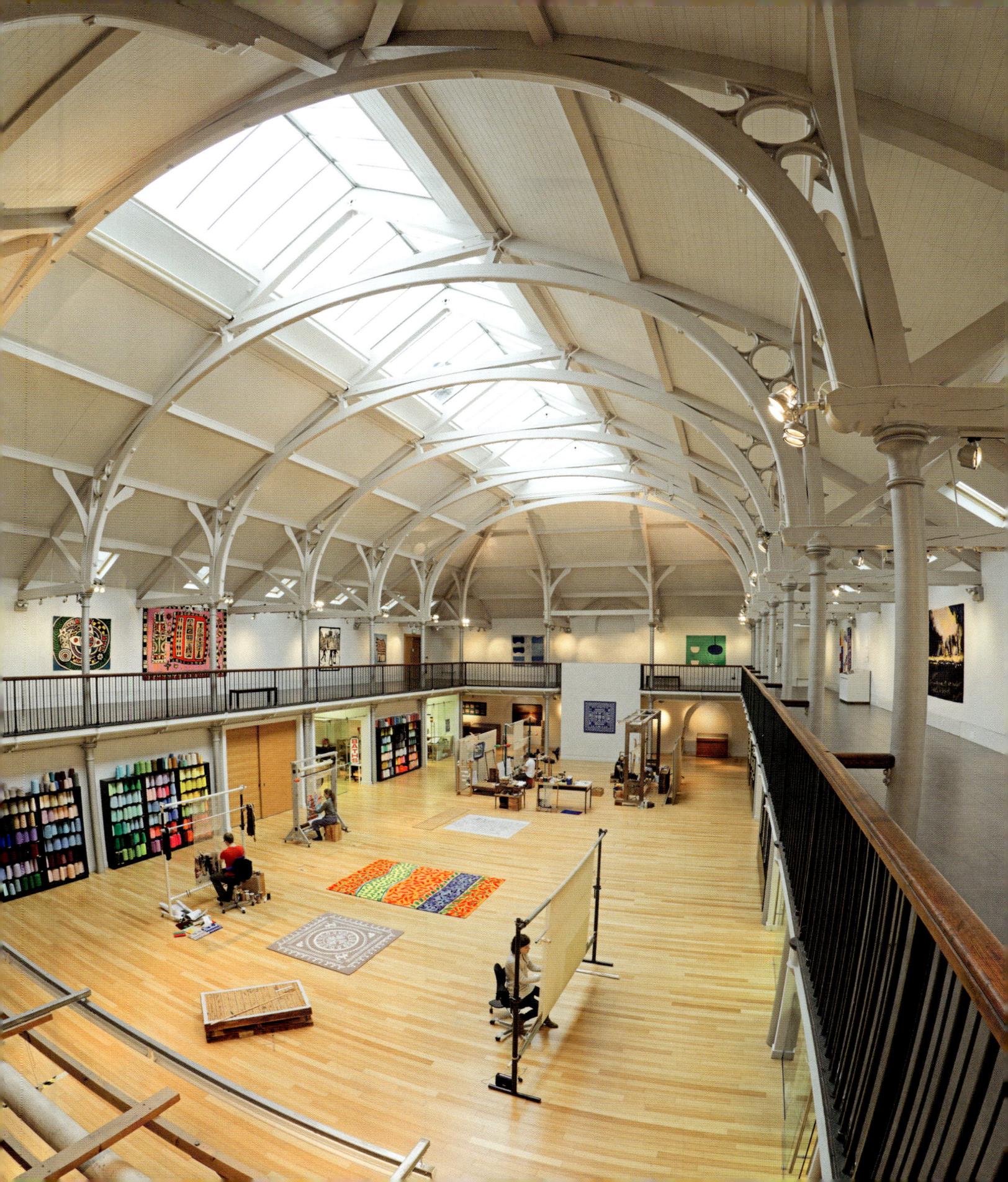

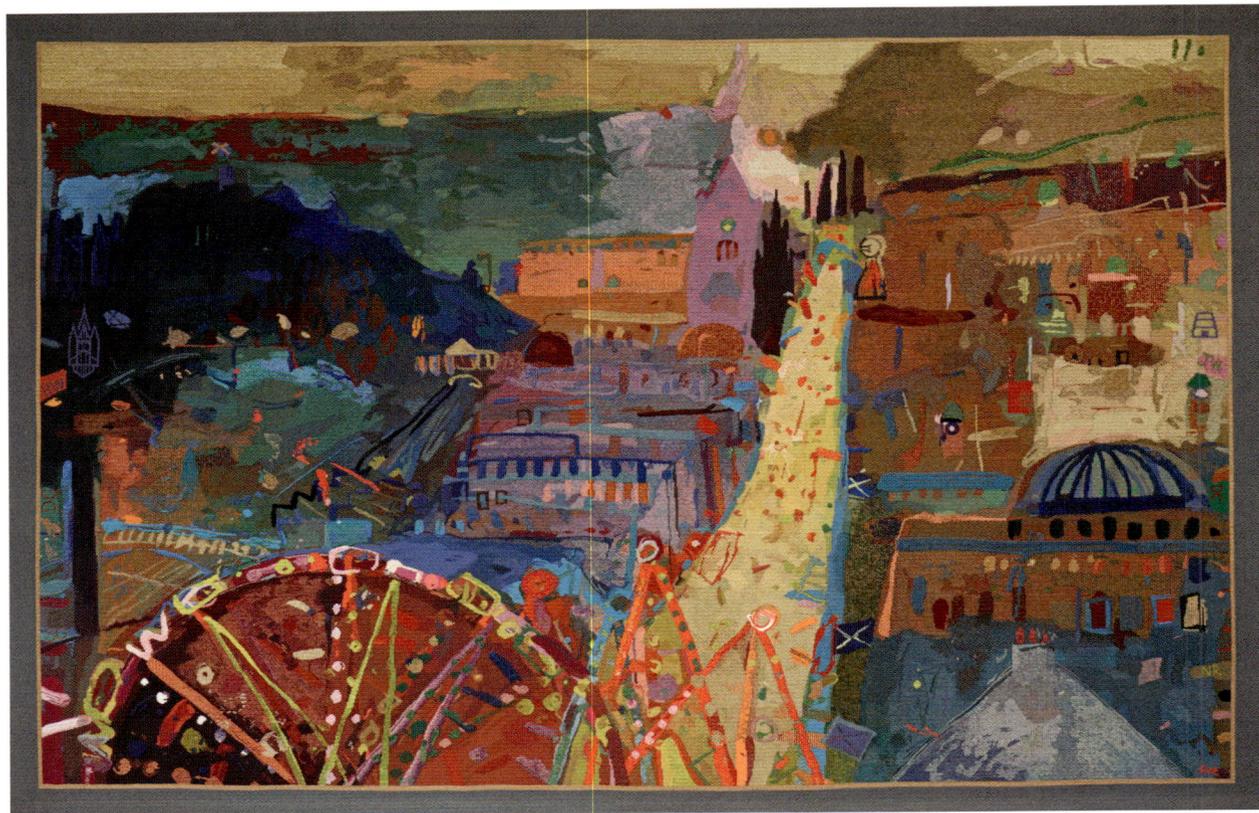

Fig.76
Barbara Rae
Carnival Edinburgh
1994
Cotton warp, wool
229 × 356 cm
(90¼ × 140¼ in)
Festival Theatre, Edinburgh

training had allowed, the invitation to come and hear more was compelling. Serendipity also seemed to play its part and a series of connections all served to fire my interest. *Master Weavers*, the last comprehensive review of Dovecot's work, published in 1980, had always had a place on the bookshelves at home, its front cover illustrated with the memorable tapestry design *At a Window III* by Archie Brennan (see fig.41). That same image, with its intriguing perspective – of a wine cask set before a window looking out on to golden fields beyond – took pride of place as a postcard pinned to the wall in successive family kitchens, albeit becoming somewhat dog-eared and greasy by the third move. I also recalled my mother returning from a lecture given by the same Archie Brennan at Stirling University, and visits to see the huge John Craxton tapestry, also at Stirling. The ground seemed to have been prepared. Returning from working in France in the 1990s, a visit to 'Glasgow Art in the Square' reconnected me with the Studios. I

recall Douglas Grierson talking carefully and thoughtfully about his craft as well as a recent collaboration with John Bellany, with whom the Studios had worked to create a stunning tapestry, *Clapham Concerto* (see fig.57). And in the late 1990s an acoustically challenging glass box extension to our own house in Edinburgh, coupled with two young children, again had us considering the possibility of commissioning a tapestry to soften the sound. The stage was set.

A visit to a 'cutting off' was my first exposure to the actual Studios in Corstorphine. I found an imposing dovecot in the grounds of a perfect Arts and Crafts studio, with a gravel path lined with box hedge leading to its entrance. The tapestry, designed by Elizabeth Blackadder for a private commissioner in London, was the last to be cut from the loom and it seemed an incongruous and poignant event. As a celebration of a new tapestry, the weavers presented the commissioners with a miniature weaving to mark the arrival of a new baby and addition to the commissioners' household. The artist and her husband John Houston were clearly at home in the Studios following a relationship that must have developed over nearly 30 years. But I also felt a sense of things coming to an end, and the realisation that the weaving team might not weave again in this purpose-built workshop suffused with so much history. It says much about the goodwill towards the Studios that so many parties were keen to ensure its survival. Historic Scotland, the National Trust for Scotland and a huge number of individuals were actively considering how best to save Dovecot and its tapestry weaving skills – particularly challenging given the economic realities of developing commissions; indeed, Archie Brennan was once quoted as describing tapestry as 'economic suicide'.

Yet commissions were in the pipeline and at the heart of the Studios remained a small and dedicated group of weavers whose commitment and skill would not easily be replaced. Six months of deliberations, negotiations and conversations followed with a host of characters from Johnny Noble, who had inherited an interest in the Studios from his father in 1973, to former Artistic Directors Archie Brennan and James More, to commissioners and to the weaving team itself. Douglas Grierson was exploring a possible future in weaving overseas in the Victorian Tapestry Workshop (now the Australian Tapestry Workshop and, incidentally, originally modelled on Dovecot); David Cochrane had already left the Studios and was considering what to do next; Harry Wright had retired and his son Johnny looked set to move into his brother's business. Eileen Lauder, then

Managing Director, was keen to retire. And one of the team, Naomi Robertson (*b*.1968), had left some years earlier to bring up a young family. Grierson's body language spoke volumes when we first met around the canteen table at Dovecot, and rightly so. What did I, neither a weaver nor an artistic director, know about the world of tapestry?

Early conversations left me in no doubt that morale was low and that, while the Bute family, and in particular Johnny and Sophie, had worked hard to bring Dovecot into the late twentieth century, there seemed to be an unfounded lack of confidence in the medium's place in today's world. Yet it seemed that there were such strong ingredients to work with. A rich history of commissioners included public buildings such as the British Library, the National Museum of Scotland and the V&A, Her late Majesty the Queen Mother and many private collectors, as well as universities and colleges in Britain and abroad, and major corporate sponsors such as PepsiCo, Morgan Grenfell and IBM. There was an equally remarkable list of artists with whom the studios had collaborated over the years, from Henry Moore and Graham Sutherland, Cecil Beaton and Edward Bawden to David Hockney, Tom Phillips, Harold Cohen and Frank Stella, alongside an impressive array of Scottish artists including Robert Stewart, Eduardo Paolozzi, Elizabeth Blackadder, John Houston, John Bellany, Willie Rodger and Barbara Rae. Over 25 Royal Academicians had worked with Dovecot since its inception, and the breadth of Dovecot's activity pointed to an energetic and dynamic past. But most important of all in the heady mix of ingredients was a craft-based skill and way of thinking that was key to the future of Dovecot. 'Collaboration' is a word frequently used by artists and practitioners but one that rarely fulfils its real potential. Dovecot seemed to embody a way of working that depended on a genuine exchange of ideas, a real dialogue between artist and weaver and a mutual respect and desire to learn from each other's medium. The weavers' skill was not simply technical ability and colour interpretation, but also the ability to work collaboratively in a three-way process involving artist/designer, weaver and commissioner.

Alastair Salvesen's commitment to ensuring the Studios fulfilled this potential was infectious. I was easily persuaded to become Director of the new organisation, which we incorporated as Dovecot Studios Limited in July 2001. Having failed to purchase the original workshops in Dovecot Road, we moved to temporary premises in the grounds of Donaldson's School in Haymarket,

Edinburgh (fig.77). A nascent weaving team of two, Douglas Grierson and David Cochrane, painted the converted classroom that was to house the looms, and Alastair, Elizabeth and I spent early days coming to grips with a bewildering new language of warp and weft, plies, counts and mixes, open and closed sheds …

It was clear that new horizons, new networks and more commissions were critical to the success of the Studios. And as we learned more of the history of the Studios it became obvious that the challenges facing them at the beginning of the twenty-first century were no different to those facing tapestry over the previous decades. Many misconceptions seemed to surround the medium. The technique was confused with embroidery; it was often associated with historical pieces or their machine-made replicas hanging in airport shops across the globe; it was the preserve of musty halls, moth-eaten, dusty, dingy and out of date; it was simply a woolly cypher for paint.

The first commission was a revelation and one that reassuringly countered all these misunderstandings. Professor Henry Walton was already skilfully manoeuvring a major tapestry commission into existence. Again stars seemed to align, with an artist, Alan Davie, already enthused about designing for tapestry, a weaving team who for years had longed to work with Davie, and an enlightened funder and advisor keen to see a tapestry hang in the new Medical School in Little France in Edinburgh's new Royal Infirmary. Early visits to the building site revealed the scale of ambition for this tapestry – a vast wall dominating the atrium of the Chancellor's Building. Six gouache designs were produced by Davie and agreement reached, after some discussion, about the best one for the space. Early sample strips were woven and Davie soon pronounced himself delighted with the work, exclaiming that 'it is in safe hands!'. This followed a wide-ranging discussion with Douglas Grierson about pitches and registers of tone and colour which echoed their shared interest in jazz and gave an insight

Fig.77
Wendy Ramshaw visits the studios when housed in the converted classroom at Donaldson's School, 2006
Left to right: David Cochrane, Douglas Grierson, Wendy Ramshaw, Naomi Robertson

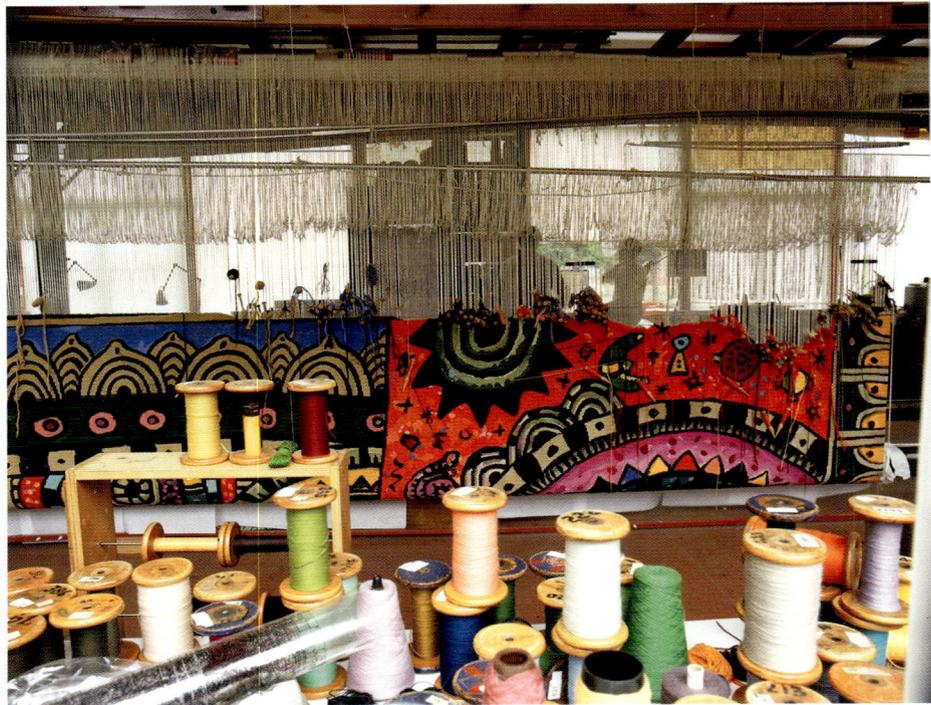

Fig.78
Alan Davie's *To a Celtic Spirit* on the loom in the converted classroom at Donaldson's School, 2002

into the special nature of a collaboration built on respect and trust. Thus work began on the first new Dovecot commission, a huge tapestry measuring 3.4 by 5.1 metres (11 ft 2 in by 16 ft 9 in), and one that took Grierson and fellow master weaver David Cochrane over eight months to complete (fig.78 and see plate 30). Grierson commented that after 40 years of weaving he was still learning as different projects brought their own challenges: a valuable first lesson.

Alongside developing commissions and reconnecting with artists and designers, raising awareness and, most importantly, understanding of the work of the Studios was a critical first task. It seemed that tapestry occupied unusual territory – it was a craft-based skill yet its history pointed to collaborations with the leading contemporary artists of successive eras.

An approach to Cunard's CEO Pamela Conover resulted in an introduction to the designers responsible for the art programme for the new liner *Queen Victoria*, later to become P&O's *Arcadia*. Elizabeth Blackadder was approached to design a tapestry for the main stairwell of this prestigious liner which was being built in Italy. The design brief was fairly open although a maritime reference was invited.

Following visits to her Edinburgh studio Grierson, Cochrane and I met her to consider the proposal. I was surprised to observe Grierson develop the conversation with the artist, making suggestions of how best the design would work in tapestry, moving objects and editing elements of her work. A tacit understanding of each other's medium built up over 30 years of an evolving relationship was at play, one that was not easily articulated by either of them. An art critic interviewing them was told that it was rather like a marriage of similar timescale – there was nothing further to say. And mid-weave, an official visit by Her Majesty the Queen in 2004; her previous visit to the Studios had been to view her late mother's heraldic tapestry now hanging in the Castle of Mey (see fig.18).

And so relationships were re-established with artists who had previously worked with the Studios. Barbara Rae was particularly generous with her time as we explored new possibilities with both rugs and tapestries to be woven for exhibitions in Edinburgh, London and New York. Again, this had been a relationship established with the Studios over many years, with tapestries and rugs in many collections: Rae's strong sense of colour and composition and her printmaking skills were perfect for the language of tapestry. Willie Rodger too, with his wry observations on people through woodcuts and linocuts, was enthusiastic and quietly supportive as we built on past projects to create rugs based on his football series – with one rug, *Red Card*, now hanging in the new Emirates Arsenal Stadium. The then Earl of Dalkeith, now the Duke of Buccleuch, was deeply involved in the choice of a design by Victoria Crowe (*b*.1945), another artist with whom the Studios had long wished to collaborate, for a new tapestry (see plate 33). An invitation to work with the Smithsonian on a project celebrating Scotland's crafts on the Mall in Washington DC witnessed a huge crate being custom built to ship a loom with an Alan Davie tapestry in mid-weave to DC, where it was completed by David Cochrane and Douglas Grierson in front of a steady stream of visitors and then installed in the Arts & Industries Museum. As part of a developing national and international ambition we worked with the British Council and Scottish Development International, enabling Dovecot to participate in exhibitions in Moscow, Tokyo, Paris and London.

Also building on the past, we were able to reactivate projects that had started but lost momentum for one reason or another. Timescales for some of these projects indicate just how long a commission might take to come to fruition. Colin (Sandy) St John Wilson spent much of his later working life designing the

new British Library in London. He had a strong sense of the need for public art in the building and, by the time of his death, over 100 artworks had been installed. Amongst those, the remarkable R.B. Kitaj tapestry *If Not, Not* – the wall for which was conceived long before the tapestry – is still the largest woven in the UK (see plate 27). A second tapestry design, by Patrick Caulfield (1936–2005), for a site-specific work in the British Library remained unwoven. Contact was made with Wilson and the decision taken to weave a large speculative sample, one fifth of the entire work, in order to act as a catalyst for a possible funder. A funder was soon identified: Simon Draper, a major collector of contemporary art. Wilson managed the conversation between Dovecot and the artist, who sadly did not live to see the tapestry installed. Colour matching was particularly challenging and, rather than using the existing palette of over 350 yarns, the Studios worked closely with one of the last remaining dye houses in the Scottish Borders to achieve a particular chroma of green for the clock face in Caulfield's interpretation of Laurence Sterne's eighteenth-century novel *The Life and Opinions of Tristram Shandy, a Gentleman* (see plate 32).

Connecting artists from differing backgrounds and across multiple disciplines to tapestry was, and is, the creative lifeblood of the Studios. One such artist is Liz Rideal (*b.*1954), who works across a variety of media, including textile, printmaking and photography. Funding from the Contemporary Art Society enabled an incredibly detailed tapestry to be undertaken by Dovecot. Working from a cartoon made up of photo-booth images of textiles and human hands, the Studios' weavers painstakingly produced a tapestry of the cartoon, itself originally inspired by a seventeenth-century Turkish carpet in the National Portrait Gallery in London. The tapestry was technically very demanding as equal tension had to be ensured across the surface to avoid the very linear pattern appearing to be distorted. Masterful colour mixes and blends were specially made to add depth to the design. Over the years the weavers' voice seemed to have diminished. Almost invisible, their marks had become relegated to the selvedge on the reverse of the tapestry. While on occasions the design simply would not lend itself to embellishment on the front, we felt it important to ensure that the inequality was redressed. And so on *Tapis Volant*, while the Dovecot weavers' initials are indeed woven into the selvedge, the Dovecot mark has been most subtly incorporated into the design itself. The success of this tapestry encouraged us to work again with Liz Rideal on another piece, *Verdure*, the following year (fig.79).

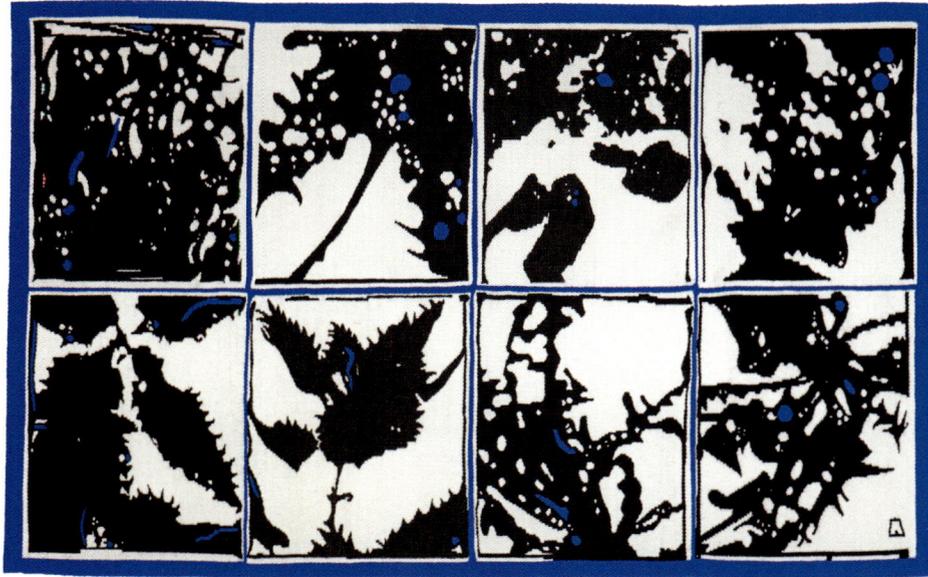

Fig.79
Liz Rideal
Verdure
2006
Cotton warp, wool
72.4 × 114.3 cm
(28½ × 45 in)
Dovecot Studios

The crossing of boundaries continued with a pilot project in London with the Royal College of Art. With the support of the Worshipful Company of Weavers and a judging panel made up of Sue Timney of Timney Fowler and Professor Clare Johnston, Head of Fashion and Textiles at the RCA, we launched a competition inviting designs for tapestry from across the spectrum of the RCA departments. A young Danish graduate in Printed Textiles, Kristine Mandsberg (*b.*1983), was selected and her work woven and displayed at the V&A at 'Collect' in 2007. Inspired by the ceremonial robes of the Royal College of Art designed by Joyce Conwy Evans and woven by Dovecot, a conversation began with Chris Clyne, the fashion designer, whose costume designs for the feature film *Moulin Rouge* were the inspiration for a tapestry corset, shoes and headpiece (see plate 34). The role of the artist weaver was also actively encouraged and their designs brought different approaches to potential tapestry commissions. David Cochrane designed a series of intricate, almost photographic tapestries depicting the surface of water (see fig.74), and a vast triptych was commissioned by a private collector for his newly renovated house. Approaches to specialist interior design companies resulted in a number of commissions for private yachts, and artists such as Barbara Rae again began to use the medium to stunning effect in the crisp, clean-lined architecture of a collector's house in Texas.

And so a five-year search began for suitable premises with a central and accessible location in Edinburgh into which to move Dovecot. The Buildings at Risk Register was scoured; disused churches, town halls, theatres (with the magnificent Leith Theatre a strong candidate), and even a new build, were all considered. And then came a eureka moment with the opportunity to acquire the derelict Infirmary Street Baths, Edinburgh's first municipal swimming baths, built in the 1880s by the City Architect Robert Morham. Faced with increasing sanitation and public health crises, Edinburgh's city fathers had determined to commission a public bath house and swimming pool in order to combat successive outbreaks of cholera. For modesty's sake the baths were to house two swimming pools: a smaller Ladies' Pool, with its own entrance and access by a separate staircase, and the Main Pool, with a wide balcony to accommodate cubicles with baths looking down to the pool below. The Ladies' Pool had suffered a fire in late 1960, causing sufficient damage to ensure that it never reopened. The pool was capped over, the roof removed, and it faded from memory. The many swimmers who continued to use the Main Pool and baths during subsequent decades remained unaware of the Ladies' Pool, its bricked-up arches and self-seeded trees developing a hidden inner-city garden. By 1989 structural problems in the main pool saw its doors close definitively, although successive students from Edinburgh College of Art were allowed access to draw, plan architectural projects and take photographs in the empty space. A queue of proposals developed, including the renovation of the baths supported by an enthusiastic action group. Residential developers were keen to build on the site and heritage bodies agonised over the possible loss of an historic building. Meanwhile the Council was also exploring its possible use as artist workshop space and early conversations with them in 2005 indicated that there was a possibility of acquiring a part of the building.

Visiting the derelict building with the Salvesens, and surrounded by the smell of pigeon guano and years of neglect, the prospect seemed daunting. But at the same time the building seemed to offer such an opportunity to put into practice the thinking that had been developing over the years. Here was the potential for a flexible, multi-disciplinary space supremely located in Edinburgh's Old Town, that would house the Studios alongside an integrated programme of exhibitions and events. A programme that would, in turn, make the Studios visible to new audiences and, critically, breathe new life into Dovecot's artistic ambition. A hunch that would have been all but impossible to prove through

hours of feasibility and desk-based research; one that needed the support and energy of a committed patron prepared to take the risk and fund both acquisition and redevelopment of the building. Early in 2002 I had lightly lobbied the author of a report commissioned by the City of Edinburgh Council into the visual art and craft strategy for the city. It was gratifying then, years later, to be able to point to the same report in which one of the imperatives noted was the need for the City to find permanent accommodation for Dovecot.

Alastair Salvesen's commitment and enthusiasm grew, and it was remarkable to be part of a project that had such endorsement from every quarter. Historic Scotland, Edinburgh World Heritage and, crucially, the City planners were fully supportive of our plans to develop the Baths into a world-class contemporary art space with Dovecot's tapestry studio at its heart. A small development of five flats and two offices, together with the need to exhibit work and the possibility of a cafe, gave the architects a challenging brief to create a flexible, contemporary space without losing elements of the original building. Professional advice was initially to concrete over the former pools. However, such was the determination of Dovecot's Directors to open up the building to the possibilities of high-quality exhibition making that the decision was taken to excavate both pools (fig.80). This was an expensive but forward-thinking move that gave us two museum-quality exhibition spaces where once there had been water. Victorian architects' plans should be read with circumspection – the 40 cm (16 in) of concrete that purportedly lay beneath the pool tiles turned out to be 160 cm (63 in) in places. This meant a massive excavation involving drilling a matrix of cores across both pools, then loosening the concrete hydraulically and removing the rubble in an endless stream of lorries. With rain pouring in from above, the site looked increasingly and forebodingly like the muddy fields of Flanders. Further unwelcome inundations came in the form of water geysers from deep within Edinburgh's subsoil as we drilled eleven 100-metre (300-ft) boreholes for a geothermal heating system.

Fig.80
Infirmary Street Baths under renovation, 2006

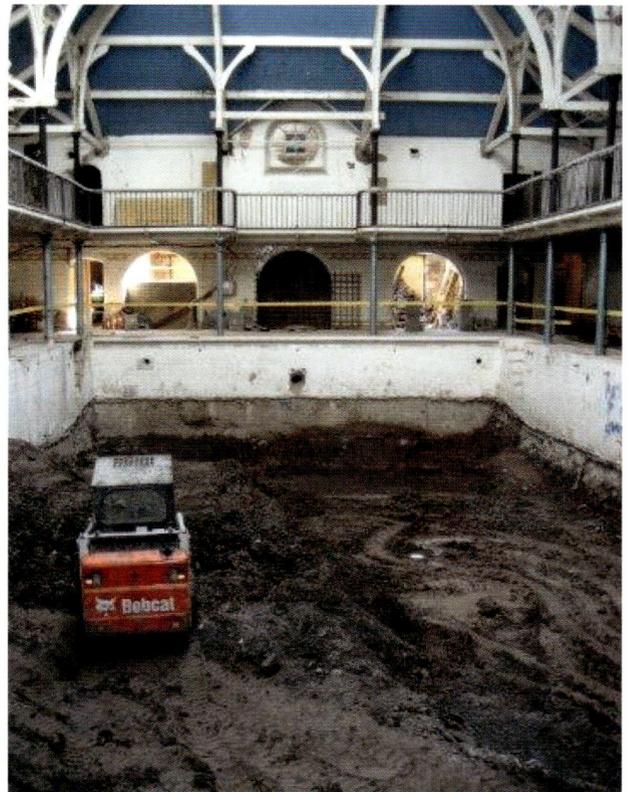

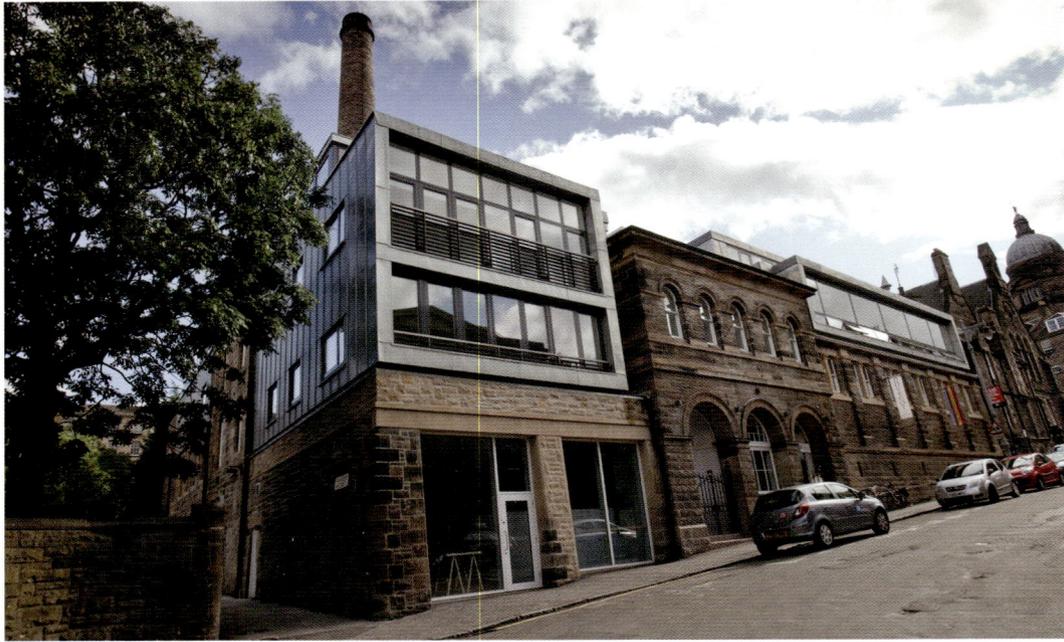

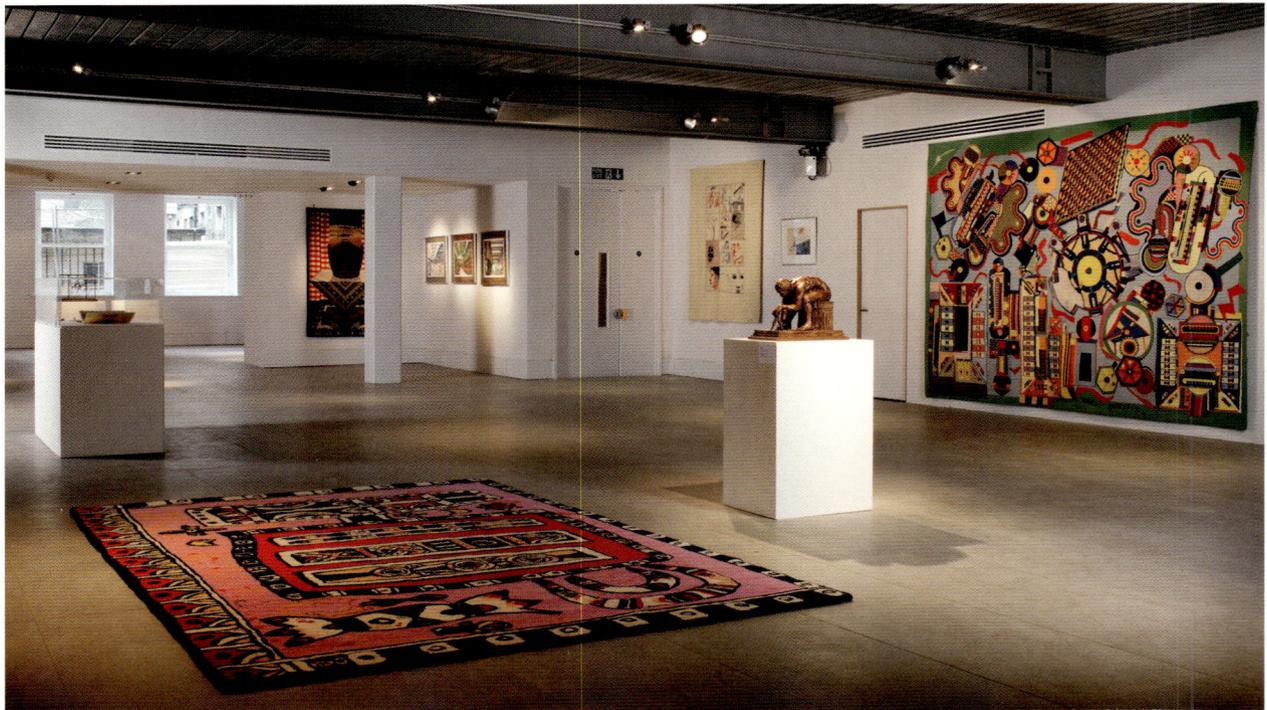

After a remarkable two years, Dovecot's new building opened in August 2008 in time – just – for the Edinburgh Festival. We showed 'Weaving Influences', a review of Dovecot's tapestry collaborations with artists set in the context of the same artists' work in their 'native' media (figs 81 and 82). Thus Wendy Ramshaw's (*b*.1939) thoughtful design response to tapestry, *Cartographer's Circle – Blue* (fig.83), hung alongside her two maquettes: one for the V&A screen, the other for gates at Mowbray Park, Sunderland; Eduardo Paolozzi's magnificent tapestry for the Pearson education and media company (now hanging in the Maggie's Centre in Dundee) complemented a bronze maquette for his British Library statue of *Isaac Newton Measuring the World*; Tom Phillips' *After Benches* tapestry (see plate 13) was shown alongside his *Studies for the Manpower Quilt* (1997); and a print by David Hockney was exhibited with one of his own collaborations with Dovecot, *Blue Guitar*, on loan from Aberdeen Art Gallery. In the former Ladies' Pool we showed 'Raising the Bar', an international silversmithing exhibition curated by IC: Innovative Craft, one of Dovecot's first partner organisations, to whom Dovecot had offered office space in return for its curatorial expertise.

This very potent two-year partnership with the three Directors of IC – Amanda Game, IC's executive director, Roanne Dods and Elizabeth Goring – based on the barter exchange economy brought a high-quality series of exhibitions around craft and making to Dovecot.

In the autumn of 2008 Dovecot worked with the Henry Moore Foundation to show a beautifully presented exhibition at Dovecot of Moore's little-known work as a designer of textiles, particularly with Ascher in New York. The fact that Dovecot had worked with Henry Moore to create a tapestry in 1950 added further context to the exhibition in Edinburgh. Visitors were surprised and delighted to learn about this unusual yet important part of Moore's cross-disciplinary creative activity.

Fig.81 (opposite, above)
Dovecot Infirmary Street
Baths renewed, *c*.2008

Fig.82 (opposite, below)
'Weaving Influences'
exhibition installation, 2008

Fig.83
Wendy Ramshaw
Cartographer's Circle – Blue
2006
Cotton warp, wool
66 × 66 cm (26 × 26 in)
Private Collection

And we explored the potential of the building, bringing together artists and designers from a multiplicity of backgrounds – all craftspeople in their own fields. A series of Royal Scottish National Orchestra (RSNO) chamber concerts starting in 2010 on the weaving floor meant moving looms, but resulted in a tapestry sold and an introduction to a foundation concerned with supporting apprenticeships. A collaboration between Dovecot and IC entitled 'Maker Curator' in 2010, supported by the Paul Hamlyn Foundation, resulted in a series of exhibitions curated by makers that featured furniture design, jewellery by established and emerging makers and film installations including one of a stunning tapestry unfolding on the loom. This, the first tapestry to be woven in the new space, was one of a series of designs created specifically by William Crozier (1930–2011) with whom we had the huge pleasure of working on both tapestry and rug projects. The exhibition 'Craft and the Slow Revolution' highlighted among other aspects some of the skills being lost through the contraction of the potteries in England. And significant partnerships with the National Galleries of Scotland included a major retrospective of the artist Alan Davie in his ninetieth year, curated by senior Scottish National Gallery of Modern Art curator Patrick Elliott, that showcased work by Davie in textile from the 1960s, and more recent Dovecot collaborations. Partnerships have extended to working with National Museums Scotland and the Edinburgh Arts Festival and, in 2011, a major collaboration with Edinburgh International Festival (fig.84). Again with Dovecot's tapestry practice at the core, we set out to explore the value and preciousness of textiles from a private collection of exquisitely produced Indian and Indonesian batiks dating from the sixteenth to the twentieth centuries, alongside a contemporary response by three Scottish textile artists. Weaver Naomi Robertson travelled to India and returned to design and weave a tapestry reflecting on her experiences.

Education and apprenticeship are continuing strands in Dovecot's history. The new building allows us to develop visits and tours for groups and individuals. A recent tour by David Cochrane to Baffin Island, to work with a small weaving studio there, continues to underline the importance of engaging with tapestry practice across the globe. With two new apprentices, Freya Sewell (b.1986) and Emily Fogarty (b.1981), recently embarking on a three-year apprenticeship, the future of the skill of weaving looks brighter than it has for some time.

Collaborations on both tapestry and rug tufting between the weaving team and an increasing number of artists and designers from a range of disciplines are

Fig.84 (opposite, above) 'Heirlooms' exhibition opening night at Dovecot, 2011, featuring Naomi Robertson's *Katha Diaries* (2001)

Fig.85 (opposite, below) Dovecot's weavers, 2011 Left to right: Freya Sewell, Emily Fogarty, Douglas Grierson, Naomi Robertson, Jonathan Cleaver, David Cochrane

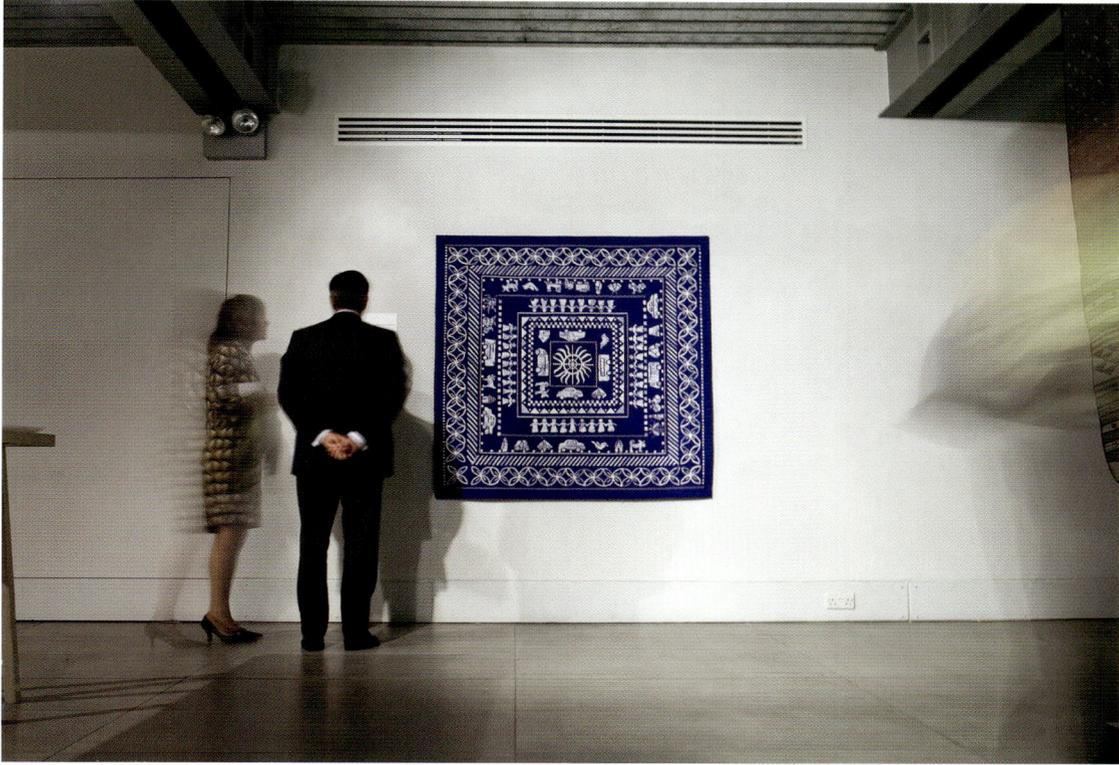

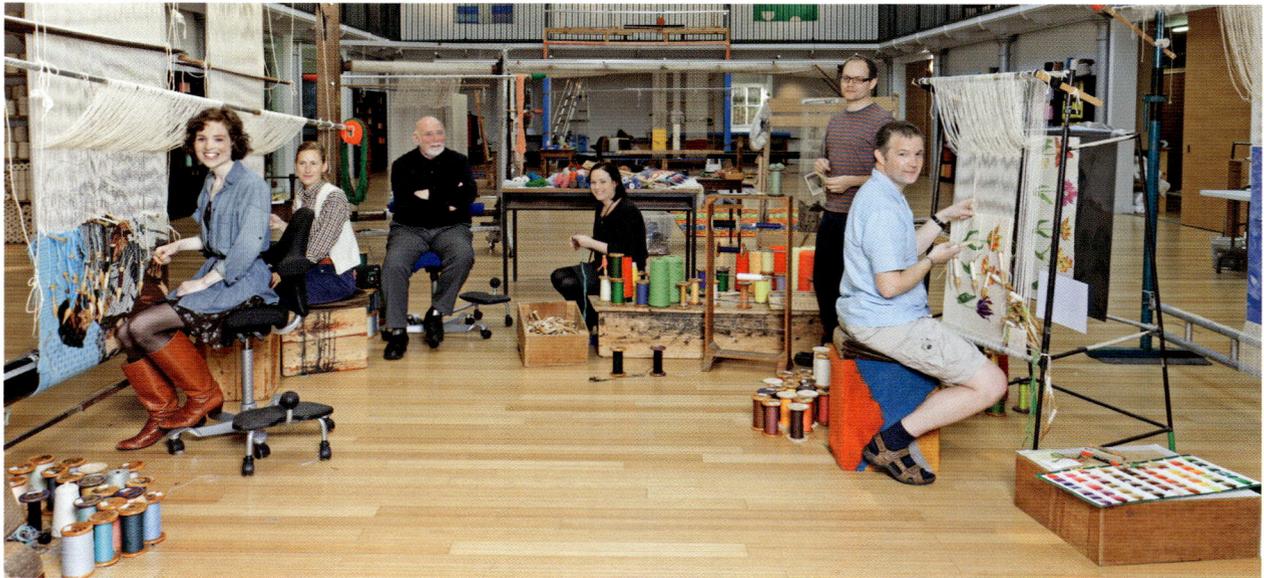

already beginning to shape this historic studio in different and sometimes unexpected ways. The highly sensual and decorative work of Marc Camille Chaimowicz resulted in an asymmetric rug shown in the Royal Botanic Garden Edinburgh's Inverleith House in a major show of the artist's work (fig.86). This in turn inspired Goldsmiths College student Than (Nathaniel) Hussein Clark (b.1981) to commission a remarkable rug – placed on a revolving plinth – as a key feature in the stage set for his 2011 degree show. And the exhibition programme has brought further stimulus with conversations across disciplines. David Poston, an artist jeweller whose own wide-ranging work has extended into design and sustainable development, is collaborating with weaver Jonathan Cleaver (b.1976) on a series of maquettes: stainless-steel frames into which Dovecot's tapestry is being woven. Claire Barclay's 2010 work *quick, slow* reflects on the very cerebral approach to making that is embedded in Dovecot, with a loom frame, polished brass bobbins and Dovecot's tapestry suspended over the work, warps and leashes still attached (see plate 35). With *ROTOR*, a touring exhibition curated by Siobhan Davies Dance, we have explored the connections to be made across a range of art forms (fig.87). This project saw nine artists, designers and makers, from Angela de la Cruz (b.1965) to Clare Twomey (b.1968), responding to a piece of dance that formed part of a series of performances in Dovecot. And the tenth work, a maquette designed by Naomi Robertson served as an example of the potential of contemporary tapestry.

A rich history, an exciting future. Foundations both physical and metaphorical, laid in the early part of the twentieth century by those original

Fig.86
Marc Camille Chaimowicz installation at Inverleith House, Edinburgh, 2010
The works shown are *Dovecot (for I.H.)* 2010 and *Man Looking Out of Window (for SM)* 2006

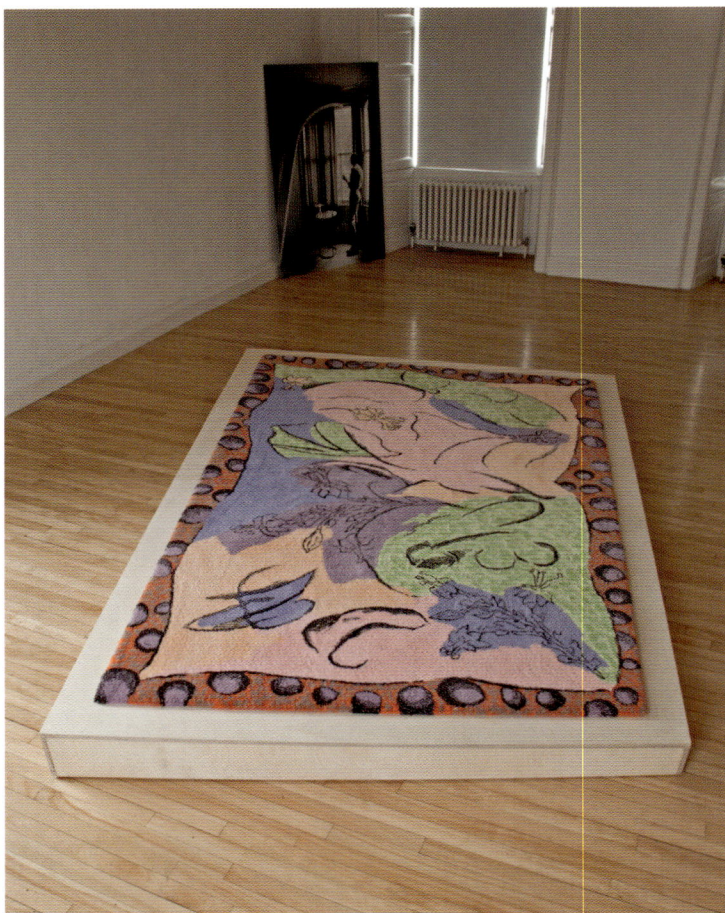

Fig.87
Siobhan Davies Dance
rehearse *ROTOR* at Dovecot,
May 2011

weavers from the William Morris workshop and supported by committed patronage over the years, have given this energetic and skilled studio a resilience as well as a creative flair of which Dovecot is rightly proud. It is an enormous testament to the passion and dedication of a series of enlightened patrons who recognised in Dovecot those essential ingredients of skill and quiet craftsmanship and their relationship to contemporary art and design. And it is also a reflection of the dedication of those who have worked at Dovecot over the years. As Director I have been hugely privileged to enjoy the energetic and passionate support of the Salvesens. And it has been an enriching experience to work with such an inspiring group of weavers, artists and commissioners as well as an expanding and dedicated team of colleagues at Dovecot. As we embark on the second decade of a new century, the Studios have a new lease of life and an international context within which to promote and develop the skill of weaving, with craft and making central to its thinking. Re-energised, with the Dovecot Foundation beginning to take shape, it is exciting to know that there are new ways of looking at making in today's technically driven world. It seems riskier not to take risks.

SELECTED TAPESTRIES EXPLORED

ELIZABETH CUMMING

Collaboration lies at the core of Dovecot's activity. When this book was first mapped out it was thus considered vital that it should have a collective identity, and that this section should sit at its very heart. The writers here have all given willingly and freely of their time to contribute: they are the weavers, the artists, the artistic directors, and not least those now living each day with Dovecot's work – the patrons or curators. Individually they narrate the creative process from a personal perspective, their voices varied in both style and content. These accounts tell how and why a tapestry or carpet was commissioned and created, and provide real insights into that unique and special, and sometimes unexpected, journey travelled together by artist and weaver, a journey where the initial artwork has always been a mere starting point.

Coming from diverse backgrounds, the writers are also at different stages in their careers, which allows an even greater balance of perspectives. Whether an apprentice weaver or the Master of an Oxford college, their contrasting viewpoints together energise the collection. The ambition to cover the full century allowed one of today's apprentices, Freya Sewell, to reflect on how little a weaver's training has changed. In the early days the legacy of fine, old European tapestry modernised by Morris & Company weavers into an Arts and Crafts aesthetic dominated Dovecot production. These first tapestries were image-based as much as craft-based, and fashioned a joint celebration of abundant nature – particularly in *The Lord of the Hunt* (plate 2) – and romanticised history. Although perhaps less obvious to our modern eyes, the early weavers were also interpreters

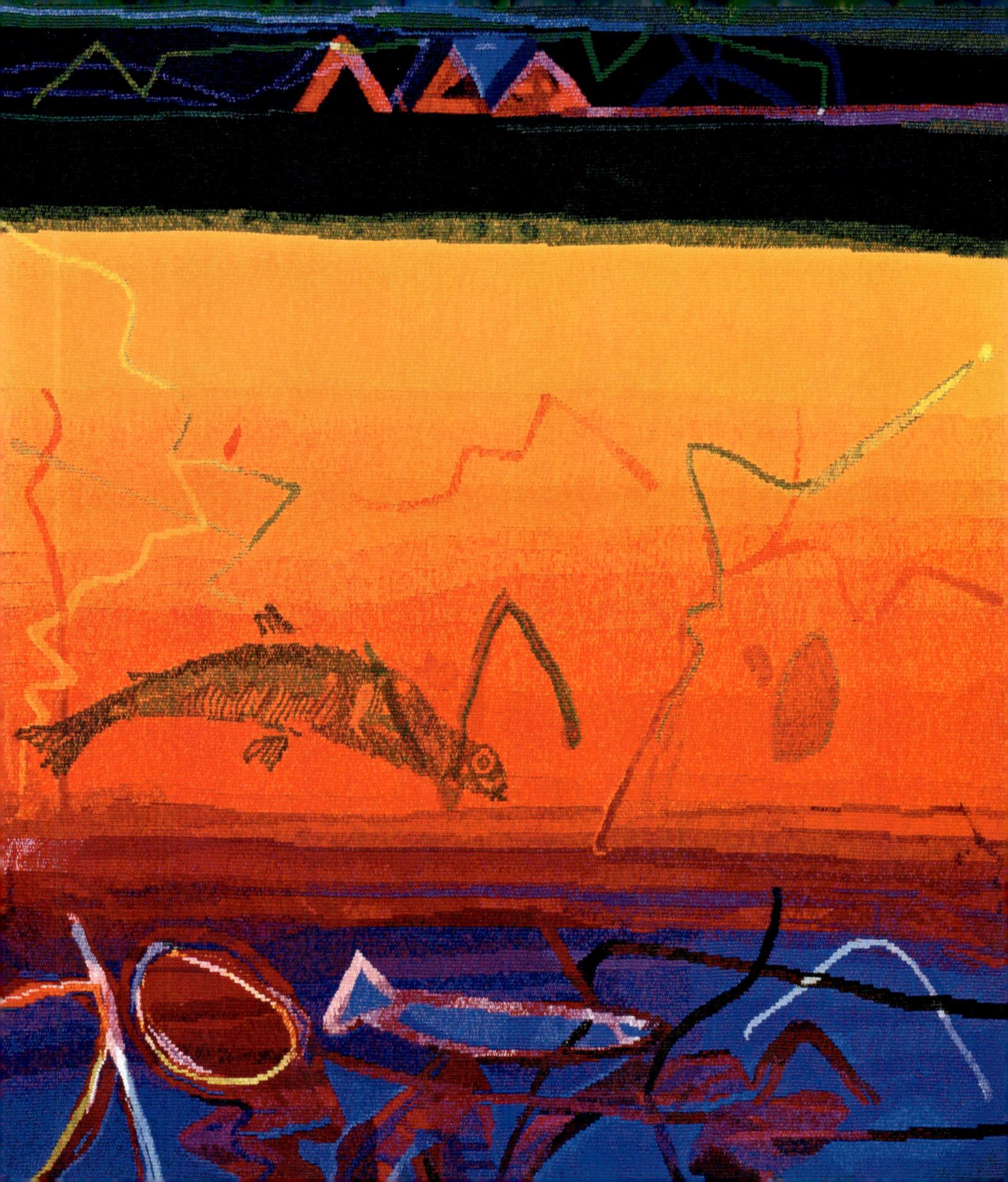

of their given designs, reworking fine art into texture and colour patterning. Dovecot's shift in the post-war years to engage English designers and modernist artists, such as Edward Bawden and Graham Sutherland, and appoint Sax Shaw as artistic director in the 1950s, developed a more dynamic sense of pattern making and colour while maintaining the vibrancy of the natural world, key to traditional work. In discussing Shaw's *The Cycle of Life* (plate 6), his son Kevan illuminates his father's passion for the craft and new ways of weaving.

Within a few years a re-evaluation of the role of the weaver, allowing a more intuitive approach to making, is here emphasised by Archie Brennan's contributions on several tapestries created under his studio direction. From his own *Aberdeen '64* (plate 8) to *At a Window VII* (plate 19) he underlines the quest for experiment. The age of Pop Art also brought new artists to the studio, not least Harold Cohen and Eduardo Paolozzi, which kick-started further creative thinking (plates 9 and 10). Maureen Hodge writes of the creative weaver working within the spirit of the original artwork but to a different scale, and also of the practical challenges of making tapestry from image details of paintings by Bernat Klein (plate 12). Better known as a fabric designer, Klein himself tells of his quest to work with light and compare the surface of paint and the creatively woven textile.

Cohen, Tom Phillips and Frank Stella all record the experimental 1960s to 1980s, their eloquent words in each case balanced by the weavers' own experiences (plates 9, 13, 17 and 21). Two weavers in particular provide insight into the many real challenges and practicalities of the work – Douglas Grierson, recently retired after a full half-century at Dovecot, and Fiona Mathison, also an artistic director in the late 1970s and early 1980s. Their commentaries especially provide a window through which can be felt the atmosphere and daily life of the studio. With Brennan's words and those of curator Ann Lane Hedlund, they also document the making of tapestries after paintings of such expressionist artists as Robert Motherwell and Louise Nevelson for Gloria F. Ross (plates 11 and 15). The most successful partnerships have been with interdisciplinary artists – Cohen, Paolozzi and Phillips – where dialogue is kept open and the creative process highly proactive. Phillips' illuminating texts on both *After Benches* and the superb tapestries for St Catherine's College, Oxford, sit right at the centre of this section (plates 13 and 17).

However, while the majority of focused studies here look primarily at the interaction between weaver, artist and the studio's artistic director, site-specific

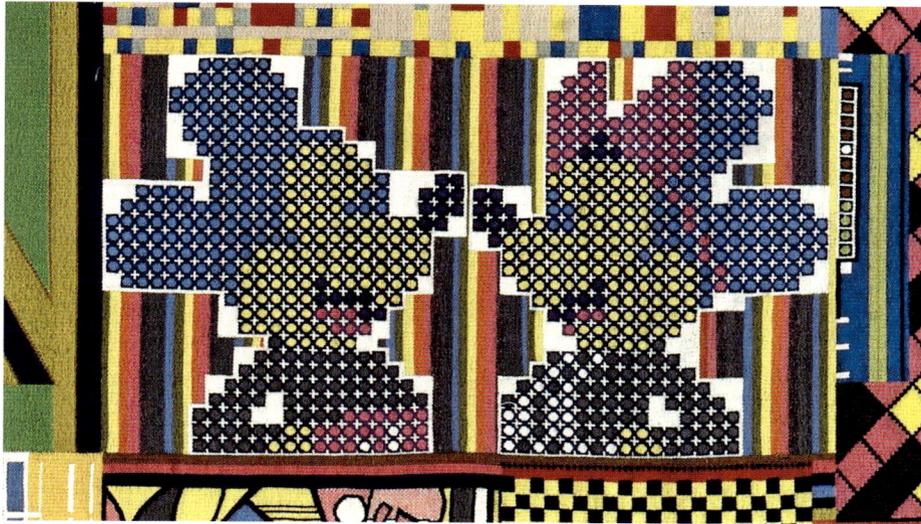

Plate 10
Eduardo Paolozzi
Whitworth Tapestry (detail)
1967–8
Cotton warp, wool
213.8 × 426 cm (84 × 168 in)
Whitworth Art Gallery,
University of Manchester

commissions provide additional insight into the many challenges in balancing the concerns of clients and studio. These include the St Catherine's College suite, Sam Ainsley's piece for General Accident (plate 20), Frank Stella's *Had Gadya* suite for PepsiCo (plate 21), Kate Whiteford's *Corryvrechan* for the Museum of Scotland (plate 28), R.B. Kitaj's and Patrick Caulfield's tapestries for the British Library (plates 27 and 32) and Alan Davie's *To a Celtic Spirit* for Edinburgh's Medical School (plate 30). It is the diverse nature of each site and developed partnership which intrigues and makes Dovecot's output unique. In other places, and with other equally technically skilled weavers, the work would not have achieved the values associated with Dovecot – creative texture, superb colour and the richest of imagination.

Such site-specific work has been largely traditional in scope and achievement, encouraging architects to introduce craft into their spaces. However, in the last decade the studio has partnered traditional tapestry and rug tufting with more experimental textile art. Fashion designer Chris Clyne's partnership with weaver Naomi Robertson here records the making of extraordinary costume (plate 34). Artist Claire Barclay's *quick, slow* used David Cochrane's fine weaving skill within an installation (plate 35). Artist-jeweller David Poston's relationship with the studio is a particularly intriguing study, here documented by partner weaver Jonathan Cleaver through email correspondence, a method of recording so much of our age (plate 36). But, as Cleaver shows here and in the final piece, a rug to artwork by the late Wilhelmina Barns-Graham (plate 38), embracing modernity never interferes with that primary quest for unique interpretation in the studio.

Plate 1

RICHARD GORDON

APPRENTICE PIECE c. 1913–14

Wool
99 × 119 cm (39 × 46¾ in)
National Museum of Scotland
Weaver: Richard Gordon

What I find fascinating about this early apprentice piece
are the similarities it shares with my own first woven
pieces as a recently recruited Dovecot apprentice. One
hundred years on, the technical aspects of weaving
remain unchanged. Training begins with the same
sequential series of techniques, from plain weaving
through diamonds, circular 'D' shapes and hatching,
during which an understanding of passes, steps and
sewing is developed. These common beginnings have
initiated the careers of many of Dovecot's master
weavers over the past century. To me, not only is this
very heartening, but it also speaks of the strong sense
of tradition and lineage underpinning the Studios'
ethos. Through close relationship between weavers and
apprentices, their skill is passed on and entrusted for a
future generation of Dovecot weavers.
Freya Sewell
Apprentice Weaver 2010–

Plate 2

WILLIAM SKEOCH CUMMING

THE LORD OF THE HUNT 1912–16, 1919–24

Wool and silk
396 × 986 cm (156 × 388 in)
The Bute Collection at Mount Stuart
Weavers: David Lindsay Anderson, Gordon Berry,
George Cribbes, Ronald Cruickshank, Stanley Ebbutt,
John Glassbrook, Richard Gordon, John Louttit,
James Wood

The scene depicts a stag hunt in the Scottish Highlands during the month of May when certain plants are in bloom and birds nesting. More than twenty local bird species – from coal tit and crossbill to heron and shrike – are included. Oak leaves from the Bute coat of arms feature prominently in both the main scene and the border. Lord Bute had firm views on the flora and fauna to be included, and even on the

This, the first tapestry to come off the Dovecot looms, is also the largest in terms of width. Epic in scale, the design combines a quite formal academic composition with an Arts and Crafts delight in the beauty and diversity of nature. A palette of wools in typical Arts and Crafts organic colours was provided by Appleton Brothers of Norwell Street, London, who may also have supplied Morris & Company. They were used in a very fine weaving of 18 warps to the inch, all very different from tapestry of a mere thirty years later.

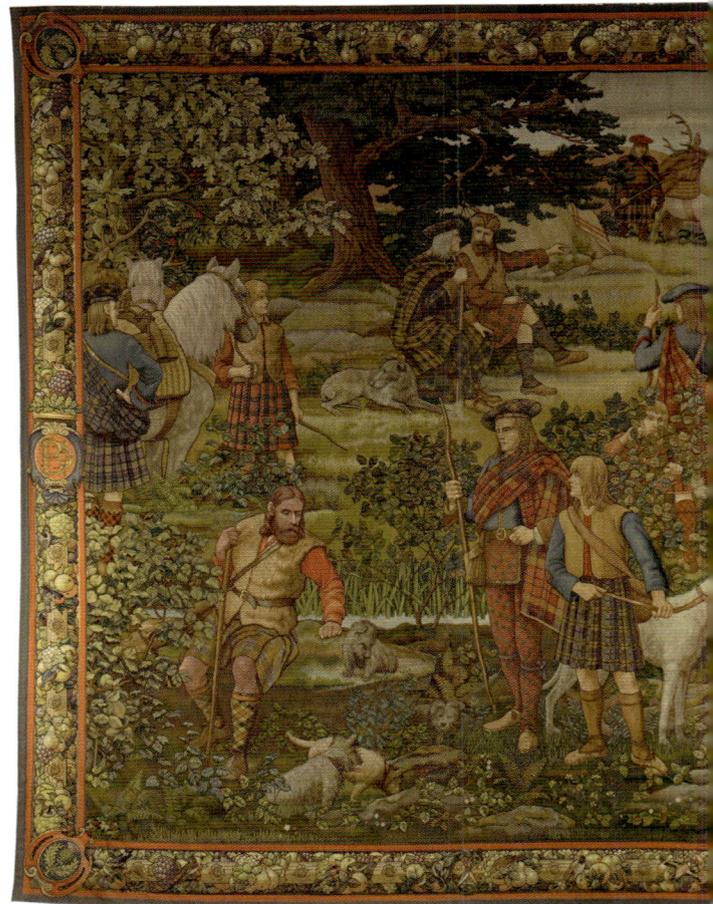

required type of shoes or the raggedness of costume. Prior to the start of weaving only the border had been worked out in any detail.

Once a fairly rough oil sketch of the design was accepted, my great-great-uncle used photography as a basis for working up individual figure studies Dovecot's night watchman, James Roddick, and several of the weavers, plus assorted beasts (alive or dead) were models. Skeoch Cumming was an antiquarian as much as an artist, and during the course of much of the weaving made a point of researching numerous old European tapestries and books relating to seventeenth-century costume and natural history. A working library was established at Dovecot including numerous volumes of detailed notes and cuttings: this became known as 'the Red Book of Corstorphine'. The tapestry thus gradually evolved, and he kept only a few steps ahead of the weavers, much to their and Lord Bute's frustration.

By 1916 the right half of the tapestry had been woven. The border commemorates the first master weavers John Glassbrook and Gordon Berry, both killed in the Great War: their initials appear in the lower border beside a bobbin, its wool thread cut by scissors. Berry's year of death should read 1917 not 1916.

Elizabeth Cumming

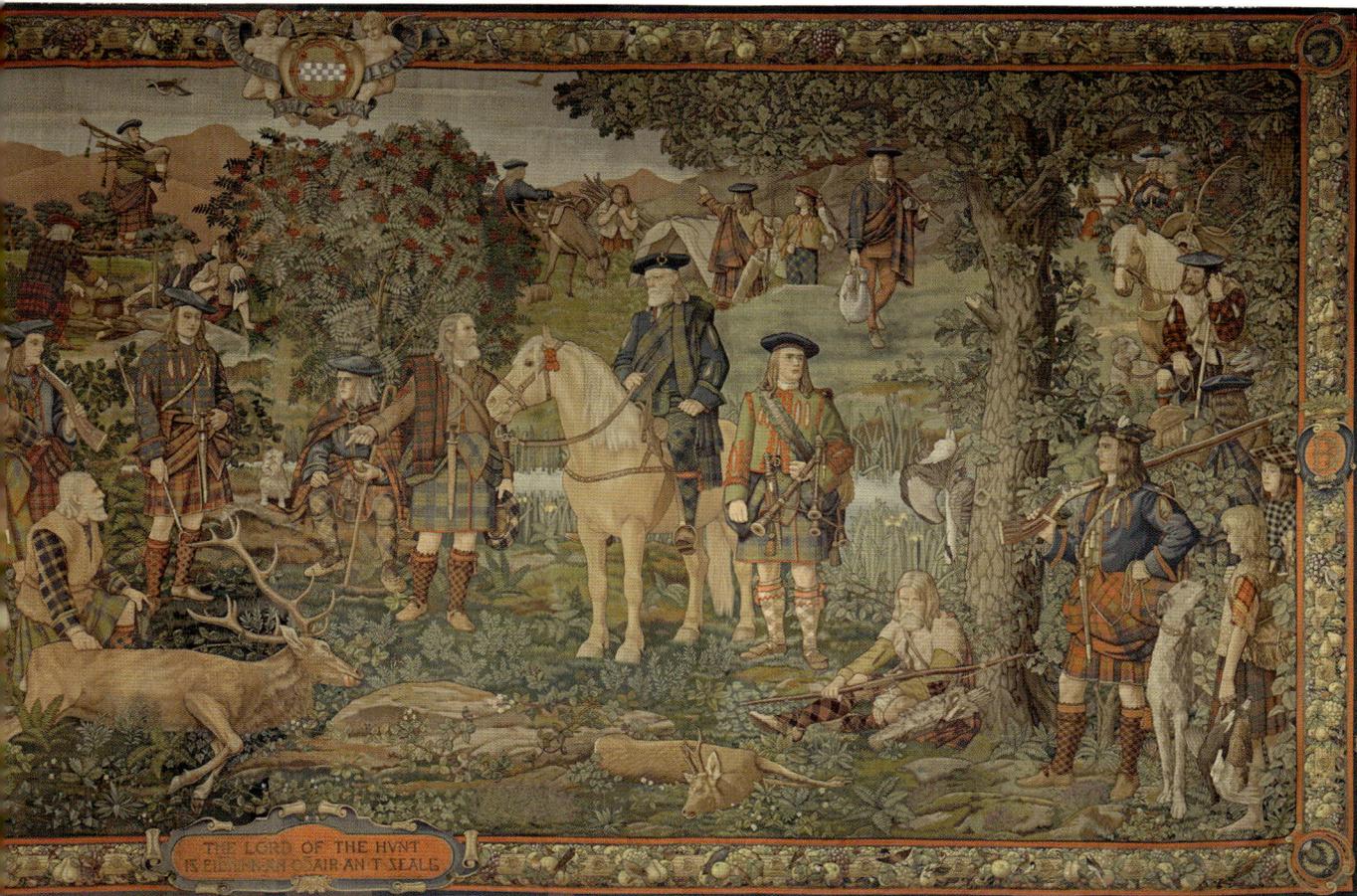

Plate 3

ALFRED PRIEST

THE ADMIRABLE CRICHTON 1927–30

Wool
335.2 × 502.1 cm (132 × 197¾ in)
The Bute Collection at Mount Stuart
Weavers: David Lindsay Anderson,
Ronald Cruickshank, Stanley Ebbutt, John Louttit

minds of his time, he was killed in a brawl in Mantua, the city whose defences he had set out to improve.
Andrew McLean
Bute Family Archivist 1997–2011

The early Dovecot tapestries reflected the fourth Marquess of Bute's great interest in (and indeed deep knowledge of) Scottish history. *The Admirable Crichton* focused on an enigmatic character, a Scot who made his mark beyond Scotland's shores. That James Crichton (1560–82) was an ancestor of Lord Bute was naturally important, but the subject matter – Crichton presenting the Duke of Mantua with his plans for the fortifications of that city – must also have appealed to Bute's antiquarian and building interests as he was then about to begin the controversial restoration of another major fortification, Caerphilly Castle, on his Glamorgan Estate in Wales.

Lord Bute would have been familiar with a portrait of Crichton in another of his properties, Dumfries House in Ayrshire. However, *The Admirable Crichton* was not to adorn Bute's Ayrshire seat but his Edinburgh townhouse at 5 Charlotte Square, also built to Robert Adam's designs. Lord Bute engaged a researcher in Mantua who was employed to look through the records for references to Crichton as well as provide details of the surviving defences, even sending Lord Bute one half of an original brick from the fortifications! Woven to a design by the London-based portrait painter Alfred Priest, the Crichton tapestry adorned the dining room -of 'No.5' until Lord Bute's death in 1947. And James Crichton? Believed to be one of the finest Scottish

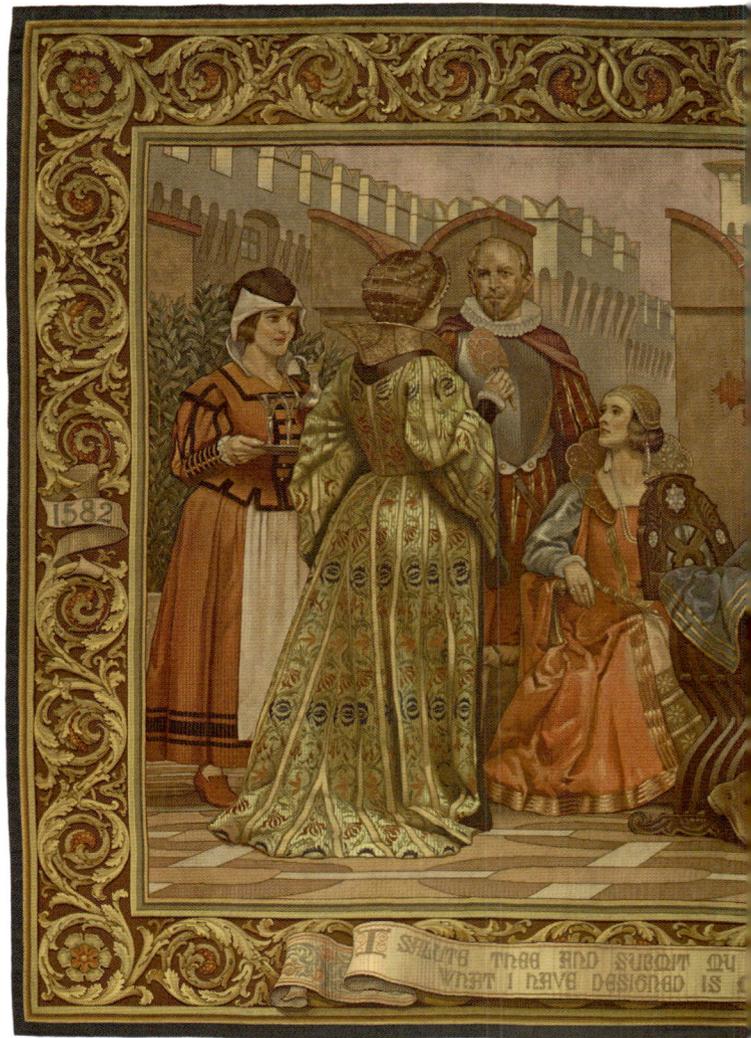

The inspiration for Priest's design may stem equally from the group narrative scenes of such later sixteenth-century artists as Paolo Veronese, well known to Priest from the National Gallery's collection, and from a contemporary interest in historical film, with its facility to focus closely then pan quickly across from scene to scene.

Interpreting the details was both a challenge and a delight for the master weavers. Velvets and brocades, here textiles within a textile (a concept and challenge also to intrigue Archie Brennan in the 1970s), are woven to perfection as are light effects. The texturing of materials is perhaps helped by being woven at 12 warps to the inch instead of the 18 still used for Priest's perhaps more traditional Dovecot design, *Verdure Piece*, completed in 1938.

Elizabeth Cumming

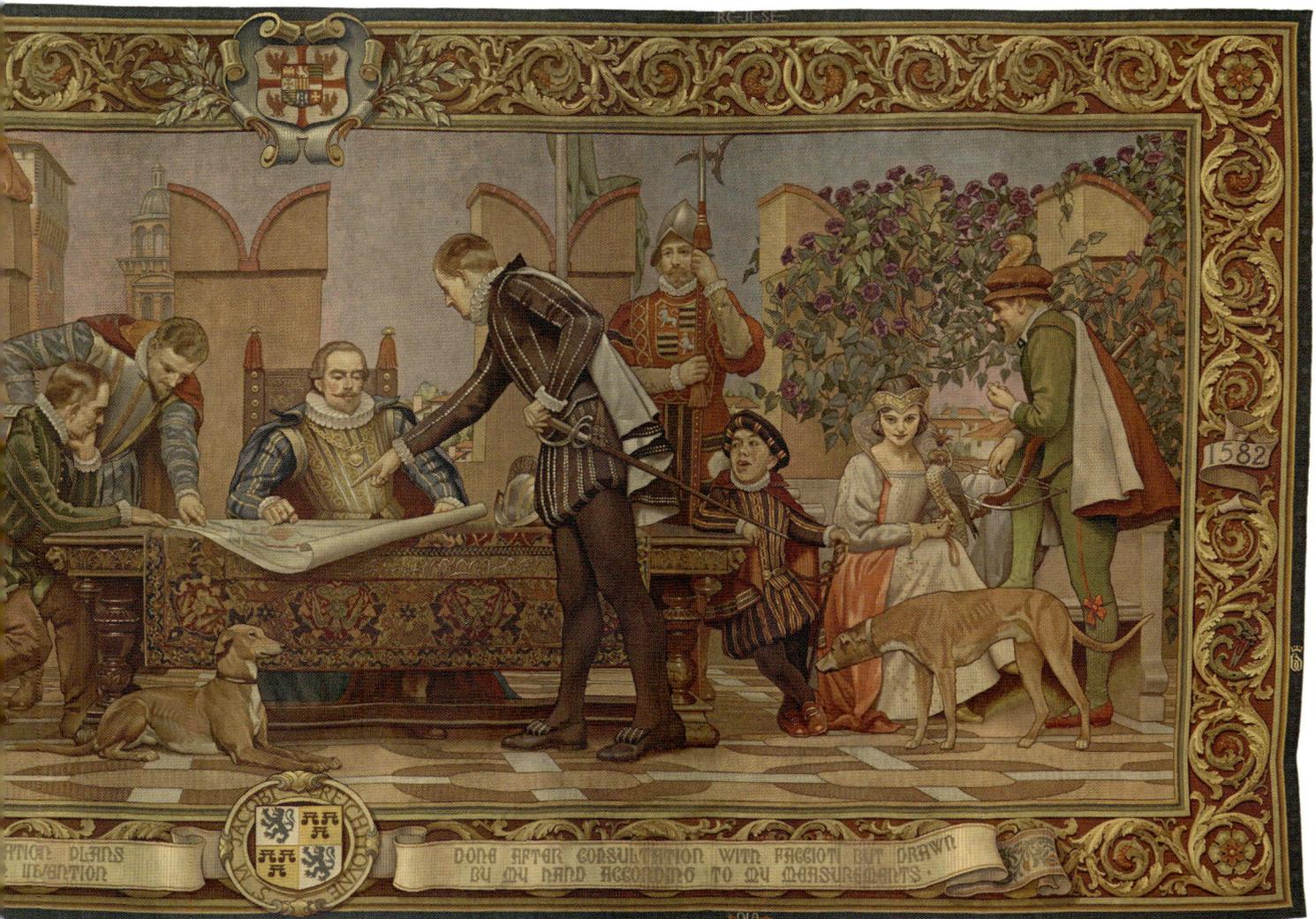

Plate 4

GRAHAM SUTHERLAND

WADING BIRDS 1949

Wool
195.5 × 200 cm (77 × 78¾ in)
Collection of the Vancouver Art Gallery, gift of Mr and
Mrs Arthur Fouks
Weavers: Archie Brennan, Ronald Cruickshank,
Richard Gordon, John Louttit, Ronnie McVinnie

In total, ten tapestries were woven at Dovecot Studios to Graham Sutherland's designs, of which *Wading Birds* was the first. Though Sax Shaw and Lord Colum Crichton-Stuart bemoaned the sketch-like nature of his small designs, their scale was intentional. Sutherland was interested in the alterations that would take place as a result of the design's enlargement and translation into tapestry. The dense brushstrokes of his gouache are represented in the tapestry by sweeping areas of carefully blended colours, a technique pioneered by head weaver Ronald Cruickshank, adding depth and variety to the violet background. In the 1940s Sutherland was known for his unnerving semi-abstract paintings; the design for *Wading Birds* is more realistic in its representation of the purple heron, which Sutherland would have observed on holiday in the Côte d'Azur. The subject matter of this piece illustrates his ability to adapt his style to suit the intended domestic audience for the tapestry, which was purchased by architect Basil Spence to hang in his home.
Francesca Baseby
Dovecot Gallery Manager 2008–10
Edinburgh University / Dovecot AHRC Collaborative
Doctoral Student 2010–

In 1948 I was coming to the end of my fourth year at Boroughmuir secondary school in Edinburgh. With Archie Brennan from the same year, I had been attending evening art classes at Edinburgh College of Art. I had been intending to carry on for a further year at school, but Archie had heard that the Edinburgh Tapestry Company was looking for boys to start a seven-year apprenticeship as an artist weaver. The two of us set off with our portfolios to the Dovecot Studios in Corstorphine. We were successful and were offered positions.

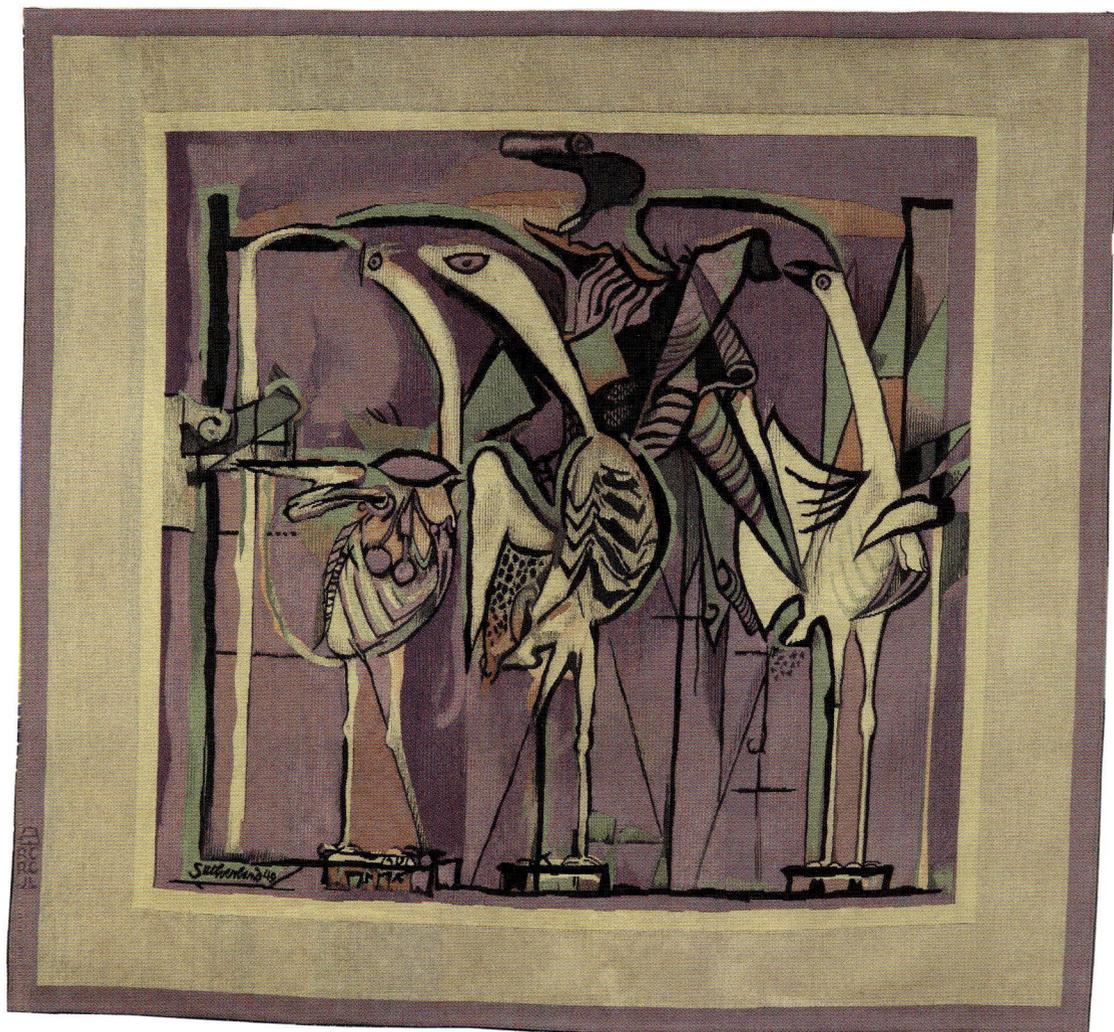

At that time the staff consisted of the boss, Ronald Cruickshank, a small man who always wore a kilt (I can't remember ever seeing him in trousers), Richard Gordon and John Louttit. There were already two apprentices, Fred Mann and Alex Jack. That was to be the start of over three pleasant years studying the art of tapestry weaving, watching the experienced weavers at work: the quick, almost impatient style of Ronald Cruickshank, the slower, more methodical approach of Dick Gordon, and the more flamboyant style of John Louttit.

I remember very well the Studios, with the dovecot on the left as you went in the gate and the path up to the door. The quietness inside, only the sound of the bobbins gently beating the weft into place, the concentration of the weavers, constantly parting the warp to look at the reflection of the work in the heavy-based mirrors. My time at the Dovecot came to an end in 1951 when we were told the Studios would be closing once current work was completed. I decided to leave. Archie carried on, and of course the Studios did not close.

Ronnie McVinnie
Weaver 1948–51

Plate 5

EDWARD BAWDEN

FARMING 1950

Wool
177.8 × 134.8 cm (70 × 53 in)
Victoria & Albert Museum
Weavers: Archie Brennan, Ronald Cruickshank,
Alex Jack, Fred Mann

Edward Bawden was a designer at heart with an intense curiosity regarding craft disciplines. His watercolour study for the tapestry, with its clean patterns and distinct colours, displays an acute awareness of the purpose of his design but also a confidence in the professionalism of the craftsmen to interpret it in their own medium. Much later, in 1977, when Bawden was commissioned to design *Bunyan's Dream*, a large hanging to be embroidered by a group of 18 women for presentation to the Cecil Higgins Art Gallery in Bedford to mark the Queen's Silver Jubilee, he threw himself wholeheartedly into the task. Following acceptance of his initial design he discussed wools, dyes and stitches per square inch with the enthusiasm of an aficionado, before making the 80 individual drawings for the team to work from. The Bedford ladies, despite their proficiency with the needle, were amateurs. When he had designed this tapestry he was dealing with the Dovecot's craftsmen, some of the most experienced weavers in the country, so he did not need to go into such technical detail. *Farming* is truly a modern classic.

When designing *Farming* Bawden was teaching at the Royal College of Art and living in the Essex village of Great Bardfield. His artist neighbours there included Michael Rothenstein, printmaker and also a post-war designer for Dovecot. The designs of both men were informed by their rural surroundings. The farmyard theme was a familiar one in Bawden's oeuvre. Cows had featured on his first wallpaper design in 1927 and a few years later on a poster for the Empire Marketing Board, while a small herd, not dissimilar to those here, would make an appearance in 1951 in *Country Life*, his mural for the Lion & Unicorn Pavilion at the Festival of Britain, and again in the linocut, *Ives Farm*, designed a year before the tapestry. The corn sheaves are reminiscent of one of his Orient Line menu designs from the previous decade, while chickens were a perennial Easter delight in his much-loved advertising material for Fortnum & Mason of the period. Only the tail-less turkey is a curiosity more reminiscent of John Tenniel's dodo from *Alice's Adventures in Wonderland*. The border, too, is typical Bawden, both in its respect for the traditions of tapestry and in its playfulness; here natural motifs vie with symbols reminiscent of medieval masons' marks.

Peyton Skipwith
Independent Art Consultant and Writer

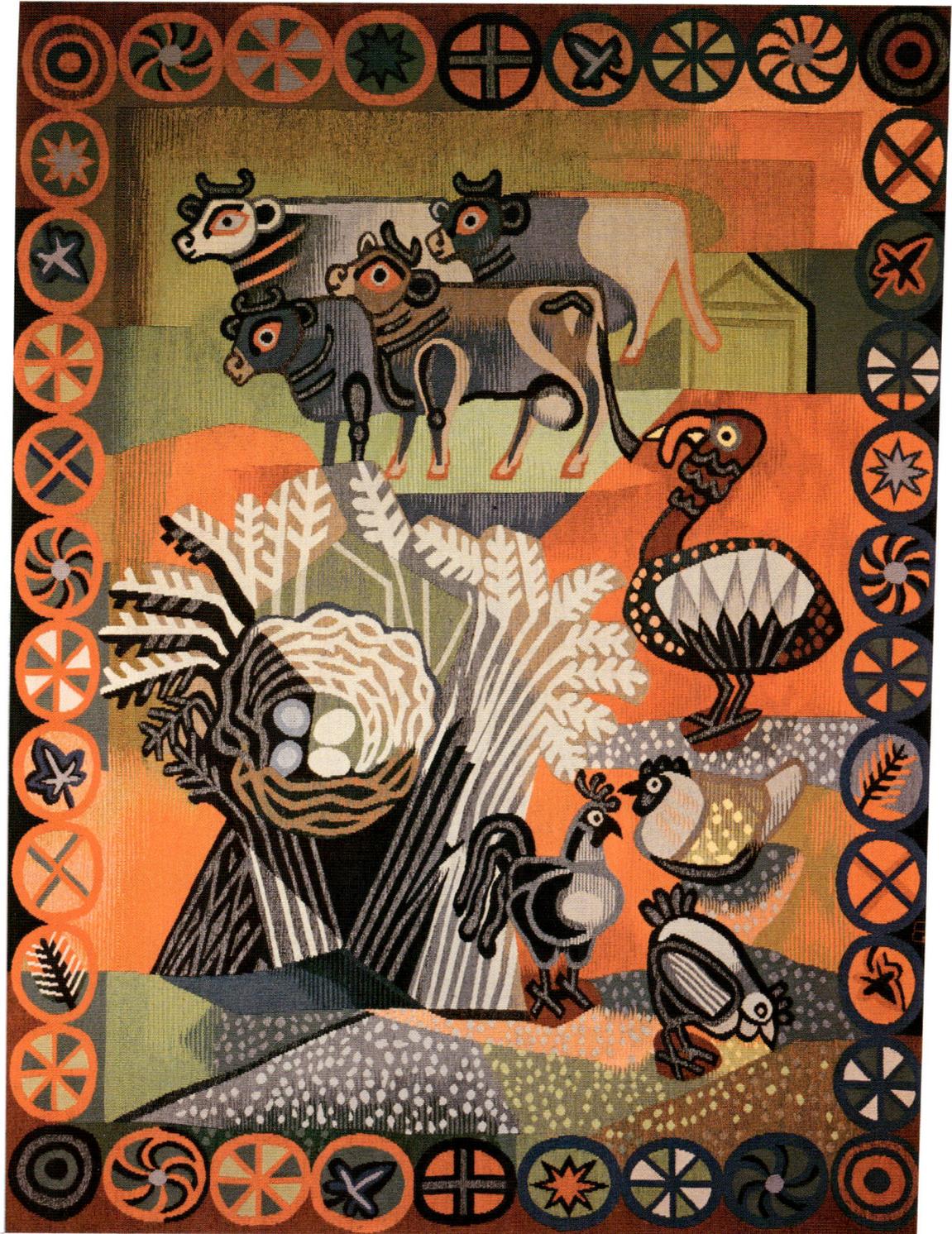

Plate 6

SAX SHAW

THE CYCLE OF LIFE 1957–8

Wool
290 × 274 cm (114 × 108 in)
City Art Centre, City of Edinburgh Museums and
Galleries
Weavers: Richard Gordon, Fred Mann, Harry Wright

My father led a minor revolution in what was called
'the Decorative Arts' up to the 1970s. In general, the
design and creativity in tapestry and stained glass were
the territory of the 'Artist', quite frequently a painter,
and the creation of the piece was the province of
the weaver or stained-glass manufacturer. Following
on from the ideas of William Morris, there had been
tentative steps towards the maker becoming the true or
even sole creator through the first half of the twentieth
century and this blossomed after the Second World War.

The Cycle of Life was one of a series of commissions
for Edinburgh Crematorium that my father undertook
during his career. The changes to working practices
championed by Sax Shaw included weaving from the
front, i.e. the finished side of the tapestry, to become the
practice at Dovecot from Archie Brennan's time, and a
greater freedom of interpretation by weavers themselves.
As part of a transition from working with a painting
to a free interpretation of a cartoon, a full-size cartoon
would have been set up immediately behind the warp
on the loom. Annotations on the cartoon denoted the
specific wool selections to be used for each colour.

Weaving practice then moved on rapidly to the use
of large black-and-white photographic enlargements
of Sax's original compositions for tapestry and more
freedom for weavers to interpret the colour selections

and make their own wool selection while weaving.
This took some discipline and practice to ensure colour
consistency throughout a large tapestry, as only a small
area is visible at one time when weaving on Dovecot's
traditional roller looms.

The Cycle of Life represents a key moment in the
transition to artist weavers pioneered by Sax Shaw
during his tenure as Director of Weaving at Dovecot.
Kevan Shaw

What immediately strikes me is the vividness of colour.
Nothing of the tapestry's freshness has been lost over
the years. The imaginatively drawn passage of life is
well matched by choice colours – lemon yellows and
pea greens for Spring, giving way to burnt ochres and
warm khakis for life's Autumn term. In such an all-over
design, colour is sensitively used to avoid competition
in the imagery. Bright hues are thoughtfully positioned
amidst muted passages, allowing areas to advance and
recede with ease; colour gives that sense of flow which
negates potential chaos. Though the effort involved is
inconspicuous, this ability to balance colour is perhaps
one of the hardest things to learn in tapestry, as in other
media concerned with colour and tone. How colours
relate to and react with each other is key, hence the
tradition of colour samples in tapestry – a woven strip
comprising a design's colours to trial mixes at an initial
production stage.

The jewel-like spots of pure colour in this particular
design seem also to reference the peculiarity of Shaw's
training in stained glass, as does the convention of
bordering within which the central imagery is held.
To me, *The Cycle of Life* is an affirmative vision. Faced
with the transiency of life, it is an image which offers

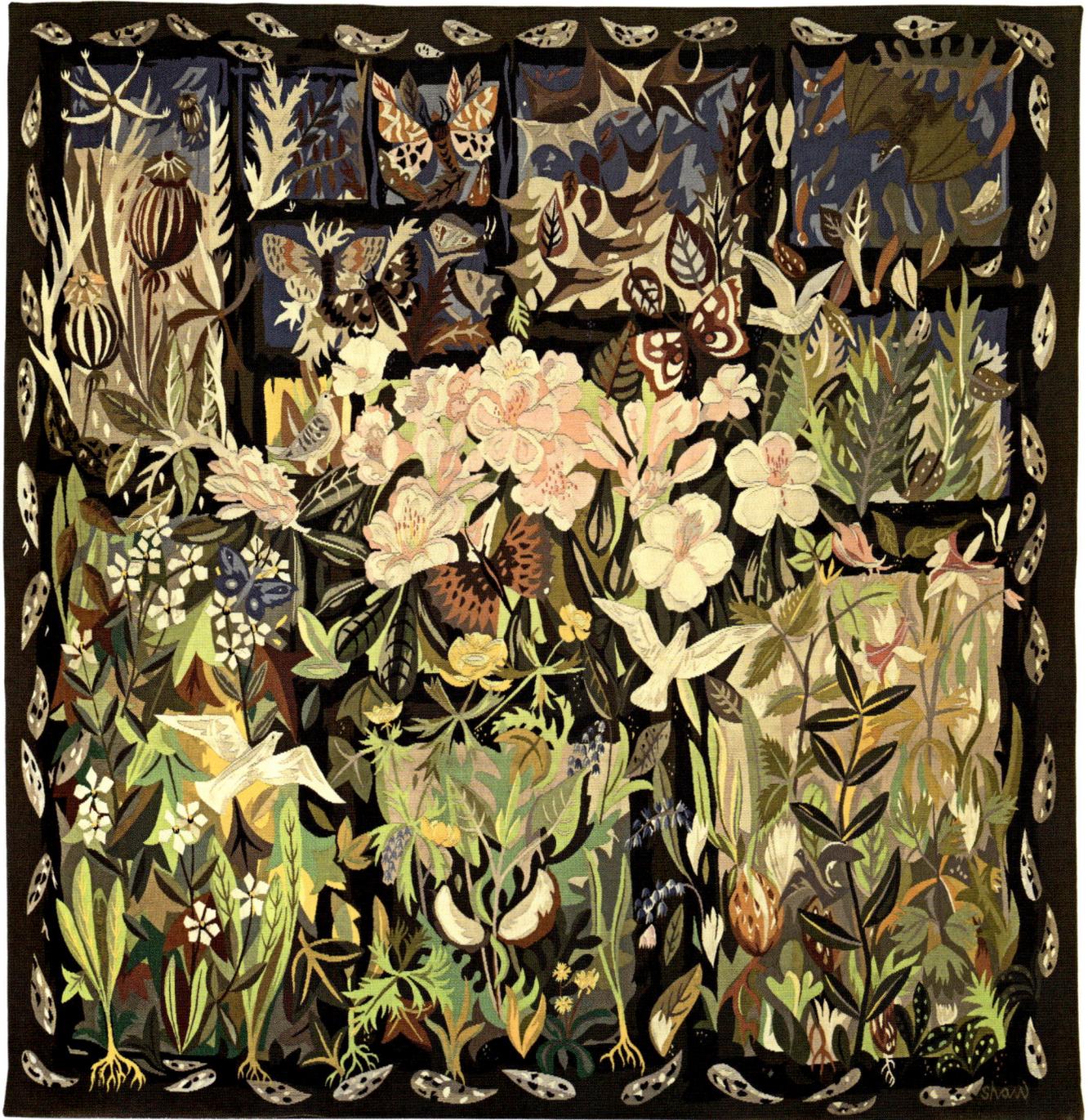

solace through the acceptance of nature's determined course. Now outwith its original setting — a site where our own mortality confronts us — this powerful message is nonetheless immediate and affecting.

Freya Sewell
Apprentice weaver 2010–

Plate 7

JOHN MAXWELL

PHASES OF THE MOON 1958

Wool
188 × 223.5 cm (74 × 88 in)
Aberdeen Art Gallery & Museums Collections
Weavers: Fred Mann, Harry Wright

This tapestry, woven to commission for the Scottish Committee of the Arts Council, illustrates the symbolic, almost dream-like images for which the Scottish artist John Maxwell is best known. His personal vision, influenced by contemporaries like Marc Chagall, sets mankind in relationship to the natural world and native folklore. Here three figures in rhythmic dance formation are juxtaposed against a backdrop of planetary and astral bodies. The waxing and waning moon reminds us of the passage of time and the life cycle of all living beings.

In a fanciful, almost pastoral, fantasy game birds and flowers are intermingled with the female figures, expressing the favourite themes of Maxwell's paintings. The border picks up on his love of moths and butterflies, interspersed with birds and other living creatures.

This rich, imaginative, whimsical mix is captured in fine detail by the tapestry. Maxwell was closely involved in the colour selection of the yarns. The palette of russet, umber, golden yellows and greens – with flashes of contrasting hues – is used with great skill and subtlety to echo the vibrancy and energy of the figures and motifs. These tones also remind us of harvest time and the fulfilment of the earth's abundance.

Christine Rew
Art Gallery & Museums Manager
Aberdeen Art Gallery & Museums
Aberdeen City Council

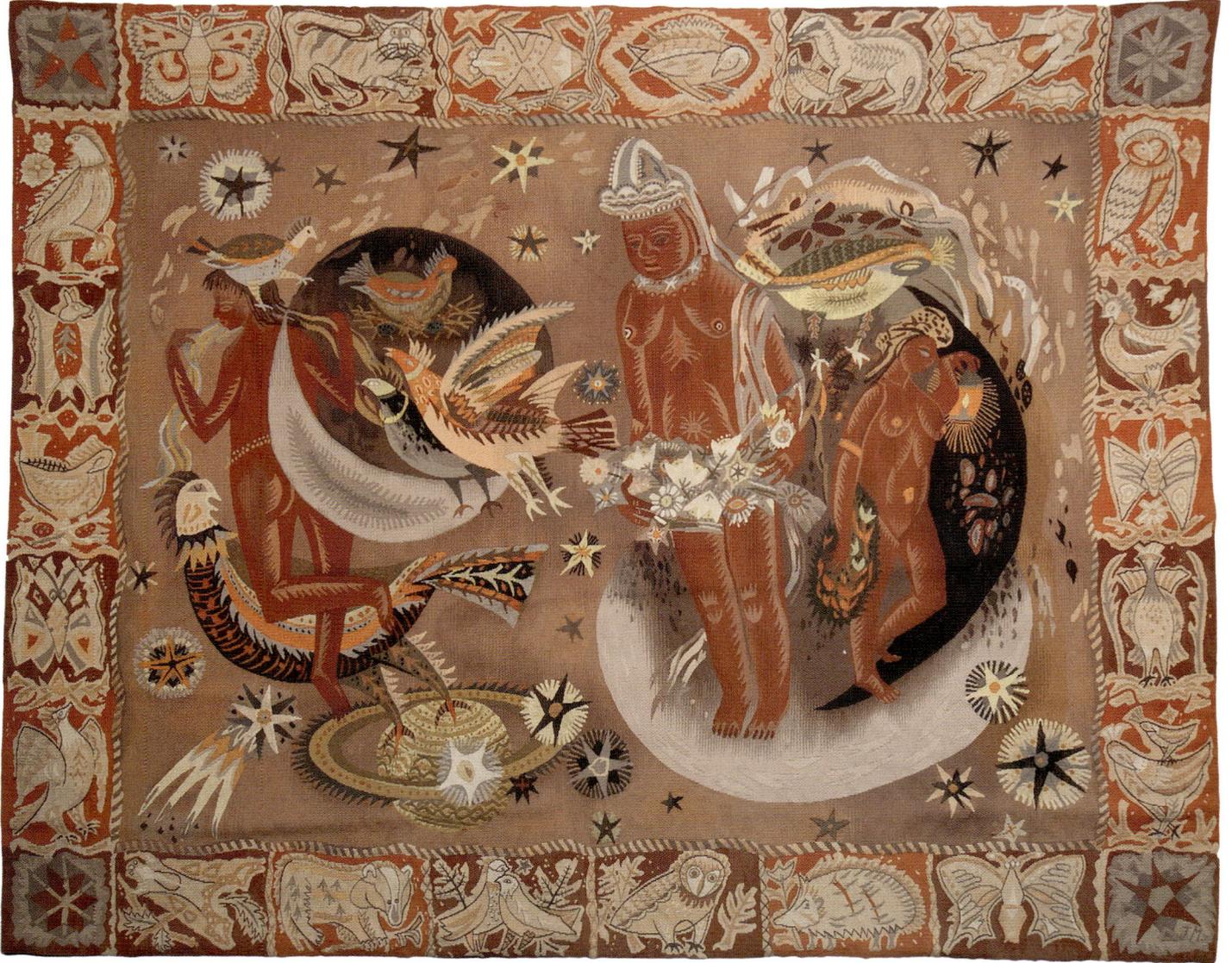

Plate 8

ARCHIE BRENNAN

ABERDEEN '64 1964

Cotton warp, wool, metal thread
215 × 290 cm (84½ × 114 in)
Aberdeen Art Gallery & Museums Collections
Weavers: Archie Brennan, Douglas Grierson,
Maureen Hodge, Fred Mann

In 1963 the Aberdeen Art Gallery Committee commissioned the Edinburgh Tapestry Company to create a tapestry for Aberdeen. The brief was to design a piece which would express something of the light and character of the city in the broadest sense. It was the first example of a provincial gallery commissioning a tapestry to act as a keynote for its modern collections. The commission provided a stimulus for this type of creative work and encouraged the retention of Scottish tapestry in Scotland.

Archie Brennan was engaged on the project and produced a design which is abstract but still strongly suggestive of the Granite City. The wind blows autumn leaves across a background of blues,

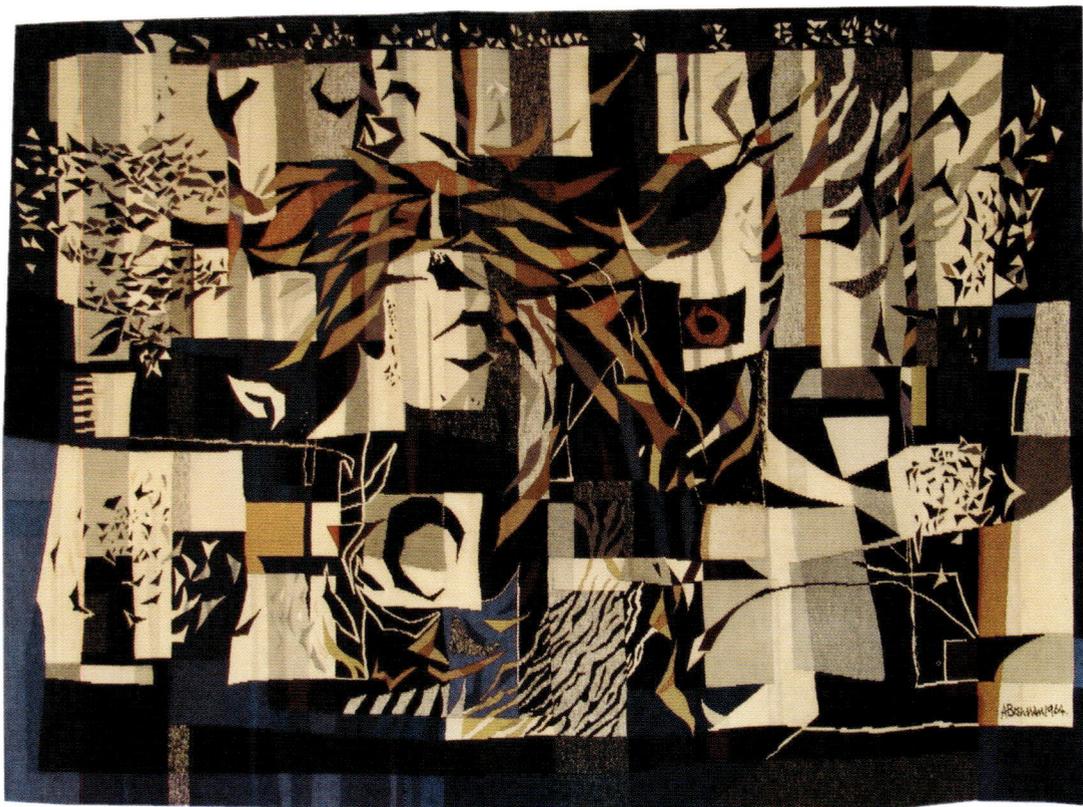

black and greys evocative of the granite buildings. A magnificent technical example of the craft, Brennan also successfully captures the crisp, clean, rectilinear lines of the Aberdeen buildings and their steely granite character with fresh winds constantly blowing through its streets. The clarity of the air and cool northern light sing from it. Brennan's brilliant choice of colours and dynamic movement create a work which today remains an exciting visual experience, with a fresh and direct quality, full of life.

Aberdeen '64 was woven before the establishment of the UK oil and gas industry in Aberdeen. It captures something of the true character and heritage of the city, now often overlooked by the brash oil supply vessels and modern office blocks which dominate today's skyline.
Christine Rew
Art Gallery & Museums Manager
Aberdeen Art Gallery & Museums
Aberdeen City Council

The hanging location suggested by the director on my first visit was at the head of the main staircase, high on a wide, generous wall that faced due south across the hallway to the gallery's entrance. The sunlight pouring into the gallery hall via three rectangular windows situated above the doorways, from mid-morning to mid-afternoon, threw dramatically lit shapes on that far wall – parallelograms that changed as they moved it from left to right.

Traditionally, this would be regarded as an undesirable location for a mural-size woven tapestry, but the question arose in my head – could I turn this to advantage by developing a design that accommodated this feature? Certainly this approach would permit, even require, a high tonal contrast and rich colour: deep blacks and dark blues, a range of whites, perhaps changing surface textures that would 'breathe' as these transient shapes moved across them, charcoal greys both light and granite dark, and not least golden yellows through to deep browns.

As a recent postgraduate student, my small tapestries had certainly been influenced by the flowing cut-out shapes characteristic of French workshops of the 1950s, but I had also recently been introducing a richer surface (with fewer warps per inch) and more emphasis on the potential, unique step-making structure that is inherent in classic woven tapestry.

I had one further thought. I had taken many colour slide transparencies of details of recent personal tapestries, and made a number of drawings by projecting whilst overlaying such slides, shuffling them, rotating some, switching them around. I built up a group of such drawings, first linear, then shapes and colour, and slowly there emerged a breezy spirit and the possible design for the tapestry, always seeking in my mind's eye the final work in its actual setting.
Once on the loom, with the team of weavers (Fred [Mann], Douglas [Grierson], Maureen [Hodge] and myself) now all in tune with this yet-evolving concept, the tapestry emerged …
Archie Brennan
Weaver 1948–53, Artistic Director 1963–78

This was Archie's first commission at the studio. Maureen Hodge and I were the main weavers on the tapestry. He was a master of line and tone and indeed most of his work at that time was monochromatic. As a young weaver I could not understand this when we were surrounded by such wonderful colours.

The tapestry was also one of the first to be woven in the studio using different types of yarn, allowing various subtle surface textures and departing from a flat, uniform cloth. The exploration into new and exciting materials for weaving became the mark of a way forward that would change tapestry and weaving trends for the foreseeable future.
Douglas Grierson
Weaver 1961–2011, Studio Manager 1994–2000, Head Weaver 2000–11

Plate 9

HAROLD COHEN

OVERALL 1967

Cotton warp, wool
243.8 × 243.8 cm (96 × 96 in)
Victoria & Albert Museum
Weavers: Archie Brennan, Douglas Grierson,
Maureen Hodge, Fred Mann, Harry Wright

My first experience of tapestry came in 1966, when I was commissioned to do a large piece for British Petroleum. *Overall*, which was done for the V&A the following year, was directly influenced by what I'd learned. I hadn't known, for example, that the first thing the weavers do when they get a new design is to trace it on to a drawing, outlining each small patch of what could be treated as a single colour. (Imagine what that means when colour transitions in the design are effectively continuous, as they would be in a photograph, for example.) Then the resultant drawing is enlarged to the required size, placed behind the warp on the loom and used to mark the threads of the warp itself.

But what a drawing! I was fascinated by the transformation from my design; by the fact that I was responsible for the drawing's existence, but I hadn't made it. (Of course, that became my regular condition a few years later, after I met my first computer.) And in *Overall* I believe I used a small part of the background in the BP tapestry to yield the outlines of the patches that cover most of the work. But I have to confess to being a bit hazy about it more than 40 years later. I know I didn't just draw it myself.

I guess the notion of transformation was central for me at that time. The image-material I used for the BP work came from photographs I'd taken of Gaudí's extraordinary Sagrada Familia in Barcelona, but

instead of using the photographs themselves I used the negatives, having discovered that printing an image in negative retains the sense of materiality, of something seen, but generates a quite different something. The motif in the bottom left corner of *Overall* is thus even more directly related to the BP tapestry. It came from one of the Gaudí negatives that I hadn't used.

Is anything more transformative than tapestry? The artist walks in with a design – a rather large, elaborate job in my case, but often just a small watercolour – and weeks or months later the cutting-off ceremony reveals a remarkable artwork, utterly different in kind and in its physical qualities from the design that had initiated its making. Rich in texture, vibrant in colour, unlike any other medium available to the artist.

I count the time I spent working with the Dovecot weavers as some of the best in a long career: a privilege I remember very clearly, even after forty years.
Harold Cohen

In my early years as a Dovecot apprentice, a highly respected group of artists, mostly British, visited the workshops as potential tapestry designers. They were all talented painters, eager to participate. Some saw their function as simply to have their pre-painted artworks scaled up and 're-orchestrated' to the inherent colour characteristics of spun and dyed wool weft.

Occasionally, an artist would, by chance, work in a manner that inherently had much in common with the nature of this medium, and on rare occasions someone came along who was creatively talented, and both sensed and was eager to explore and extend the potential of the medium. An Irishman, Louis Le Brocquy, whose tapestry design *Tinkers* is still one of my all-time favourites, was one; Eileen Mayo, later of New Zealand, also Hans Tisdall, Joyce Conwy Evans and for sure Sax Shaw were all of this breed. In 1965 Harold Cohen was selected by British Petroleum to design a very big 26-foot-wide [8-metre] tapestry for their new headquarters. He arrived in Edinburgh with a prepared design and a reputation as a leading painter of that era in the UK. It was clear that his initial need was also to impress us. He did however treat our team of weavers as colleagues and in long discussions showed interest in exchanging approaches and perhaps collaborating in a creative journey. He returned to his studio with enthusiasm to prepare a revised approach for a 3-by-3-foot [1-by-1-metre] woven test. His reaction to ours was to undertake another trial weave, and yet another. This was the start of a number of journeys to Edinburgh.

It is important here to say that it opened up our thinking too; there were changes on woven tests, on paper, on canvas, and mutual questioning that explored all our strengths, avoided weaknesses and undertook other kinds of journeys that profited BP, British Airways, Harold and the Dovecot staff – and later produced two, no, three more subsequent, and so eloquent, Cohen–Dovecot tapestries.

Archie Brennan
Weaver 1948–53, Artistic Director 1963–78

Overall was quite a challenging tapestry to weave. The design was a canvas painting with an acetate overlay sheet of dots denoting the areas of the design to be covered. These dots were curiously at slight angles across the warps which had to be accurately woven to give a precise effect, and, to add to this, the background colours behind the dots graduated from a maroon into a sky blue.

Some of the colours had to be dyed up specifically, or we would scour the wool shops in Edinburgh to get the right shades. The dots were what we would now call 'day-glo' green and the sky-blue background was only obtainable in a manmade fibre.

Cohen made many visits to the studio during the making of his tapestries. He engaged in the weaving process; he would have us search for a technique that brought out aspects of his work that could not easily be achieved from just copying his design. We were asked to incorporate things into the tapestry that we had not done before. After the serious work was done we would produce the guitars, mandolins and pipes for a tune or two over a cup of tea.

Douglas Grierson
Weaver 1961–2011, Studio Manager 1994–2000, Head Weaver 2000–11

The design for *Overall* relates closely to the paintings Cohen was simultaneously producing which used spray paints and stencils. The samples for the tapestry show how the weavers experimented with different weaving methods in order to achieve the sense of overlay and stencilled patterns. After creating samples with knots and double weaving, it was decided to weave the tapestry in a flat manner, employing a sophisticated use of colour and blending to achieve different colour patterns.

Francesca Baseby
Dovecot Gallery Manager 2008–10
Edinburgh University / Dovecot AHRC Collaborative Doctoral Student 2010–

Plate 10

EDUARDO PAOLOZZI

WHITWORTH TAPESTRY 1967–8

Cotton warp, wool
213.8 × 426 cm (84 × 168 in)
Whitworth Art Gallery, University of Manchester
Weavers: Archie Brennan, Douglas Grierson,
Fred Mann, Harry Wright

In 1967 we were asked to weave a small tapestry of *Mickey Mouse* (now Scottish National Gallery of Modern Art). It turned out to be a large sample for the tapestry to be woven for the Whitworth Art Gallery

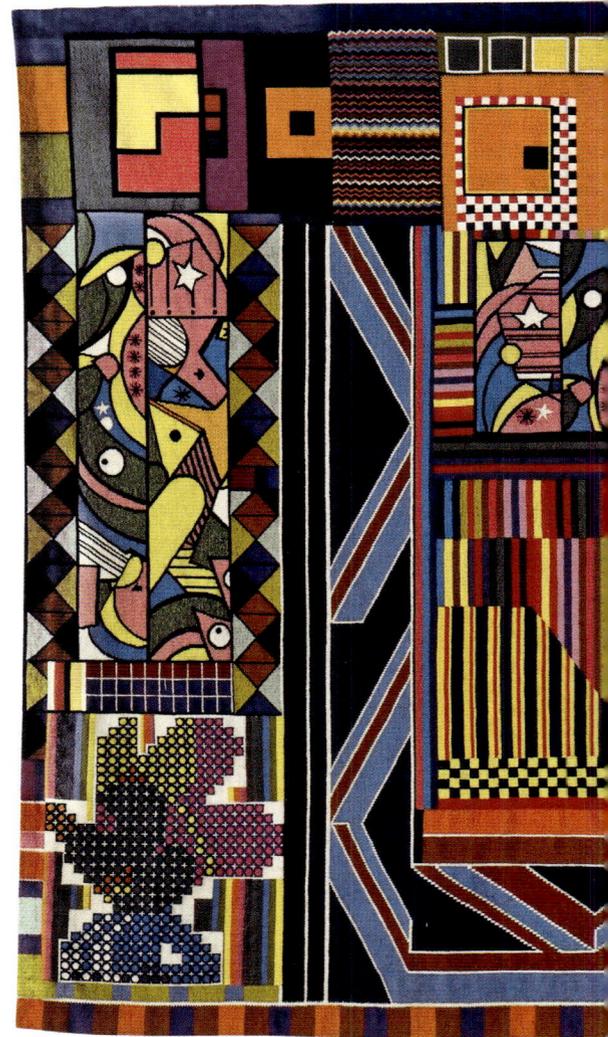

Commissioned by the University of Manchester to celebrate the renovation of its art gallery, the *Whitworth Tapestry* brought Eduardo Paolozzi and Dovecot Studios together for the first time. Paolozzi's design was created using a collage of existing prints. In the 1960s prints had become a substantial part of the artist's output and elements of this tapestry design were taken from the series *Universal Electronic Vacuum* (1967). The weaving was supervised by Archie Brennan and a comparison of the print and finished work highlights the transformation which the image underwent. The colours of the tapestry are more vibrant and less sugary than the print, and the tone of some areas has been altered in order to create a more unified vision. Brennan wrote to the Whitworth's curator that the tapestry was 'great fun to weave' due to the variety of patterns in the panel. A number of different weaving techniques, such as half-passes and colour blending, were employed to reflect the surface patterns on the print. The success of the collaboration led to a further seven tapestry projects with Paolozzi.

Francesca Baseby
Dovecot Gallery Manager 2008–10
Edinburgh University / Dovecot AHRC Collaborative
Doctoral Student 2010–

a year later. We were looking into the possibilities of translating Eduardo's collage into a tapestry. This image was to form an important component of his imagery for the final Whitworth design.

All the weavers thought this was fun. As I remember, it was not a technically difficult piece to weave, but the colours and the subject matter were very exciting. This was a great departure from our norm of translating painterly marks. Eduardo did not involve himself with the mechanics of the weaving: he was the artist and we were the weavers. I love his images and his use of popular culture as the source of his work and I thought we were doing something meaningful from our time. With Cohen and Paolozzi working at the studios at the same period, this was cutting-edge stuff.

Douglas Grierson
Weaver 1961–2011, Studio Manager 1994–2000, Head Weaver 2000–11

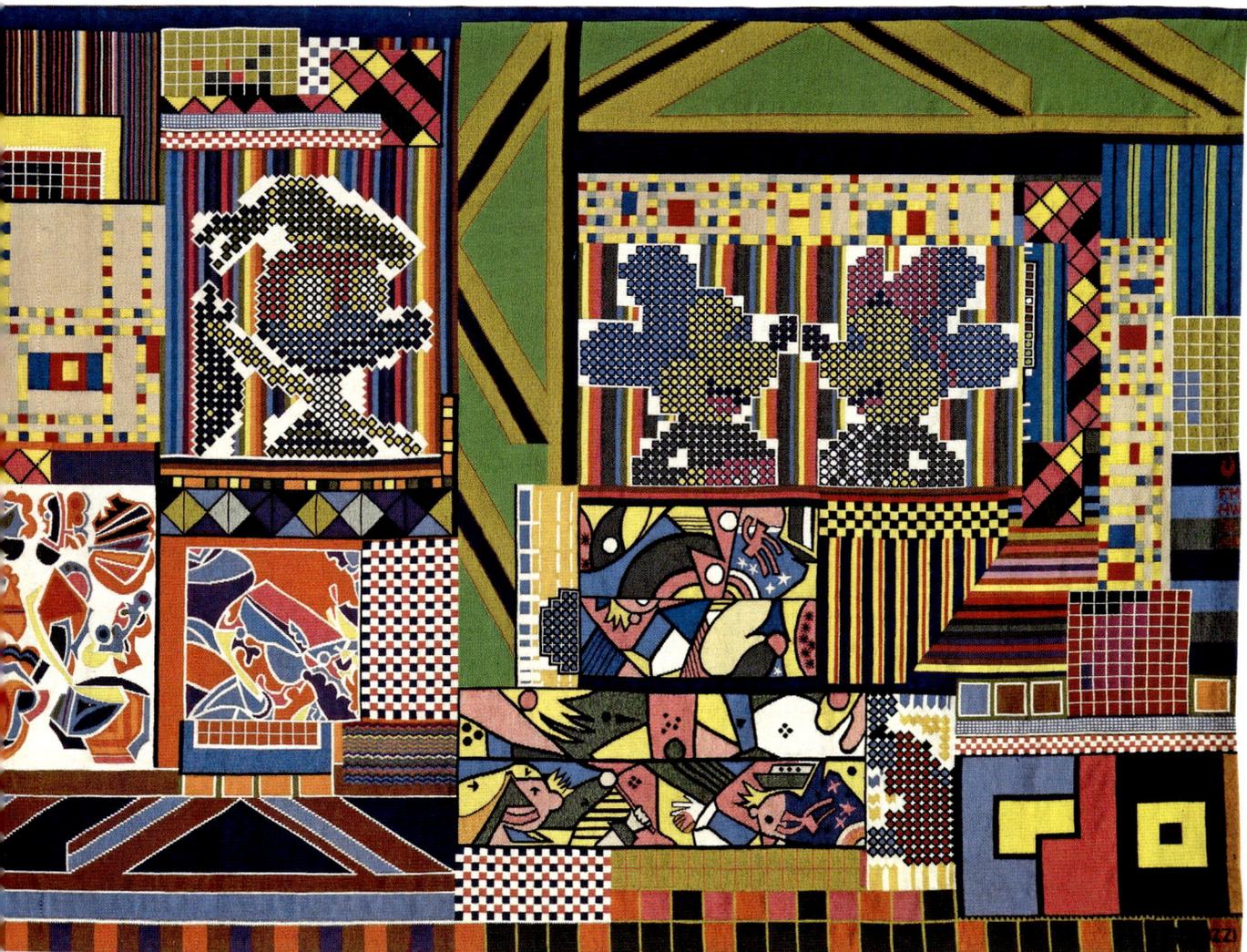

Plate 11

ROBERT MOTHERWELL

AFTER ELEGY TO THE SPANISH REPUBLIC No. 116 1970

Cotton warp, wool
213.4 × 274.3 cm (84 × 108 in)
Private Collection
Weavers: Archie Brennan, Douglas Grierson,
Maureen Hodge, Fiona Mathison, Fred Mann. Harry
Wright

A painter, collagist and printmaker, Robert Motherwell led the abstract expressionist movement in post-war America. He was married to Gloria Ross's sister, Helen Frankenthaler, another highly accomplished American painter. Ross, a Manhattan-based tapestry *éditeur* collaborating with both artists and weavers, worked with her brother-in-law and Dovecot Studios to adapt his boldly brushed imagery into masterful tapestries. The process required frequent transatlantic communications via telegram and mail (no email or faxes in the 1970s!). As well, Ross often travelled to Edinburgh and Archie Brennan met with Motherwell in New York City.

Motherwell created the 1969 model for this large tapestry with acrylic paint on a canvas board, measuring a mere 7 by 9 inches [18 by 23 cm]. Brennan established innovative means to express Motherwell's characteristic layering and texturing of a painted surface. Woven between 1970 and 1976 as an edition of five plus two artist's proofs, each tapestry included linen as well as the more traditional wool yarns; the flat tapestry weave was augmented with knotting and weft-wrapping.

Ann Lane Hedlund
Director, The Gloria F. Ross Tapestry Program
Arizona State Museum

University of Arizona
Tucson, Arizona

The Motherwell tapestry ushered in a long and fruitful relationship with Gloria F. Ross, tapestry impresario extraordinaire. For the next 15 years we wove around fifty tapestries for her. Most of these were in editions, a new departure for Dovecot, though popular in European workshops. We were so thrilled to be working with these famous abstract expressionist artists.

Motherwell's small black-and-white canvas was sent to us. It was immediately apparent that his powerful gestural brushstrokes had to be interpreted with the same strength and directness as the small painting. Archie was in favour of limited surface texture so the black motif was woven with knots and half-hitches where the paint thickened most. Special attention was paid to where the black met the background. In the background itself different thicknesses of linen weft were used again to catch the differing applications of paint and the directional movement. We heard that Motherwell was not keen on the texture, but I do not think it detracts from what still remains a powerful image.

Douglas Grierson
Weaver 1961–2011, Studio Manager 1994–2000, Head Weaver 2000–11

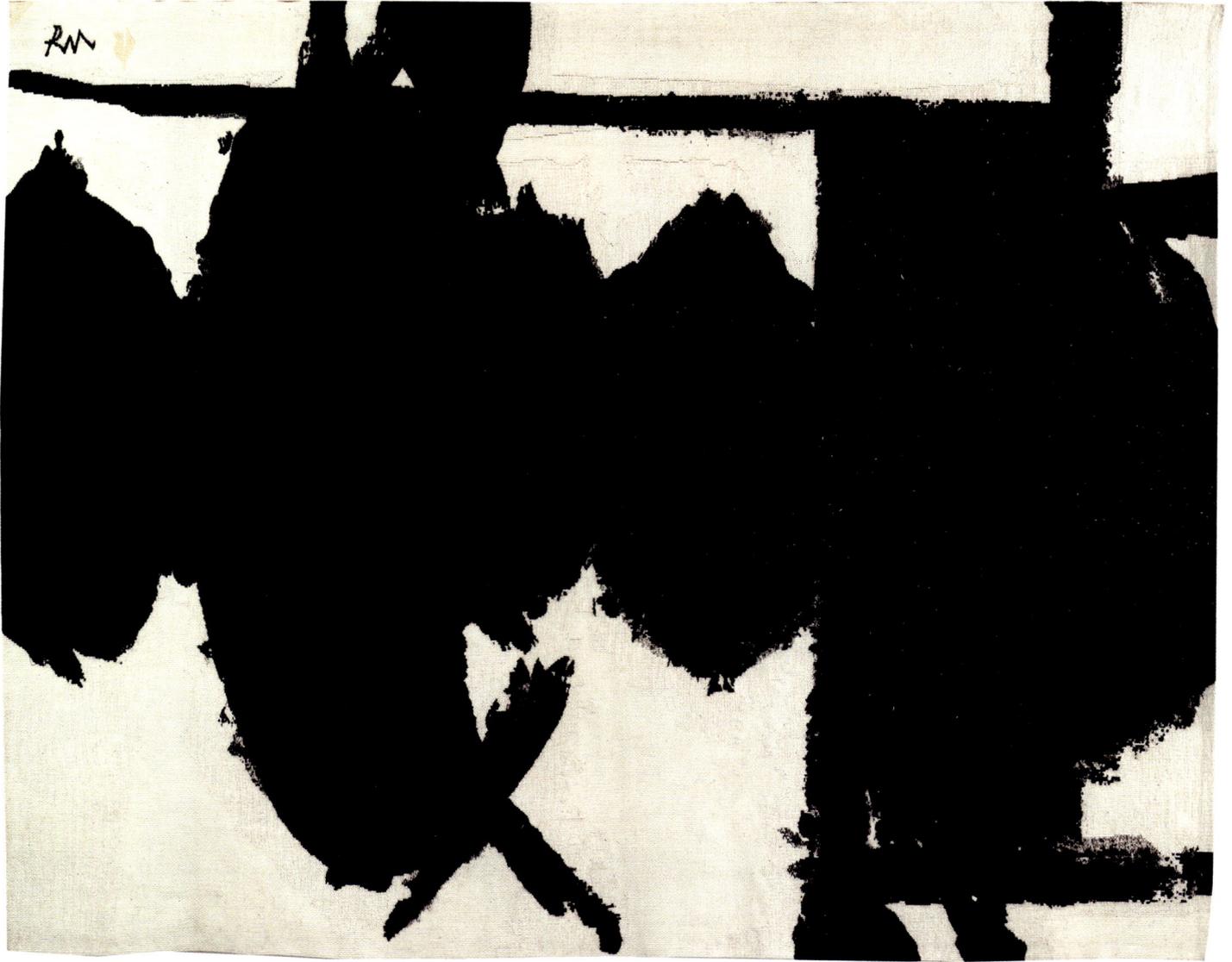

Plate 12

BERNAT KLEIN

HIGHLAND POOL 1971

Cotton warp, wool
99.1 × 99.1 cm (39 × 39 in)
National Museum of Scotland
Weaver: Maureen Hodge

There are a number of limitations on the work of the designer of colour-woven fabrics, especially if the fabrics are to be produced on power looms.

In order to overcome some of these limitations, and also in order to keep my colour sense in trim, I started to paint in the early 1960s. I then became fascinated with the way light was reflected on large areas of flat, dried, hard paint and wondered how similar areas would look and feel in woven fabrics. Would light reflect differently on these than on paint?

As I remember it, this was my reason for commissioning Dovecot weavers in the early 1970s to reproduce several of my painted designs as tapestries. I gave the weavers colour transparencies of the designs measuring 2½ inches [6.5 cm] square, and from these they wove very accurate, enlarged reproductions of the shapes, textures and colours of the originals.

The resulting ten tapestries influenced the way in which I subsequently approached my work and looking at them still gives me much pleasure.
Bernat Klein

The ten Bernat Klein panels, which were woven for his house in the Borders, broke new ground for the Edinburgh Tapestry Company. Each 'cartoon' consisted of a 3-inch-square [7.5 cm] colour transparency of a series of impasto paint surfaces, and these were duly transcribed straight into tapestries each 3 feet 3 inches [99 cm] square. There were no full-scale cartoons on the ones I wove. The images were of paint surfaces laid on top of one another with slits and holes revealing further layers below. There were up to five layers.

The panels were realised mainly by using tapestry but knit, whipping, crochet and tufting were also employed. The layers were sometimes woven separately, and then attached to the basic square but others were worked by adding additional warps and were woven in place in the tapestry, with the warp ends then being passed through to the back, sometimes to reappear and be re-warped further up the tapestry again. Yet other pieces were woven beyond the top of a tapestry, or at the side and folded back over it and attached before it was cut off. Often the warps were pulled to curve or shape the pieces, produce the 'wrinkled paint' surfaces, or make the edges stand up; and, unusually, various woollen warps were used to match the surface colours. I do not think a whole image of the total group was available when the weaving was in progress: single transparencies arrived as needed, so no attempt was made to relate one to another. The designer wanted

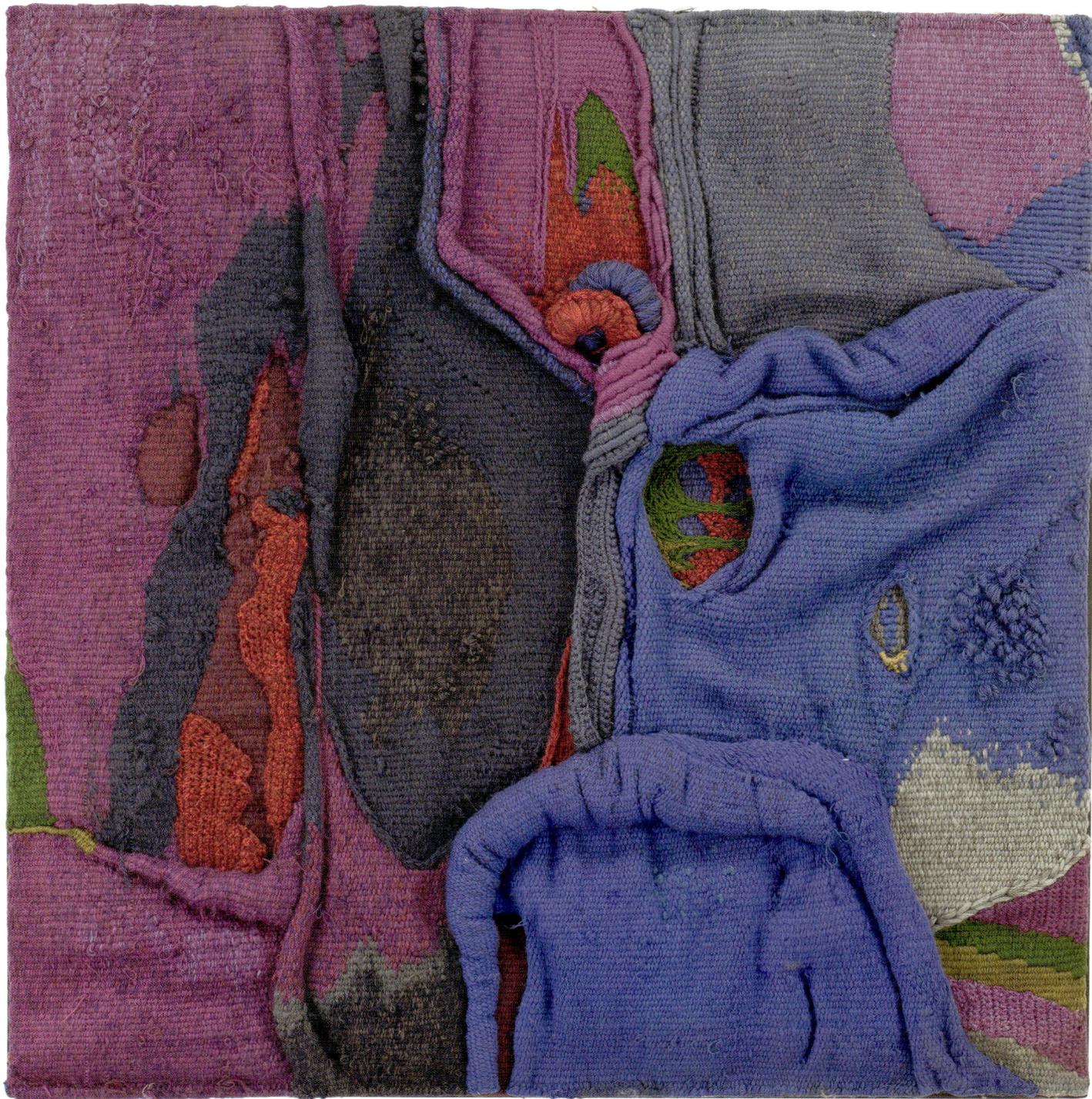

to be able to change the order of them on the wall. In retrospect I think these panels were very much of their time, but the information gained on this project would prove invaluable when it came to the later (and much more restrained) series of Louise Nevelson tapestries.

Maureen Hodge
Weaver 1964–73
Head of Tapestry Department, latterly Intermedia, Edinburgh College of Art 1973–2006

The Bernat Klein tapestries were mainly woven by Maureen Hodge and Ellen Lenvik, although Neil McDonald and I did weave one. As the paintings had many layers, so too did the tapestries. The weaving called on every skill and technique in the weavers' vocabulary. A background was started and as the design was worked, new and often coloured warps were inserted into the background and a new layer or fold created. Slits, knots, embroidery knitting and braiding were all used alongside the weaving to create the sculptural quality that the design required.

Douglas Grierson
Weaver 1961–2011, Studio Manager 1994–2000, Head Weaver 2000–11

I find this piece constantly thought-provoking in that it marks a point of self-interrogation within the tapestry medium about the limits of representation, technique and ultimately the purpose and scope of tapestry weaving.

The tapestry translates the sculptural forms of thickly applied paint into an expanded range of weaving techniques and can be aligned with wider innovations in fibre arts which were made in the 1970s. The relationship of painted designs to woven tapestry has an unstable history: from the exacting imitation of oil paint in the eighteenth century, to the revival of medieval weaving styles at the start of Dovecot's history, on to woven interpretations of the work of abstract expressionist painters and then to this tapestry.

The question is still how to make best use of tapestry's unique properties whilst retaining the character of a design made in another medium.

The debate about the preferred approach to design and interpretation carries on within the mind of the weaver and between colleagues. The styles change over the years and with each move there is the risk of losing the knowledge and skills of the style which falls from favour, balanced by the possibility of finding new life within the medium.

Jonathan Cleaver
Weaver 2008–

Several members of the Dovecot team were involved in these experimental pieces. The character, techniques employed, approach and style of each tapestry vary slightly, depending on the weaver. The colourways of the woven tweeds and textiles that Klein's own Galashiels mill produced were also informed by these paintings. His 1940s Bezalel Art School training in Jerusalem was shaped by his Bauhaus-trained German weaving tutor. Arguably, it's this anti-hierarchical approach to fine and applied arts that informed Klein's approach to colour and design. The original paintings on which the tapestries are based use thickly applied oils, blocks and facets of pure colours; he describes spending a long time mixing colour to get the exact shades for the base, its balancing or contrasting colour depending on the nature of the experiment.

In the 1970s Klein's colour experiments were used as patterns for vividly coloured Diolen fabrics; again the abstract splodges and scrapes of the paintings were the inspiration and reference for the printed patterns. In other experiments he has used the coloured tweeds and polyesters as a canvas, painting new harmonies and oppositions over the existing colours. It seems like a strange circular activity where the paint was applied to the textile that had been inspired by the paint.

Gráinne Rice
2012 Project Manager, Dovecot Studios 2011–

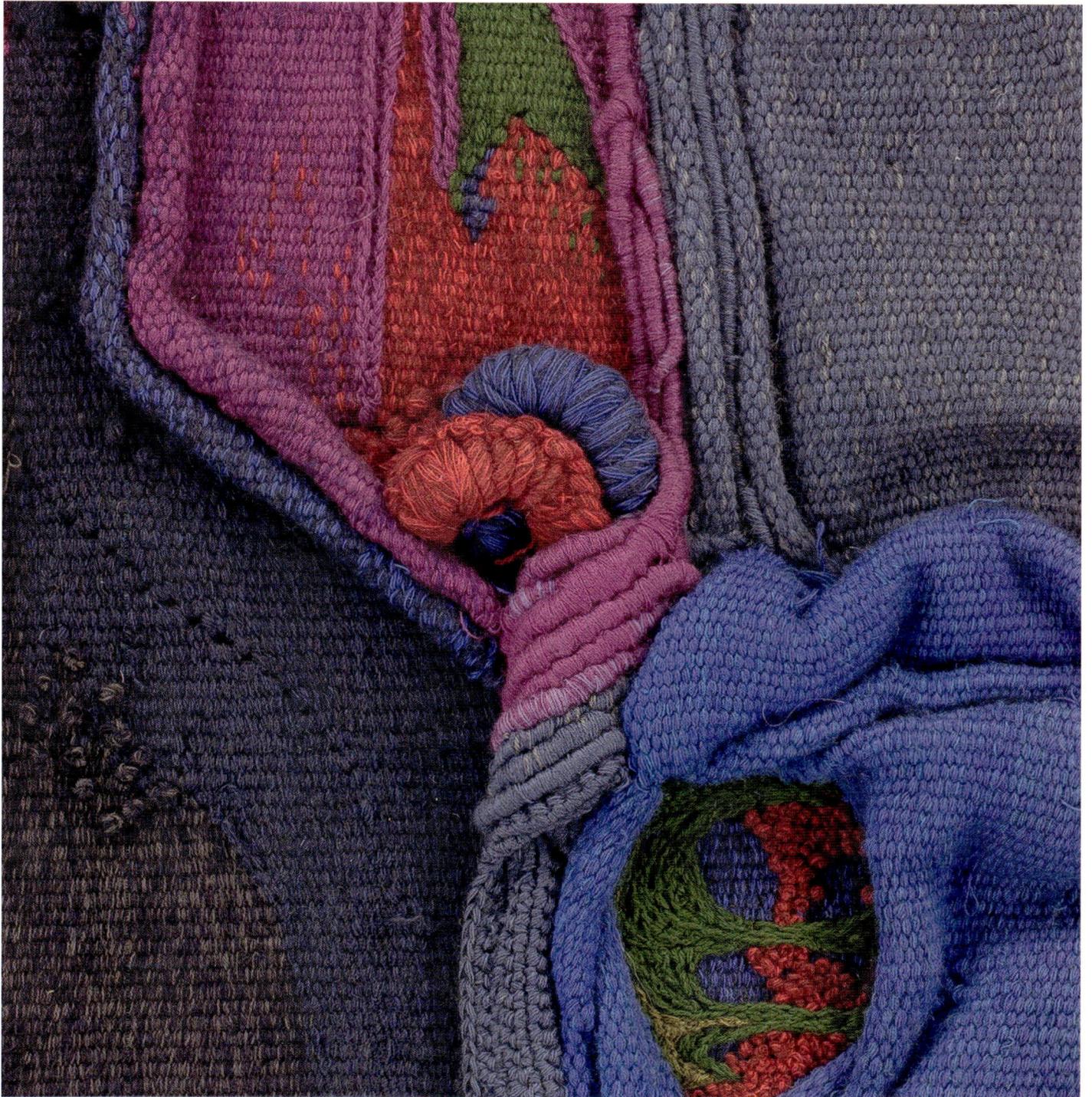

Plate 13

TOM PHILLIPS

AFTER BENCHES 1973

Cotton warp, wool
152.4 × 304.9 cm (60 × 120 in)
The Artist
Weavers: Douglas Grierson, Fred Mann,
Neil McDonald, Jean Taylor

After Benches was my initiation into the world of tapestry and the beginning of an association with Dovecot and Archie Brennan. The picture derives from a postcard of Battersea Park via a painting now in the Tate. My chief pleasure in the project was to find a way of working with the weavers rather than to use them as highly skilled copyists. Thus the tapestry was divided into four sections, the weaver of each having decided on a strategy of transcription mirroring the different modes of colour printing. Their invention gives the whole image a revelatory liveliness which still excites me when I see it.

The coloured bands across the top and bottom represented the various colours of wool that were used. We expanded this idea later in a long fabric which catalogued the colours used by the whole workshop over a period.

Tom Phillips

I met Tom at his London studio as a result of his contacting Dovecot with an interest in extending his ongoing series *After Benches* into tapestry. Even before we met I had been intrigued by this series – a picture postcard that had become a painting that became a screenprint that became a poster for his one-man exhibition in Paris.

Here was an artist who was asking Dovecot to be involved in an open creative journey! My only question was 'involved – how – by him and by me?' In a day or two my proposal was to have the four likely weavers – Harry, Fred, Douglas and myself – each independently seeking a personal approach to the manner of handling one quarter of a 10-foot-long [3-metre] journey, with one weaver at a time guiding the others in the manner of treating his 30 inches [76 cm]. My belief was that the power of the linear image, now based on the poster, would hold it visually together. Tom leapt at the risk and began regular visits, eager to join in this unknown journey up the warp.

For technical reasons the tapestry was woven sideways – not an unusual event. It grew at about 10 square feet [1 square metre] each week, with each weaver in turn leading his colleagues through his section. It was a breath-holding, delightful journey. A journey that subsequently led to a group of even more adventurous tapestries, planned (but in an open, seemingly unplanned approach) by Tom. It was an exhilarating period. We had discovered a more open-minded manner of thinking.

It is important that I write of another great collaboration here, with the late Eduardo Paolozzi who, over some 25 years from 1967, played such a huge role in stimulating Dovecot production. This was a time when the two guiding and so generous directors, John

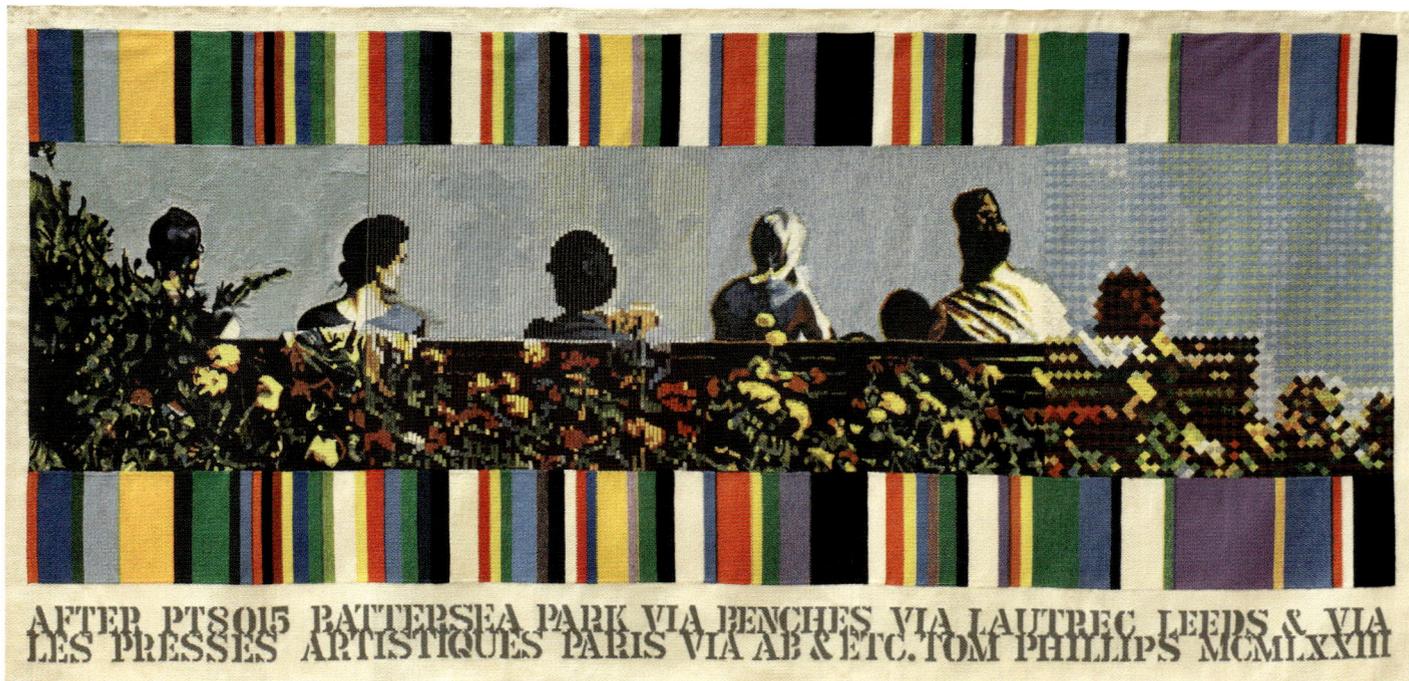

AFTER PTSO15 BATTERSEA PARK VIA BENCHES VIA LAUTREC LEEDS & VIA LES PRESSES ARTISTIQUES PARIS VIA AB & ETC. TOM PHILLIPS MCMLXXIII

Noble and Harry Jefferson Barnes, gave the staff such sensitive yet open support.
Archie Brennan
Weaver 1948–53, Artistic Director 1963–78

Tom Phillips' design originated in his extensive collection of postcards which are now in the Bodleian Library. The postcard went through various processes to arrive at the final image, and indeed the idea was to develop the process throughout the weaving. The tapestry was to be sectioned into four parts, each to be woven in a different manner. At this time the development of a tapestry from an artwork was brought into sharp focus. Not all artists were interested in this, but Tom welcomed this opportunity to explore.

Tom's *Complete Colour Catalogue* is a good example of this experimental approach. The colours being used across the studio over a given period were woven into a colour strip, with the throw of dice to determine the thickness of each band. This approach was immediately followed up in *After Benches*. Fred Mann wove the first section straight from the artwork, the rest of the tapestry was put through a system of lines, dots and diamonds. This for me was an enjoyable experience – not only because I wove two sections, but also since it brought home to me how the strength and visual quality of the image can be enhanced by exploring the language of weaving.
Douglas Grierson
Weaver 1961–2011, Studio Manager 1994–2000, Head Weaver 2000–11

Plate 14

JEAN DUBUFFET

UNTITLED (WITH PERSONNAGE) 1974

Cotton warp, wool
Two parts
111.8 × 53.3, 182.9 × 310 cm (44 × 21, 72 × 122 in)
Minneapolis Institute of Arts
Weavers: Gordon Brennan, Douglas Grierson,
Fred Mann

One of France's most famous painters and sculptors during the second half of the twentieth century, Jean Dubuffet often made up new words and concepts for his creations. The stylised figures of *L'Hour'loupe* became one series that he explored from the 1960s to 1974. These enigmatic tri-colour forms, in part designed as inhabitants for the artist's fanciful sculpted landscapes, reflect Dubuffet's quirky sense of humour and philosophy. Toward the end of this period, Gloria Ross and the Dovecot partnered with the artist and his New York representative, Pace Gallery, to create a large shaped tapestry onto which a separately woven life-sized figure was to be positioned.

The models for background and 'personnage' were experimental 1971 paintings in acrylic on a pliable background called *Klégécell*, and so Dubuffet had originally envisioned these designs in a flexible medium, although not in tapestry *per se*. In an extremely rare move for any tapestry orchestrated by Ross, the tapestries were woven smaller than the original models, which measured 115 by 160 inches and 74 by 38 inches [292.1 by 406.4 cm and 188 by 96.5 cm]. Before being shipped to New York, the handwoven figure, which stood just under four feet [1.2 metres] tall, became a studio mascot with many pet names besides 'personnage' such as 'Mini Dubuffet', 'Little Fellow',

'Wee Man', 'The Funny Man', 'Dubuffetino', and 'Dubuffet petit'.
Ann Lane Hedlund
Director, The Gloria F. Ross Tapestry Program
Arizona State Museum
University of Arizona
Tucson, Arizona

Through the 1970s Dovecot had an arrangement with Gloria F. Ross, a very active tapestry enthusiast from New York City. She was effectively our American agent, and Dovecot wove tapestries for her, based on paintings or tapestry designs prepared by eight well-established New York-based artists.

We were normally required to carry out an edition of seven tapestries. This was not our preference, but it did give Dovecot a degree of economic stability. There were two exceptions to this, however. We wove a set of seven 'unique' tapestries based on paper collage designs by Louise Nevelson. It was a fascinating collaboration that generated much planning, creative construction and involvement between us.

The other 'unique' project was the Dubuffet tapestry, and along with the Nevelsons this was arguably a favourite of all the New York works. We were told that there would be strictly no available direct

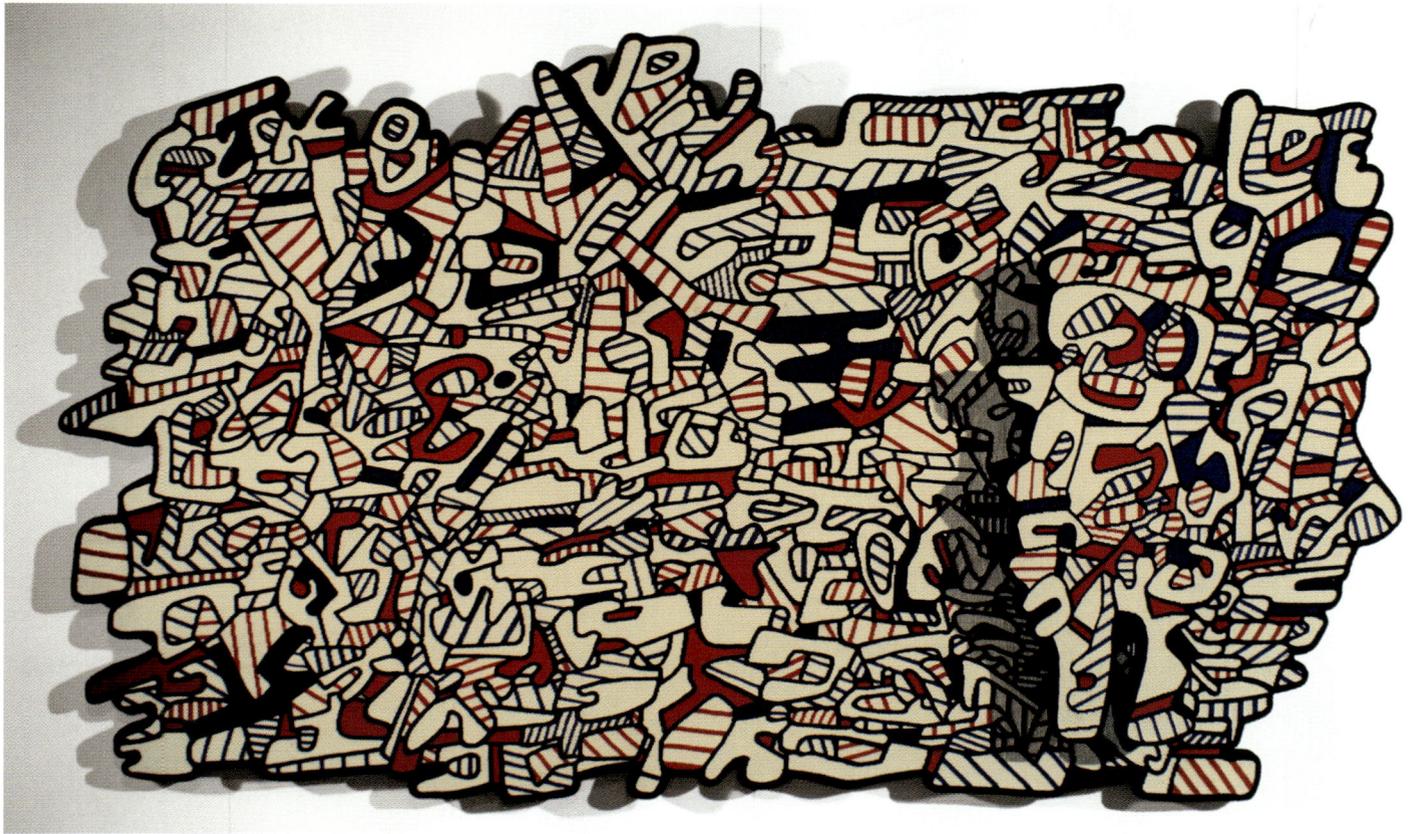

communication with Dubuffet, and Gloria brought his two-part design over to Scotland. The main panel was a meandering jigsaw-like shaped rectangle upon which were marked three possible locations for attaching the figure, the 'personnage', to the front. This was also a jigsaw-like shape. It was clear that, once woven, both these tapestry parts had to be physically supported. After discussion with Gloria we opted for similarly shaped thick plywood backing boards. In fact many complex and inventive technical decisions had to be made. It had been a stimulating project, and Douglas, myself and the others were very content with the result. It was packed and shipped off to New York City.

There was an unusually long silence. Later I was over there concerning other business and an apologetic Gloria told me that Dubuffet was dissatisfied with the result and he wanted the work destroyed! But there were some odd things. Gloria had retained the 'personnage'. Later it emerged that Gloria had been dealing through Pace Gallery, not Dubuffet; that one of the major tapestry studios in France had also woven a version; that the Fondation Dubuffet had somehow been involved; and that Dubuffet had now seen the Dovecot version and preferred it by far to all the other versions, including the tufted ones. He found the Dovecot white too yellow and it seemed somehow that a second version of the Dovecot 'personnage' was now in the Minneapolis Institute of Arts!

So what Dubuffet actually ever saw, how many versions were ever made, and whatever happened to our version, I have no idea. There is one thing, however, for sure. When an artwork disappears, it begins to improve, and it gets better and better and better, until one day it is found …
Archie Brennan
Weaver 1948–53, Artistic Director 1963–78

This, a favourite tapestry from 'the Gloria Ross period', has a modern jazzy style and it was I think the first major piece to be woven at the studio as a free shape, away from the confines of the rectangular format.

We did a pilot tapestry of the small 'personnage' figure, to be just over three feet [about a metre] high. It was woven in wool, but there seemed to be an issue between Archie and Gloria over the materials. When we started on the main tapestry, the white areas were changed from wool to a bright, white linen. I preferred this because it gave a sharp appearance that is not often achievable in tapestry. We would thin down the woollen weft colours of blue and red where they met the white linen background, again to sharpen the image. The weaving was fairly straightforward although we had to weave under the outside edge to support the shape. When the tapestry was finished, this weaving was discarded.

Some time later we heard through Gloria that Dubuffet did not like the tapestry and dumped it in his garage. However, the tapestry is mentioned in his book where he wrote that he thought it a success. Unfortunately we did not weave another.
Douglas Grierson
Weaver 1961–2011, Studio Manager 1994–2000, Head Weaver 2000–11

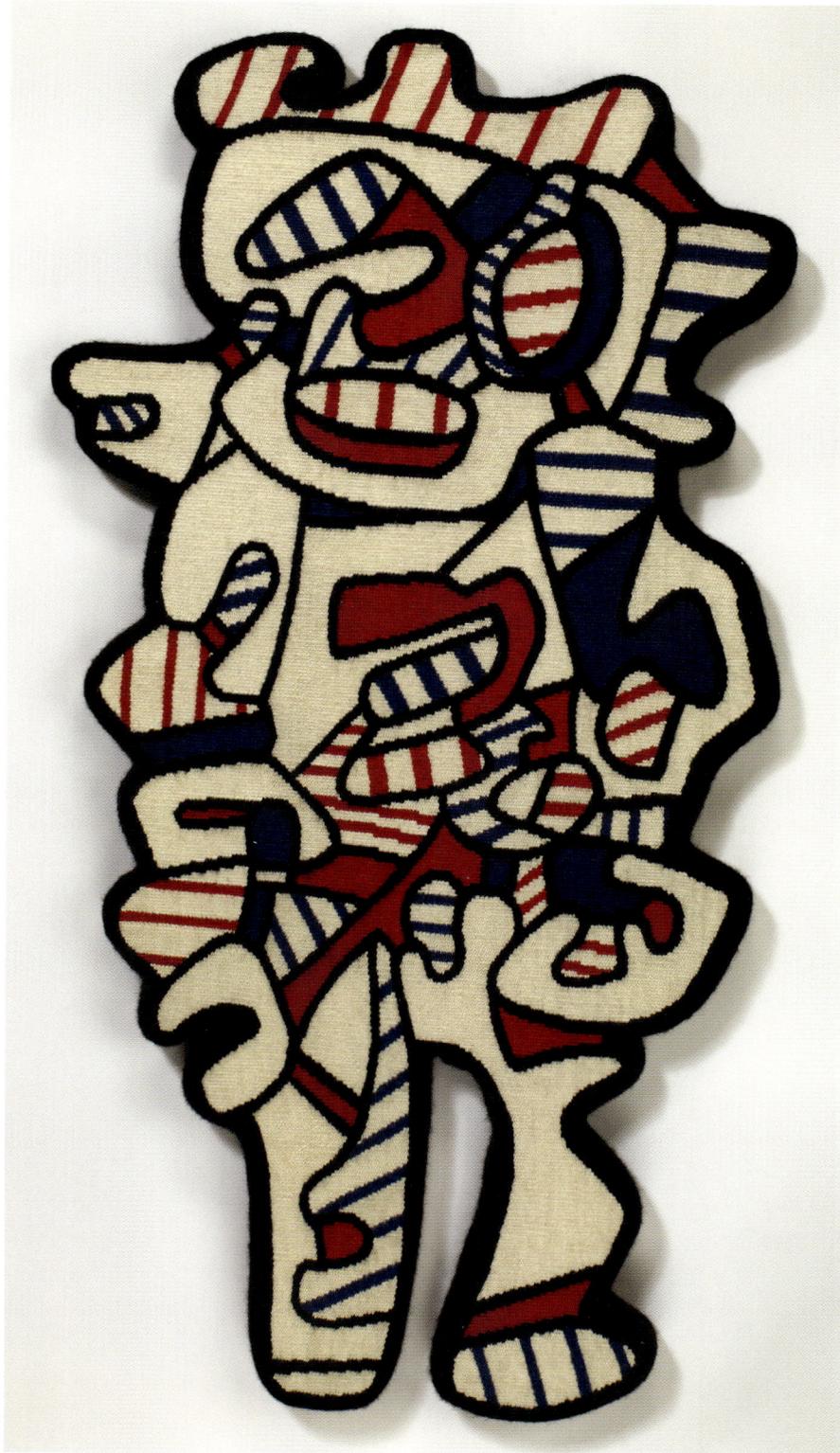

Plate 15

LOUISE NEVELSON

SKY CATHEDRAL II 1974

Cotton warp, wool
223.5 × 177.8 cm (88 × 70 in)
Teleflex Incorporated
Weavers: Gordon Brennan, Fiona Mathison,
Neil McDonald, Jean Taylor

The Ukraine-born American sculptor Louise Nevelson described herself as 'an architect of shadows'. Her monumental and monochromatic constructions of starkly painted wood gained international recognition during the twentieth century. Between 1972 and 1980, she designed nine tapestries specifically for Gloria Ross, who decided to have them woven in Edinburgh.

The earliest two were woven from the same maquette, a series of small grey lead intaglio reliefs each measuring 29 by 23½ inches [73.7 by 59.7 cm] and bonded to cream-coloured paper to form a larger asymmetrical patchwork, and yet the results for the tapestries were radically different. The non-editioned *Sky Cathedral I* has a solid black wool background with crinkled gold-coloured metallic threads forming the relief areas. For *Sky Cathedral II*, Archie Brennan and Dovecot's weavers created a dark blue wool and mohair background and used an array of cream and tan yarns in wool, cotton and linen for the relief patterns. The relief textures were interpreted using intriguing two-colour 'pick-and-pick' and diagonal float weaves. Following *Sky Cathedral*, Nevelson designed, and Dovecot wove, seven additional pieces, all from small purpose-made cardboard collages created expressly for the unique tapestries.
Ann Lane Hedlund
Director, The Gloria F. Ross Tapestry Program

Arizona State Museum
University of Arizona, Tucson, Arizona

The development of an artist's maquette into a final woven interpretation is fascinating and in the case of *Sky Cathedral* particularly well documented. The first samples for Nevelson's small, lead maquette were made by Maureen Hodge and were woven using only a grey hair yarn as both warp and weft. She employed a variety of knotting and weaving techniques to create surfaces which echoed Nevelson's maquettes, but on a much greater scale. These innovative and exciting samples were rejected by Gloria Ross who asked that the work be made instead in black and gold. Samples were made and agreed and the tapestry woven in 1972, nicknamed 'Woolies at Christmas' by the weavers [a reference to the seasonal displays at F. W. Woolworth stores]. It was titled *Sky Cathedral I*, but the artist withheld permission to have more woven as she felt it was too much a 'Gloria Ross tapestry' and asked that new samples be made and agreed by her.

I had been weaving at Dovecot over my college holidays, both in my final years at Edinburgh College of Art and during my Master's at the Royal College of Art. To be asked to do the samples for this tapestry was indeed an honour. The background colour was a deep rich blue, with the imprinted lead collage

creating an area of lighter tones within it. Using mainly cotton warp of different thicknesses, and a variety of knots and techniques borrowed from cloth weaving, I made a sample strip that echoed the grainy wood marks of the lead maquette. Additional weft threads of grey were used to throw out the pattern of the wood grain, making the translation part graphical, part textural. The samples were discussed and agreed with Archie and then presented to and accepted by Louise Nevelson and Gloria Ross. They became the basis for the interpretation for *Sky Cathedral II*, an edition of tapestries begun in 1974.

When Archie formally quit the Dovecot in the spring of 1978, and left me with the daunting task of taking over as artistic director, Gloria was initially hesitant about continuing to work with the Studios. The success of *Sky Cathedral II* helped in continuing that good working relationship. Although the set of Nevelson 'uniques' had been discussed and begun with Archie, many of the set were made after he had left. A number were interpreted through the ingenuity and inventiveness of weaver Jean Taylor.

Fiona Mathison
Weaver 1969–74, Artistic Director 1978–82, Artistic Consultant 1982–4
Lecturer, Tapestry Department, latterly Intermedia, Edinburgh College of Art 1974–2010

We completed a sensitive interpretation of Louise Nevelson's work, entitled *Sky Cathedral II*, after producing a number of practice pieces and agreeing the results with the artist.

Various grades of white cotton warp were used as weft, in conjunction with a natural soft fibre, mohair, to explore Nevelson's maquette, a collage of lead intaglio prints. Subtle changes were made in the weaving of each of the separate interpretations within this tapestry to emphasise tone and texture. The variations were achieved through the use of several weaving techniques and the materials. Pattern and twills were created

to enhance surface textures, empathising with the embossed quality of the maquette. The entire panel was finished with a woven ground of deep-royal-blue fine Cheviot wool.

Many of Louise Nevelson's artworks were catalogued with only a number. If they were then further developed in some way, and she was satisfied with the result, she would give them a title, and *Sky Cathedral II* was one of these works.

Jean Taylor
Weaver 1972–81

Plate 16

JOHN PIPER

THE FIVE GATES OF LONDON 1974–5 (DETAILS)

Cotton warp, wool
244 × 914.5 cm (96 × 360 in)
Guildhall Art Gallery, London
Weavers: Douglas Grierson, Fred Mann

Commissioned in 1974 by the Sedgwick Forbes insurance company, Piper's design drew its inspiration from the firm's location in the City of London. His iconic paintings of Coventry Cathedral during the Second World War and the city of Bath, had cemented his reputation as a topographical painter. Of the five gates depicted (Aldgate, Bishopsgate, Moorgate, Temple Bar and Kingsgate), only Temple Bar remains standing, albeit now removed from its original context. Piper studied the historic print collection at the Guildhall Print Room (where the tapestry now hangs) to ensure the gates were truthfully represented.

The long landscape format of the tapestry, and its inherently soft, malleable texture, evoke theatre backdrops. Piper's design is Italianate and operatic in style; he had worked as a set designer on numerous operas and ballets, including *Don Giovanni* at Glyndebourne in 1950.

Francesca Baseby
Dovecot Gallery Manager 2008–10
Edinburgh University / Dovecot AHRC Collaborative
Doctoral Student 2010–

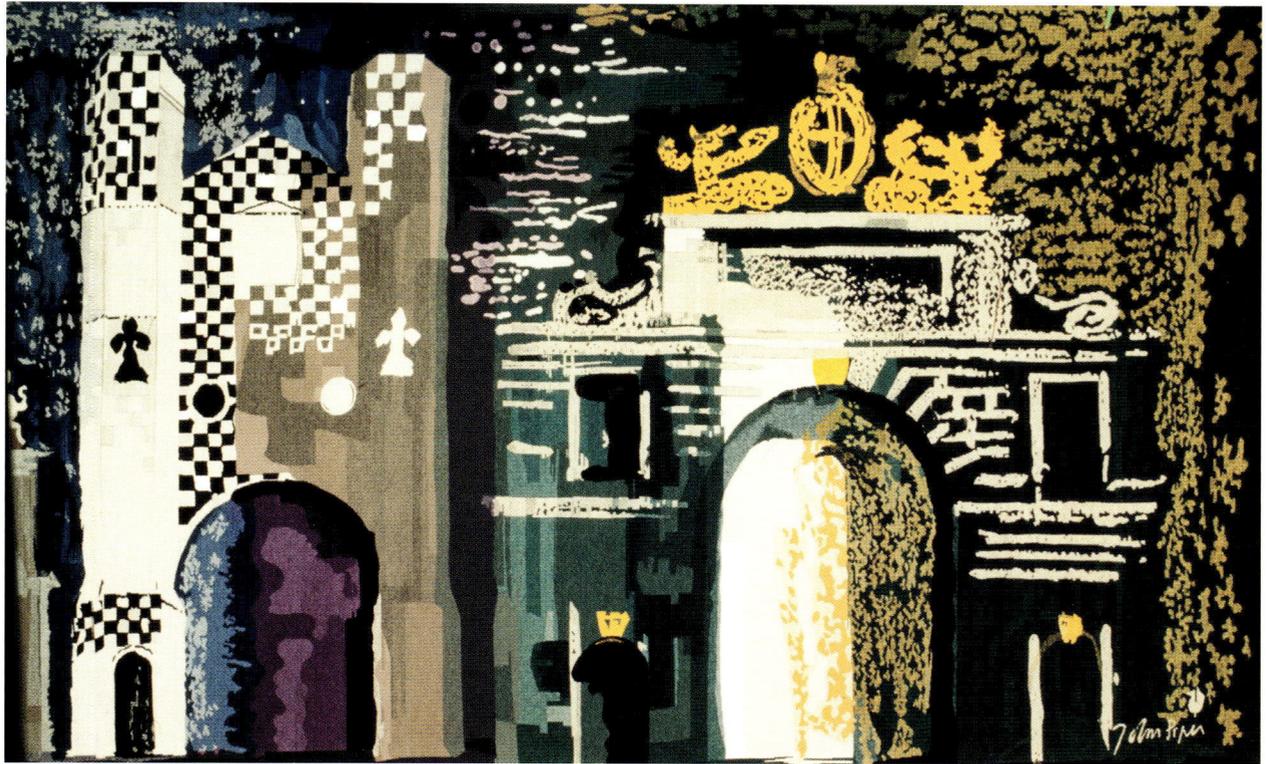

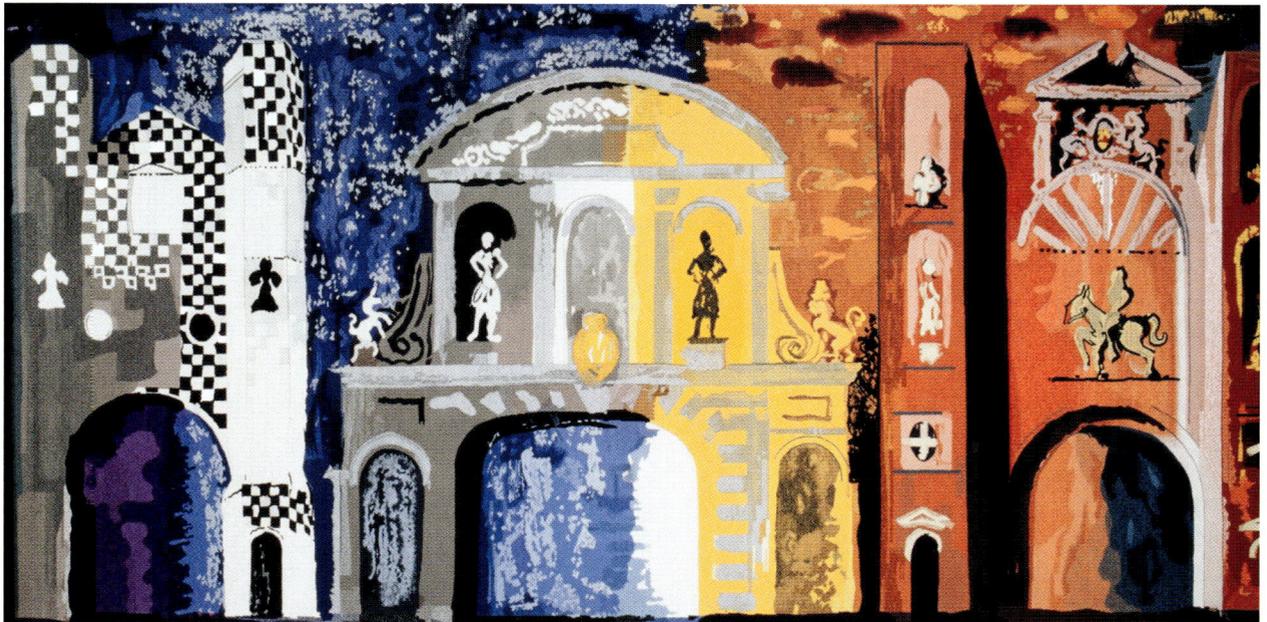

Plate 17

TOM PHILLIPS

SUITE OF SIX TAPESTRIES FOR ST CATHERINE'S COLLEGE, UNIVERSITY OF OXFORD 1978–81

Cotton warp, wool
Three sizes of tapestry
442 × 221 cm; 240 × 213 cm; 300 × 213 cm
(174 × 87 in; 94½ × 83¾ in; 118 × 83¾ in)
St Catherine's College, University of Oxford
Weavers: Gordon Brennan, Douglas Grierson,
Shirley Gatt, Fred Mann, Fiona Mathison, Jean Taylor,
Janette Wilson, Annie Wright, Harry Wright,
Johnny Wright

Arne Jacobsen's St Catherine's College was designed as a complete work of art, encompassing a vision well beyond existing 1950s practice. While the buildings have resisted extensive artistic embellishment, Tom Phillips' tapestries represent a beautiful and complementary addition to Oxford's largest dining hall. Giant concrete beams sweep the breadth of the Hall, enhancing its voluminous grandeur. The desire to add a little warmth prompted the Fellowship to commission Tom to produce pieces which have added considerable colour and character.

Yet they add much more than a splash of colour and succeed in communicating both the values at the very heart of our institution and the wider University of Oxford. In combining the mottos of the University, *Dominus Illuminatio Mea* ('The Lord is my Light'), with that of our College, *Nova et Vetera* ('The New and the Old'), Tom's tapestries are a daily reminder of the vitality and dynamism of a College also celebrating an important anniversary in 2012, and of the way we have advanced within an ancient tradition. Similarly, his

fragmented Catherine wheels are an apt tribute to one of Oxford's youngest Colleges and the extent to which our students, Fellows and alumni explosively expand existing boundaries of knowledge.

When Alan Bullock, our Founding Master, commissioned the pieces in 1977 he insisted that 'in years to come, when people look at these tapestries, they will approve the decision and say that we were right not to take too short or narrow a view of what a college represents'. Thirty years on, I am delighted to affirm the accuracy of that prediction, and to voice real pride in their timeless ability to express so beautifully the spirit of St Catherine's.
Professor Roger Ainsworth
Master, St Catherine's College, University of Oxford

Designing the tapestries for the Dining Hall of St Catherine's College Oxford was my first large-scale public commission. The huge hall was dauntingly severe and needed both enlivening of colour and softening of texture. The motifs were taken from the Ordeal of St

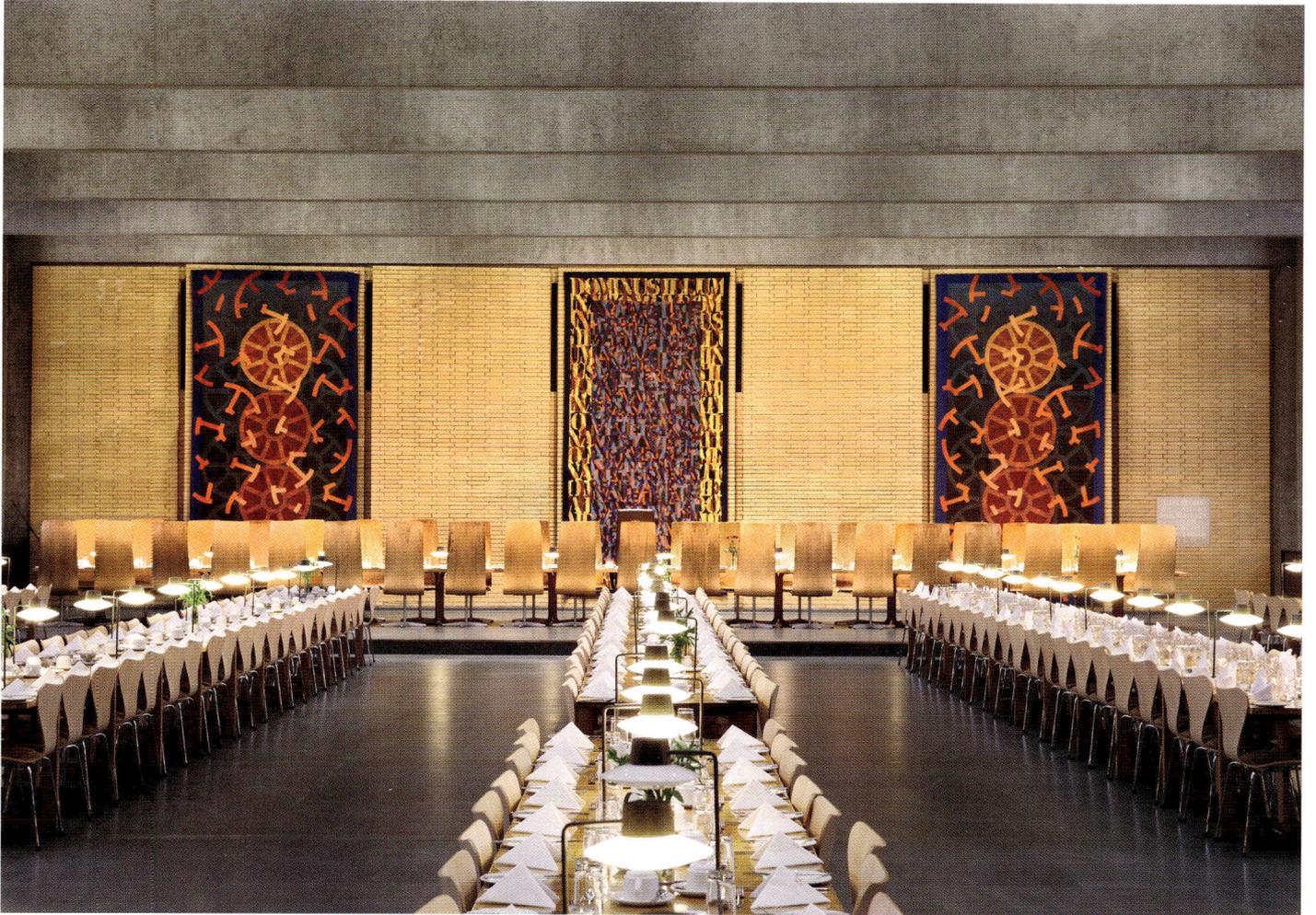

Catherine who was meant to perish on the wheel, but instead she caused it to explode and free her. The centre tapestry incorporates the motto of the college (*Nova et Vetera*) with that of the university (*Dominus Illuminatio Mea*) using their respective heraldic colours. Three smaller tapestries involving the same texts decorate the rear wall of the hall in the manner of pennants. The whole project took many months in making the cartoons, and involved many trips to Edinburgh where I learned some of the subtleties of the weaver's art and was given a free hand in the mixing of wool, a process as difficult and intriguing as making colours in my studio.

The other two adventures in tapestry that made up my enriching association with Edinburgh Tapestry Company were a wall hanging for Morgan Grenfell and a reworking in wool, in 1986, of a picture I had done for my book of Dante's *Inferno* embodying his opening image of a dark wood (*Una Selva Oscura*) (fig.51). Here the subtleties of colour obtainable in wool mixtures were more evocative of nature than any I had found in printmaking. The wood became dark in an autumnal rather than in a nocturnal mood, just right for Dante's image.

Tom Phillips

Feast and famine is the norm in tapestry studios, and the famine that existed in the order books in 1978 was suddenly reversed a year later when two orders, each for three large panels, began the process of finalisation. It became a rush for loom space for Glasgow Cathedral and St Catherine's College commissions, with the first on the loom the first to be completed.

The studios were desperate to start the work, so the loom was warped in preparation for the first of the side panels, and a watercolour design which had been left at Dovecot several years earlier was looked out and the colours selected. In the eagerness to realise the project, both artist and studio agreed that the weaving of one of the two side panels should begin as soon as possible, as this would cut down on the to-ing and fro-ing of small woven samples. Two weeks and a foot [30 cm] of

weaving across the loom later, Tom Phillips visited the studio to see the work. His disappointment was palpable; the intensity of colour he expected to see was not there. There was only one decision possible, everyone in the studio agreed that, and half an hour later, to his astonishment, the work on the loom was being undone while Tom selected a new set of colours, ably assisted by calm and steady master weaver Douglas Grierson. Establishing a tapestry at the start of a project always takes time – the first third of a project takes as long as the other two thirds – but this was a dramatic move. Getting it right is always the priority. By the end of that day artist, artistic director and weavers were all very relieved, even elated, and the tapestries established that day went on to be enormously successful, a stunning set of six rather than the original plan for three.

Tom is a highly intelligent, positive and generous artist to work with, and the dialogue that developed with the studios resulted in the work *Una Selva Oscura* being agreed as the tapestry woven during the 1980 'Master Weavers' exhibition. This work was developed from an illustration for a volume of Dante's *Inferno* translated and illustrated by the artist: Phillips is a real Renaissance man. The deep and subtle palette of colours for this work was arrived at, indeed almost sensed, through an understanding that comes from conversations about ideas between artist and weavers.

Fiona Mathison
Weaver 1969–74, Artistic Director 1978–82, Artistic Consultant 1982–4
Lecturer, Tapestry Department, latterly Intermedia, Edinburgh College of Art 1974–2010

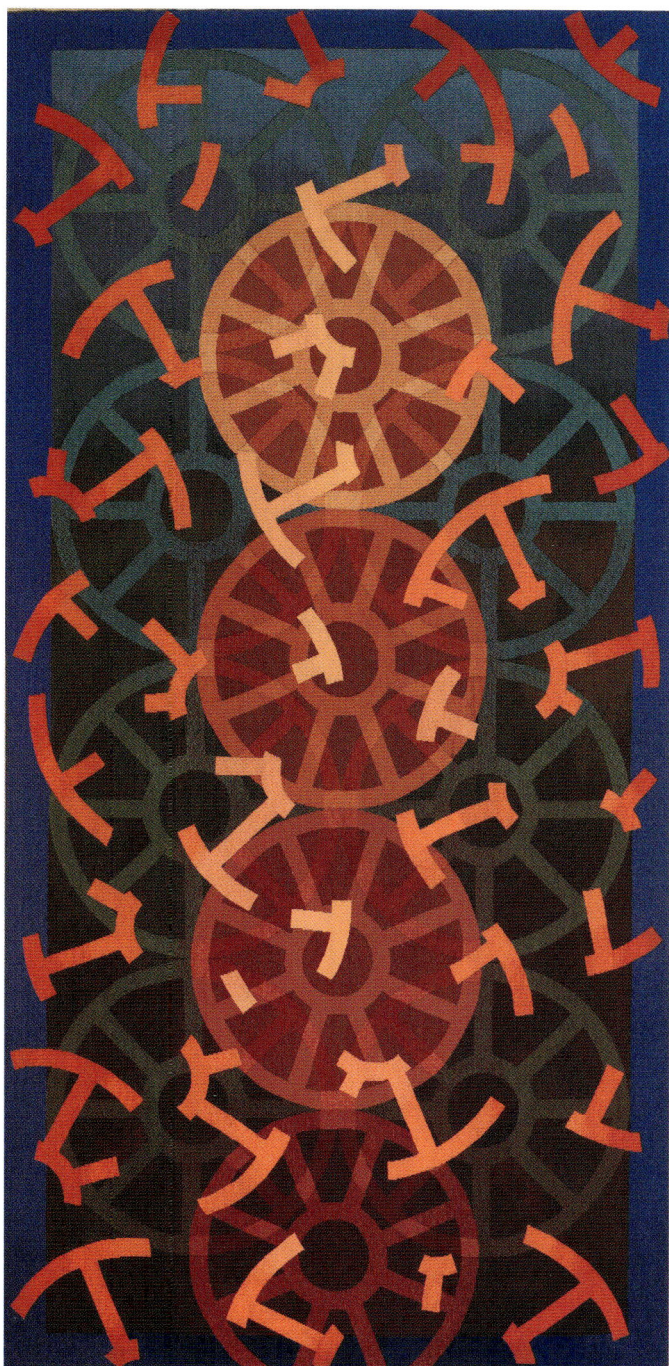

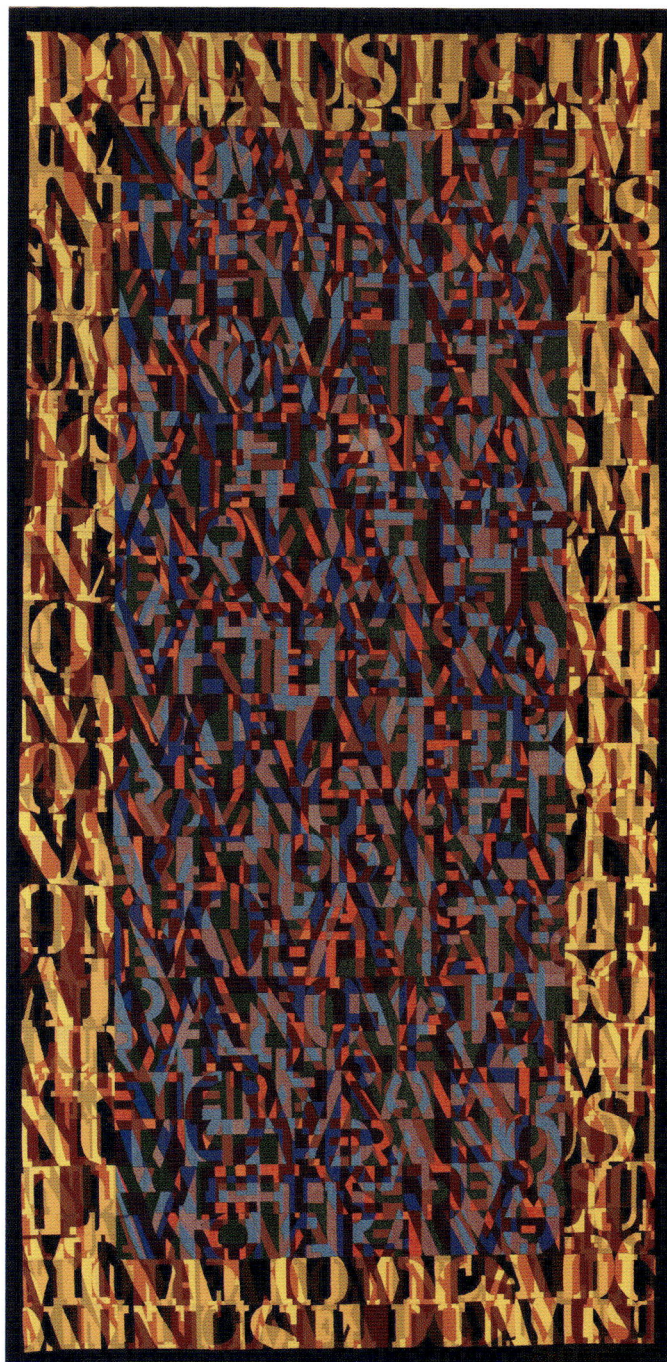

Plate 18

ELIZABETH BLACKADDER

EASTERN STILL LIFE 1980

Cotton warp, wool
142.2 × 213.2 cm (56 × 84 in)
UK Government Art Collection
Weavers: Jean Taylor, Annie Wright, Johnny Wright

In 1980, as Dovecot's 'Master Weavers' exhibition was approaching, it was decided that some works should be made speculatively to showcase the artists Dovecot worked with. Elizabeth Blackadder had already worked with the studio, but some years earlier. The process of selecting a work for weaving was a dialogue between artist and artistic director. Elizabeth had been making a number of watercolour paintings at that time, based on the objects she collected from her journeys to Japan and the Far East. These objects themselves were often woven constructions and brightly coloured. She painted the objects, adding them to the paper consecutively to form the composition. We looked through a few paintings and were both excited about the idea of interpreting a work on Japanese paper, a more fibrous material than standard watercolour paper. *Eastern Still Life* was a work in progress at that time, and many of the objects already painted within it would allow more experimental approaches in the translation.

As a watercolour, it would be mounted and framed; with tapestry however, the composition has to work within itself, there is no frame unless it is integral. With characteristic enthusiasm and openness Elizabeth offered to bear this in mind while completing the work, which she did almost immediately. The resulting tapestry had many intriguing solutions in its translation and was sold soon after it was exhibited.

Fiona Mathison
Weaver 1969–74, Artistic Director 1978–82, Artistic Consultant 1982–4
Lecturer, Tapestry Department, latterly Intermedia, Edinburgh College of Art 1974–2010

Plate 19

ARCHIE BRENNAN

AT A WINDOW VII (ALSO KNOWN AS THE SPOTTED DRESS)

1980

Cotton warp, wool
213.4 × 152.4 cm (84 × 60 in)
Victoria & Albert Museum
Weavers: Douglas Grierson, Jean Taylor, Annie Wright,
Harry Wright, Johnny Wright

This is the seventh of an ongoing series I call *At a Window*. Of these, four were woven by Dovecot, the others independently by myself. They all begin by contradicting the traditional view that tapestry should respect the wall and avoid making a 'hole', and emphasising that tapestry – with its unique textile presence – is explored and exploited to advantage by the interplay of assembling diverse textiles in an illusionary setting. It is just one of a number of series to explore values embedded in this uniquely creative medium.

The origins of what has over the course of 38 years become an ongoing obsession began when, as a postgraduate student, I was visiting London museums. As a tapestry maker I had long been disenchanted by the consistent use of a technique expressing form, light and shade in everything from drapery to shadows, highlights and so on. It is a sophisticated weaving process evolved over many centuries, known as hatching. However at the V&A, when examining the wonderful set of four huge mural works known as the Devonshire Hunting Tapestries, I noticed how the weavers in the sixteenth century had employed a technique of describing the form of a young man's shoulder garment by adjusting the pattern of dots on

the textile there. Further study showed this approach was employed with variations on the clothing of a number of the many personages across these tapestries, and I realised at once how I might transpose extensions of such thinking to my tapestries at that time.

A door had opened that still generates questions and new possibilities.
Archie Brennan
Weaver 1948–53, Artistic Director 1963–78

I have always been drawn to this tapestry. I like the attention to drawing and its geometric content which is well suited to tapestry. The design has many references to textiles and pattern, the rug and curtains being classic, traditional patterns and the spotty dress giving a more contemporary feel. The entire body is sculpted by the spots on the dress and the clever use of shading sculpts the folds of the fabrics, giving depth to the design. The tapestry incorporates many traditional patterns yet the overall feeling is of a modern design. I like the concept of woven fabrics being rewoven.

Archie Brennan is known to be colour-blind, which I believe contributed to his working in tones of black, grey and white. This seems to emphasise the design elements and weaving techniques. I think most of the technical issues would have been worked out at the beginning of the tapestry along with the colour and tones. This would not have left much interpretation during the weaving for the individual weavers.
Naomi Robertson
Weaver 1990–98, 2003–

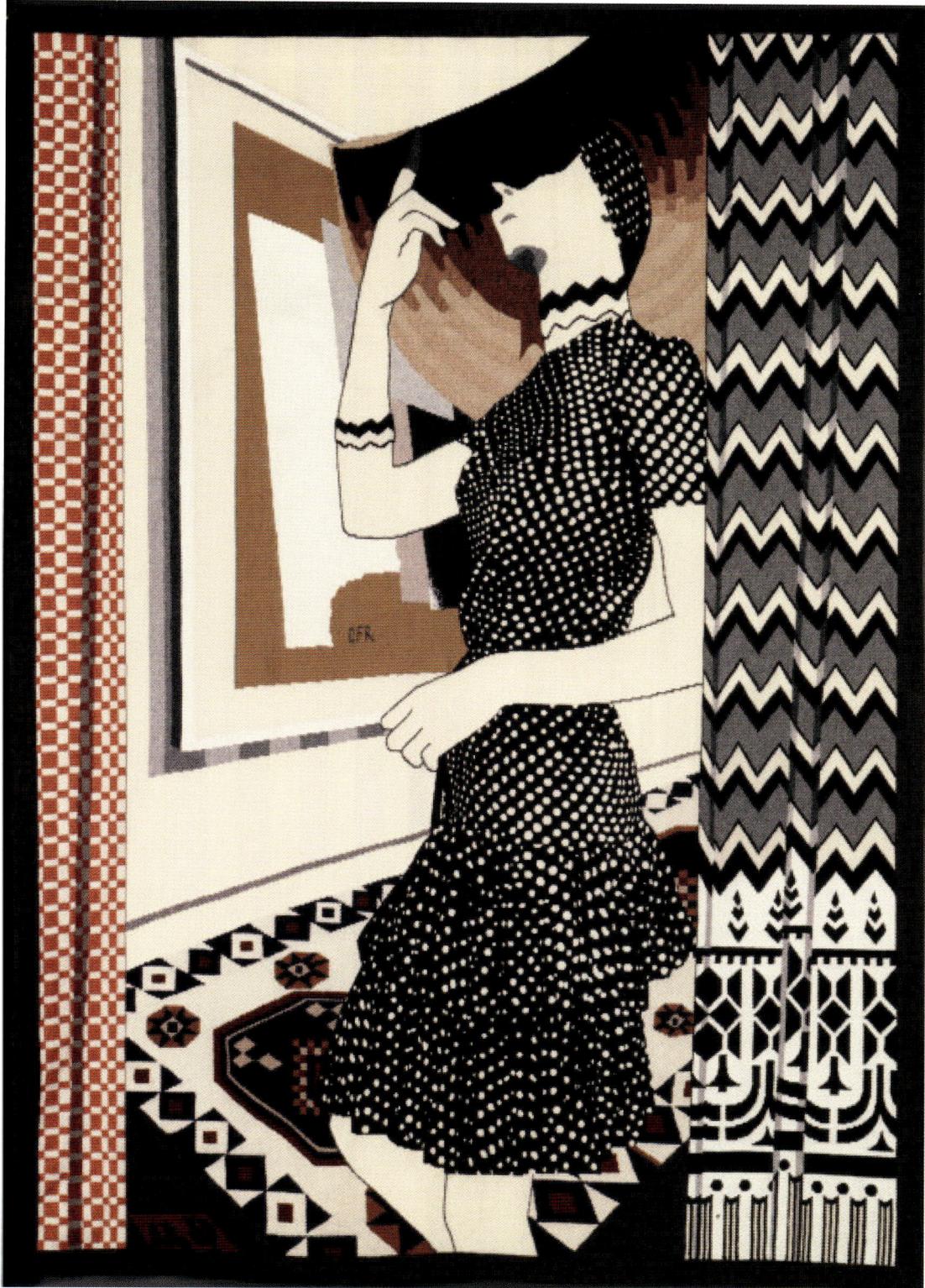

Plate 20

SAM AINSLEY

GENERAL ACCIDENT TAPESTRY 1983

Cotton warp, wool, wire mesh
In 15 sections, various dimensions
Aviva, Perth
Weavers: Dot Callender, Douglas Grierson, Shirley Gatt, Fred Mann, Harry Wright, Johnny Wright

I was commissioned in 1982 by the architect James Parr and Robert Breen of Art in Partnership to come up with some ideas for a tapestry for the General Accident and Fire Assurance Corporation headquarters in Perth. I spent a long time going through ideas in drawn and collage form before we decided on the final proposal. I was interested in representing Scotland by looking at the way mountain ranges change as they recede into the distance and used elements of geology and rock strata, albeit in an imagined rather than any real way. The idea was that those mountains at the bottom of the tapestry (nearest to the viewer) would be much more three-dimensional and heavily worked whereas those at the top would be much flatter and paler, suggesting distance.

Although I had very little knowledge of tapestry as a craft (and indeed had never made one myself) I felt complete confidence in the team of weavers' ability to interpret the final drawing, which they did beautifully. It was much more of a collaboration as they suggested ways to translate the drawing into tapestry form.

Master weaver Douglas Grierson in particular was instrumental in this translation but also produced samples which displayed his sure understanding of what I was trying to achieve. The sheer scale of the tapestry was daunting but there was another obstacle to overcome: I had drawn these overlapping 'mountain ranges' with gaps or spaces in between. Again, Douglas was able to resolve this technical problem by sewing the tapestry in sections on to a metal grid which stabilised it and enabled the tapestry to retain its shape. I have very fond memories of the Dovecot team at that time; their incredible skills and professionalism made it a joy to work with them and the final tapestry is, I think, a testament to their extraordinary craftsmanship.

Sam Ainsley
Former Head of Master of Fine Art Department, The Glasgow School of Art 1990–2005
Senior Lecturer Fine Art, The Glasgow School of Art 2005–

Sam Ainsley's brief was 'the Scottishness of General Accident', and she used the Scottish landscape as her source. We were presented with a collage of torn and painted paper, measuring about 14 by 24 inches [36 by 61 cm], which was to be scaled up to 17½ feet by 30 feet [5.3 by 9.1 metres], becoming the largest tapestry ever to have been woven in the UK. It was to be woven in 15 overlapping sections, with the corrugated concrete wall on which it would hang showing between the areas of tapestry.

The small collage was only a rough guide to what the finished tapestry would become. We decided that the tapestry should be strongly coloured and heavily textured, in particular at the bottom, so that the exposed wall would not overpower it. There were also delicate areas, allowing detail and contrast with the bolder sections.

Each of the pieces had to be backed with heavy wire mesh for stability, and hanging took two days – with great nervousness that there might be an unexpected gap or other problem, since it had never been possible to see the work as a whole – but it all went to plan.

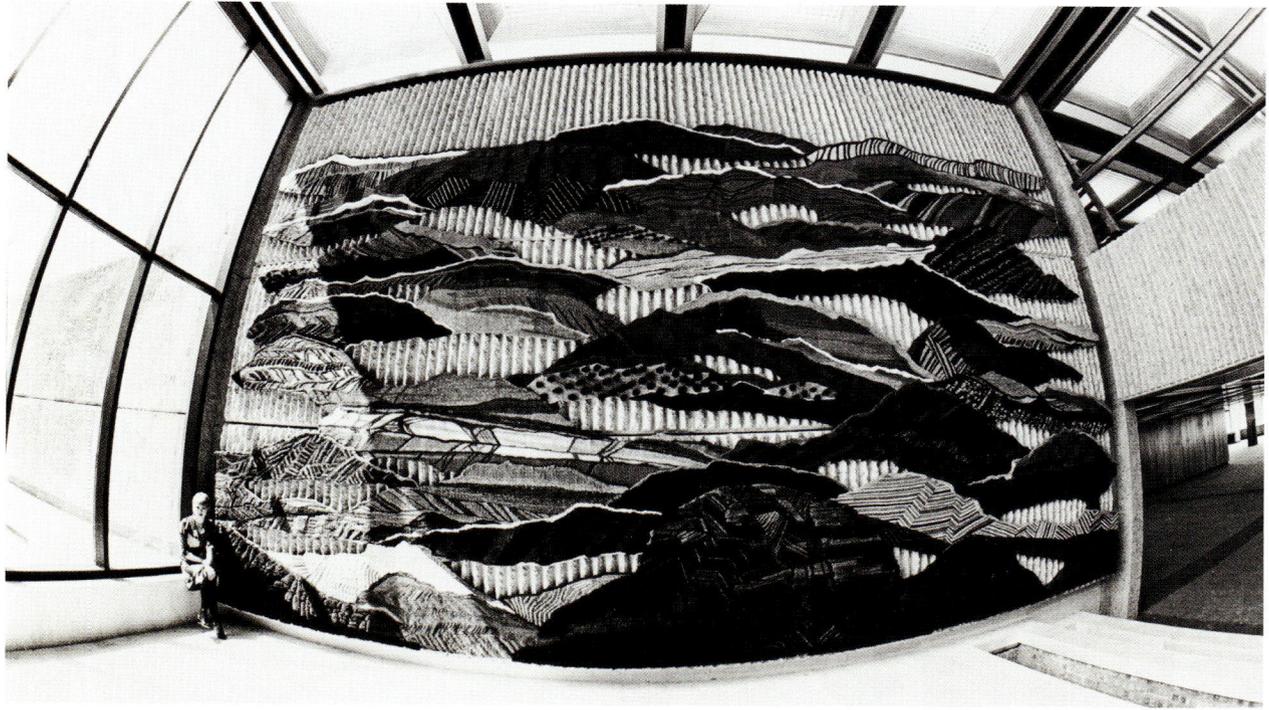

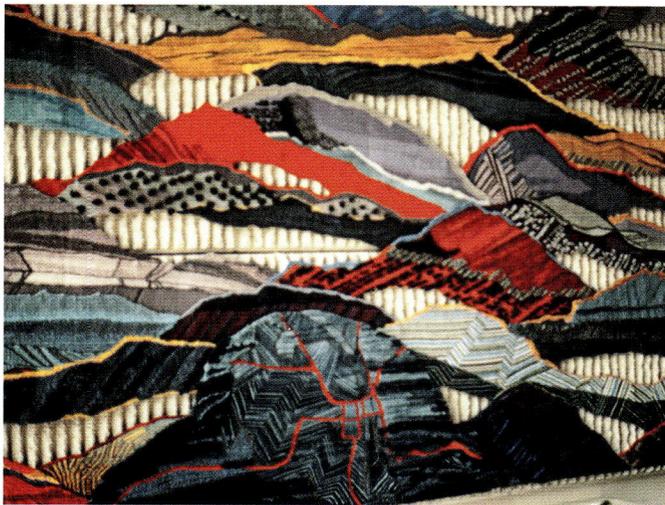

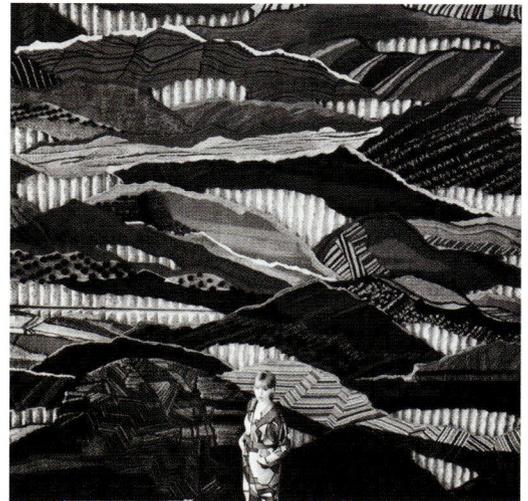

And it won an award from the Saltire Society.

It is worth saying that Fiona Mathison remained a consultant to the Edinburgh Tapestry Company during the period of both this commission and the subsequent Frank Stella one for PepsiCo, and played an important role in the creation of the tapestries.

Joanne Soroka
Artistic Director 1982–7
Lecturer, Tapestry Department, latterly Intermedia, Edinburgh College of Art 1992–2010

Plate 21

FRANK STELLA

THE HAD GADYA TAPESTRIES 1985–6

Cotton warp, wool
'Cover' image (illustrated) 223.5 × 154.9 cm (83 × 61 in)
Suite of ten each 223.5 × 223.5 cm (88 × 88 in)
PepsiCo, New York
Weavers: David Cochrane, Shirley Gatt,
Douglas Grierson, Harry Wright, Johnny Wright

I had a very happy experience working with Dovecot because every work was problem-free. I was so impressed with the weavers who carried on on their own and worked together very smoothly. Things you could make complicated were uncomplicated. The tapestries took their lead from the suite of prints I had made but the colours were quite different on paper from the weavings. The weavers were miraculously good at balancing colours – the colours really took off. They were so focused. There was never any feel of repetition.

Donald Kendall really loved Dovecot and wanted something pretty major. He was relieved I was willing to do something, and I settled into the commission for PepsiCo. Everything was wonderful. Joanne did a great job too, and I am sure was quietly cracking the whip in the background.
Frank Stella

We knew that the Hon. David Bathurst, one of our board members, was in discussion with Don Kendall, the chairman of PepsiCo. Mr Kendall wanted a set of tapestries for the company's world headquarters in upstate New York, and he wanted the eminent artist, Frank Stella, to design them. But when the commission actually came through in December 1984, it turned out to be the biggest and most lucrative ever secured by the Edinburgh Tapestry Company. We were elated and terrified – 11 large tapestries designed by a world-famous artist who had never before worked with tapestry.

Stella arrived on Concorde later that month. On virtually the shortest day of the year, and the dreariest, we tried to choose whites for the borders. He paced up and down the studios as his firecracker mind considered the options. Later, once we had done samples and I brought them to his New York studio with questions, he repeatedly said, 'Use your judgment.' He did know that he wanted the strongest colours possible, including fluorescents, but put the details into our hands.

The tapestries stretched the weavers to the fullest, with Fred Mann saying that he had had to tackle problems he had avoided in forty years of weaving. When the completed set went on display at the Scottish National Gallery of Modern Art, Stella inspected them thoughtfully and then gave me a hug. I knew it was meant for all of us
Joanne Soroka
Artistic Director 1982–7
Lecturer, Tapestry Department, latterly Intermedia, Edinburgh College of Art 1992–2010

This is probably the most prestigious commission ever woven by Dovecot. Initially Stella was asked to do three designs, but he came up with the idea for 11 panels inspired by the Jewish folk tale *Had Gadya* and based on illustrations by the Russian artist El Lissitsky. The artworks arrived in a huge crate and we eagerly opened it up to find that the collages were life-size, 7 feet [2.1 metres] square and in free forms. Immediately we thought the free shapes were going to be a problem to weave and the finished tapestries would have to be mounted on boards.

The compositions were abstract, incorporating black and white cones, cylinders and circles. There were painted areas that gave each panel a dominant colour, but superimposed on them were crayon marks, cut-out paper shapes, graphs and pencil lines that were part of a vast array of marks to which the weaver had to find solutions. However, the designs were also very clean cut in appearance and worked splendidly as artwork for tapestry. Nonetheless, the cut-out feature of the paintings became something of an issue. Stella preferred the free shape. After much discussion we decided to go with a soft white border that contained the composition. I don't think Stella was altogether convinced.

The weaving was technically quite difficult, especially the graded cones and cylinders that lay at odd angles across the tapestry. We would often have to 'run the weft', a technique that could help maintain the sharpness of the shapes. The trouble with some of the imagery in tapestry is that the smoothness of shapes can only be achieved at shallow angles, so that as the shape becomes steeper, the weaving becomes more stepped and can give a jagged appearance.

The tapestries were woven at 8 warps to the inch and a variety of materials were used. Black and white mohair was used in the conical elements and, in the borders, Australian botany wool. Silks, cottons and synthetics were also deployed with fluorescent colours of pink and orange that had to be specially dyed.

Douglas Grierson
Weaver 1961–2011, Studio Manager 1994–2000, Head Weaver 2000–11

This series stylistically relates to a period in Stella's practice when he was experimenting in representing sculptural forms after early concerns for representing 'flatness' and a conceptual, almost mechanical, approach to painting minimalist lines on the canvas surface. This can be clearly seen in the columns and pyramids in these compositions which relate strongly to prints and collages such as *The Science of Laziness* (1984). Produced

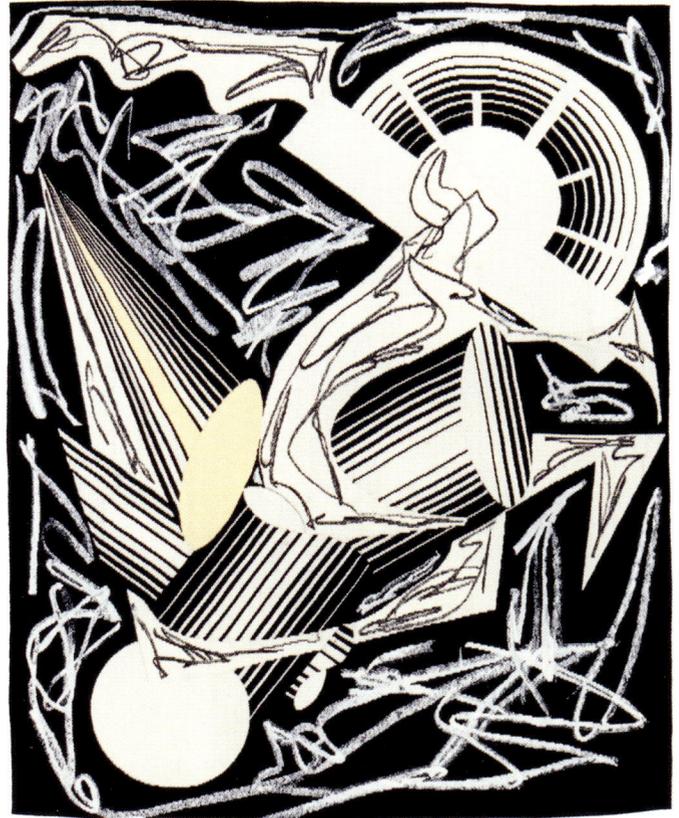

in 1985–6, these tapestries were the first that master weaver David Cochrane encountered as an apprentice; he has spoken of them as inspirational in showing what a tapestry can achieve.

Gráinne Rice
2012 Project Manager, Dovecot Studios 2011–

Stella's visits to the studio left a clear impression on me. As a new apprentice, I wasn't involved with talking with him, that would have been Douglas or Harry, but to have an international artist at that level come to visit the tapestry studio in Corstorphine, it was impressive! He felt like an important visitor.

David Cochrane
Weaver 1986–

Plate 22

JAMES MORE

DUNEDIN FUND TAPESTRY 1987

Cotton warp, wool
Dimensions unknown
Location unknown
Weavers: Shirley Gatt, Douglas Grierson,
Naomi Robertson, Harry Wright, Johnny Wright

I was asked to design the Dunedin tapestry as soon as I had accepted the managing director's job at the Edinburgh Tapestry Company. As with all my own Dovecot artwork, it was designed under an incredible pressure of time. ETC needed the work for some crucial cash flow and the client required the tapestry for the opening of their newly refurbished headquarters.

The brief was to design a tapestry for the reception area of the company, to be seen immediately on exiting the lift. The tapestry would comprise quite a long list of imagery depicting investments made by the company that had secured its international reputation and financial standing. Key to all the imagery, however, the company had asked that the tapestry should depict Sisyphus, a king of Greek mythology who promoted navigation and commerce. Sisyphus was compelled by the gods to roll an immense boulder up a hill, never quite to make it to the top before it rolled down again, in a never-ending cycle of effort and commitment that the company felt encapsulated its own endeavours.

With so much imagery fighting for space within the design, I felt the need to develop energy and perspective, and made a few pencil sketches first to discuss with the master weavers the next day. Those discussions around the preliminary sketches proved invaluable, informing me how the master weavers thought and worked, and acted as the basis for a real

balance between their creativity and the ideas of the artists later on. As I designed the tapestry for the next day, I kept the work simple, yet as lively as possible, retaining the energy and perspective within the shapes. I wanted clients emerging from the lift to be surprised by a train from the American West rushing towards them.

The tapestry was woven and hung in the Dunedin headquarters before I took up my post.
Professor James J. More
Managing Director 1987–93
Emeritus Professor, Northumbria University at Newcastle-upon-Tyne

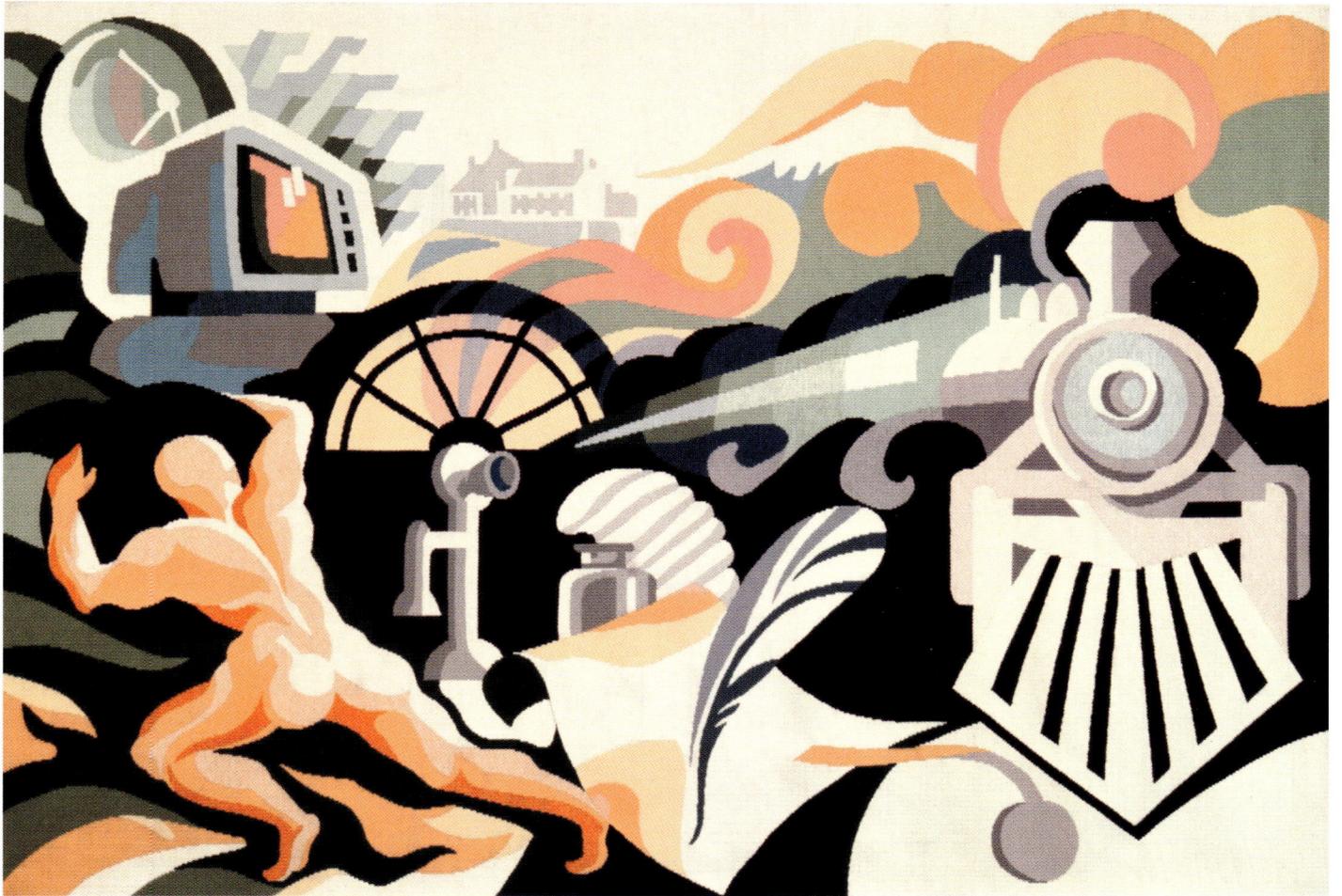

Plate 23

ROBIN PHILIPSON

HUMANKIND 1988

Cotton warp, wool
213.5 × 213.5 cm (84 × 84 in)
Culture & Sport Glasgow (Museums)
Weavers: David Cochrane, Shirley Gatt, Harry Wright,
Johnny Wright

The painting *Humankind* takes us back to the times of apartheid and shows the love of a white boy for a black girl set within the landscape of South Africa, its beauty made more poignant by the hazy, rich and wonderfully coloured twilight. Whether this is morning and the beginning of a new day, or evening and the end of the current day, is not divulged; only the love of the young couple is unquestioned and eternal.

As the artistic director, I saw my charge as that of setting the scene for the work on the tapestry with the artist and the weavers separately ahead of their meeting, to ensure each understood their respective roles. During their first meeting I facilitated and eased the discussion; once the discussion was up and running, I withdrew, returning only periodically to make sure everything was alright. I wanted the relationship between artist and weaver to be as natural and responsive as possible.

The quality of this wonderful tapestry arises from the robust and enthusiastic relationship that developed then, between the master weavers and Sir Robin, and their shared commitment to producing a vibrant work in tapestry that responded to the nature and the passion of the painting, the ideas it represented and the way in which they were portrayed. The tapestry took on a life of its own. It began and continued to develop through rich and detailed discussions between the artist and the weavers about the abounding, opulent diversity of

colour, shape and texture; the psychology of seeing, sensitivity and understanding; the perceptions of cultural sensibilities; and the politics of art. Yarn and woven sample trials were produced and, while the original painting was available for a very short time, work progressed in relation to exceptionally good slides and Sir Robin's frequent visits.

As part of the Studios' 'Scottish Collection', this speculatively woven tapestry became an important feature of our international exhibitions and was shown in London, Houston, Kyoto, Basle and Edinburgh. The discussions between the artist and the weavers also became a feature in their own right, with Sir Robin and head master weaver Harry Wright discussing how they worked in front of invited audiences of the Royal Society for the Encouragement of Arts, Manufactures and Commerce (RSA) in both Edinburgh and London.
Professor James J. More
Managing Director 1987–93
Emeritus Professor, Northumbria University at Newcastle-upon-Tyne

Alastair's and my involvement with Dovecot came about as the result of my long-term friendship with Diana, Robin's wife. They introduced us socially to so many artists, not only Scottish but from further afield, and set us on our love of art. Out first introduction to Dovecot was at the Cutting Off of this tapestry.
Elizabeth Salvesen
Director, Dovecot Foundation

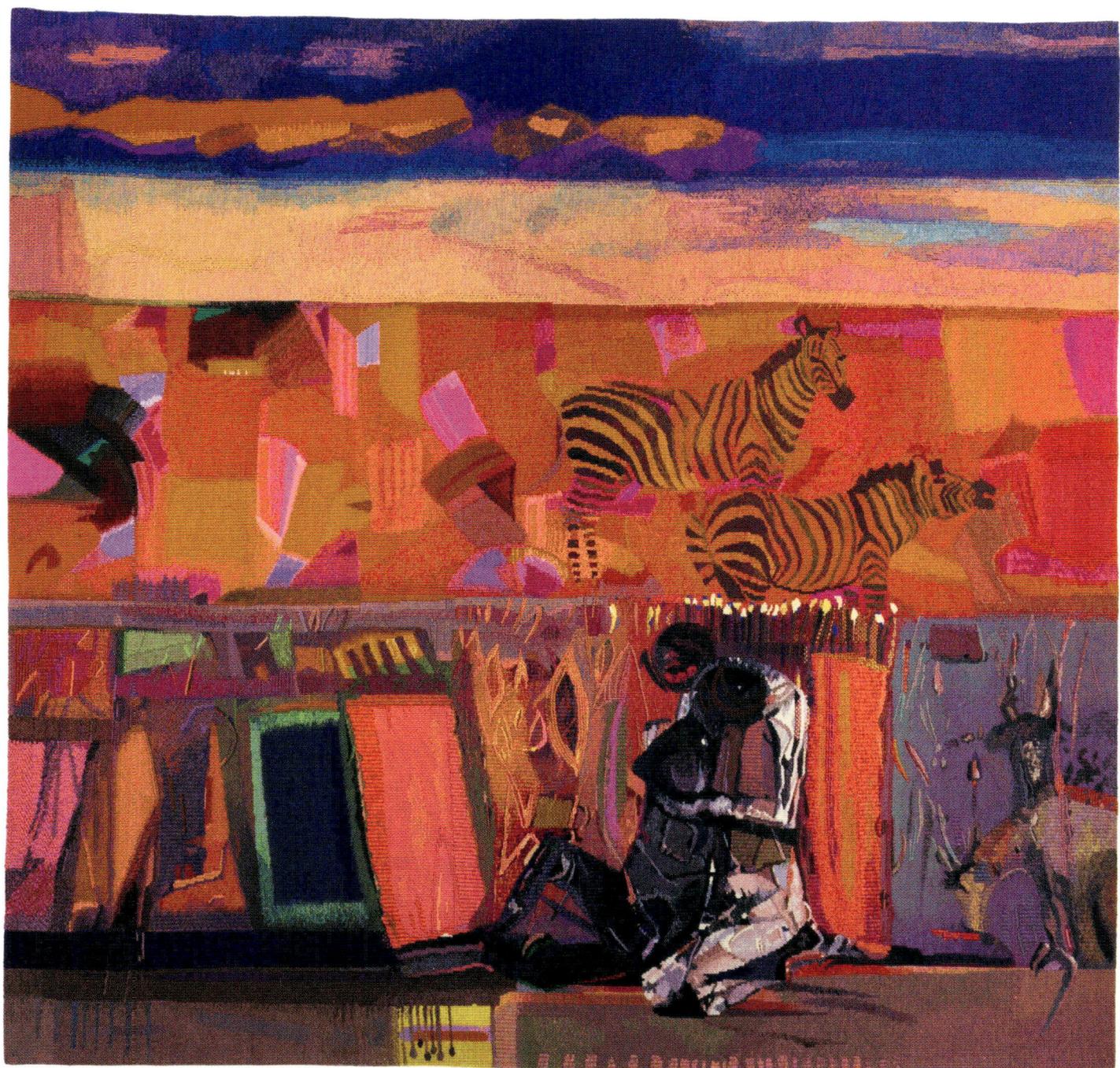

Plate 24

ADRIAN WISZNIEWSKI

THROUGH THE GARDEN WALL 1989

Cotton warp, wool
Diagonal 340 cm (134 in)
Private Collection
Weavers: Samantha Clark, Shirley Gatt, Fred Mann

Every time I go to London I pop in to the Victoria & Albert Museum and have a good look at the Raphael cartoons. These brilliant works of art were never really matched in quality by the tapestries that followed. How does one do a cartoon for a successful tapestry? I looked at the wonderful tapestries in the Burrell Collection and gathered that a certain flatness in design helped create a successful outcome. This was underlined by the tapestries that David Hockney and Frank Stella did at the Dovecot.

I did however want to capture a painterliness as well as a flatness in my own design. I achieved this by using the mono printing process where I painted directly onto perspex sheets and passed them through the printing press. Through discussion with the master weavers we decided to increase the scale by an additional 50 per cent. This was in consideration of the particular nature of the weave. The lozenge shape suggests a garden trellis and the wild, painterly flowers frame the serenity of a distant church.
Adrian Wiszniewski

The year 1990, when Glasgow was designated European City of Culture, was considered something of an apogee for the so-called New Image Glasgow group with whom Wiszniewski was then associated. The sugary, Watteau-esque colour palette of the central motif in *Through the Garden Wall* relates strongly to his paintings from this time and the dreamy landscape settings of the artist's earlier poetic work. The church, traditional symbol of solidity and continuity, relates back to earlier compositions such as *Toying with Religion* (1987) that featured in the 'Vigorous Imagination' exhibition at the Scottish National Gallery of Modern Art the same year. As the catalogue then commented, 'The imagery is left to work much more on its own, set against a plain background … there is a heraldic feeling about these new works … moving away from improvisation towards more planned compositions.' These early paintings have been compared to surrealism in their spontaneous, free-flowing process of composition, the romanticism of Samuel Palmer's Shoreham landscapes and the nervous energy of van Gogh's style. Wiszniewski is also following in a neo-romantic tradition in Glasgow painting reaching back to the likes of Colquhoun and MacBryde and James Cowie.
Gráinne Rice
2012 Project Manager, Dovecot Studios 2011–

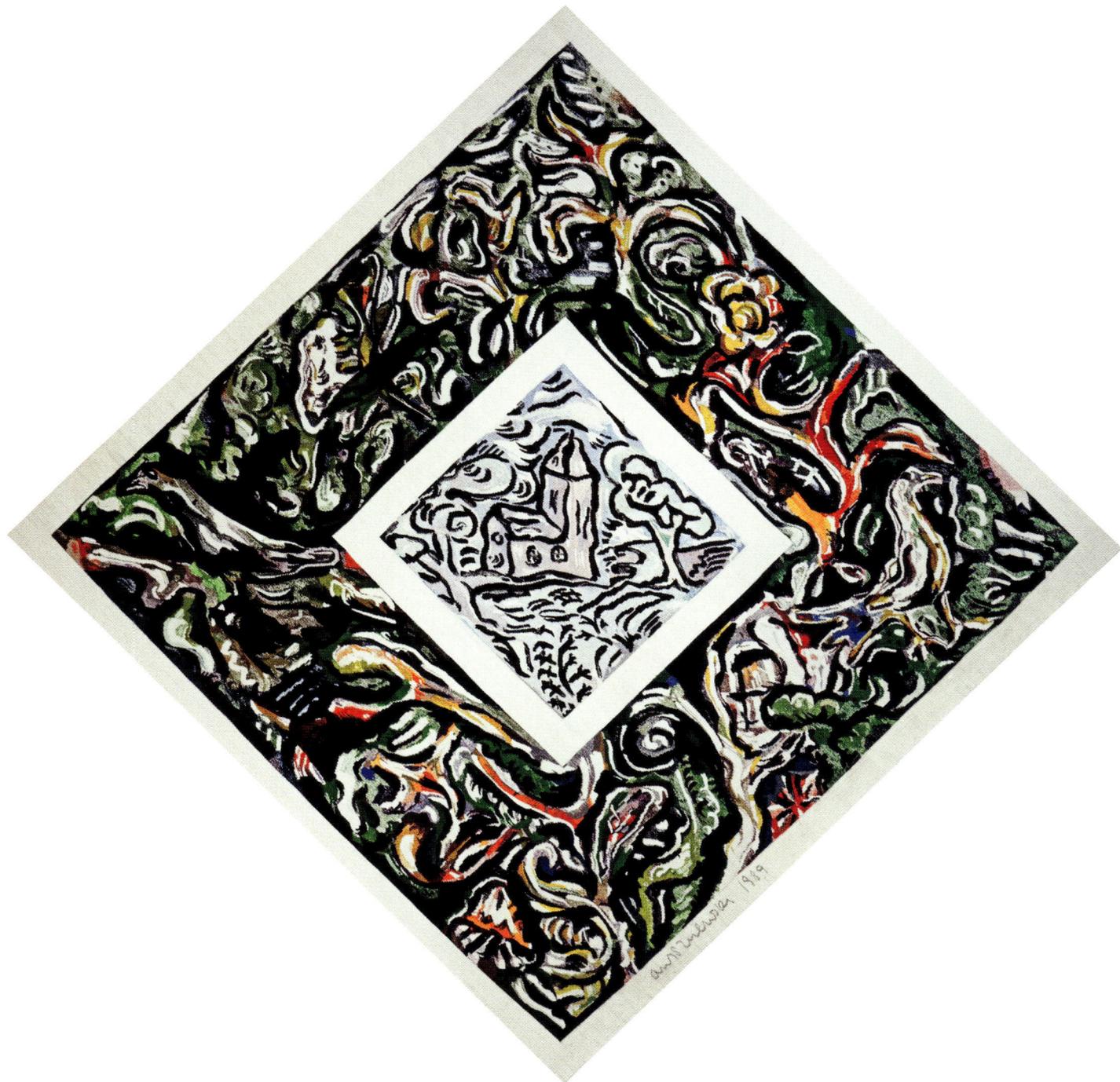

Plate 25

FROM A PHOTOGRAPH BY FRITZ VON DER SCHULENBURG

CHARLIE'S RETIRED 1990

Cotton warp, wool
96 × 166 cm (37¾ × 65¼ in)
Private Collection
Weavers: David Cochrane, Shirley Gatt

To someone of my age *Charlie's Retired* says much about the closing decades of the twentieth century. As a child, my siblings and I were not unaccustomed to hearing our parents, grandparents and their friends discussing Russia and the Eastern Bloc with great trepidation. It seemed to me that there was a tangible political and military threat from the mighty USSR – the Beatles even wrote a song about it.

It seemed impossible that on the doorstep of our liberal European world there existed the sinister and secretive USSR where reports of the KGB in Russia and the Stasi in East Germany gripped my imagination. I studied George Orwell's *1984* for O-Level English which further fed my fear of Europe's sleeping giant.

The fall of the Berlin Wall represents the apotheosis of Gorbachev's *perestroika*. I remember it very clearly, not least because of the huge emotion I felt on hearing the news, but also because it seemed, at last, as if Europe could finally move on from the dreadful legacy of the Second World War and more recently the spectre of the Cold War.

The Von der Schulenburg photograph from which my tapestry is derived depicts a larger section of the Berlin Wall including the date '10 November 1989' after the words 'Charlie's Retired' – Charlie of course refers to the infamous Checkpoint Charlie. Because the tapestry depicts a tiny section of wall it becomes a more intriguing image, leaving more to the imagination than

the original photograph which includes the famous black roll-top at the head of the wall structure. The inclusion of Mickey Mouse is a bizarre nod to the USA and western consumerism.

I am very fond of *Charlie's Retired* not only because of what it represents culturally, politically and in terms of civil rights, but also because it is such a compelling image of such a momentous event in modern history.
John Crichton-Stuart
7th Marquess of Bute

Charlie's Retired is an exceptionally fine example of photography as source for tapestry, a Dovecot 'house style' that was pioneered and disseminated by former Artistic Director Archie Brennan. It continues to this day in the wider field of contemporary weaving, such as David Noonan's 2010 *Untitled* tapestry produced by the Australian Tapestry Workshop. The photograph from which this tapestry derives is a series documenting the graffiti on the Berlin Wall at this time. The image's author, Fritz von der Schulenburg, is better known as a photographer of luxury interiors and architecture.

The year of this tapestry's production is key to understanding the imagery here. The Berlin Wall was the backdrop for one of the most heart-swooning moments of popular dissent ever caught on camera; who can forget the moment in December 1989 when the people of divided Berlin jumped up on to the wall

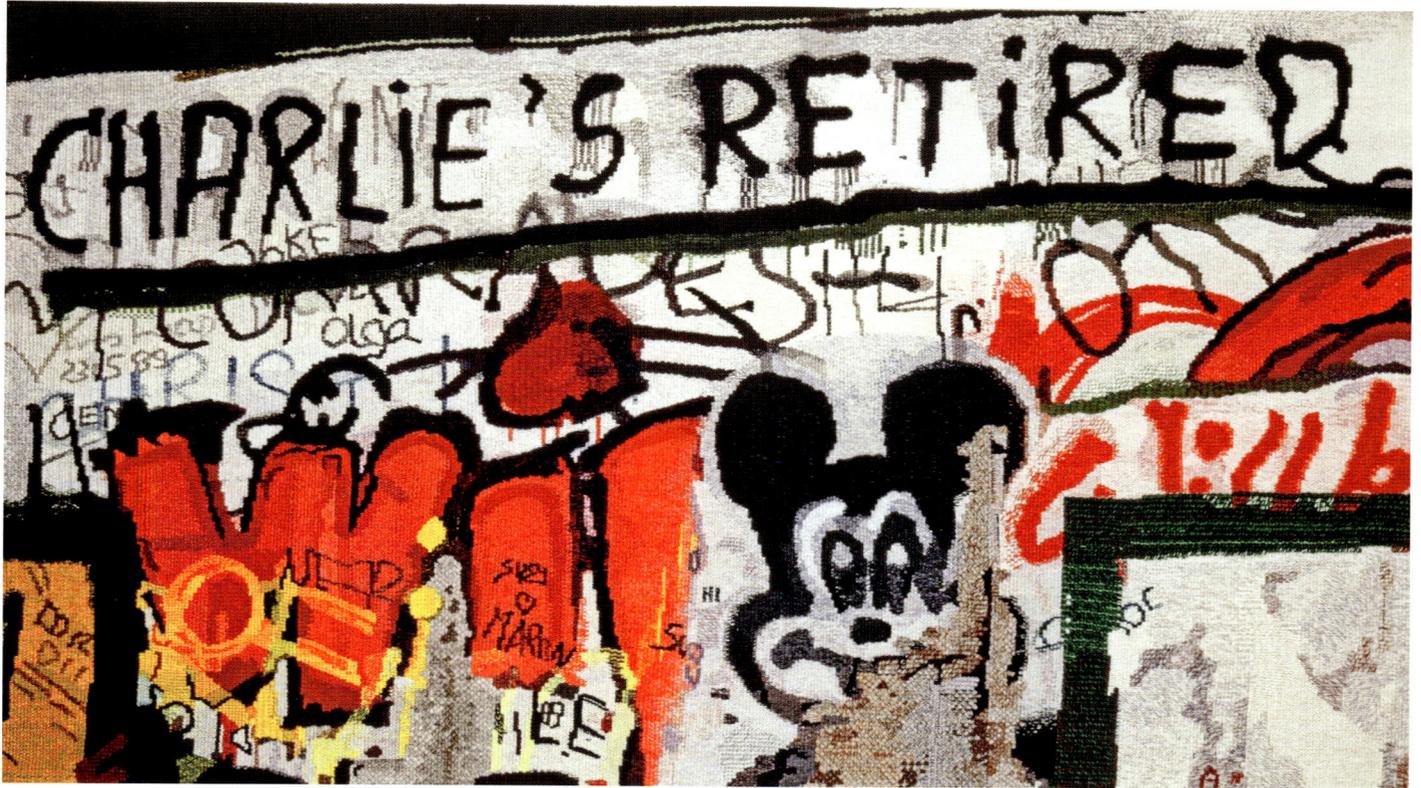

and began to smash it to pieces? Remnants of the wall became a large outdoor canvas, a site for permanent artworks such as Scottish artist Margaret Hunter's iconic two faces now immortalised at the Eastside Gallery (a section of wall preserved in the Kreuzburg district). Enterprising Berliners sold tiny colourful fragments of the wall in presentation boxes, contributing to the explosion in *ostalgie* souvenirs; a lady objectophiliac 'married' it; and of course it was a public space on which political sloganeering was graffitied. By 1990 the wall had stopped being a piece of architecture and had evolved into a potent visual symbol of the new huge cultural and political shifts.

This was the tapestry on which master weaver David Cochrane graduated from apprentice to weaver. He says it was a particularly interesting tapestry to work on with Shirley Gatt, to translate the texture of the brutalist concrete wall surface into a chunky weave and by adding in his own graffiti tag to the overall design.
Gráinne Rice
2012 Project Manager, Dovecot Studios 2011–

Plate 26

JAMES MORE

REVELATION OF ST JOHN 1992

Cotton warp, wool
107 × 205 cm (42 × 80¾ in)
The Bute Collection at Mount Stuart
Weavers: Naomi Robertson, Harry Wright

The sixth Marquess of Bute was passionate about supporting and nurturing the work of craftsmen, craftswomen and artists. Acquiring the controlling shares of the Edinburgh Tapestry Company in 1983, his plan to establish the Company in a new or refurbished building in Edinburgh was central to his vision of an international craft centre with workshops, exhibition and lecture space and a cafe: a dream which sadly he himself was not to fulfil but has happily more or less come to pass under the Company's current ownership.

This passion for craft skill was also the driving force that prompted John Bute, the fourth Marquess, to restart the unfinished building work of the third Marquess at Mount Stuart. While mindful that he was continuing work that had lain unfinished for almost a century, Lord Bute wanted the work he commissioned to be current in its interest and comment while respecting the building itself.

The handwoven tapestry I designed was one of a number of works which Lord and Lady Bute commissioned from various craftspeople as part of this programme of activity. The tapestry was to be situated on the dais in front of the altar of the Marble Chapel at Mount Stuart. The chapel's design was based on La Seo Cathedral in Saragossa. Entirely surfaced in white Carrara marble, the chapel had a rose-coloured lantern set within a handsome cupola, creating a most extraordinary and evocative space. The Marble Chapel

is dedicated to St John the Divine, and reflects the deep spiritual and intellectual interest of the third Marquess and his architect Rowand Anderson in the last book of the Bible.

Perhaps not surprisingly then, the tapestry commemorates this dedication. It was coloured

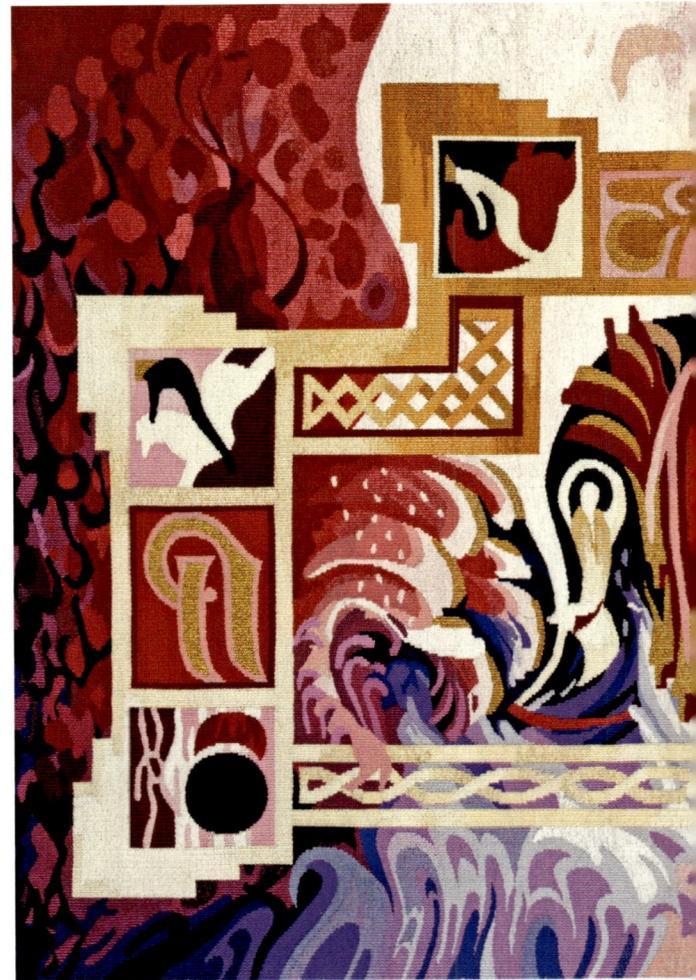

to resonate with the blood-red light from the lantern spilling onto the marble. The design was set within a frame of Celtic ornament and depicted imagery from the Book of Revelation. The tapestry was woven by master weavers Harry Wright and Naomi Robertson in collaboration with myself as the artist. Even though I was the director of the Studios at the time, my conversations with the master weavers on colour, texture, shape and meaning were as lively as those with other artists. I remember facing the challenge of finding a way of depicting a world darker than black

with Harry and Naomi. After a number of trials Harry came up with a blend of black and red yarns that was perfect. The effect of this colouration in yarn made the planet seem to recede and was an eloquent statement as to how, in the hands of the weavers, yarn may be made to behave differently from paint, yet make the artist's intentions clearer than ever.

Professor James J. More
Managing Director 1987–93
Emeritus Professor, Northumbria University at Newcastle-upon-Tyne

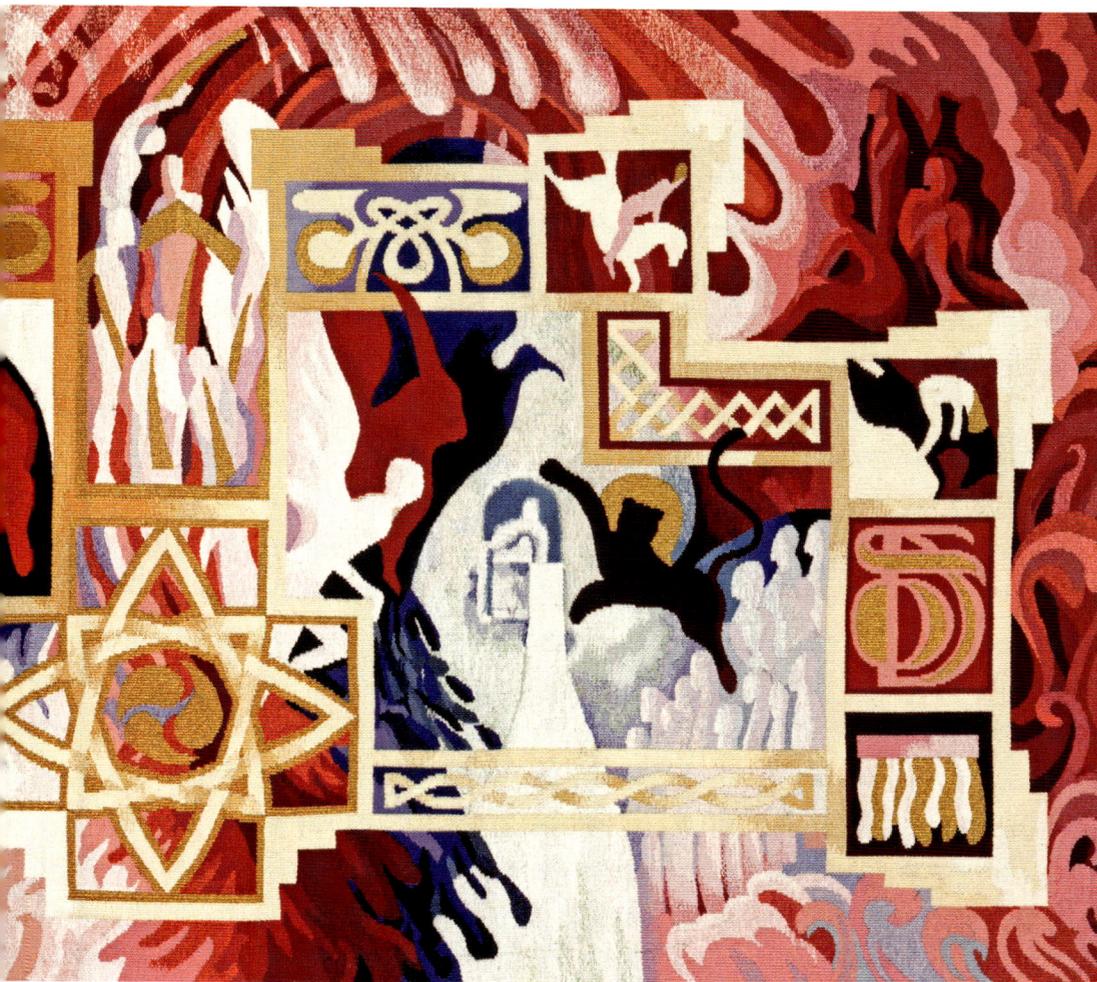

Plate 27

R.B. KITAJ

IF NOT, NOT 1996–7

Cotton warp, wool
Approx. 700 × 700 cm (275½ × 275½ in)
The British Library
Weavers: John Brennan, David Cochrane,
Douglas Grierson, Naomi Robertson, Alice Shaw,
Harry Wright, Johnny Wright

Ever since the 1960s there had been the promise of a tapestry for the new British Library. Colin St John Wilson, the architect, planned the building and the artworks together. The work he chose for the entrance hall tapestry was from the painting *If Not, Not* by Ron Kitaj.

In 1989 the Government gave the go-ahead for funding the work, only to renege on its commitment in 1991. But there were always rumours about private funding. Samples had been woven by the two studios contending for the contract, and we were selected to weave the tapestry. A glimmer of hope was given by Clare Henry's appreciation of the late John Bute (fourth Marquess) in *The Herald* in July 1993 when she called for donations for the Library cause. A further two samples were made to establish the warp sett and colours for some of the passages. Slowly it emerged that funding had been arranged through the Heritage Lottery Fund and from private donations.

For a tapestry nearly 23 by 23 feet [7 by 7 metres] a new loom had to be built. Kitaj's painting was on display during the 1995 Edinburgh Festival and was to tour abroad. As a result, Harry Wright and I had to travel to Luxembourg armed with shade cards to select the colours. When we returned to the studio 300 lbs [136 kg] of wool was put on order. And not only was the choosing of the colours unorthodox. The painting

belonged to the National Galleries of Scotland so we were allowed limited access; the gallery staff would arrive with the painting for a day once every couple of months for us to view. On other days we made trips into the gallery armed with the shade cards. We had only a good poster-size photo for reference when the painting was not around.

The subject matter struck me as a modern version of the great storytelling sagas, those mythological and historical tapestries of the past. The imagery is a complex composition of the horrors of war that plagued the twentieth century and the painting littered with artistic and literary references.

Kitaj's technique meant that on many of the colours the canvas showed through the paint and mixtures had to be made to tie the imagery to the background. The sky was particularly tricky. Kitaj overpainted blues, pinks, yellows and oranges that subtly changed all the time. Similarly, with the black areas of the mire, many mixes were made to cope with the various paint applications.

Seven weavers wove the tapestry and most were involved in the installation in London. The tapestry weighed 250 lbs [113 kg], and my abiding memory is of being harnessed on top of a scaffold with six people underneath holding the weight of this huge roll. During the installing, Kitaj came to see the tapestry and meet the weavers. I asked him why he had not come to the studio, and he replied that he did not want to influence the weaving. He was delighted with what he saw.
Douglas Grierson
Weaver 1961–2011, Studio Manager 1994–2000, Head Weaver 2000–11

Plate 28

KATE WHITEFORD

CORRYVRECHAN 1997

Cotton warp, wool
Approx. 800 × 425 cm (315 × 167¼ in)
National Museum of Scotland
Weavers: David Cochrane, Douglas Grierson,
Naomi Robertson, Johnny Wright

The *Corryvrechan* tapestry was commissioned for the Museum of Scotland which opened in 1998. This work, inspired by the Corryvrechan whirlpool off the island of Jura, links the architecture of the building, the historic collections of the museum and contemporary art in an innovative way. Kate discussed her design with the architects Benson & Forsyth, and in association with the weavers at Dovecot Studios produced the monumental work which combines her signature colours, of red and black, with abstract motifs which can be read as aerial views of archaeological settlements.

From time to time the Museum has acquired work to record the progress of the Edinburgh Tapestry Company and the collection includes works designed by Cecil Beaton, Nadia Benois, Graham Sutherland, Sax Shaw and Bruce McLean. In 1991 the Museum was given the Scottish Craft Collection formed by the Scottish Development Agency which includes tapestry designed by Archie Brennan and Fiona Mathison.
Rose Watban
Senior Curator, Applied Art & Design
National Museums Scotland

There were certain recurring images from archaeology which I knew I wanted to include in the design for the *Corryvrechan*, from very early carved stones in the Museum to the tree runes from Maes Howe, Orkney, which ran like a timeline through the length of the tapestry. As you entered the Museum, you were to be welcomed by a runic script, walking like figures along the bottom of the tapestry and looking upwards; the barcode in vibrant colour running across the top could also be seen from the upper floor. Although designed for the narrow entrance hall, the tapestry was later moved to the main reception area which allows a wider view and a closer link with archaeology.

Working with a Dovecot weaver is akin to working with a master printer, in the sense that you have to trust their judgment and professional integrity to translate your work, and on a massive scale. The weavers can mix infinite variations of colour by hand by twisting multiple strands of dyed wool. This technique is astonishing in its complexity and when woven the colour is extremely accurate.

Working directly from my drawing, a full-scale cartoon was made of the design, tracing every line and every nuance of colour. I was fascinated by this under-drawing which peeked through the warps and wefts on the loom. Gradually the tapestry appeared in full colour, emerging from a forest of multicoloured bobbins. The whole process took two years and was a magical experience. During the design stage I had witnessed the mythical Corryvrechan whirlpool in the Straits of Jura and its underlying energy and surface calm seemed to be an apposite metaphor for the work.
Kate Whiteford

The tapestry for the Museum of Scotland was on a monumental scale. A new loom was built with rollers to accommodate the 26-foot [8-metre] length: traditionally and for technical reasons the tapestry was woven on its side. The design of the loom was based on the seventeenth-century French one we had in the studio.

On her first visit to the studio, Kate was a bit apprehensive about the translation of her work, especially the scaling up of tapestry from a relatively small design; she did not want the tapestry to be merely an enlargement of the painting. In the weaving great care was taken in getting the correct colour. The tapestry was woven at 4 warps to the inch, and with the heavy warping the reds were specially dyed in different counts of wool. The turquoise colour posed a problem; it was difficult to dye at the intensity to achieve the resonance, and we searched new suppliers to find the appropriate shade.

Kate painted several designs, and we had chosen one at Dovecot; but when we visited her London studio some weeks later we were shocked to find she had changed both the colour and composition. So we adapted our thinking and found ourselves working from the original for colour and the most recent for composition. This was a great time for me, working with Kate, as she got involved right from the start; I only wish we could have worked with her again.

Douglas Grierson
Weaver 1961–2011, Studio Manager 1994–2000, Head Weaver 2000–11

Plate 29

IAN HAMILTON FINLAY

BCK 75 (PROEM) 1998

Cotton warp, wool
140 × 90 cm (55 × 35½ in)
Estate of Ian Hamilton Finlay
Weavers: David Cochrane, Douglas Grierson

Throughout his career, Ian Hamilton Finlay worked with a wide range of collaborators, using the skills and understanding of others to capture his ideas in almost every conceivable artistic medium. *BCK 75 (Proem)* is a typical Finlay work: simultaneously playful and severe, the word 'proem' stemming from a simple visual and linguistic pun between a poem and the prow of a boat. Like so many of Finlay's ideas it was first realised as a printed card (drawn by the designer Ron Costley in 1997), a modest form perfectly suited to the communication of ideas. The following year it appeared as a larger silkscreen print, and then in the woven form that we see here. The interdisciplinary shift from one medium to another came naturally to Finlay and suited the multilayered approach that characterised his life's work.

Although now celebrated as an artist, philosopher and gardener, Ian Hamilton Finlay was first and foremost a poet, guided by a belief that poetry could be found wherever you look, a sense perfectly expressed by the rich associations provided by boats and the sea. The 'classification' numbers of the fishing fleet provided a simple prompt for imaginative association, suggesting both the specific of the boat (the number of the vessel) and the place on land from whence it came (in this case the letters BCK signifying the port of Buckie on the Moray Firth). This reductive combination of letters and numbers sets up a relationship between land and sea

with all the imaginative potential that lies between: a simple poem distilled to the essence of the thing.
Richard Ingleby
Director, Ingleby Gallery, Edinburgh

In 1998 we wove a couple of tapestries by Ian Hamilton Findlay. We did the first one, *Green Waters*, for the Poetry Library. Finlay had had the tapestry made elsewhere, and the result had displeased him. We visited Little Sparta, his home and poet's garden in the Scottish Borders, to discuss a re-weaving and he went on at length about the difficulties he had had; nevertheless we were pleased to get the job.

Finlay was very reclusive and rarely left his home, working on his art and his garden. He said to me that gardening is a war against nature. He had the reputation of being difficult, but on the few occasions we met I found him genial and unassuming and we got on fine. We remade the tapestry without any problems. This follow-up panel *Proem* was woven for an exhibition in Barcelona. Both works were given the names of fishing boats that had gone down at sea. The script that he used had to be woven with the utmost care, keeping very fine, precise edges.
Douglas Grierson
Weaver 1961–2011, Studio Manager 1994–2000, Head Weaver 2000–11

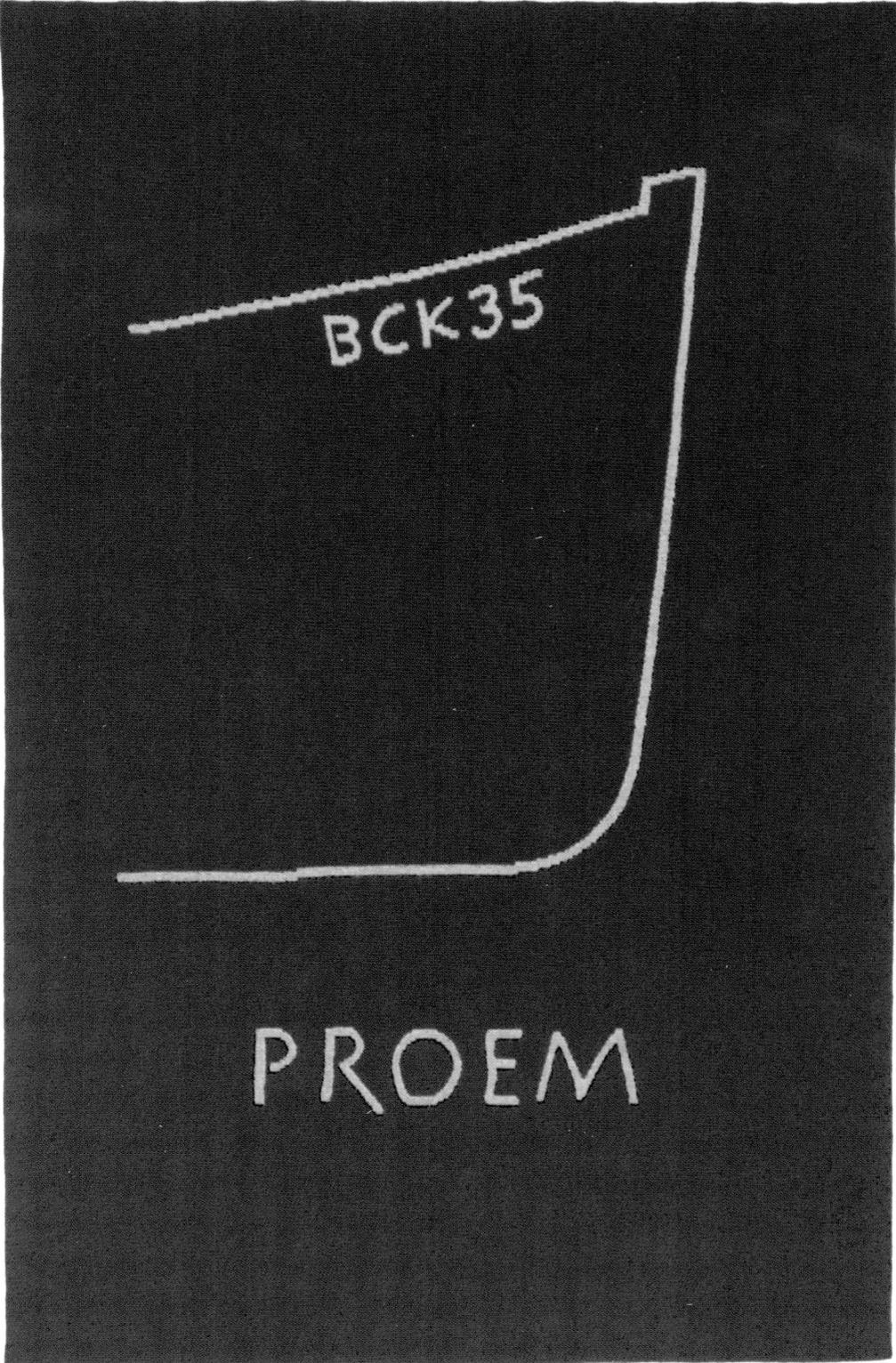

Plate 30

ALAN DAVIE

TO A CELTIC SPIRIT 2002

Cotton warp, wool
340 × 510 cm (133¾ × 200¾ in)
Chancellor's Building, Medical School, University of
Edinburgh
Weavers: David Cochrane, Douglas Grierson

I commissioned this vast tapestry from Alan Davie to
hang in the atrium of the Chancellor's Building of
the new Medical School at Little France on the Old
Dalkeith Road. My intention from the start was that
the tapestry would be on show to the public and in
time become a tourist magnet.

Alastair Salvesen had told me that Dovecot
was in real danger of closure. Months earlier I had
independently mobilised the chief weaver Douglas
Grierson, and together we plotted how the weaving of
a vast Davie tapestry might be done. I had this in mind
in my encouragement of Alastair's plan to acquire the
Dovecot rights and start it up at Donaldson's School for
the Deaf so that the weaving could begin.

Davie submitted seven designs, each a fine gouache
painting. The first one I chose was disallowed by
Douglas Connell (who was centrally implicated in
the funding) on grounds it called to mind 'Coffins!' –
and any connotation of fatality was naturally deemed
unsuited to a location adjacent to the Royal Infirmary.
The second choice of artwork was a gouache, *To a
Celtic Spirit*, which was expanded into a design for
weaving and also hangs today near the tapestry.

The weavers immensely appreciated Davie's
opposition to slavish copying. He was dead keen
for his design to be woven as a true tapestry, not a
reproduction of a painting. His welcome invitation
to weave freely and interpretatively was in contrast to
their previous assignment for the British Library, during
which they had been instructed not to deviate in the
slightest degree from the painting *If Not, Not* in the
Scottish National Gallery of Modern Art. The latter's
artist, R.B. Kitaj, unlike Davie who visited constantly,
did not come to the Dovecot.

Professor Henry Walton
*Emeritus Professor of Psychiatry and of International Medical
Education, University of Edinburgh*

This was one of the most joyous experiences in my
weaving life and was the first major tapestry woven
after Dovecot closed in Corstorphine and was re-
established in Donaldson's School. The commission was
made possible by the Morton Charitable Trust and Mrs
Elizabeth Lornie, head of the Trust, and Henry Walton
from the University of Edinburgh whose tenacity and
belief in the project cannot be underestimated.

On 1 October 2001 we started warping the tapestry.
With Alan, we were about to embark on a wonderful
journey. A piece of this size normally would have been
woven by four weavers but here it was woven by two,
David Cochrane and myself. We still often talk about
it. The tapestry was made at 4 warps to the inch; the
idea was to maintain a woven appearance when it was
installed. A large number of samples were produced to
establish colours and the manner of weaving. The weft
was quite thick and chunky but the tapestry surface
remained flat overall.

Alan and his wife Bili visited the studio many
times: with his white flowing beard and wearing an
Afghan coat, he would greet us with a big bear hug.
Collaboration is an overused term these days but in this
case it is entirely appropriate. There are only a handful

of artists that truly see their tapestry as part of their own work, and Alan Davie was one.

Douglas Grierson
Weaver 1961–2011, Studio Manager 1994–2000, Head Weaver 2000–11

A key thing to bear in mind before delving into Alan Davie's work and world is that there is no specific meaning to uncover. His paintings are not riddles with a solution or diagrams to be decoded. They are crammed with symbols – culled from subjects as various as ancient Carib rock-carvings, aboriginal paintings, medieval maps and Celtic jewellery – but ultimately the symbolism is Davie's own. I suspect that the little 'mounds' in the strip in the top left half of the *Celtic Spirit* tapestry derive from an ancient gravestone in Baden, France; the sort of bird head in the lower left is probably derived from Hopi Indian pottery decoration; and there are little ankh and cross symbols in there which he has used since the 1960s.

What he wants to do is animate the work with a kind of symbolism that is cross-cultural and timeless, really symbols that signify the excitement of being alive and the wonder of being in the world. His works begin as drawings, either brush and ink drawings or, in recent years, tiny sketches in ballpoint pen. Some are worked up into coloured gouaches, and others into large-scale oil paintings, but the translation process is always a creative and, for Davie, almost mystical act in which the study grows into something rather different, with a life of its own. It is the process of painting that generates much of the imagery and detail. Just as Davie doesn't want to copy his own drawings when making large-scale paintings, so it excited him that the master weavers at Dovecot interpreted rather than copied his design.

Patrick Elliott
Senior Curator, Scottish National Gallery of Modern Art

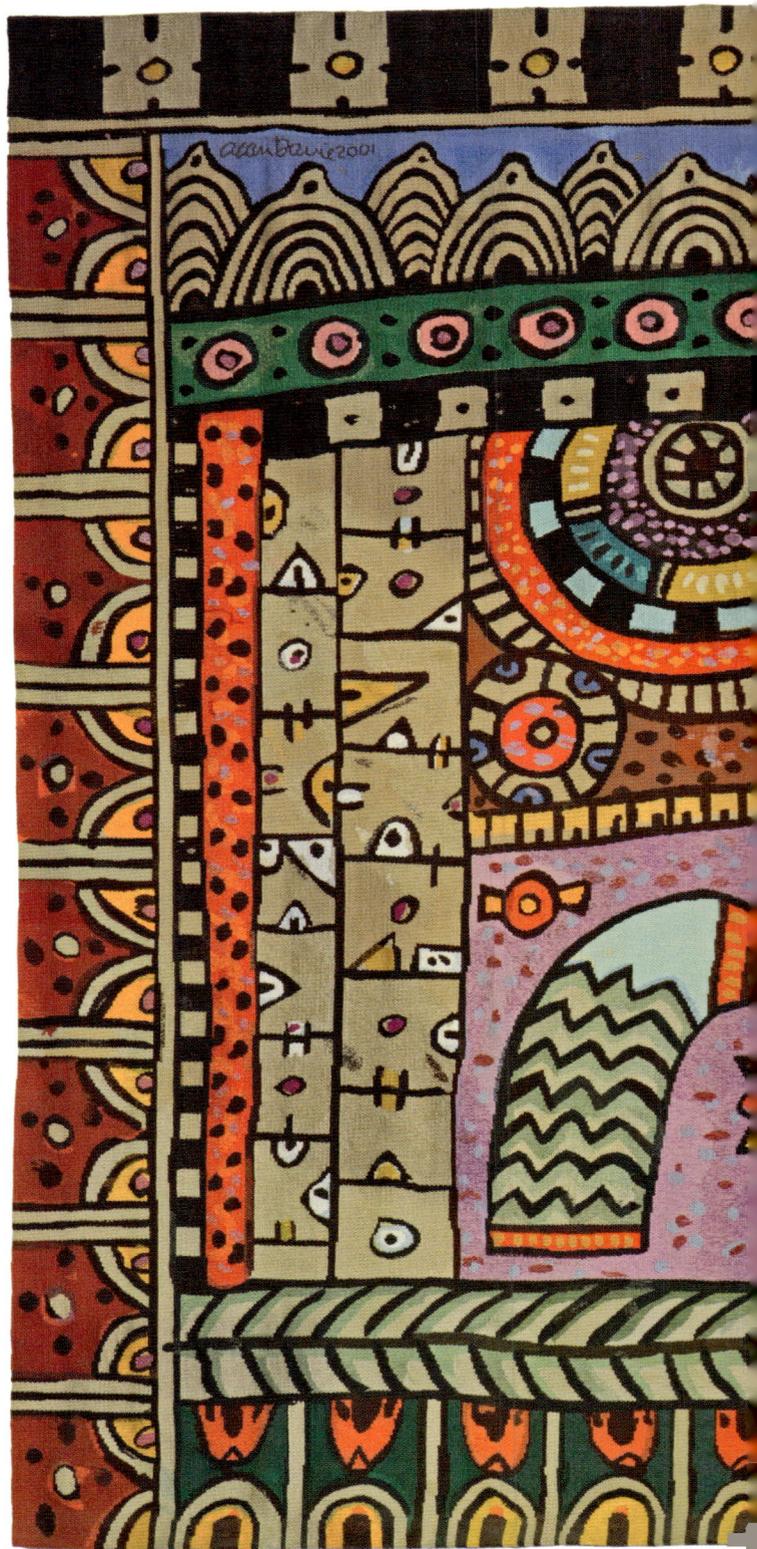

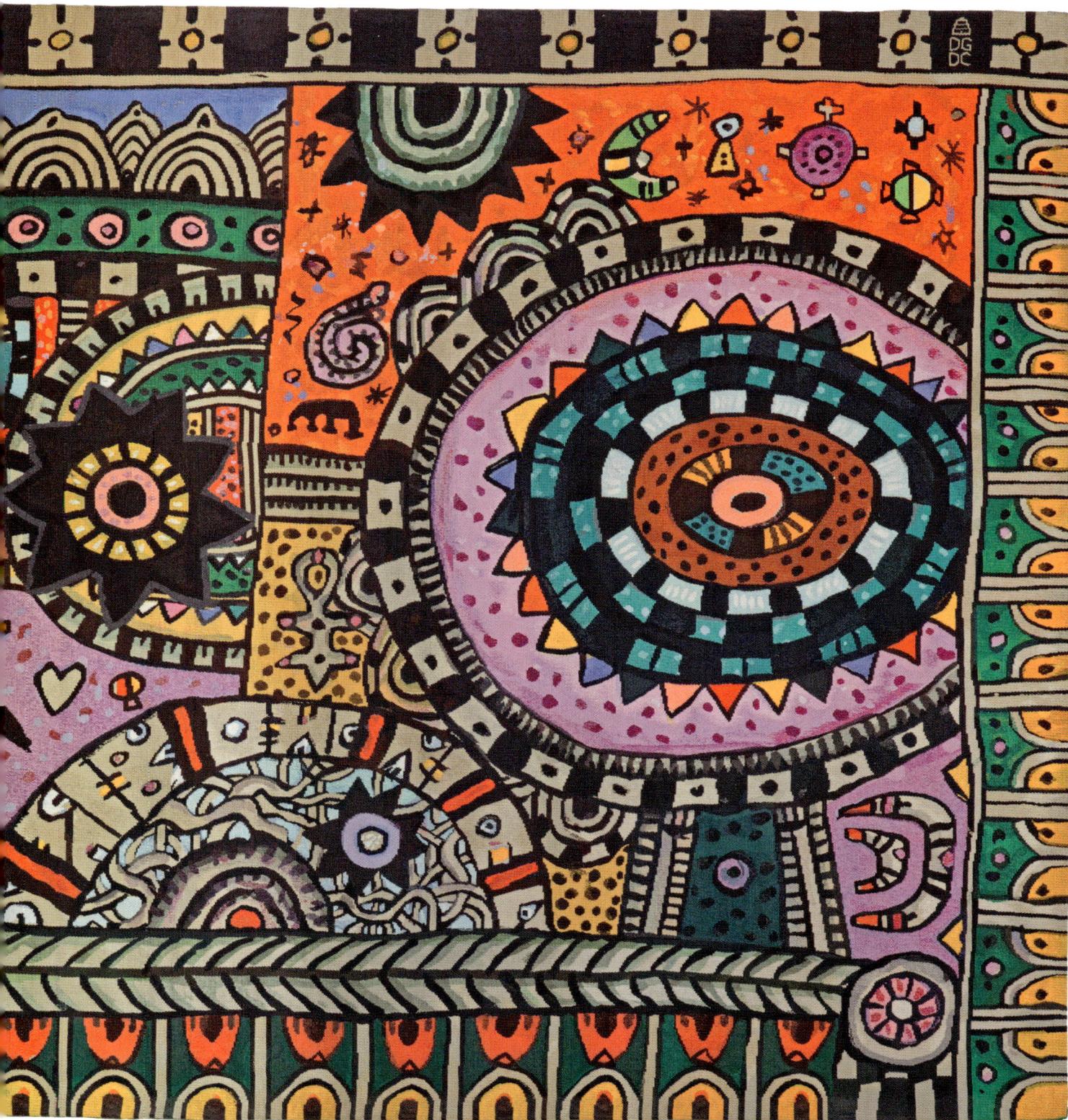

Plate 31

DOUGLAS GRIERSON

SUNSET OVER CORRIB 2004

Cotton warp, wool
114.5 × 166.5 cm (45 × 65½ in)
Dovecot Studios
Weaver: Douglas Grierson

In 2003 I spent a week fishing on the world-famous
Lough Corrib in Ireland at the time of the Mayfly.
The tapestry came about from an experience on the
Lough, one evening as the sun was going down. It was
so beautiful, very calm and warm and the light was
shimmering over the water. I took a picture of this
idyllic scene and sometime after tried to re-create the
atmosphere in weaving.

I have always been interested in the diversity of
geometric designs in pattern making from all cultures.
I decided to use a diamond pattern over the tapestry
to try to recapture the play of light and also in some
way break up the picture; this can give a different
experience of the tapestry when viewed close to or at a
distance. The real winners that evening were the fish: I
didn't catch any!
Douglas Grierson
Weaver 1961–2011, Studio Manager 1994–2000,
Head Weaver 2000–11

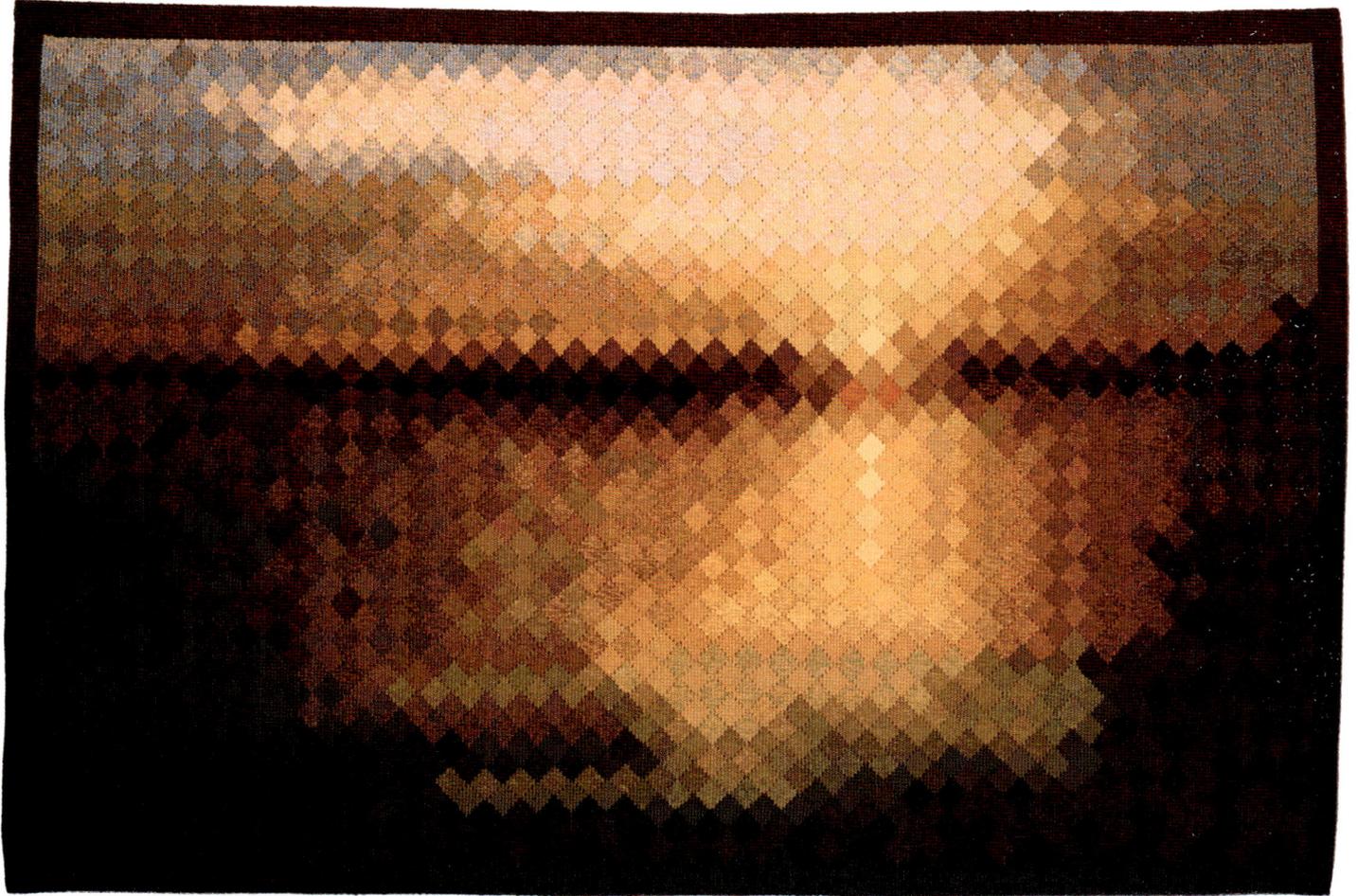

Plate 32

PATRICK CAULFIELD

PAUSE ON THE LANDING 2005

Cotton warp, wool
293 × 466.5 cm (115½ × 183¾ in)
The British Library
Weavers: David Cochrane, Douglas Grierson,
Naomi Robertson

'Is it not a shame to make two chapters of what passed in going down one pair of stairs?' So says Walter Shandy, the protagonist's father in Laurence Sterne's eighteenth-century comic novel *The Life and Opinions of Tristram Shandy, a Gentleman*. Despite Caulfield's Pop Art credentials, *Tristram Shandy* had always been his favourite book and he had even organised the performance of an excerpt in his home. The theme of time dominates the novel.

The tapestry's subject matter is an apt choice for a building which encourages people to enter and take part in reading, an activity which allows us to pause in our busy everyday lives. Just as the novel twists and manipulates our concept of linear time, so does Caulfield's design which refers to key elements in the story through emblematic imagery: Tristram's broken nose, the grandfather clock and Uncle Toby's military crutch. The tapestry is further disrupted by the two great tassels protruding out of it. The installation of the tapestry in 2005 marked the completion of architect Colin St John Wilson's vision for the British Library.
Francesca Baseby
Dovecot Gallery Manager 2008–10
Edinburgh University / Dovecot AHRC Collaborative
Doctoral Student 2010–

Sandy Wilson designed two spaces of the British Library quite specifically for tapestries. One was for the Kitaj in the main entrance hall, the other for Patrick Caulfield's tapestry on the landing halfway up the staircase leading to the library conference centre.

Patrick's picture, in acrylic on paper, was proposed as an idea for a tapestry in 1994 and exhibited at the Venice Biennale for architecture in 1996. Sandy Wilson was always determined to have the tapestry woven, but funding had to be found, and only 11 years later in 2005 did the weaving begin. First a large sample, almost a tapestry in itself, was woven to help us in deciding a manner of weaving and choosing the appropriate colours. These eventually had to be specially dyed. On the trial weave the background was woven in a flat colour. When we came to weave the tapestry I thought it would be more interesting to introduce some close mixtures into the background. Tassels were made for Uncle Toby's crutch which added a bit of fun. It is often the case that a tapestry with a few elements and not many colours can be most difficult to get right.

Unfortunately Patrick was not a well man during the weaving of the tapestry, but Sandy Wilson kept him informed with photos of the tapestry's progress.
Douglas Grierson
Weaver 1961–2011, Studio Manager 1994–2000, Head
Weaver 2000–11

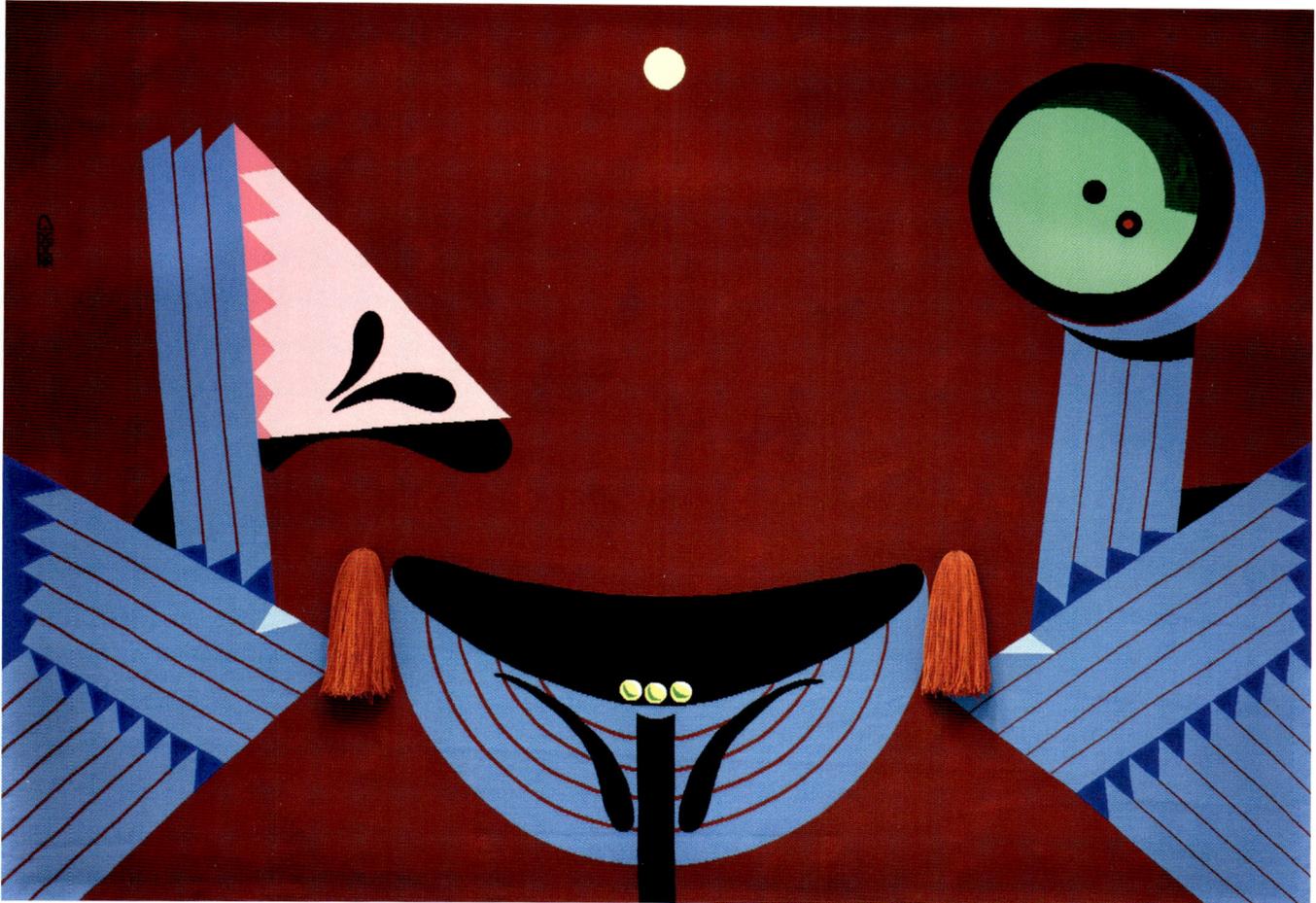

I have been collecting art for almost 20 years which, in 2003, inspired me to build my own art gallery in West Sussex. Soon after completion, the Pallant House Gallery in Chichester closed for some time whilst major renovation was going on and, looking to make better use of my new art gallery, I approached Stefan van Raay, the Director of Pallant House, to see if we could collaborate in some way.

Sandy Wilson, the architect in charge of the redevelopment of Pallant House, had a wonderful collection of twentieth-century British art, much of which he had either lent or donated to Pallant House.

This seemed in many respects to complement my own collection, particularly with Patrick Caulfield and Richard Hamilton, and so two exhibitions were staged at my gallery in conjunction with Pallant House: in July 2004 Patrick Caulfield, and in 2005 Richard Hamilton.

As a result of meeting and getting to know Sandy, he asked me to finance the making of the tapestry *Pause on the Landing*. As a huge fan of Patrick Caulfield, this I was more than happy to do.
Simon Draper
Private Collector

Plate 33

VICTORIA CROWE

TWO VIEWS 2007

Cotton warp, wool
244 × 122 cm (96 × 48 in)
Buccleuch Collection, Boughton House
Weavers: David Cochrane, Douglas Grierson,
Naomi Robertson

When Vicky [Crowe] and David [Weir] tentatively
sowed seeds with my wife and me for the
commissioning of a tapestry from one of her evocative
'A Shepherd's Life' series, they can little have anticipated
the fertile ground in which they would germinate.
Tapestry from the seventeenth century is one of the
most striking elements of the Buccleuch Collection,
and the notion of making a contemporary addition
hand-in-hand with an artist whose work we hugely
admire and whom we dearly love was at once appealing.

That it should be undertaken not only by Dovecot
but by some of the very hands that my parents had
known when they had been involved on the fringes
of a commission several decades earlier, made it all the
more poignant. Little, though, did we anticipate the
pleasure of seeing *Two Views* come to fruition – from a
wonderful rummage and ruminate in the artist's home,
to the early steps of the weaving, to the emotion of
the 'cutting off' ceremony. The result is miraculously
at once hers and theirs – a work of art that transports
us unerringly to the timeless routine of a shepherd
for all seasons in the Scottish Borders. Vicky's painting
is complex and the colours and tonality challenging,
but the weaving finds a new richness and power. *Two
Views* has no difficulty in holding its own amongst
masterpieces of earlier ages.
Richard Buccleuch

My exhibition 'A Shepherd's Life', originally curated
for the Scottish National Portrait Gallery's Millennium
programme, was re-gathered in 2009 for the Fleming
Collection. The tapestry *Two Views*, commissioned by
Richard Buccleuch and his family, was a major addition
to this London showing.

Most of the design aspects of the tapestry, which
closely followed the composition of the original
painting, were discussed with the weavers while
walking the area around Kittley Knowe where Jenny,
the eponymous shepherd, lived and worked. The feel of
the landscape, its bleached winter colour, its markings
and patterns and the small cottage windows were all
important to the weavers' emotional understanding of
this work. Warming up later in the Carlops pub, we
discussed how the glowing snow, transparent curtain
and dark, patterned interior could be interpreted by the
richly absorbent colours of woven wool.

It was a wonderfully distancing process to see the
tapestry, twice the size of the painting, being woven
vertically from the left side upwards. I was fascinated by
the weavers' mixing of numerous coloured plies into a
single thread, making a rich variant of colour.

I was so pleased to finally see the tapestry at
Richard's home softly hanging against a grey panelled
wall, bringing with it all that sense of place.

A subsequent development was a sampler piece
which master weaver David Cochrane and I worked on,
to be completed using only the greys, creams, whites
and browns of undyed wool, making a natural palette
for the Borders landscape in winter. I hope this is one
for the future.
Victoria Crowe

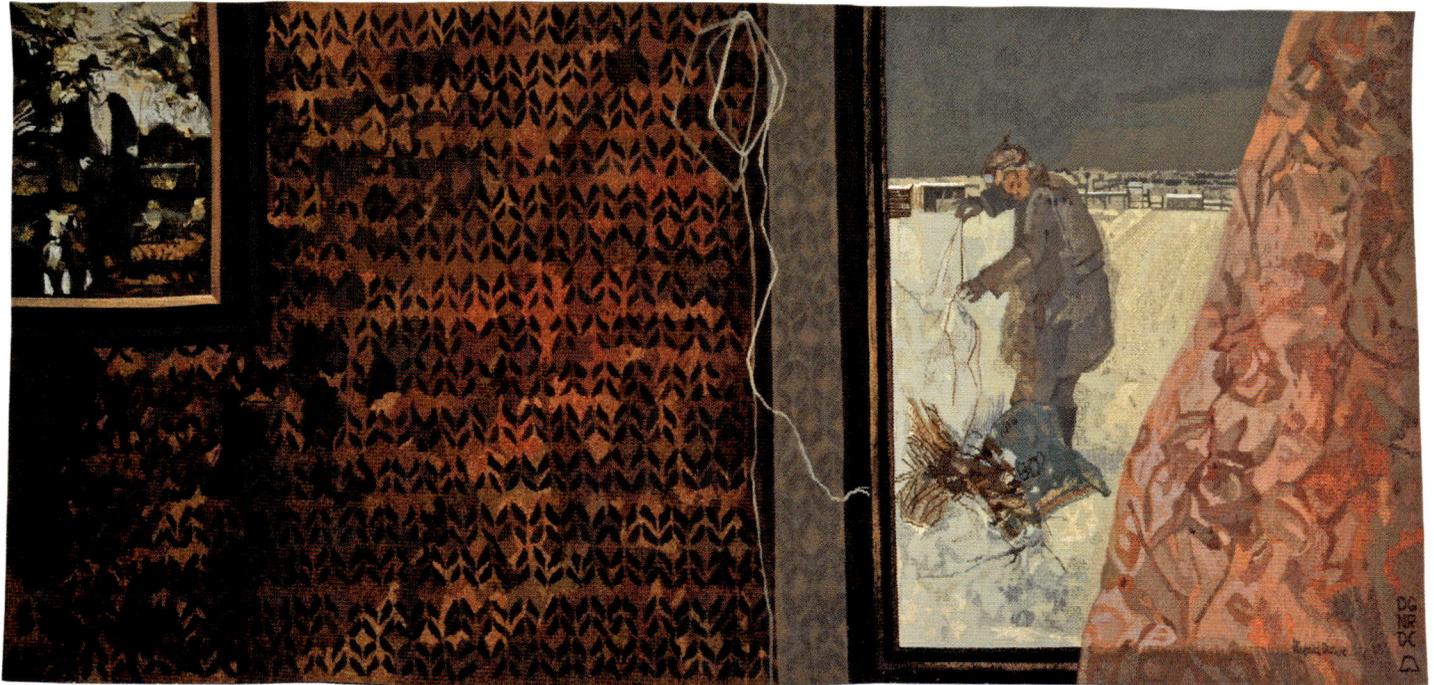

This was one of the last commissions we wove at the Donaldson's College studio. Vicky's paintings of Jenny Armstrong honoured her life as a shepherd, as her father had been before her. I remember going to see the exhibition and being captivated by these very moving pictures, but I never for the life of me thought that I would ever weave one.

David Weir asked me to select a painting. The composition of *Two Views* included a photograph of Jenny's father against a darkly patterned wallpaper with, to the viewer's right, a window looking on to a wintry snow scene with the shepherd feeding her sheep and a diaphanous curtain blowing across the window. It was quite a dark and very subtle painting. I don't think it was Vicky's first choice or the Duke's, but they decided to go with mine.

The way I wanted to approach the weaving was to imagine winter sunlight on the wallpaper bringing up the colours and tones of browns and golden honey yellows and ochres. Capturing the quality of the delicate pink curtain was also important, to play against the monochrome photograph and the snow scene. Some of the wools we used in the tapestry were original dyeings from before and after the First World War.

Vicky and her husband Mike Walton would invite the weavers to Kittley Knowe in the Pentlands for us to get the feel of the land where Jenny spent her life.
Douglas Grierson
Weaver 1961–2011, Studio Manager 1994–2000, Head Weaver 2000–11

Plate 34

CHRIS CLYNE

CORSET, HEADPIECE, SHOES 2008

Polyester cotton warp, wool, boning, pigskin, feather, wood
Corset 46 (with feather 153) × 32 × 24 cm
(18 (60¼) × 12½ × 9½ in)
Headpiece 28 × 46 × 34 cm (11 × 18 × 13½ in)
Shoes each 34 × 23 × 37 cm (13½ × 9 × 14½ in)
Dovecot Studios
Weaver: Naomi Robertson

When David Weir of Dovecot approached me to design and create the ultimate in wearable art in the form of a tapestry installation piece, it was a challenge I was unable to resist.

As a fashion designer, I have produced many Collections in addition to one-off commissions for clients, film, theatre and ballet, and this was an offer which I embraced with excitement, especially when world-class weaver Naomi Robertson was assigned to work with me. To begin with, I suggested a Corset and Headpiece, and the Shoes followed on later in a frivolous moment. Naomi had woven many flat wall pieces, but weaving diminutive pieces to form a Corset bodice was a task involving extraordinary patience and hundreds of hours of intense work.

Immediately we started, Naomi and I bonded as a team which led to mutual admiration for each other's creativity and a determination to produce completely original pieces of tapestry. Patterns were drawn up for the Corset consisting of 12 shaped pieces. Each piece was individually painted to reflect parrot-like colours creating the design for the tapestry work. From brightly coloured brushstrokes, Naomi ingeniously interpreted and wove the intricate pieces. The Headpiece and Shoe pattern pieces were also painted and woven in the same way.

Following months of weaving, all of the pieces were completed to meet a tight deadline and the delicate and time-consuming construction commenced. Like a jigsaw, the tiny pieces were hand-stitched together and placed onto a heavily boned silk satin under-corset, the design on the woven tapestry panels exactly matching the original painted pieces. The bright orange threads used in the weaving process were gathered into sections and incorporated into the finished design, some knotted and some with tassels. The back of the corset was laced

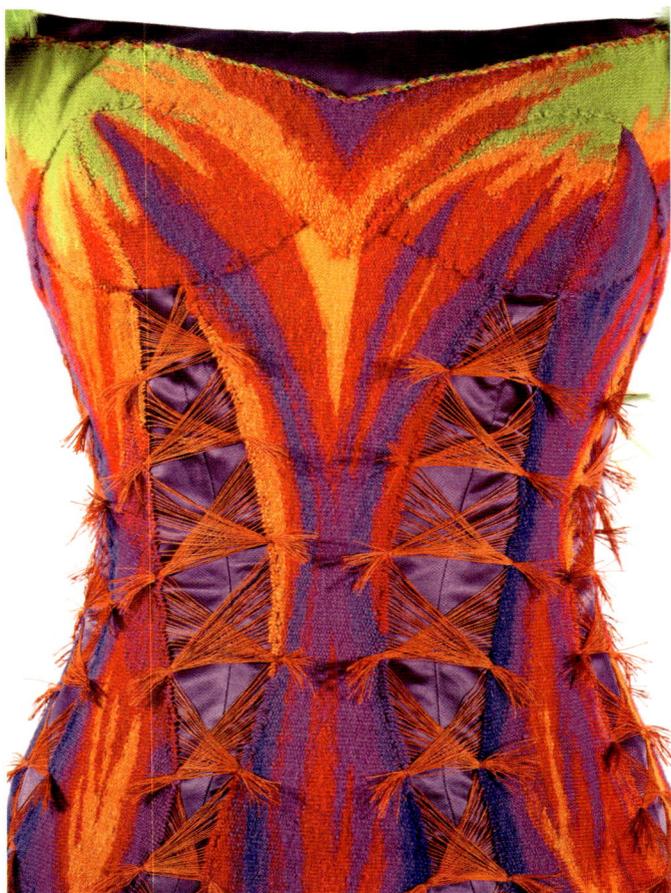

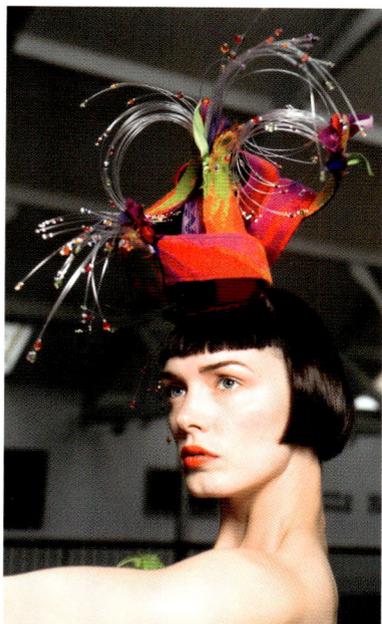

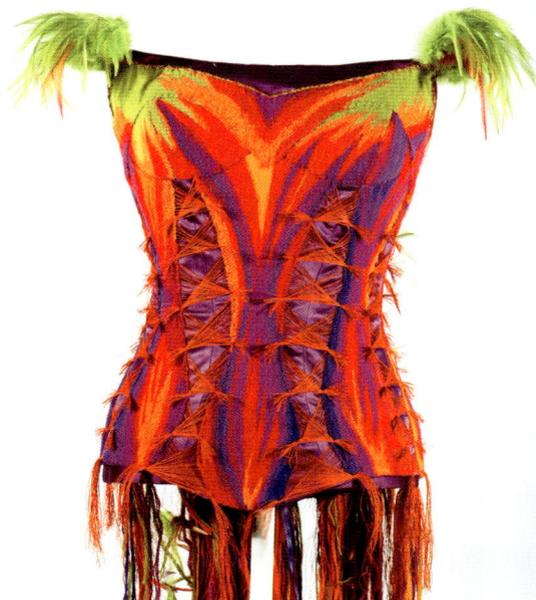

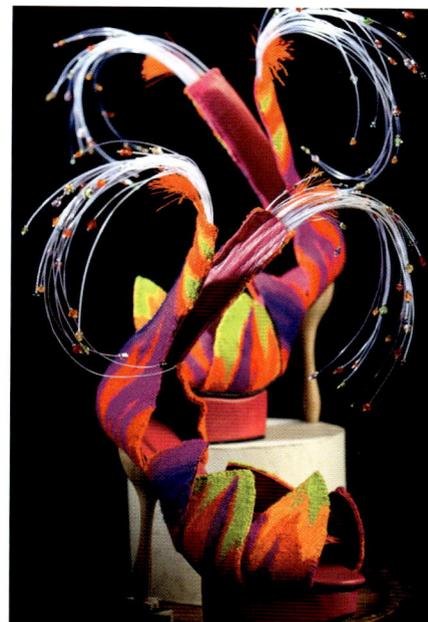

with orange pigskin and adorned with a flamboyant multicoloured wool bustle threaded with coloured feather tassels tied around miniature bobbins of varying sizes, replicas of the larger bobbins used in the weaving process.

The sections woven for the Headpiece, long strips of varying lengths, were stiffened with corset boning, backed with multicoloured strips of stitched satin and then twisted and shaped into exotic loops and curves. The Shoes were constructed from seven intricately woven pieces and built onto a platform with a fine wooden stiletto heel carved in the shape of a tapestry bobbin.

It has now become an iconic work. When worn by top model Tottie Greer, it created a huge stir as we both arrived at a London Fashion Week party held at the Victoria & Albert Museum. The cameras were rolling! Both Naomi and I enjoyed every moment of the unique construction process we shared – a collaboration of two artists working in very different media.
Chris Clyne
Chris Clyne Limited, Edinburgh & London

I enjoyed working with Chrissie Clyne, a lively and colourful character.

We were both determined to find a way to create a piece of tapestry that could be worn. This was a new concept for me, a cloth that could be sculpted and shaped into a wearable piece of clothing. Dovecot had previously worked with Joyce Conwy Evans on robe edgings such as those for the Wax Chandlers in 1969. These were tapestry panels stitched on to cloth.

The Corset was very fine, at 16 warps per inch. The warps, a strong bright orange thread rather than the usual cream cotton, were gathered into sections and incorporated in a decorative way into the finished design. The Corset was constructed by Chrissie and her team.
Naomi Robertson
Weaver 1990–98, 2003–

Plate 35

CLAIRE BARCLAY

QUICK, SLOW 2010

Painted steel, tapestry, wool, silk, linen, printed fabric,
machined brass
Sculpture dimensions 189 × 100 × 45 cm
(74¼ × 39¼ × 17¾ in)
Woven pice dimensions 73.7 × 58.4 cm (29 × 23 in)
Arts Council Collection, Southbank Centre, London
Weaver: David Cochrane

Claire Barclay's use of tapestry in this installation was
the first time Dovecot's weavers had produced a piece
which was to be absorbed into an artist's own work:
the artist's presentation of the tapestry was outside their
control. Barclay's freedom to manipulate the tapestry
element is what makes its subversive form so successful.
The traditional display of tapestries against a wall is
challenged with a work which is laid bare, loose threads
and warps left hanging. The tapestry has been freed
from the wall and placed in space, allowing the viewer a
three-dimensional experience of its nature.

Francesca Baseby
Dovecot Gallery Manager 2008–10
Edinburgh University / Dovecot AHRC Collaborative
Doctoral Student 2010–

In *quick, slow*, Barclay has drawn on the forms of the
workshop equipment and the weaver's method of
working. The metal framework is comparable to the
structures in other examples of her work, but here one
can infer the shapes of a sample-loom and of a weaver's
box seat. Similarly, protruding brass cones like the ones
in this sculpture have appeared in her work before as
a way of punctuating or complicating a structure, but
in this piece they also explicitly refer to the tips of
bobbins and fingers poking through warps. The tapestry
panel remains as a three-dimensional object, its weight
balanced by that of the untrimmed warp ends.

Barclay's image, repeated on the digitally printed
silk cloth, is of a continuous pattern repeat. It's an
intriguing design in that the weave structure of tapestry
is specifically adapted for making unique images rather
than repeating pattern. Although Barclay's image is of
a generic motif, each of the squares which make up
the overlapping design is individual in its detail and
is woven as such. Technically, it's a weave requiring
immense precision which master weaver David
Cochrane accomplished with great subtlety.

Jonathan Cleaver
Weaver 2008–

Plate 36

DAVID POSTON

M799 GREEN CIRCLES 2011

Viscose and stainless wire
20 × 21 × 18 cm (7¾ × 8¼ × 7 in)
Dovecot Studios
Weaver: Jonathan Cleaver

Recognising a likely synergy, David Weir and I were determinedly introduced by Amanda Game of Innovative Craft; we sparked and rapidly agreed an initial collaboration. Without any consultation I would make small, three-dimensional structures to which any interested Dovecot weavers would then be free to respond in their own way.

If tapestry weaving is about using flat pattern to generate interest in a two-dimensional surface, then the pre-existing interest of a third dimension might well challenge the weavers in interesting ways.

The excitement and pleasure of collaboration lie in the risk-taking and the necessary concomitant trust. The relinquishing of control is an essential validating element. Given the geographical separation there were a few tentative exploratory emails with Jonathan Cleaver, but he quickly accepted and enjoyed the responsibilities, the shared ownership of the piece, the decisions about colour, texture and which parts he should weave or leave.

I really enjoy the surprises of what Jonathan does with the starting points that I offer and our mutual pleasure in the process of collaboration, the quality of partnership and the outcomes. We are so different; with wonderful results he uses colours I would never consider. With the adventurous encouragement of Dovecot we hope to continue to work together on as large a scale as future commissions may allow. This three-dimensional tapestry integration has no limitations of scale or context and perfectly lends itself to architectural and natural environments. Functional considerations may even offer Jonathan colouring opportunities beyond the textile.

David Poston

The weaver writing to the artist during making:
'The green section was done with three colours of thread, like the grey piece you saw. I think it has produced a really good surface, glossy and somehow 'harder' and more harmonious with the metal ... I kept the design to a minimum and was guided by the way the light fell on the warps, emphasising it ...

'When you hold the thing in your hands the woven section is perhaps more evidently a patterned cloth than in the photos, but of course I have become used to looking at it very close up ...

'I think I've found a satisfactorily balanced arrangement of sections to weave, having started to think of it less as a terrain to be mapped and more like a Japanese flower arrangement ...

'The sense of navigating the structure has been with me all the time I've worked on it, especially since I made the map of the parts. I'm aware that both of us have spent hours minutely staring at its various planes and gaps ...

'You have literally looked microscopically at every point on it and I have walked the points of needles up and down some of the flights of warps like someone trying to square-dance their way out of an Escher drawing ... We've probably both worn it in most of the possible ways too, trying to get hands into the less accessible places ...'

Jonathan Cleaver
Weaver 2008–

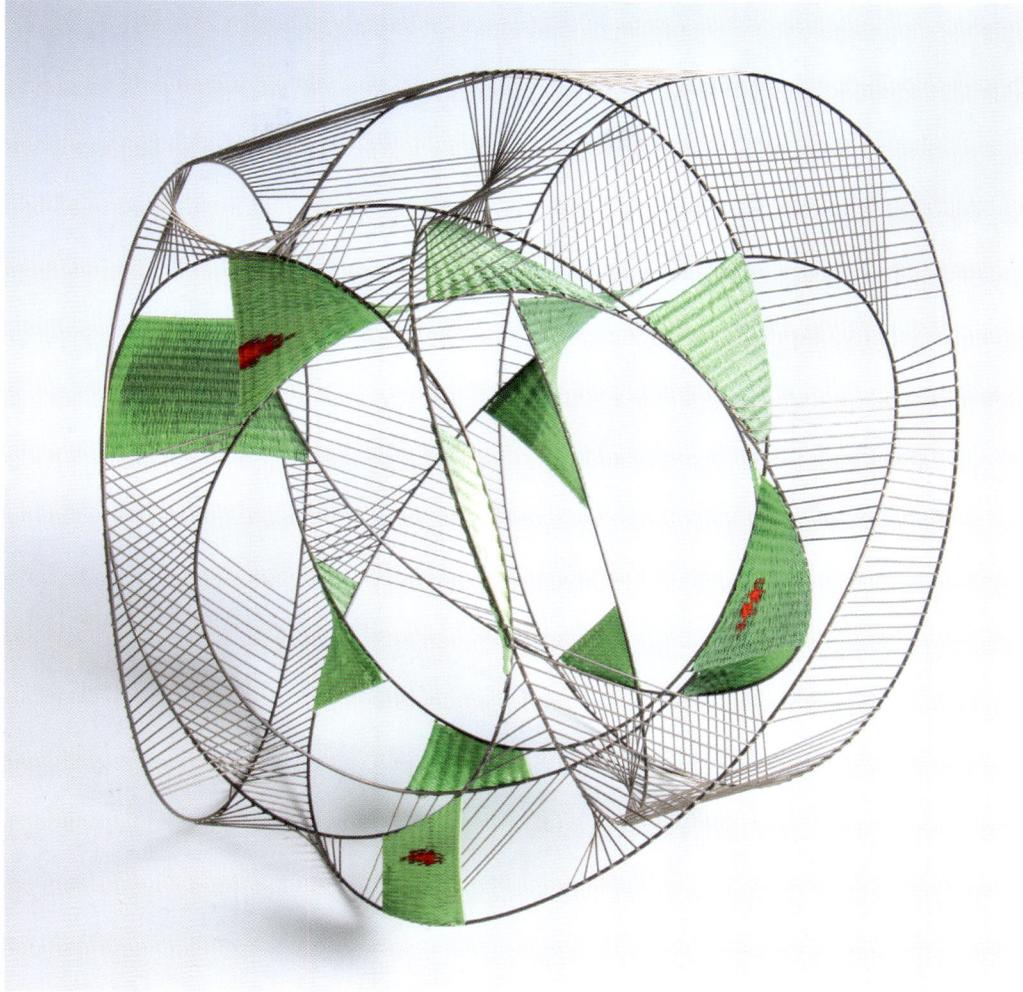

Although it opened at Dovecot in July 2010, I have to confess I didn't get to see 'Sitting and Looking' until it arrived at London's Somerset House a year or so later. Curated by Jim Partridge and Liz Walmsley, the show contained an eclectic collection of designers and disciplines, ranging from Ann Sutton's weaving to a sofa by the industrial designer Vico Magistretti. Its central idea was to encourage visitors to take their time over the exhibits: to use the furniture dotted around the floor plan to sit, inspect and contemplate.

To my mind the most striking work came from jewellery designer-cum-artist David Poston. Made from a combination of stainless-steel wire and cotton, his two pieces – called appropriately enough *Green Circles* and *Red Rectangles* – were made in collaboration with weaver Jonathan Cleaver and pulled off the trick of being both visually bold yet extremely subtle. While the strong, geometric shapes catch the eye from the other side of the room, it's only when you get closer that you can appreciate the extraordinary intricacy with which they were made.

In short I felt compelled to sit and look, extremely carefully – which, after all, was the very point of the exhibition.

Grant Gibson
Editor, Crafts

Plate 37

BARBARA RAE

FISHPOOL, LACKEN 2010

Cotton warp, wool
210 × 122 cm (82¾ × 48 in)
Dovecot Studios
Weavers: David Cochrane, Douglas Grierson,
Naomi Robertson

Douglas Grierson, then head weaver, chose *Fishpool*, a monotype from a series of images I had created from studies undertaken in the West of Ireland. The colours and composition greatly impressed him though he knew immediately translation from the monotype to loom, from ink to wool, was sure to be technically difficult. After a long discussion we agreed upon a banner-like form.

The image is highly indicative of what fascinates me: the symbols, mythology and history of a rural, windswept area to which I am constantly drawn, and the leaping salmon the marker of the Moy River in County Mayo. The underlying text in the imagery is a memory of folktales and inventories handed down, generation to generation. The monotype, a unique print on paper with additions of block-printed shapes, includes the Celtic spiral in addition to the salmon itself.
Barbara Rae

It is always a great pleasure working with Barbara. A tapestry or rug starts life with a visit to her studio, looking through her latest series of works. The choice can either be from an entire picture or maybe simply a small section from one.

Although Barbara likes tapestry she prefers to work with the rugs, and it is through this that we have formed a close working relationship. An early favourite of mine, *North Field*, was made for her exhibition at the Scottish Gallery, but the one that filled me with most trepidation was the 6-metre-wide [20-foot] circular rug for the Bute Room at the new Museum of Scotland. The rug had to be made in two pieces and joined, and was installed into a recess in the marble floor. For her *Carnival Edinburgh* tapestry, commissioned for the refurbished Festival Theatre, Barbara had painted several large canvases. That tapestry was donated by Alastair and Elizabeth Salvesen; at this time we had no idea how important their involvement was to be in the future of Dovecot Studios. *Fishpool, Lacken* is our latest work together, a speculative tapestry. Barbara's colour and composition is exciting for a weaver to translate.
Douglas Grierson
Weaver 1961–2011, Studio Manager 1994–2000, Head Weaver 2000–11

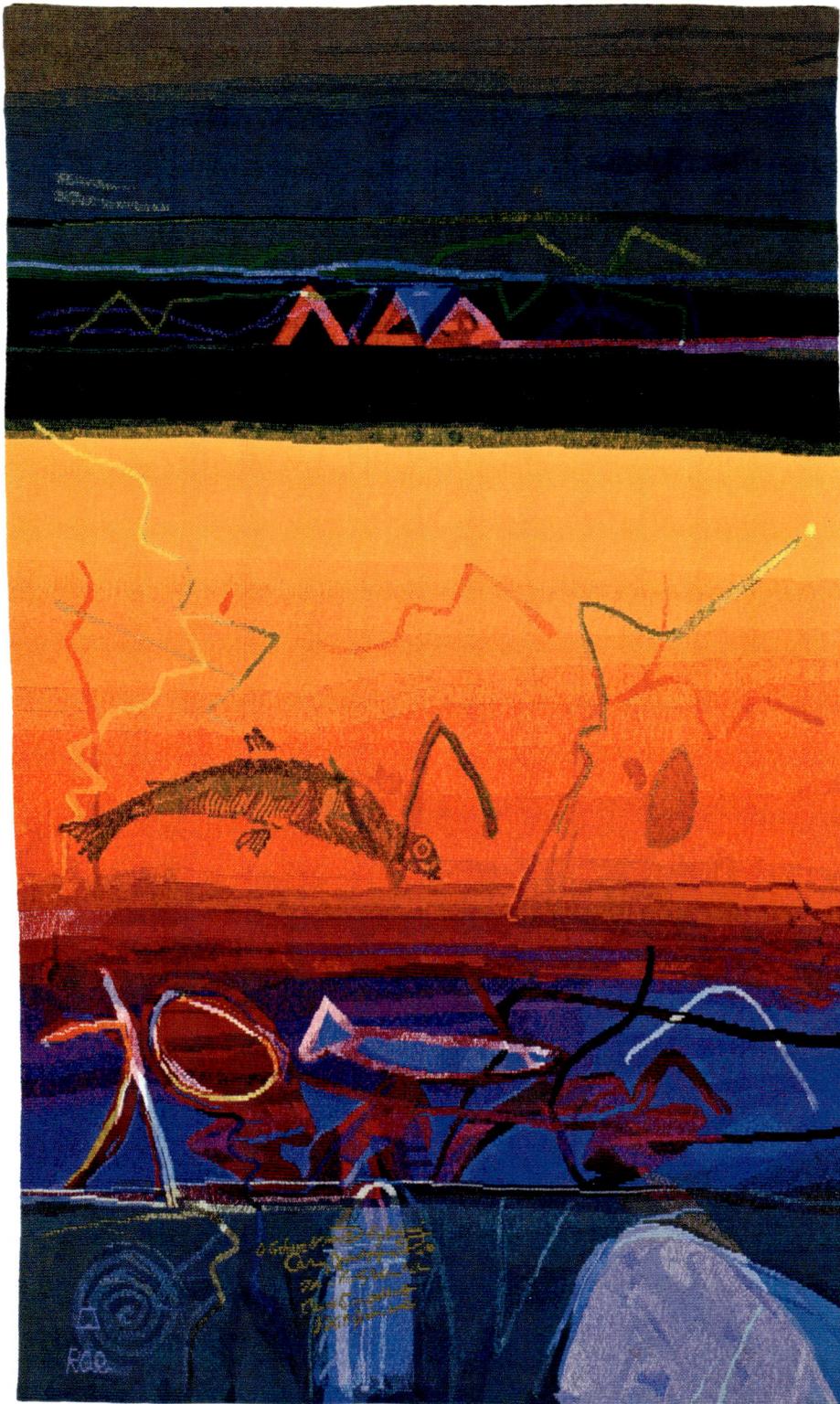

Plate 38

WILHELMINA BARNS-GRAHAM

WIND DANCE 2011

Wool
275 × 275 cm (108¼ × 108¼ in)
The Barns-Graham Charitable Trust, Balmungo House,
St Andrews
Weaver: Jonathan Cleaver

The Barns-Graham Charitable Trust was established by the renowned Scottish artist Wilhelmina Barns-Graham (1912–2004). In the recent remodelling of her family home as the Trust's administrative centre, the trustees decided early on that Balmungo House needed a focal

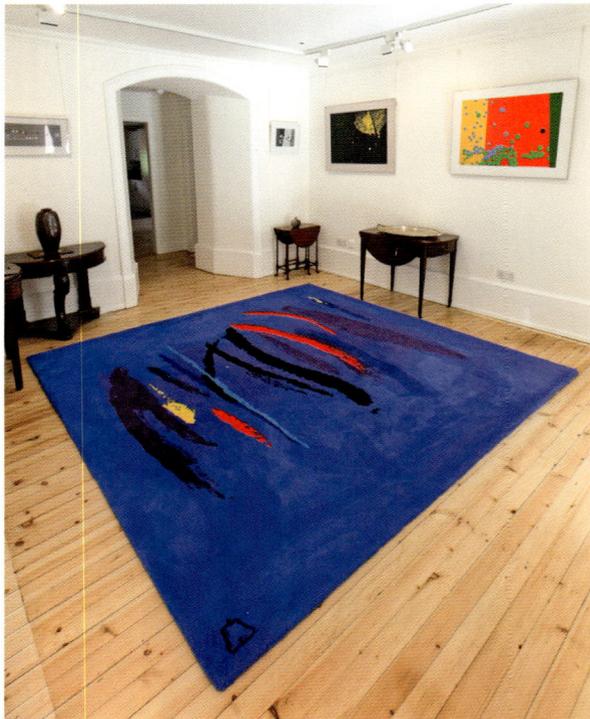

point for visitors on first entering the building. With the work of the Dovecot Studios being well known to several trustees, a decision was quickly reached to commission a rug for the front hall based on one of Wilhelmina Barns-Graham's images.

Early meetings with David Weir to discuss the commission proved highly valuable in determining the nature of the proposed rug, and it was agreed that he and the head weaver, Douglas Grierson, should visit the site before making a decision on the most appropriate design. Questions of scale and lighting could only be determined by the direct experience of standing in the hall. They were allowed a free hand to select the image from books and exhibition catalogues provided. In the end they opted for one of the artist's late works, a strongly coloured, vibrant screenprint in a square format deemed best suited for this particular space.

On the Trust's part, the project has been an easy collaboration. However we appreciate the remarkable lengths to which the weaver, Jonathan Cleaver, went in sourcing the right colours of wool. The completed rug, now installed, brilliantly captures the talents of both the artist and the weaver in a work that lights up the space for which it was intended.

Geoffrey Bertram
Chairman, The Barns-Graham Charitable Trust

The relationship between artist and weaver involved in the creation of a tapestry or rug is often emphasised when matters of interpretation are considered. In this project, which was commissioned posthumously by the artist's trustees, the relationship had to be built directly with the artwork. It was a privilege to spend weeks with the image, learning how its colour and tone work and how to communicate that in the carpet – the key

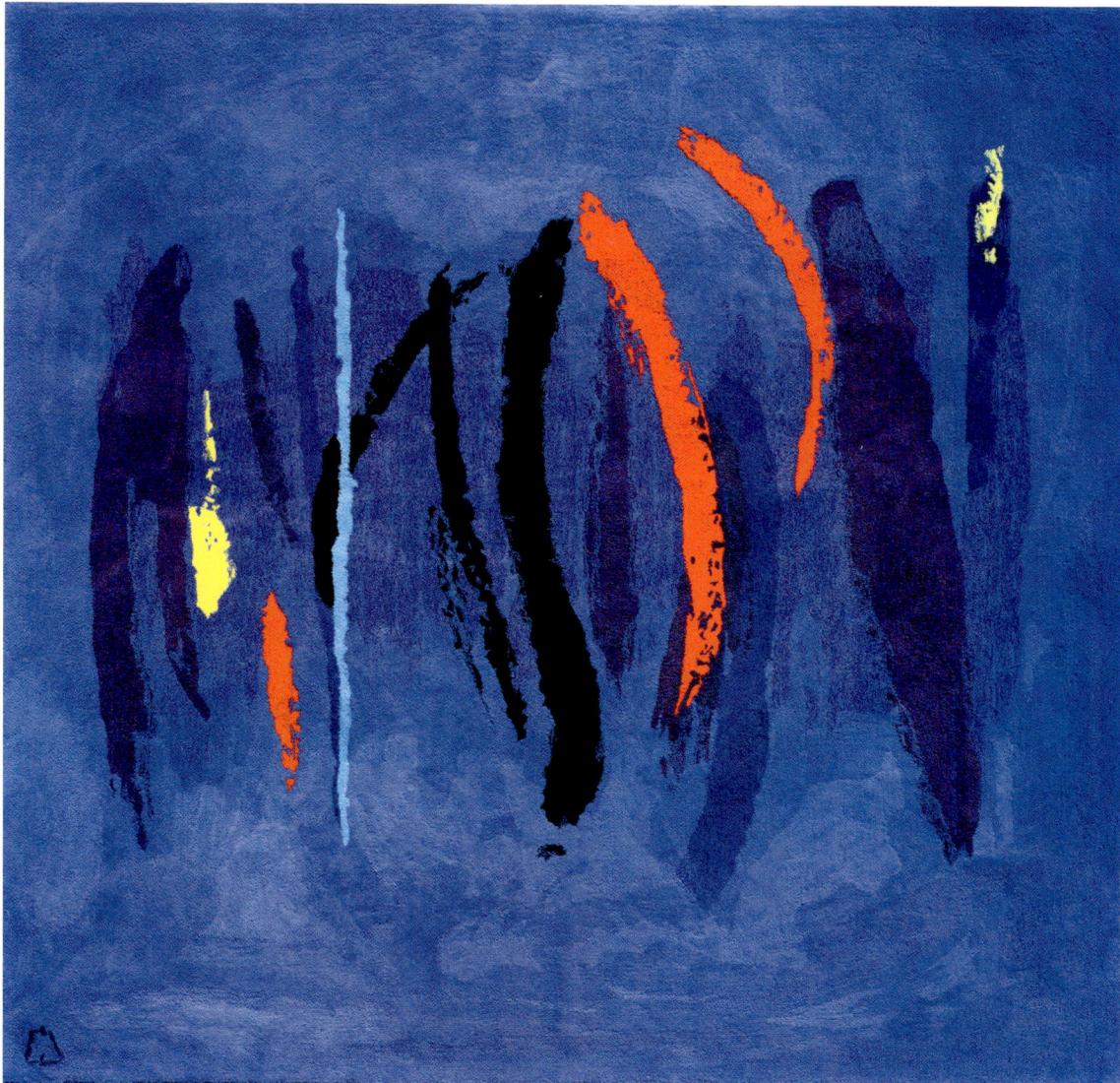

feature being intense colour combined with subtle tonal range. The blues proved so difficult to equal in wool that several custom dyeings were required.

At Dovecot, the approach to blending coloured yarns together in rug-tufting leads directly from experience gained in tapestry weaving. Single colours may be used but, more often, the variation and liveliness which mixed colours bring is preferred by the weavers. In *Wind Dance*, the reds are blended from wools which have a slightly more purple or orange bias. This sets off a quiver within the colour mix which is amplified by the saturated blue background. Similarly, the components of the pale blue stroke appear flat individually, but vibrant when mixed. Even the darkest black has navy-blue wool running through it to marry it to the background. Working through these mixes gives richness to both the appearance of the work and the maker's respect for the original artwork.

Jonathan Cleaver
Weaver 2008–

DOVECOT'S WEAVERS

John (Jack) Glassbrook
Gordon Berry
David Lindsay Anderson
Ronald Cruickshank
Richard Gordon
James Wood
Hadden Crawford
John Louttit
George Cribbes
Stanley Ebbutt
Alex Jack
Fred Mann
Ronnie McVinnie
Archie Brennan
Ian Inglis
Sydney Ramage
Harry Wright
Harry Whitmore
Douglas Grierson
Maureen Hodge
Fiona Mathison (also
 artistic director)
James Langan
Dot Callender

Erika Betty
Neil McDonald
Jean Taylor
Gordon Brennan
Ellen Lenvik
Belinda Ramson
Joan Baxter
Willie Jefferies
Johnny Wright
Annie Wright
Janette Wilson
Maggie Liddle (also
 artistic director)
Shirley Gatt
David Cochrane
Samantha Clark
Naomi Robertson
Valerie Dijkmen
John Brennan
Alice Shaw
Jonathan Ashworth
Jonathan Cleaver
Freya Sewell
Emily Fogarty

The people who actually make the tapestries are the weavers, and to do this effectively they need to have the confidence of the director, artist and client, and be expected to use all their skills and technical abilities, not just weave in a manner akin to painting by numbers. The Edinburgh Tapestry Company was always very aware that what was being produced was something entirely new, not just a woollen copy of paint on paper. If this is not understood, the result is usually a rather lifeless piece of work. When a cartoon is enlarged, there is an area between the size of the original design and the new cartoon which has to be reinvented; if the design is blown up ten times then there is a space between 0 and 10 which in mark terms doesn't exist. Alongside this the lines have to be scaled up too, the density of colour intensified, marks redefined in weaving terms and so on. To give one example: if colour is merely matched to that on the small original sketch it will appear very insipid in a much larger tapestry. That is why the weavers are striving to produce the *sum* of the cartoon, not simply copy each passage individually. How the colours interact, the quality and character of the lines, the overall mood and atmosphere of the cartoon all have to be orchestrated so in the end the *spirit* of the original has been captured.

Maureen Hodge
Weaver 1964–73
Head of Tapestry Department, latterly Intermedia, Edinburgh College of Art 1973–2006

LIST OF TAPESTRIES AND CARPETS

Completion date of individual tapestries (including series)	Title	Designer or Artist	Medium	Location
1924	*The Lord of the Hunt*	William Skeoch Cumming	Tapestry	The Bute Collection at Mount Stuart
1926	*The Duchess of Gordon*	William Skeoch Cumming	Tapestry	The Bute Collection at Mount Stuart
1930	*The Admirable Crichton*	Alfred Priest	Tapestry	The Bute Collection at Mount Stuart
1933	*Prayer before Victory, Prestonpans*	William Skeoch Cumming	Tapestry	The Bute Collection at Mount Stuart
1936	*The Time of the Meeting*	William Skeoch Cumming, Paul Woodroffe	Tapestry	The Bute Collection at Mount Stuart
1938	*Veráure Piece*	Alfred Priest	Tapestry	The Bute Collection at Mount Stuart
started 1938	*The Prince of the Gael* (aka *Glenfinnan*, also *The Raising of the Standard*)	William Skeoch Cumming, Paul Woodroffe	Tapestry	The Bute Collection at Mount Stuart
1946	*Ia Orana Maria*	after Paul Gauguin	Tapestry	National Museum of Scotland
1947	*The Wine Press*	Frank Brangwyn	Tapestry	Unknown
1947	*Celtic Pastoral*	Donald Moodie	Tapestry	Private Collection
c.1947/8	*Jacob Wrestling with the Angel (The Vision after the Sermon)*	after Paul Gauguin	Tapestry	Unknown
1948	Stein carpet	Francis Rose	Carpet	Unknown
1948	*Tinkers*	Louis Le Brocquy	Tapestry	Private Collection
1948	*The Lion and the Oak Tree*	Sax Shaw	Tapestry	Private Collection
1948	3 carpets	Francis Rose	Carpets	Private Collection
1948	Chair backs	Lady Jean Bertie	Tapestry	Private Collection
1948	*Pastoral* (aka *Decorative Panel*, also *Hammersmith Garden*)	Julian Trevelyan	Tapestry	Private Collection
1948	Chair seats	Ronald Cruickshank	Tapestry	Private Collection
1948	Chair seat (*Tulip*)	Cecil Beaton	Tapestry	National Museum of Scotland
1948	5 chair seats	John Louttit	Tapestry	Private Collection
1949	*Seated Woman*	Jankel Adler	Tapestry	Private Collection
1949	*Marine Still Life* (aka *Stars and Shells*)	Edward Wadsworth	Tapestry	Private Collection
1949	Stool cover	Francis Rose	Tapestry	Private Collection
1949	*Madonna of the Sea* (aka *Ave Maria*)	John Armstrong	Tapestry	Private Collection
1949	*Kent Caverns*	Princess Fahrelnissa Zeid-el-Hussein	Tapestry	Private Collection
1949	Carpet for Whytock & Reid	Design supplied	Carpet	Unknown
1949	*The Gardener* (aka *A Man with Cabbages*, also *Chestnuts*)	Stanley Spencer	Tapestry	Private Collection
1949	*The Garden of Fools*	Cecil Collins	Tapestry	Unknown
1949	*Wading Birds*	Graham Sutherland	Tapestry	Vancouver Art Gallery
1949	*Crucifixion*	Francis Rose	Tapestry	Unknown
1950	*Three Figures*	Henry Moore	Tapestry	Unknown
1950	*Fighting Cocks*	Sax Shaw	Tapestry	Private Collection
1950	*Recumbent Figure* (aka *Blue Bowl*, *Reclining Figure*)	Ronald Searle	Tapestry	Private Collection
1950	Arms of HM Queen Elizabeth	Stephen Gooden	Tapestry	HM Queen Elizabeth
1950	Carpet	Graham Sutherland	Carpet	Private Collection
1950	*Dahlias*	Ronald Cruickshank	Tapestry	Unknown
1950	*Farming*	Edward Bawden	Tapestry	Victoria & Albert Museum
1950	*The Butterflies*	Michael Rothenstein	Tapestry	Private Collection
1950	*Tiger Rug I*	Don Pottinger	Tapestry	Private Collection
1950	Chair seats for Edinburgh Public Library	Design supplied	Tapestry	Edinburgh Museums and Galleries
1950	*Bird of Paradise*	Robert Stewart	Tapestry	Unknown
1951	6 chair seats (British tree designs)	Louis Le Brocquy	Tapestry	Private Collection
1951	*Phoenix*	Humphrey Spender	Tapestry	Private Collection
1951	4 chair seats for Festival of Britain	Bianca Minns	Tapestry	Unknown
1951	Carpet for Festival of Britain	Bianca Minns	Carpet	Unknown
1951	*Sea Piece* (aka *Echinoderms*)	Eileen Mayo	Tapestry	Private Collection
1951	*Scottish Landscape*	Alexander Williamson	Tapestry	Unknown
1951	*Cacti*	Dore Usher	Tapestry	Private Collection
1951	Carpet	Stephen Gooden	Carpet	Unknown
1952	*Bull's Head*: sample for Coventry Cathedral Tapestry (aka *Head of Beast*)	Graham Sutherland	Tapestry	Private Collection
1952	Carpet	Dore Usher	Carpet	Unknown
1952	*St John* (apprentice piece)	Fred Mann	Tapestry	Private Collection
1952	Carpet	Princess Fahrelnissa Zeid-el-Hussein	Carpet	Private Collection
1952	Furness coat of arms	Don Pottinger	Tapestry	Unknown
c.1952	*Capricorn*	Stephen Gooden	Tapestry	Unknown
1952	Chair backs	Stephen Gooden	Tapestry	Private Collection
1952	*Tiger Rug II*	Don Pottinger	Carpet	Private Collection
c.1952	*Fools of Summer*	Archie Brennan	Tapestry	Unknown
c.1952–3	Chair seat, the design incorporating a lion rampant	Unknown	Tapestry	National Museum of Scotland

Year	Title	Designer	Type	Location
1953	Water Carrier	Archie Brennan	Tapestry	Private Collection
1953	Bertie coat of arms	Don Pottinger	Tapestry	Private Collection
1953	Hogg coat of arms	Don Pottinger	Tapestry	Unknown
1953	Pheasant	John Louttit	Tapestry	Private Collection
1953	Saltire flag	Don Pottinger	Tapestry	Unknown
1953	Greys rug	Ronald Cruickshank	Carpet	Unknown
1953	Tiger Rug III	Don Pottinger	Carpet	Unknown
1953	Butterflies	Sax Shaw	Tapestry	Unknown
c.1953	Lined figure rug	Archie Brennan	Carpet	Unknown
c.1953	Celtic animal rug	Archie Brennan	Carpet	Unknown
c.1953	Red and white rug	Ronald Cruickshank	Carpet	Unknown
c.1953	2 floral rugs	Ronald Cruickshank	Carpet	Unknown
c.1953	Watered rug	Richard Gordon	Carpet	Unknown
c.1953	Geometric rug	Fred Mann	Carpet	Unknown
c.1953	Grey, white and pink rug	Richard Gordon	Carpet	Unknown
c.1953	Green, grey and brown rug	John Louttit	Carpet	Unknown
c.1953	Seated Figure with Jug	Harry Wright	Carpet	Unknown
c.1953	Fruit Seller	Harry Wright	Carpet	Unknown
c.1953	Indian rug	Harry Wright	Carpet	Unknown
c.1953	Fishing Birds	Harry Wright	Carpet	Unknown
c.1953	Reclining Figure	Archie Brennan	Tapestry	Private Collection
c.1953	Celtic Design (Birds)	Archie Brennan	Tapestry	Unknown
c.1953	Shepherd Boy	Archie Brennan	Tapestry	Unknown
c.1953	Striped rug	Ronald Cruickshank	Tapestry	Unknown
c.1953	6 abstract rugs (set)	Archie Brennan	Tapestry	Unknown
1954 –7	Yellow Bird	Sax Shaw	Tapestry	Unknown
1954	Harlequin	Fred Mann	Carpet	Unknown
1954	Lord Trent coat of arms	Don Pottinger	Tapestry	Unknown
1954	Stuart coat of arms	Don Pottinger	Tapestry	Unknown
1954	Cockatoo	John Louttit	Tapestry	Private Collection
1954	Fishers	John Louttit	Tapestry	Private Collection
1954	Woman with Jug (aka Water Carrier)	Archie Brennan	Tapestry	Private Collection
1954	Figure and Sickle	Archie Brennan	Tapestry	Unknown
1954	Abstract	John Louttit	Tapestry	Unknown
1954	St Mark	Sax Shaw	Tapestry	Unknown
1954	St Luke	Sax Shaw	Tapestry	Private Collection
1954	St John	Sax Shaw	Tapestry	Private Collection
1954	Two Foxes	Sax Shaw	Tapestry	Unknown
1954	Cockerel	Sax Shaw	Tapestry	Unknown
1954	Pulpit fall (Burning Bush)	Don Pottinger	Tapestry	Unknown
1954	Pulpit fall (PAX)	Don Pottinger	Tapestry	Unknown
1954	Pulpit fall (Cross)	Don Pottinger	Tapestry	Unknown
1954	Pulpit fall (Cross)	Don Pottinger	Tapestry	Unknown
1954	Towsy Tyke	Sax Shaw	Tapestry	Private Collection
1954	Abstract blue and white	Sax Shaw	Tapestry	Unknown
1954	Eagle of St John	Sax Shaw	Tapestry	Unknown
1954 –7	Over 20 chair seats	Sax Shaw	Tapestry	Ardkinglas Collection, Private Collections
1955	8 pulpit falls (thistle design)	Sax Shaw	Tapestry	Unknown
1955	Night and Day	Sax Shaw	Tapestry	Unknown
1955	Flame (chair seat)	Sax Shaw	Tapestry	Unknown
c.1954 –6	Butterfly	Sax Shaw	Carpet	Unknown
c.1954 –6	Flower Pot	Sax Shaw	Carpet	Unknown
c.1954 –6	Christmas Leaf	Sax Shaw	Carpet	Unknown
c.1954 –6	Twigs	Sax Shaw	Carpet	Unknown
c.1954 –6	Twigs (with border)	Sax Shaw	Carpet	Unknown
c.1954 –6	Candle Flame	Sax Shaw	Carpet	Unknown
c.1954 –6	Persian Trees	Sax Shaw	Carpet	Unknown
c.1954 –6	Birds with Foliage	Sax Shaw	Carpet	Unknown
c.1954 –6	Mexico	Sax Shaw	Carpet	Unknown
1955	St Matthew	Sax Shaw	Tapestry	Private Collection
1955	St John	Sax Shaw	Tapestry	Unknown
1955	St Luke	Sax Shaw	Tapestry	Unknown
1955	Liberty coat of arms	Design supplied	Tapestry	Liberty, London
1955	Georgian Building	Peter Shepherd with Sax Shaw	Tapestry	Martins Bank, London
1955	Celtic Figures	Sax Shaw	Tapestry	Unknown
1955	Piper and Dancer	Sax Shaw	Tapestry	Rolls-Royce
1955	Two Foxes	Sax Shaw	Tapestry	Private Collection
1955	Light and Day (Aether and Hemera)	Nadia Benois	Tapestry	National Museum of Scotland
1955	Sunshine and Showers (aka Wet and Dry)	Sax Shaw	Tapestry	National Museum of Scotland
1955	Noble carpet	Nadia Benois	Carpet	Ardkinglas Collection
1956	Mille Fleurs	Sax Shaw	Tapestry	Unknown
1956	Pantry Larder	Sax Shaw	Tapestry	Unknown
1956	Theseus and the Minotaur	Sax Shaw	Tapestry	Private Collection
1956	Music panel	Sax Shaw	Tapestry	Private Collection
1956	3 church panels	Sax Shaw	Tapestry	Unknown
1956	Christ Carrying Cross	Walter Pritchard	Tapestry	Unknown
1956	3 samples for Coventry Cathedral	Graham Sutherland	Tapestry	Unknown
1956	Mulberry Bush	Sax Shaw	Tapestry	Private Collection
1957	The Lamb of God	Sally Pritchard (Sadie McLellan)	Tapestry	Cambuslang Parish Church
1957	Still Life	Sax Shaw	Tapestry	Private Collection
1957	Pulpit fall	Sally Pritchard (Sadie McLellan)	Tapestry	Cambuslang Parish Church
1957	The Women of Jerusalem	Walter Pritchard	Tapestry	Cambuslang Parish Church
1957	Celtic Beasts	Sax Shaw	Tapestry	Unknown
1957	Cappers Room tapestry	Sax Shaw	Tapestry	Coventry Cathedral
1957	Coat of arms	Sax Shaw	Tapestry	Unknown
1957	Altar frontal (Blacadder Tapestry)	Sax Shaw	Tapestry	Glasgow Cathedral
1957	Fox and Hens (aka Red Raider)	Sax Shaw	Tapestry	Private Collection
1957	Burning Bush	Sax Shaw	Tapestry	Unknown
1958	Fox and Hen border	Sax Shaw	Tapestry	Private Collection
1958	American Ships	Mrs G. Agranat	Tapestry	Unknown
1958	Eagle (Red, Green and Black)	Graham Sutherland	Tapestry	Victoria & Albert Museum

Year	Title	Designer	Type	Location
1958	*The Cycle of Life*	Sax Shaw	Tapestry	City Art Centre, Edinburgh Museums and Galleries
c.1958	*Re-entry*	Sax Shaw	Tapestry	Christian Salvesen
1958	Gould memorial tapestry	Canon West, Cathedral of St John the Divine, New York	Tapestry	St Thomas's Episcopal Church, New York
1958	*Phases of the Moon*	John Maxwell	Tapestry	Aberdeen Art Gallery & Museums Collections
1959	Arms of the Leathersellers	Robin and Christopher Ironside	Tapestry	Leathersellers' Hall, London
1960	*Space*	Hans Tisdall	Tapestry	Aston University
1960	*Time*	Hans Tisdall	Tapestry	Aston University
1961	*The Risen Christ*	Sally Pritchard (Sadie McLellan)	Tapestry	Cambuslang Parish Church
1961	*The Golden Lion*	Hans Tisdall	Tapestry	Unknown
1961	Crombie coat of arms	existing design worked by Harry Jefferson Barnes	Tapestry	J&J Crombie, Aberdeen
1962	Wallace coat of arms	existing design worked by Harry Jefferson Barnes	Tapestry	Private Collection
1962	2 kneelers	Unknown	Tapestry	Unknown
1962	*Abstract*	Harry Wright	Tapestry	Unknown
1962	Armorial (Wallace) and landscape, 1st panel	Harry Jefferson Barnes	Tapestry	Private Collection
1962	*Music* (aka *Lotus*)	Harry Jefferson Barnes	Tapestry	Ardkinglas Collection
1962	*Armada*	Hans Tisdall	Tapestry	University of Edinburgh
1962	*Thistle, Rose and Daffodil*	Harry Jefferson Barnes	Tapestry	Private Collection
1962	*Cockerel*	Archie Brennan after Gordon Huntly	Tapestry	Unknown
1962	*Spirit of Dance*	Joyce Conwy Evans	Tapestry	Hilton Hotel, London
1963	*Gloucestershire Tapestry*	Hans Tisdall	Tapestry	Gloucestershire College
1963	*Florence*	Harry Jefferson Barnes	Tapestry	Unknown
1963	*The Elements*	Hans Tisdall	Tapestry	University of Manchester (on loan to Whitworth Art Gallery)
1963	*Ants* (aka *Desert*) (2 panels)	Harry Wright	Tapestry	Private Collection
1963	4 chair seats for Hayfields	M.R. Coats	Tapestry	Private Collection
1963	*Grey Cockerel*	Archie Brennan	Tapestry	Unknown
1964	Tapestry and pulpit falls	Jerzy Faczynski	Tapestry	Metropolitan Cathedral of Christ the King, Liverpool
1964	Crucifix	Jerzy Faczynski	Tapestry	St Mary's Priory, Preston
1964	*Geiger Panel*	Archie Brennan	Tapestry	Private Collection
1964	*Boquhan Tapestry*	Harry Jefferson Barnes	Tapestry	Private Collection
1964	*Abstract*	Alan Reynolds	Tapestry	Clydesdale Bank, London
1964	*Aberdeen '64*	Archie Brennan	Tapestry	Aberdeen Art Gallery & Museums Collections
1964	Armorial (Wallace) and landscape, 2nd panel	Harry Jefferson Barnes	Tapestry	Private Collection
1964	*Man in the Moon I*	Hans Tisdall	Tapestry	Unknown
1964	*Music*	Stanley Spencer, Harry Jefferson Barnes	Tapestry	Private Collection
1965	*Crucifix*	Archie Brennan	Tapestry	St John's Kirk, Perth
1965	*Man in the Moon II*	Hans Tisdall	Tapestry	Unknown
1965	Untitled	Archie Brennan	Tapestry	Unknown
1965	*Chance Tapestry*	Harry Jefferson Barnes	Tapestry	Private Collection
1965	Glastonbury panels (2)	Alan Barlow	Tapestry	Glastonbury Abbey
1965	Bearsden Church tapestry	Archie Brennan	Tapestry	Old Kilpatrick Church
1965	*The Elements*	Joyce Conwy Evans	Tapestry	Eastbourne Waterworks Co.
1965	*Dove*	Archie Brennan	Tapestry	Unknown
1966	*Shorescape Mizzen*	Hans Tisdall	Tapestry	Private Collection
1966	BP Tapestry	Harold Cohen	Tapestry	BP London
1966	*Flight into Egypt*	Archie Brennan	Tapestry	National Museum of Scotland
1966	Untitled	Charles Mitchell	Tapestry	Private Collection
1966	Spital Farm tapestry	Archie Brennan	Tapestry	Private Collection
1966	Untitled	Harold Cohen	Tapestry	Edinburgh Museums and Galleries
1966	*Still Life (Tulips)*	Elizabeth Blackadder	Tapestry	Unknown
1966	Rug	Harry Jefferson Barnes	Carpet	Unknown
1966	*Edinburgum Scotiae Metropolis*	Archie Brennan	Tapestry	Banqueting Hall, Edinburgh Castle
1966	*London & Edinburgh Insurance Tapestry*	Archie Brennan	Tapestry	Unknown
1966	Chair seat, back and arms	Joyce Conwy Evans	Tapestry	Worshipful Company of Furniture Makers
1967	Motherwell and Wishaw Civic Centre tapestry	Archie Brennan	Tapestry	Motherwell and Wishaw Council
1967	*Overall*	Harold Cohen	Tapestry	Victoria & Albert Museum
1967	*Woodthorpe*	Joyce Conwy Evans	Tapestry	The Artist
1967	Corstorphine pulpit fall	Sax Shaw	Tapestry	Corstorphine Parish Church
1967	*Mickey Mouse*	Eduardo Paolozzi	Tapestry	Scottish National Gallery of Modern Art
1967	*Twa Corbies*	Archie Brennan	Tapestry	BBC Glasgow
1967	Royal College of Art robe edgings	Joyce Conwy Evans	Tapestry	Royal College of Art
1967	Trumpet tabard	Joyce Conwy Evans	Tapestry	Royal College of Art
1968	*Whitworth Tapestry*	Eduardo Paolozzi	Tapestry	Whitworth Art Gallery, University of Manchester
1968	Modern Art Gallery tapestry	Elizabeth Blackadder	Tapestry	Scottish National Gallery of Modern Art

Year	Title	Designer	Type	Location
1968	Newcastle coat of arms	Harry Jefferson Barnes	Tapestry	Newcastle Civic Centre
1968	Montreal Metro tapestry	Kenneth McAvoy	Tapestry	University of Montreal
1968	Untitled	Kenneth McAvoy	Tapestry	Private Collection
1968	Chair seat and back	Archie Brennan	Tapestry	Creative Scotland
1968	3 rugs	Joyce Conwy Evans	Rugs	Private Collection
1968	McDonald crest	Design supplied	Tapestry	Unknown
1968	Altar frontal for King's College Chapel, Cambridge	Joyce Conwy Evans	Tapestry	King's College Chapel, University of Cambridge
1968	Vestments for King's College, Cambridge	Joyce Conwy Evans	Tapestry	King's College Chapel, University of Cambridge
1969	*Berlioz Tapestry*	Gustav Doré	Tapestry	Private Collection
1969	*Midlothian County Map*	Archie Brennan	Tapestry	Lothian Council
1969	Two banners	Archie Brennan	Tapestry	Unknown
1969	*Progression*	Archie Brennan	Tapestry	Unknown
1969	*Collector's Pieces*	Archie Brennan	Tapestry	Destroyed
1969	Altar frontal for side chapel, King's College Chapel, Cambridge	Joyce Conwy Evans	Tapestry	King's College Chapel, University of Cambridge
1969	McKenzie coat of arms	Design supplied	Tapestry	Unknown
1969	London–Edinburgh coat of arms	Unknown	Tapestry	Unknown
1969	Wax Chandlers robe edgings	Joyce Conwy Evans	Tapestry	Wax Chandlers Company
1969	Untitled	Mr Hunter	Tapestry	Private Collection
1969	*Progression*	Archie Brennan	Tapestry	Unknown
1969	*Donald Duck*	Eduardo Paolozzi	Tapestry	First National Bank of Chicago, Edinburgh
1969	*Sunflower*	Archie Brennan	Tapestry	Private Collection
1970	*A Tapestry made from a Painting, Made from a Painting of a Tapestry, Made from a Painting*	David Hockney	Tapestry	The Artist
1970	Easson Crest (Scottish Lion)	Harry Wright	Tapestry	Private Collection
1970	Scottish Arts Council Tapestry	Archie Brennan	Tapestry	Aberdeen Art Gallery & Museums Collections
1970	Kings College second frontal (set of two)	Joyce Conwy Evans	Tapestry	King's College Chapel University of Cambridge
1970	Lectern fall	Jerzy Faczynski	Tapestry	Metropolitan Cathedral of Christ the King, Liverpool
1970	*Benziger Tapestry*	Archie Brennan, Harry Jefferson Barnes	Tapestry	Private Collection
1970–76	After *Elegy to the Spanish Republic No. 116*	Robert Motherwell	Tapestry	Edition of 5 plus 2 artist's proofs authorised.★
1970–90	After *1969 Provincetown Study*	Helen Frankenthaler	Tapestry	Edition of 5 plus 2 artist's proofs authorised. 6 woven. 4th in edition burnt. Private Collections
1970	*Genesis*	Robert Stewart	Tapestry	Strathclyde University
1971	*Hope-Scott Tapestry*	Hans Tisdall	Tapestry	Murray Beith Murray, Edinburgh
1971	Wax Chandlers tapestry	Joyce Conwy Evans	Tapestry	Wax Chandlers Company
1971	Two pulpit falls	Jerzy Faczynski	Tapestry	Metropolitan Cathedral of Christ the King, Liverpool
1971	*Triple Portrait*	Archie Brennan	Tapestry	Edinburgh City Council (for Lady Stair's House Museum, now the Writers' Museum)
1971	*Fisherman*	Zeljko Kujundzic	Tapestry	University of Southern California
1971	*The Matriachy*	Zeljko Kujundzic	Tapestry	University of Southern California
1971	*The Ceremonial*	Zeljko Kujundzic	Tapestry	University of Southern California
1971	*Anniversary*	Archie Brennan	Tapestry	Private Collection
1971	Klein No.1 (aka *Red Harmonies*, also *Sea and Sky*)	Bernat Klein	Tapestry	National Museum of Scotland
1971	Klein No.2 (aka *Scandia*)	Bernat Klein	Tapestry	Private Collection
1971–5	*Red/Blue Abstraction*	Robert Goodnough	Tapestry	Edition of 5 plus artist's proof authorised.♦
1971	St Cuthbert's Church tapestries (2 panels)	Archie Brennan	Tapestry	St Cuthbert's Church, Slateford Road, Edinburgh
1971	*Queen of Diamonds*	Archie Brennan	Tapestry	Private Collection
1971	Pulpit fall	Archie Brennan	Tapestry	Unknown
1971	*Hanover Trust Tapestry* (2 panels)	Norman Ives	Tapestry	Manufacturers Hanover Trust, London
1971	*Masnik panel*	Archie Brennan	Tapestry	Unknown
1971	*Tartan Scarf*	Archie Brennan	Tapestry	Dovecot Studios
1971	*Table Tartan*	Archie Brennan	Tapestry	Unknown
1971	*Queen*	Archie Brennan	Tapestry	The Artist
1971	Klein No.3 (aka *Highland Pool*)	Bernat Klein	Tapestry	National Museum of Scotland
1971	Klein No.4 (aka *Sutherland*)	Bernat Klein	Tapestry	Private Collection
c.1971	Untitled	Hans Tisdall	Tapestry	Unknown
c.1971	Kaftan	Archie Brennan	Tapestry	Private Collection

★Proofs both Private Collections; Port Authority of New York and New Jersey (sold 1997); River Tower Association, New York; Private Collections

♦Artist's proof Museum of Fine Arts, Boston; Port Authority of New York and New Jersey, Kennedy International Airport; Palmer Museum of Art of The Pennsylvania State University; Ernst & Ernst, New York; Liquid Paper Company, Oak Brook, Illinois; IBM Corporate Art Collection, Armonk, New York (sold 1995)

Date	Title	Artist	Type	Location
c.1971	Untitled	Alan Reynolds	Tapestry	Unknown
1972	Stock Exchange tapestry (no.1 panel)	Christopher Ironside	Tapestry	Stock Exchange, London
1972–7	*Blackout*	Jack Youngerman	Tapestry	Edition of 5 plus 2 artist's proofs authorised, 6 made by Dovecot. †
1972	Klein No.5 (aka *Brown with Blue*)	Bernat Klein	Tapestry	Private Collection
1972	Klein No.6 (aka *Grey Harmonies*)	Bernat Klein	Tapestry	Private Collection
1972	Klein No.7 (aka *Waterfall*)	Bernat Klein	Tapestry	Private Collection
1972	Klein No.8 (aka *Deep Waters*)	Bernat Klein	Tapestry	National Museum of Scotland
1972	Woolmark coat of arms	Archie Brennan	Tapestry	Woolmark, London
1972	*Steak and Sausages*	Archie Brennan	Tapestry, knitting	Private Collection
1972	Posthouse tapestries (3 panels)	Archie Brennan	Tapestry	Posthouse Hotel, Edinburgh
1972	*Sky Cathedral I*	Louise Nevelson	Tapestry	Edition of 5 plus 1 artist's proof authorised. 1 made but not located
1972	After *Seventh Night*	Kenneth Noland	Tapestry	Edition of 5 plus 1 artist's proof authorised. 1 made (lost in transit 1982)
1972	After *Black Disc on Tan*	Adolf Gottlieb	Tapestry	Edition of 5 plus 2 artist's proofs. ‡
1972	Klein No.9 (aka *Grey Mountain*)	Bernat Klein	Tapestry	Private Collection
1972	Klein No.10 (aka *Aegean*)	Bernat Klein	Tapestry	Private Collection
1972	*Stock Exchange Tapestry* (2 panels)	Christopher Ironside	Tapestry	Stock Exchange, London
1973	*Play within a Play* (2nd edition)	David Hockney	Tapestry	Unknown
1973	Cleish Castle blinds (3 panels)	Eduardo Paolozzi	Tapestry	City Art Centre, Edinburgh Museums and Galleries
1973	Untitled	Hans Tisdall	Tapestry	Unknown
1973	*Wintermane*	Ivon Hitchens	Tapestry	Chase Manhattan Bank
1973	*Complete Colour Catalogue*	Tom Phillips	Tapestry	Private Collection
1973	*Tyre I*	Archie Brennan	Tapestry	Glasgow Life (Museums)
1973	*Tyre II*	Archie Brennan	Tapestry	Unknown
1973	*At a Window I* (aka *Spotted Dress*)	Archie Brennan	Tapestry	Private Collection
1973	*Muhammad Ali*	Archie Brennan	Tapestry	Private Collection
1973	*After Benches*	Tom Phillips	Tapestry	The Artist
1974	*Kitchen Range*	Archie Brennan	Tapestry	Private Collection
1974	*Untitled (with Personnage)*	Jean Dubuffet	Tapestry	Not editioned. *
1974	*Hearth*	Archie Brennan	Tapestry	Private Collection
1974–7	*Sky Cathedral II*	Louise Nevelson	Tapestry	Edition of 5 plus 2 artist's proofs authorised and made. ◊
1974	Untitled	Hans Tisdall	Tapestry	Unknown
1974	*At a Window III* (aka *The Wine Cask*, also *The Wine Flask*)	Archie Brennan	Tapestry	Ardkinglas Collection
1974	Ninewells tapestry	Archie Brennan	Tapestry	Ninewells Hospital, Dundee
1974	*Tiger* panels	Fleur Cowles	Tapestry	The Artist
1974	*Enrichments* (2 panels)	Joyce Conwy Evans	Tapestry	Unknown
1975	Untitled	Eduardo Paolozzi	Tapestry	Unknown
1975	*Grampian Tapestry*	Archie Brennan	Tapestry	Grampian Council
1975	St Mary's pulpit fall no.1 panel	Archie Brennan	Tapestry	Lamp of Lothian Collegiate Centre, Haddington
1975	St Mary's pulpit fall no.2 panel	Archie Brennan	Tapestry	Lamp of Lothian Collegiate Centre, Haddington
1975	*Chains*	Archie Brennan	Tapestry	Victoria & Albert Museum
1975	*For the Autumn of '75* (1st edition)	Archie Brennan	Tapestry	Unknown
1975	*The Five Gates of London*	John Piper	Tapestry	Guildhall Art Gallery, London
1975	Tapestry for Intercontinental Hotel, London	Sevil Peach (aka Sev Gence)	Tapestry	Victoria & Albert Museum
1976	*The Four Seasons*	John Craxton	Tapestry	University of Stirling
1976	*Form Against Leaves* (1st edition)	Graham Sutherland	Tapestry	Private Collection
1976	*Dawn*	Fleur Cowles	Tapestry	The Artist
1976	*Picnic with Wine and Bees*	Fiona Mathison	Tapestry	Aberdeen Art Gallery & Museums Collections
1976	Carpet	Graham Sutherland	Carpet	Private Collection
1976	*For the Autumn of '75* (2nd edition)	Archie Brennan	Tapestry	Unknown
1976	*YRM Tapestry*	Archie Brennan	Tapestry	YRM, London
1976	*Runner*	Archie Brennan	Tapestry	Victoria Art Gallery, Melbourne
1976	*Blue Guitar I*	David Hockney	Tapestry	Aberdeen Art Gallery & Museums Collections
1977	*For the Autumn of '75* (3rd edition)	Archie Brennan	Tapestry	Unknown
1977	*Emblem on Red* (1st edition)	Graham Sutherland	Tapestry	Private Collection

† Proofs both artist's collection; Clifford Ross; Private Collection; City National Bank, Los Angeles; IBM Corporate Art Collection, Armonk, New York (sold 1995); Drake University, Des Moines, Iowa

‡ Artist's proofs Adolph and Esther Gottlieb Foundation, and IBM Corporate Art Collection, Armonk, New York (sold 1995); Private Collection; First National Bank of Tampa; City National Bank, Los Angeles; The Limited Stores, Columbus, Ohio; Clifford Ross

* 2 prototypes: Minneapolis Institute of Art; Fondation Dubuffet.

◊ Proofs: Clifford Ross, Private Collection; Private Collection; Union Federal Savings & Loan, Kewanee, Illinois; Port Authority of New York and New Jersey; Private Collection; Teleflex Incorporated (formerly Arrow International), Reading, Pennsylvania.

1977	*Aeroplane*	Mathias Kauage	Tapestry	The Artist
1977	Meadowbank Stadium tapestry	Archie Brennan	Tapestry	Edinburgh City Council
1977	Edinburgh Airport tapestry	Archie Brennan	Tapestry	BAA
1977	*Emblem on Yellow*	Graham Sutherland	Tapestry	Private Collection
1977	*Chain I*	Archie Brennan	Tapestry	Victoria & Albert Museum
1977	*Serenade*	David Hockney	Tapestry	Private Collection
1977	*Night Mountain*	Louise Nevelson	Tapestry	Private Collection
1977	*Brendan Foster*	Archie Brennan	Tapestry	Gateshead Sports Centre
1977	*Hills and Skies of Love (Absence)*	Maureen Hodge	Tapestry	Victoria & Albert Museum
1977	*Chain II*	Archie Brennan	Tapestry	National Museum of Scotland
1977	*Dusk in the Desert*	Louise Nevelson	Tapestry	Wells Fargo Bank, San Francisco
1978	*Blue Guitar II*	David Hockney	Tapestry	Private Collection
1978	*Desert*	Louise Nevelson	Tapestry	Museum of Fine Arts, Boston
1978	*Mirror Desert*	Louise Nevelson	Tapestry	Private Collection
1978	*Burn*	Archie Brennan	Tapestry	National Museum of Scotland
1978	*Reflection*	Louise Nevelson	Tapestry	Private Collection
1978	Sussex University tapestry	John Piper	Tapestry	Meeting House, Sussex University
1978	Bathurst tapestry	Archie Brennan	Tapestry	Private Collection
1978	Hanging for Master's Lodging, University College, University of Oxford	Joyce Conwy Evans	Tapestry	University College, University of Oxford
1978	*Ant Walk*	Fiona Mathison	Tapestry	Disposed of by the artist
1978	*Tiger Rug*	Harry Wright	Tapestry	Unknown
1978–81	6 panels for St Catherine's College, University of Oxford	Tom Phillips	Tapestry	St Catherine's College, University of Oxford
1979	3 panels for Glasgow Cathedral	Robert Stewart	Tapestry	Glasgow Cathedral
1979	*Welsh Griffin*	Harry Wright	Tapestry	Private Collection
1979	Pulpit fall	Harry Wright	Tapestry	Unknown
1979	Royal Scot tapestries (2 panels)	Fiona Mathison	Tapestry	Royal Scot Hotel, Edinburgh
1979	St Cuthbert's Church tapestries (2 panels)	Fiona Mathison	Tapestry	St Cuthbert's Church, Slateford Road, Edinburgh
1979	*Landscape (within Landscape)*	Louise Nevelson	Tapestry	Private Collection
1979	*Sunset over the Sea I*	John Houston	Tapestry	IBM, Buchan House, Edinburgh
1979	*Portrait of Mr Noble*	Archie Brennan	Tapestry	Ardkinglas Collection
1979	*Sunset over the Sea II*	John Houston	Tapestry	Private Collection
1979	*Dovecot*	Jean Taylor	Tapestry	Dovecot Studios
1980	*The Late, Late Moon*	Louise Nevelson	Tapestry	Private Collection
1980	*Form Against Leaves* (2nd edition)	Graham Sutherland	Tapestry	Ardkinglas Collection
1980	*Eastern Still Life*	Elizabeth Blackadder	Tapestry	UK Government Art Collection
1980	*A Clean Sheet*	Fiona Mathison	Tapestry	National Museum of Scotland
1980	*At a Window VI*	Archie Brennan	Tapestry	Private Collection
1980	*At a Window VII* (aka *The Spotted Dress*)	Archie Brennan	Tapestry	Victoria & Albert Museum
1980	*Emblem on Red* (2nd edition)	Graham Sutherland	Tapestry	National Museum of Scotland
1980	*Country Village*	Johnny Wright	Tapestry	Unknown
1980	Morgan Grenfell tapestry	Tom Phillips	Tapestry	Deutsche Bank
1980	Pulpit fall	Jean Taylor	Tapestry	Unknown
1980	Untitled	Eduardo Paolozzi	Tapestry	Unknown
1980	*Chelsea I*	Karen Nelson	Tapestry	The Artist
1980	*Una Selva Oscura*	Tom Phillips	Tapestry	Unknown
1981	Quilt sample	Karen Nelson	Tapestry	The Artist
1981	Chartered Accountants tapestry	Eduardo Paolozzi	Tapestry	Whitfield & Partners, London
1981	Canterbury Cathedral tapestry	Joyce Conwy Evans	Tapestry	Canterbury Cathedral
1981	*Emblem on Red* (3rd edition)	Graham Sutherland	Tapestry	Formerly Picton Gallery
1981	*Chelsea II*	Karen Nelson	Tapestry	Private Collection
1981	*Wormesley Tapestry*	Joyce Conwy Evans	Tapestry	Private Collection
1981	Miniature	Tom Phillips	Tapestry	Private Collection
1981	*Portrait of Mr Noble* (2nd weaving)	Archie Brennan	Tapestry	Ardkinglas Collection
1981	Vesti Corporation tapestry	Taha Al-Sabban	Tapestry	Vesti Corporation
1981	Adler tapestry	M. & E. Adler	Tapestry	A Kuwait hotel
1981	*Bread Slices*	Fiona Mathison	Tapestry	Private Collection
1981	*Map*	Fiona Mathison	Tapestry	Private Collection
1982	*Glescau*	Robert Stewart	Tapestry	Glasgow Council (City Chambers)
1982	Leicester University tapestry	Eduardo Paolozzi	Tapestry	Leicester University
1982	Untitled	John Mooney	Tapestry	Scottish National Gallery of Modern Art
1982	Carrickknowe Church tapestry	Margaret Liddle	Tapestry	Carrickknowe Church, Edinburgh
1982	*Eden*	Margaret Liddle	Tapestry	Royal Edinburgh Hospital
1983	Untitled	Helen Frankenthaler	Tapestry	A Miami bank
1983	*A Child's Garden of Verses* (3 panels: *The Land of Counterpane, Looking Glass River* and *Picture-Books in Winter*, after illustration of poem by Robert Louis Stevenson)	Jessie Willcox Smith	Tapestry	Children's Mercy Hospital, Kansas City
1983	*The Island of Montreal*	Antoine Dumas	Tapestry	Unknown
1983	General Accident tapestry	Sam Ainsley	Tapestry	Aviva, Perth
1983	Parr tapestry	Sam Ainsley	Tapestry	Private Collection
1983	Miniature	John Mooney	Tapestry	Ardkinglas Collection
1983	*The Water of Life*	Joanne Soroka	Tapestry	William Grant, Glenfiddich Distillery, Dufftown
1983	Untitled	Phillida Nicholson	Tapestry	Private Collection
1983	Samples	Sheila Hicks	Tapestry	Private Collection
1983	*Computer Tapestry I*	Harold Cohen	Tapestry	Glasgow Life (Museums)
1983	*Computer Tapestry II*	Harold Cohen	Tapestry	Standard Life

Year	Title	Artist/Designer	Type	Collection
1983	Old Jeddah	Design supplied	Tapestry	Vesti Corporation
1983	Kruger	Archie Brennan	Tapestry	Private Collection
1983	Boswell tapestry	Robin Philipson	Tapestry	Private Collection
1983	Hope Scott Trust tapestry	William McLaren	Tapestry	Queen's Hall, Edinburgh
1983	Glasgow Council tapestry	Robert Stewart	Tapestry	Glasgow Council
1983	Birds in Flight	Design supplied	Tapestry	Riyadh Airport
1984	White Computer	Harold Cohen	Tapestry	Private Collection
c.1984	Air II	Fiona Mathison	Tapestry	Unknown
1984	Still Life with Indian Toy	Elizabeth Blackadder	Tapestry	Aberdeen Art Gallery & Museums Collections
1984	Reckitt & Colman tapestry	Elizabeth Blackadder	Tapestry	Reckitt Benckiser
1984	Variation II	John Houston	Tapestry	Unknown
1984	3M tapestry	Shirley Gatt	Tapestry	3M
1984	Scottish Gas motif	Design supplied	Tapestry	Scottish Gas
1984	Old Friends, New Foes	Peter Davies	Tapestry	Newcastle University
1984	Ruby Wedding tapestry	Joanne Soroka	Tapestry	Private Collection
1985	Esso kites	Sam Ainsley	Kites	Esso, Mossmorran Staff Centre
1986	Edinburgh Tapestry Company brochure tapestry	Fred Mann	Tapestry	Private Collection
1986	Time and Tide	Joyce Conwy Evans	Tapestry	Worshipful Company of Haberdashers, London
1986	Proscinemi for Kore	Joe Tilson	Tapestry	Private Collection
1986	Had Gadya – front cover	Frank Stella	Tapestry	PepsiCo, New York
1986	Had Gadya – 'One Small Goat Papa Bought for Two Zuzim'	Frank Stella	Tapestry	PepsiCo, New York
1986	Had Gadya – 'A Hungry Cat Ate Up the Goat'	Frank Stella	Tapestry	PepsiCo, New York
1986	Had Gadya – 'Then Came a Dog and Bit the Cat'	Frank Stella	Tapestry	PepsiCo, New York
1986	Had Gadya – 'Then Came a Stick and Beat the Dog'	Frank Stella	Tapestry	PepsiCo, New York
1986	Had Gadya – 'Then Came a Fire and Burnt the Stick'	Frank Stella	Tapestry	PepsiCo, New York
1986	Had Gadya – 'Then Water Came and Quenched the Fire'	Frank Stella	Tapestry	PepsiCo, New York
1986	Had Gadya – 'Then Came an Ox and Drank the Water'	Frank Stella	Tapestry	PepsiCo, New York
1986	Had Gadya – 'Then Came the Butcher and Slew the Ox'	Frank Stella	Tapestry	PepsiCo, New York
1986	Had Gadya – 'Then Came Death and Took the Butcher'	Frank Stella	Tapestry	PepsiCo, New York
1986	Had Gadya – 'And the Holy One, Blessed Be He, Came and Smote the Angel of Death'	Frank Stella	Tapestry	PepsiCo, New York
1986	Unknown	Frank Stella	Tapestry	Private Collection
1986	Sailing	Joanne Soroka	Kites	Eastgate Shopping Centre, Inverness
1986	Isetan tapestries	Joanne Soroka	Tapestry	Isetan Department Store, Tokyo
1986	Canada Map	Design supplied	Tapestry	Bell Telephone Company
1986	Portrait of Mrs Noble	Archie Brennan	Tapestry	Ardkinglas Collection
1987	Still Life, Sunflower & Cactus	Alberto Morrocco	Tapestry	Unknown
1987	Multilayers	Richard Smith	Tapestry	Private Collection
1987	Miniatures (set of 2)	Elizabeth Blackadder	Tapestry	Private Collection
1987	Irises	Elizabeth Blackadder	Tapestry	Robert Fleming Holdings
1987	Tulips	Elizabeth Blackadder	Tapestry	Murray Johnston
1987	Dunedin Fund tapestry	James More	Tapestry	Unknown
1987	Granite Crystal Landscape	John Busby	Tapestry	Bute Fabrics, Rothesay
1987	Fish, Lantern and Sunset	William Littlejohn	Tapestry	Aberdeen Art Gallery & Museums Collections
1987	Rug	Elizabeth Blackadder	Rug	Unknown
1987	Rug	Elizabeth Blackadder	Rug	Unknown
1987	Multistripe rug	Shirley Gatt	Rug	Unknown
c.1987	Landscape	James More	Rug	Unknown
1987	Terrazzo Swirl	James More	Rug	Unknown
1987	Camouflage – Black Spot	James More	Rug	Unknown
1987	Rug (chevrons)	James More	Rug	Unknown
1987	Octagon and Square	James More	Rug	Unknown
1987	Snake Motif	Douglas Grierson	Rug	Unknown
1987	Rug No.3	Douglas Grierson	Rug	Unknown
1987	Lemons	Douglas Grierson	Rug	Unknown
1987	White with Patterned Squares	Douglas Grierson	Rug	Unknown
1987	Blue-Black	Douglas Grierson	Rug	Unknown
1987	Interchangeable Stripes	Douglas Grierson	Rug	Unknown
1987	Interchangeable 8-inch Squares	Douglas Grierson	Rug	Unknown
1988	Scroll, Paper Bird and Moon	William Littlejohn	Tapestry	Private Collection
1988	Blue on Yellow	Derek Roberts	Tapestry	Private Collection
1988	Clapham Concerto	John Bellany	Tapestry	Northumbria University
1988	Still Life with Sunflower and Cactus	Alberto Morrocco	Tapestry	Unknown
1988	Blue on Yellow	Derek Roberts	Tapestry	Private Collection
1988	Square 1 & 2	Elizabeth Blackadder	Tapestry	Private Collection
1988	Patchwork	James More	Rug	Unknown
c.1988	Swinton Rug	James More	Rug	Unknown
1988	Primitif Rug	James More	Rug	Unknown
1988	Squares	James More, Douglas Grierson	Rug	Unknown
1988	The Forth Bridge	Douglas Grierson	Rugs	Dovecot Studios
c.1988	Dream Garden	James More	Tapestry	Unknown
1988	Byzantine Land	James More	Rug	Unknown
1988	Octagon II	James More	Rug	Unknown
1988	Shards	James More	Rug	Unknown
c.1988	Circular rug	James More	Rug	Unknown

Year	Title	Artist	Type	Collection
c.1988	London University rug	James More	Rug	Faculty of Arts, London University
c.1988	Scheherazade	James More	Rug	Unknown
1988	Italian Piazza	James More	Rug	Unknown
1988	Glow	James More	Rug	Unknown
1988	Sunset I	James More	Rug	Unknown
1988	Sunset II	James More	Rug	Unknown
1988	Ben Dawson rug	James More	Rug	Ben Dawson
c.1988	Rug	Leo Duvall	Rug	Unknown
c.1988	Rug	Alice Tatham	Rug	Unknown
c.1988	Who Loves Ya, Baby	Andrew Stafford	Rug	Unknown
1988	Humankind	Robin Philipson	Tapestry	Culture & Sport Glasgow (Museums)
1988	Untitled	Unknown	Tapestry	Private Collection
1989	Poppies on a Blue Ground	Robin Philipson	Tapestry	Private Collection
1989	Tulips and Irises	Elizabeth Blackadder	Tapestry	Private Collection
1989	Cockfight	Robin Philipson	Rug	Private Collection
1989	Nude in a Black Hat	Edward Piper	Rug	Catto Gallery
1989	Areois (Te Aa No Areois)	after Paul Gauguin	Tapestry	Unknown
1989	Meadows	Robin Philipson	Tapestry	Standard Life
1989	The Kiss	John Bellany	Rug	Sold to artist
c.1989	Oil platform rug	James More	Rug	BP Oil Rig Restaurant
1989	Prudential logo	Design supplied	Tapestry	Prudential Assurance
1989	Pictish Portal	James More	Tapestry	Private Collection
1989	St Charles Hospital tapestry	James More	Tapestry	St Charles Hospital, London
1989	Miniature with bird and ball	Elizabeth Blackadder	Tapestry	Private Collection
1989	Fenestration VI	Charlotte Ingle	Unknown	Unknown
1989	Waves	James More	Tapestry	Private Collection
1989	Pond and Irises	Jacqueline Watt	Tapestry	Private Collection
1989	Corrugated	James More	Tapestry	Private Collection
1989	Coat of arms of His Most Eminent Highness Fra' Andrew Bertie, Prince and Grand Master of the Order of Malta in Great Britain and Ireland	Design supplied	Tapestry	Private Collection
1989	BP tapestry	Livia Edelstein	Tapestry	BP Hemel Hempstead
1990	Through the Garden Wall	Adrian Wiszniewski	Tapestry	Private Collection
1990	Banner	Jane Carroll, Alistair McCallum	Tapestry	Scottish Trades Union Congress, Glasgow
1990	Berlin Wall	James More	Tapestry	Private Collection
1990	Charlie's Retired	after photo by Fritz von der Schulenburg	Tapestry	Private Collection
1990	Oil chapel rug	Shona McInnes	Rug	Memorial Chapel, Kirk of St Nicholas Uniting, Aberdeen
1990	Vine Leaves and Grapes	Joyce Conwy Evans	Tapestry	Private Collection
1990	The Four Seasons	John Cunningham	Tapestry	Clydesdale Bank, Glasgow
1990	Culzean Barn	Susan Stewart	Tapestry	National Trust for Scotland
1990	Irises II	Elizabeth Blackadder	Tapestry	Unknown
1990	Miniature: Irises I	Elizabeth Blackadder	Tapestry	Unknown
1990	Miniature: Irises II	James More	Tapestry	Private Collection
1990	Dream Garden	James More	Tapestry	Unknown
1990	Wild Garden in Carradale	Glen Scouller	Tapestry	Unknown
1990	Abbey National tapestry	Shirley Gatt	Tapestry	Santander, Milton Keynes
1990	Play on Light	James More	Tapestry	Private Collection
1990	Orchid House	Christine McArthur	Tapestry	Private Collection
1991	Fruit and Fish	Robin Philipson	Tapestry	Ardkinglas Collection
1991	Shells	Kaffe Fassett	Tapestry	Private Collection
1991	Scottish Provident tapestry	Elizabeth Blackadder	Tapestry	Scottish Provident HQ, Edinburgh
c.1991	Cockfight	Robin Philipson	Rug	Private Collection
1991	Guineafowl Three	Francesca Pelizzoli	Tapestry	Private Collection
1991	Green Triangle	Design supplied	Tapestry	Capital & Counties plc, Slough
1991	Tapestry for an Ante Room in a Cultural Cathedral (Museums as Cathedrals)	Bruce McLean	Tapestry	National Museum of Scotland
1991	Judgement of Paris (2 panels)	Robin Philipson	Tapestry	Private Collection
1991	The Source of the Clyde	Duncan Shanks	Tapestry	Glasgow Royal Concert Hall
1991	Coloured rope work	James More	Knot-work	Private Collection
1991	Coloured rope work II	James More	Knot-work	Private Collection
1992	Pink Ginger Jar	Kaffe Fassett	Tapestry	Private Collection
1992	Blue Ginger Jar	Kaffe Fassett	Tapestry	Private Collection
1992	Fleur	Adrian Wiszniewski	Rug	Private Collection
1992	Oil chapel tapestry	Shirley Gatt	Tapestry	Memorial Chapel, Kirk of St Nicholas Uniting, Aberdeen
1992	Tapestry panels (at least 4)	Shirley Gatt	Tapestry	Great Western Auctions, Glasgow
1992	Nationwide tapestry	Shirley Gatt	Tapestry	Nationwide Building Society
1992	Lamination	Charlotte Ingle	Rug	Unknown
c.1992	Bench	Charlotte Ingle	Rug	Unknown
c.1992	Red circular rug	Charlotte Ingle	Rug	Unknown
c.1992	46-ply	Charlotte Ingle	Rug	Unknown
c.1992	2 rugs	Charlotte Ingle	Rugs	Scottish Executive Office
c.1992	Rug	Unknown	Rug	HMSO
1992	Buried Treasure	Mick Rooney	Tapestry	Unknown
1992	Meadows	Robin Philipson	Tapestry	Scottish Life, Edinburgh
1992	Flower design	James More	Tapestry	Private Collection
1992	Orchids	Elizabeth Blackadder	Tapestry	Ellis Campbell Group
1992	Revelation of St John	James More	Rug	The Bute Collection at Mount Stuart
c.1992	Mustarde	John Brennan	Rug	Private Collection
c.1992	Mermaids and Mackerel	Mick Rooney	Rug	Unknown

Date	Title	Designer	Type	Location
c.1992	Rug	Elizabeth Cook	Rug	Unknown
c.1992	John Scott rugs	Unknown	Rugs	Private Collection
1992	St George and the Dragon	James More	Tapestry	Private Collection
1993	Cats	Elizabeth Blackadder	Tapestry	Private Collection
1993	Lord Goold commemorative tapestry	James More	Tapestry	Mearnskirk Church
1993	Irises III	Elizabeth Blackadder	Tapestry	Unknown
1993	Cats and Orchids	Elizabeth Blackadder	Tapestry	Private Collection
1993	Still Life with Fan	Elizabeth Blackadder	Tapestry	Private Collection
1993	Yellow Ginger Jar	Kaffe Fassett	Tapestry	Private Collection
1993	Unison tapestry	Shirley Gatt	Tapestry	Unison Centre, London
1993	Rug	Shirley Gatt	Rug	Private Collection
1993	Green Ginger Jar	Kaffe Fassett	Tapestry	Private Collection
1993	Family Plot	Adrian Wiszniewski	Rug	Private Collection
1993	Sunburst	John Houston	Tapestry	Private Collection
1994	Triptych	Shirley Gatt	Tapestry	Bank of Scotland
1994	Oak Village Golf Club tapestry	Mary Montague Designs	Tapestry	Oak Village Golf Club, Kokumoto, Ichihara-shi, Chiba, Japan
1994	Carnival Edinburgh	Barbara Rae	Tapestry	Festival Theatre, Edinburgh
1994	China Landscape	Rosamund Brown	Tapestry	Private Collection
1994	Fishes & Invertebrae Under the Ocean	Leonard McComb	Tapestry	Boots plc, Nottingham
1994	Belgrave Gardens	Lynn Kirkwood	Tapestry	Private Collection
1994	Dynasty series	Adrian Wiszniewski	Rugs	Various collections including Scottish Nuclear Enterprise
1994	2 hangings	Philip Hughes	Tapestry	Boots plc, Nottingham
1994	Rug	John Bellany	Rug	Shepherd & Wedderburn, Edinburgh
1994	Rug	Shirley Gatt	Rug	Dunfermline Building Society, Dunfermline
1994	Rug	Norma Starszakowna	Rug	Creative Scotland
1994	British Linen Bank crest	Design supplied	Tapestry	British Linen Bank
1994	Rug	Kaffe Fassett	Rug	The Artist
c.1995	Untitled	Mary Cuthbert	Tapestry	Unknown
c.1995	Orange	Susan Kumi	Rug	Unknown
c.1995	Design A (Orange and Black)	Susan Kumi	Rug	Unknown
1995	Cats at Play	Elizabeth Blackadder	Tapestry	Private Collection
1995	Rug	Leonard McComb	Rug	Private Collection
1995	Cross Your Heart	Naomi Robertson	Rug	Private Collection
1995	Firedance	Lynn Kirkwood	Rug	Private Collection
1995	Compass	Shirley Gatt	Rug	Private Collection
1995	Cats I	Elizabeth Blackadder	Rug	Private Collection
1995	Cats II	Elizabeth Blackadder	Rug	Private Collection
1995	Adam & Eve	Willie Rodger	Rug	Private Collection
1995	Once in a Blue Moon	Willie Rodger	Rug	Private Collection
1995	Old Palace Hotel tapestry	John Houston	Tapestry	Trafalgar House, Princes Street, Edinburgh
1995	Union Banner	Shirley Gatt	Tapestry	Communications Workers' Union, London
1995	Shout for Joy	Lynn Kirkwood	Tapestry	Holy Trinity Church, Edinburgh
1995	Orchids	Elizabeth Blackadder	Tapestry	Private Collection
1995	Rug	Vasey McKeown	Rug	The Artist
1995	2 tapestries	Philip Hughes	Tapestry	The Artist
1996	2 panels for St Cuthbert's Chapel	Naomi Robertson	Tapestry	St Cuthbert's Church, Slateford Road, Edinburgh
1996	Mrs Brotherstone tapestry	John Brennan	Tapestry	Private Collection
1996	Pearson tapestry	Eduardo Paolozzi	Tapestry	Maggie's Centre, Dundee, on loan from Pearson Group
1996	Cube Design	Charlotte Ingle	Rug	Private Collection
c.1996	Rug	Sarah Brennan	Rug	Private Collection
?	Rug for Langs Hotel	Sarah Brennan	Rug	Langs Hotel, Glasgow
c.1996–7	Oslo Rug	Barbara Rae	Tapestry	Unknown
c.1996–7	Lothian Rug	Barbara Rae	Rug	Unknown
c.1996–7	North Field	Barbara Rae	Rug	Private Collection
1996	4 rugs for 'Living at Belsay' exhibition, Belsay Hall, Northumberland	Sally Greaves-Lord	Rugs	Unknown
1996	Blue Squares	Sally Greaves-Lord	Rug	Unknown
1996–7	If Not, Not	R.B. Kitaj	Tapestry	British Library, London
1997	Mrs Pain tapestry	Susan Hawker	Tapestry	Private Collection
1997	The Way of Life	Forbes Mutch	Rug	St Helen's Church, Burton Joyce, Nottinghamshire
1997	Rug	James More	Rug	Northumbria University
1997	Corryvrechan	Kate Whiteford	Tapestry	National Museum of Scotland
1997	Seafish	Virginia Powell	Tapestry	Ardkinglas Collection
1997	Rug	Jo Barker	Rug	Private Collection
1998	Green Waters	Ian Hamilton Finlay	Tapestry	Scottish Poetry Library, Edinburgh
1998	BCK 75 (Proem)	Ian Hamilton Finlay	Tapestry	Estate of Ian Hamilton Finlay
1998	Fireworks	Alice Shaw	Tapestry	Private Collection
1998	Heron Tapestry	Unknown	Tapestry	Private Collection
1998	Rug I	Dawn Dupree	Rug	Unknown
1998	Rug II	Dawn Dupree	Rug	Unknown
1998	Circular rug	Jo Barker	Rug	Private Collection
1998	Westlakes rug	Joanna Kinnersley-Taylor	Rug	Innovation Centre, Whitehaven
1998	Circular rug	Jo Barker	Rug	Private Collection
1998	Hill Fort	Barbara Rae	Rug	National Museum of Scotland
1998	Rug	Ellie Jones	Rug	Private Collection
1998	Counterpart	Isa Glink	Rug	Private Collection
1998	Sign × II	Isa Glink	Rug	Private Collection
c.1998	Stirling Castle rugs	Designs supplied	Rugs	Stirling Castle Restaurant
1998	Untitled	Alice Shaw	Tapestry	Private Collection

Year	Title	Designer	Type	Location
1998	*Norway Tapestry*	Barbara Rae	Tapestry	Private Collection
1999	McLellan tapestry	Elizabeth Blackadder	Tapestry	Private Collection
1999	Mrs Young's tapestry	Dovecot Design	Tapestry	Private Collection
1999	Royal Bank of Scotland No.36 & Waterhouse Square (2 panels)	Ann Oram	Tapestry	Younger Building, Gyle, Edinburgh
1999	Miro-inspired tapestry	Unknown	Tapestry	Private Collection
1999	*Camouflage*	Isa Glink	Rug	Private Collection
?	*Well Hung*	Adrian Wiszniewski	Rug	Unknown
1999	*Sand*	Adrian Wiszniewski	Rug	Private Collection
1999	*Alphabet Design*	Andrew Stafford	Rug	Unknown
1999	*Counterpart II*	Isa Glink	Rug	Private Collection
2000	*Fish* (8 panels)	Unknown	Tapestry	Ardkinglas Collection
2000	*Edinburgh Castle*	Unknown	Tapestry	Private Collection
2000	Tapestry for Lady Hesketh	Elizabeth Blackadder	Tapestry	Private Collection
2000	Tapestry for Patricia Fotheringham	Elizabeth Blackadder	Tapestry	Private Collection
2001	Saskia's rug	Saskia Weir	Rug	Mr and Mrs David Weir
2001	Sample rug	Alan Davie	Rug	Dovecot Studios
2002	*Loaves and Fishes*	David Cochrane	Tapestry	Dovecot Studios
2002	Agricultural Society coat of arms	Design supplied	Tapestry	Royal Highland Agricultural Society of Scotland, gift from outgoing President Alastair Salvesen
2002	John Lewis rug	Christine McArthur	Rug	John Lewis Partnership, St James Centre, Edinburgh
2002	Stripes rug with logo (Dovecot)	Douglas Grierson	Rug	Dovecot Studios
2002	*To a Celtic Spirit*	Alan Davie	Tapestry	The Morton Charitable Trust†
2002	Sample rug	Alan Davie	Rug	Dovecot Studios
2002	*Dots*	Douglas Grierson	Rug	Dovecot Studios
2002	Rug	Barbara Rae	Rug	Private Collection
2002	*Striped Boxes with Green Background*	Douglas Grierson	Rug	Dovecot Studios
2002	*Runner Orange*	Douglas Grierson	Rug	Dovecot Studios
2002	*Morphic Stripes*	Douglas Grierson	Rug	Private Collection
2002	*Benaderreen*	Barbara Rae	Tapestry	Private Collection
2003	*Woman With Fish*	John Bellany	Tapestry	Dovecot Studios
2003	*Marina Rug*	Unknown	Rug	Private Collection
2003	Lord Lyon coat of arms	Tim Milner	Tapestry	Private Collection
2003	*Celtic Spirit*	Alan Davie	Rug	Dovecot Studios
2003	*East Coast Idyll*	John Bellany	Tapestry	Private Collection
2003	*Cosmic Spiral*	Alan Davie	Tapestry	Dovecot Studios
2003	Dovecot logos	Douglas Grierson	Tapestry	Dovecot Studios
2003	Dovecot Tapestry	Douglas Grierson	Tapestry	Dovecot Studios
2003	*Red Card*	Willie Rodger	Rug	Emirates Stadium, Arsenal F.C.
2003	*Inner Landscape*	Paul Furneaux	Tapestry	Dovecot Studios
2003	Rug	Ailie Corbett	Rug	The Artist
2003	*Night Division*	Barbara Rae	Rug	Dovecot Studios
2004	*My Wee Sweetie*	Willie Rodger	Rug	Dovecot Studios
2004	*Iris*	Elizabeth Blackadder	Tapestry	Dovecot Studios
2004	*Gorgeous George Macaulay*	Craigie Aitchison	Tapestry	The Artist
2004	*Bird of Oppedette*	Craigie Aitchison	Tapestry	Private Collection
2004	*Still Life (Miniature)*	Craigie Aitchison	Tapestry	Dovecot Studios
2004	*Waxing Lyrical*	Douglas Grierson	Tapestry	Dovecot Studios
2004	*Sunset over Corrib*	Douglas Grierson	Tapestry	Dovecot Studios
2004	Alison Young tapestry	Design supplied	Tapestry	Private Collection
2004	*Humming Bird*	Naomi Robertson	Tapestry	Unknown
2004	*Arcadia* tapestry	Elizabeth Blackadder	Tapestry	P&O MV *Arcadia*
2004	Port Seton tapestry in squares	Douglas Grierson	Tapestry	Private Collection
2004	*Wee Valentine*	Willie Rodger	Tapestry	Dovecot Studios
2004	*Heart and Fish Rug*	Martine Frame	Rug	Dovecot Studios
2005	Kilim rug	Douglas Grierson	Tapestry	Dovecot Studios
2005	Rug	Anne Delahunty	Rug	Private Collection
2005	*Heart Rug*	Hama Bead Design	Rug	Dovecot Studios
2005	*Bathtub*	Willie Rodger	Rug	Dovecot Studios
2005	Rug	Jo Barker	Rug	Private Collection
2005	*Tapis Volant*	Liz Rideal	Tapestry	Nottingham Castle Arts Centre
2005	*Greenhouse Rug*	Willie Rodger	Rug	The Artist
2005	*Pause on the Landing*	Patrick Caulfield	Tapestry	British Library, London
2005	*Jocelyn's Rug*	Jocelyn Pringle	Rug	Private Collection
2005	*Bird of Oppedette II*	Craigie Aitchison	Tapestry	Private Collection
2006	*St George's Rug*	Sophie Renton	Rug	Royal Hospital for Sick Children, Edinburgh
2006	*Hawk Tapestry Rug*	Douglas Grierson	Tapestry	Dovecot Studios
2006	*Waterlilies*	Theo Weir	Tapestry	Private Collection
2006	Skipwith christening tapestry	Douglas Grierson	Tapestry	Private Collection
2006	Dovecot logo banner	Douglas Grierson	Tapestry	Dovecot Studios
2006	*Verdure*	Liz Rideal	Tapestry	Dovecot Studios
2006	*Lesser Black Backed Gull*	Didi Edwards	Rug	Private Collection
2006	*Cartographer's Circle – Blue*	Wendy Ramshaw	Tapestry	Private Collection
2007	*Untitled*	Kristine Mandsberg	Tapestry	Dovecot Studios
2007	*Water Surface*	David Cochrane	Tapestry	Private Collection
2007	*Still Life Made Oval*	William Scott	Tapestry	Dovecot Studios
2007	Rug	Paul Furneaux	Rug	Private Collection
2007	*David at the Loom*	Jonathan Ashworth	Rug	Dovecot Studios
2007	*Ski Rug*	Dione Verulam	Rug	Private Collection
2007	*Rose against Green Wall*	Craigie Aitchison	Tapestry	Dovecot Studios
2007	*Two Views*	Victoria Crowe	Tapestry	Buccleuch Collection, Boughton House
2007	*Emerald*	William Scott	Tapestry	Dovecot Studios
2007	Devonshire hunting tapestry detail	Design supplied	Tapestry	Dovecot Studios
2008	Highland Division tapestry	Alan Heriot	Tapestry	Highland Division
2008	Bannenberg Yacht tapestry	Dovecot Design	Tapestry	MV *Elandess*, interior by Bannenberg & Rowell
2008	*Corset*	Chris Clyne	Tapestry	Dovecot Studios
2008	*Headpiece*	Chris Clyne	Tapestry	Dovecot Studios

†On loan to University Collections, Edinburgh University, at Chancellor's Building, Edinburgh Medical School, Little France

Year	Title	Artist	Type	Location
2008	*Snoes*	Chris Clyne	Tapestry	Dovecot Studios
2008	*Rug 01*	Jamie Bruski Tetsill	Rug	Dovecot Studios
2008	*Baths and Bathers*	Douglas Grierson	Tapestry	Dovecot Studios
2009	*Easter Day*	William Crozier	Tapestry	Dovecot Studios
2009	*Pool Sounds*	Jonathan Cleaver	Tapestry	Dovecot Studios
2009	*Borka Rug*	John Burningham	Rug	The Artist
2009	*Racing Results*	John Burningham	Rug	The Artist
2009	*Golden Plover*	Douglas Grierson, after John Gould	Tapestry	Private Collection
2009	*Water Surface II*	David Cochrane	Tapestry	Private Collection
2010	*Ski Rug* (2nd edition)	Dione Verulam	Rug	The Sladmore Gallery, London
2010	*Olive Terraces*	Barbara Rae	Tapestry	Private Collection
2010	*Skating in Verulamium Park*	Dione Verulam	Rug	Dovecot Studios
2010	*quick, slow*	Claire Barclay	Tapestry	Arts Council Collection, Southbank Centre, London
2010	*Miniature No.1*	Elizabeth Blackadder	Tapestry	Private Collection
2010	*Miniature No.2*	Elizabeth Blackadder	Tapestry	Private Collection
2010	*Bunkered*	Willie Rodger	Tapestry	Dovecot Studios
2010	*Green Stripes*	Philip Hughes	Rug	The Artist
2010	*A Wee Romp*	Willie Rodger	Rug	The Artist
2010	*Seascape*	Douglas Grierson	Rug	Private Collection
2010	*Reflections* (aka *Baths Tapestry*)	Naomi Robertson	Tapestry	Dovecot Studios
2010	*Green and Blue Forms*	William Scott	Tapestry	Dovecot Studios
2010	*Railway Station*	Willie Rodger	Tapestry	Dovecot Studios
2010	*Fishpool, Lacken*	Barbara Rae	Tapestry	Dovecot Studios
2010	*Dot* (Maggie's Centre Rug)	Linda Green	Rug	Dovecot Studios
2010	*Rug*	William Crozier	Rug	Dovecot Studios
2010	*Rug*	Marc Camille Chaimowicz	Rug	The Artist
2010	Polynesian-themed yacht tapestry	Naomi Robertson	Tapestry	MV *Polynesia*
2010	Lucy Bull rug	Pippa Bull	Rug	Private Collection
2011	*M799 Green Circles*	David Poston	Viscose, stainless wire	Dovecot Studios
2011	*M797 Red Rectangles*	David Poston	Pearl cotton, stainless wire	The Artist
2011	*Grangemouth at Night, Smoke and Lights*	Kurt Jackson	Rug	Dovecot Studios
2011	*Bighorn*	Barbara Rae	Rug	Private Collection
2011	St Machar's Tapestry	Douglas Grierson	Tapestry	St Machar's Cathedral, Aberdeen
2011	St Machar's Miniature	Douglas Grierson	Tapestry	Private Collection
2011	*Transatlantyk (Get The Fuck Out Of Dodge)*	Than (Nathaniel) Hussein Clark	Rug	The Artist
2011	*Wind Dance*	Wilhelmina Barns-Graham	Rug	The Barns-Graham Charitable Trust, Balmungo House, St Andrews
2011	*Pivot*	Naomi Robertson	Tapestry	Dovecot Studios
2011	*Lighthouse Rugs*	Pupils from North Queensferry, Queensferry and Law School, with Jonathan Cleaver	Rug	Dovecot Studios
2011	*Katha Diaries*	Naomi Robertson	Tapestry	Dovecot Studios
2011	*Fragments*	Jonathan Cleaver	Tapestry	Dovecot Studios
2011	*Waterbaby*	David Cochrane	Tapestry	Dovecot Studios
2011	*India Rug*	Naomi Robertson	Rug	Dovecot Studios
2011	*Three Tulips*	Elizabeth Blackadder	Tapestry	Dovecot Studios
2011	*Abydos (Doves and Dovecots)*	Edward Bawden	Tapestry	Dovecot Studios
2011	*Lost Ball*	Willie Rodger	Tapestry	Dovecot Studios
2012	*Abydos (Man with Ox)*	Edward Bawden	Tapestry	Dovecot Studios
2012	*Cave Canem*	Willie Rodger	Tapestry	Dovecot Studios
2012	*Look Thy Last …*	Willie Rodger	Tapestry	Dovecot Studios
2012	*Large Tree Group*	Victoria Crowe	Tapestry	Dovecot Studios

NB: *My Victorian Aunt* (1968), Archie Brennan studio, has previously been incorrectly credited to Dovecot Studios.

GLOSSARY

atelier a tapestry studio

Aubusson the French centre for low-loom tapestry and carpet production

bead how the weaving of weft appears on the tapestry surface

bobbin a pointed wooden tool used to pass weft threads through the warps; the yarn is wrapped around the stem and the point is used to beat down the weft

cartoon the full-size working drawing. In many ateliers the colours would be written in by the *cartonnier*

count a spinning term applied to the thickness of a given yarn

cut-back lines a practical device of diagonal weaving lines, visible often within a large plain area of weaving. Commonly used when a weaver has to keep to his own passage and not interfere with those of his fellow weavers

dividing rod a rod or pole that is used to divide every second warp into back and front rows of warp thereby creating the shed

double weaving a common way of weaving when texture is required, picking two or more warps together at a time, thus reducing the number of warps per inch

flat colour an area of weft where no mixtures are used

floating weft a weft thread is hitched or knotted into the tapestry and carried across the weaving surface by a free bobbin, missing one or more warps and so 'floating' over the tapestry surface

Gobelin Gobelins Royal Manufactory in Paris has been the centre of tapestry weaving since 1663. The term 'Gobelin' is often used to describe high-loom tapestry weaving

half-hitch a basic running knot, employed in duplicate, and used during the preparation stage of warping and leashing, and at the start and finish of the tapestry

half-passes a popular technique that appears as alternate dots in a passage of weaving

hatching/hachure a technique using a series of woven lines of weft that dovetail together to shade from dark to light. Used to mould or give the appearance of form to tapestry e.g. drapery, features in figurative work, or light and shade in foliage

high-loom (haute lisse) the tapestry is woven on a vertical loom where the warp is held at right angles to the floor

inking on a method of marking the design onto the warps with pen and ink, following the lines drawn on the working drawing or cartoon which is pressed behind the warps

knotting a variety of knots are used in tapestry, most being derived from rug making, i.e. Persian and Turkish knots. The half-hitch knot (see above) is also used as a weaving technique

leash a loop of twine or string that goes behind the back warps of the shed and is attached to a rod or leashing bar at the front of the loom

low-loom (basse lisse) the tapestry is woven on a horizontal loom that is parallel to the floor, like a cloth loom. (Tapestries are usually woven from the back to allow easy access to bobbins, and the cartoon is reversed)

mixture when more than one coloured yarn is used in the weft

pass a pass of weaving is when the weaving passes between both the open and closed sheds

pick-and-pick the USA term for 'half-passes' (see above)

ply a method of mixing two or more yarns together for colour blending and weft thickness known as 'plying up'

reed a comb-like implement that determines the even spacing of the warps

ribbing weaving where every second warp protrudes. This is mainly caused by the weft in one shed being pulled tighter than that in the other

rollers the cylindrical parts of the loom to which the warp is attached top and bottom. The warp is stored on the top roller, and moves to the bottom roller as the tapestry is woven

running weft when the weft is woven at an angle across the warps over a previously woven shape (eccentric weft) to give a sense of directional movement

sett the desired warp spacing to the inch or centimetre

sew as you weave the process of sewing together the slits that happen naturally in tapestry weaving where two colours meet

shed the open shed is created by the weaver sliding his hand between the front and back warps already separated by the dividing rod. The closed shed is created when the weaver pulls the back warps forward, completing a pass of weaving

steps the increasing and decreasing of passes of weaving to form shapes such as curves and diagonals

sheep on the hills a defect that occurs when the weft is pulled too tightly or when too thick a weft for the warp sett is being used: the warp threads show between the passes as small white dots

slits openings that appear when two woven shapes abut. A slit occurs when three or more passes build up on the same warp

spool a cylinder-like reel onto which weaving material is wound from hanks and then in turn wound onto bobbins

tapestry weaving differs from all other ways of weaving as the weft does not travel the whole width of the loom (discontinuous weft). The warp is completely covered by the weft threads (weft faced), allowing individual shapes to be built up

tapestry woven on its side/as you look at it figures, trees, flowers and indeed all things with a vertical emphasis are more easily woven across the warps, or on their side. Traditionally Gobelin tapestries

were always woven on their side for this reason. In contemporary tapestry the decision as to whether to weave a tapestry on its side or as it is viewed is based on the image to be woven, considering artistic, technical and economic criteria

tracing tapestry designs are often traced onto acetate and then enlarged to full size to become the working drawing or cartoon

translation developing and adapting an artwork created in another medium into that of tapestry

turn back/padding an extra piece of weaving at the start and finish of a tapestry that is sewn back when the tapestry is cut from the loom

verdure describes tapestries or passages of tapestries where the subject is largely of foliage and forest scenes

warps the threads that are the foundation of a tapestry. These can be made of wool but are now more commonly cotton. The warps are attached to the top and bottom of the loom and are kept under tension during weaving

weft the material woven between the warps. It forms the structure, but most importantly creates the design or image

wpi an abbreviation for 'warps per inch'

BIBLIOGRAPHY

The principal archive resource used in the compilation of this book is the Dovecot Studios archive to 2000, which forms part of the Bute Archive at Mount Stuart. As this is currently uncatalogued, it has not been possible to footnote its information.

Publications, catalogues and articles on Dovecot Studios

Cumming, Elizabeth, 'The Marquess of Bute and the beginnings of the Dovecot Studio', *The Journal of the Scottish Society for Art History*, vol.2, Glasgow, 1997, pp 10–23

Davies, Ivor, *Tapestries from Dovecot Studios*, Talbot Rice Art Centre, Edinburgh, 1975

Grierson, Douglas, 'A weaver's view: 35 years of *Desert Island Discs*', *Edinburgh Sessions: A Tapestry Seminar*, unpublished transcript, Edinburgh College of Art, Edinburgh, 1998

Hedlund, Ann Lane, 'Scotland: understanding handwoven tapestry – Archie Brennan and the Dovecot Studios', *Gloria F. Ross and Modern Tapestry*, Yale University Press, London and New Haven, 2010, pp 39–57

Hodge, Maureen et al, *Master Weavers: Tapestry from the Dovecot Studios 1912–1980*, Canongate, Edinburgh, 1980

The Jubilee of Dovecot Tapestries 1912–62, The Scottish Committee of the Arts Council of Great Britain, Edinburgh, 1962

R.M., 'Contemporary British tapestry', *The Ambassador*, vol.7, 1949, pp 126–9

Paul, Iain, *Dovecote Tapestries at Gladstone's Land, Lawnmarket, Edinburgh*, The Saltire Society, Edinburgh, 1950

Soroka, Joanne, *The Edinburgh Tapestry Company 1912–1985*, Edinburgh College of Art, Edinburgh, 1985

Thomson, W.G., *A History of Tapestry from the Earliest Times until the Present Day*, Hodder & Stoughton, London, 1930, pp 160–79

General publications

Adamson, Glenn (ed.), *The Craft Reader*, Berg Publishers, Oxford, 2010

Albers, Anni, *Anni Albers: On Weaving*, Studio Vista, London, 1965

Arthur, Liz, *Robert Stewart Design 1946–95*, Glasgow School of Art in association with A&C Black, London, 2003

Blast to Freeze: British Art in the 20th Century, Hatje Cantz, Ostfildern-Ruit, 2002

Cumming, Elizabeth, 'Living tradition or invented identity? The restructuring of the crafts in post-war Edinburgh', *Obscure Objects of Desire? Reviewing the Crafts in the Twentieth Century*, Crafts Council, London, 1997, pp 66–72

Cumming, Elizabeth, *Hand, Heart and Soul: The Arts and Crafts Movement in Scotland*, Birlinn, Edinburgh, 2006

Harrod, Tanya, *The Crafts in Britain in the Twentieth Century*, Yale University Press, London and New Haven, 1999

Klein, Bernat and Jackson, Lesley, *Bernat Klein: Textile Designer, Artist, Colourist*, Bernat Klein Trust, Gattonside, 2005

Lurçat, Jean, *Designing Tapestry*, Rockliff, London, 1950

Oddy, Revel, *Archie Brennan Tapestry*, Scottish Arts Council, Edinburgh, 1971

Phillips, Barty, *Tapestry*, Phaidon Press, London, 2000

Wilcox, Timothy and Penney, Caron, *Tapestry: A Woven Narrative*, Black Dog Publishing, London, 2011

EDITOR'S ACKNOWLEDGEMENTS

This book owes everything to its many and varied contributors – Dovecot's weavers and artistic directors, the artists, the patrons and the owners of the Studios past and present – without whose pursuit of excellence in tapestry and related textile art there would be nothing to discuss or publish. To attempt a major studio's history from so many varied perspectives has been a challenge but a rewarding one. There are so many others also to thank by name for their support in realising this aim. Lord Bute, Andrew McLean, formerly Bute archivist, Lynsey Nairn and Barbara McLean were immensely helpful and allowed access to Dovecot's remarkable tapestry archive during 2010 and 2011. Fiona Mathison and Douglas Grierson were tireless in their ready responses to my endless queries and kindly commented on an early draft of my essay; Dovecot's current weavers David Cochrane, Naomi Robertson, Jonathan Cleaver, Freya Sewell and Emily Fogarty enormously helped my appreciation of this special craft. Peregrine Bertie, David Bertie, Eileen Lauder, the late James More, Joanne Soroka, Maureen Hodge, Tom Phillips, Joyce Conwy Evans, Liz Arthur, Janet Barnes, Anthony Blee, Rosalind Marshall, Ann Lane Hedlund and many others gave generously of their time to share their knowledge with me, as did Dovecot gallery manager-turned-doctoral student Francesca Baseby. David Sumsion and the Lobnitz family were especially kind in opening their collections.

At Lund Humphries, Lucy Myers and Lucy Clark responded warmly to the proposal and have supported it helpfully all along. My sincere thanks are also due to Abigail Grater for her thorough and sensitive copy-editing and to head of production Miranda Harrison, Sarah Thorowgood, and designers Caroline and Roger Hillier for making a beautiful book. At Dovecot, production of the book would have foundered completely without Gráinne Rice who, with Katrin Davidson, gathered the book's images: Gráinne also skilfully negotiated the case study texts, and dealt with many and varied problems. Antonia Reeve with Ron Anderson travelled the country to take many of the beautiful photographs published here for the first time, and Dr Elizabeth Goring carefully helped edit the final texts. The costs of production have been substantially borne by the Dovecot Foundation established by Elizabeth and Alastair Salvesen as part of its strong commitment to celebrating the centenary of the studio. The Carnegie Trust for the Universities in Scotland, the Pasold Research Fund and the Inches Carr Trust all contributed to my own travel expenses to work in the archives and in search of fine work woven by Dovecot, and to them all I am deeply grateful. In this Olympian year my husband Murray, bored with hearing the word 'Dovecot' morning, noon and night for the past two years, deserves a gold medal.

Elizabeth Cumming

PICTURE CREDITS

Every effort has been made to identify copyright holders of the photographs in this book. Further information is always welcome and should be addressed to the publisher.

INDEX